Picasso *The Artist of the Century*

Designed and edited by

ALBERT SKIRA

Picasso *The Artist of the Century*

Text by

JEAN LEYMARIE

with appreciations by poets and friends of the artist

A Studio Book

THE VIKING PRESS

New York

On the binding: *Portrait of Jacqueline*, linocut. 1966.

PICASSO: MÉTAMORPHOSES ET UNITÉ
© 1971, by Editions d'Art Albert Skira, Genève

Translated from the French by James Emmons
English language translation Copyright © 1972
by Editions d'Art Albert Skira, Geneva, Switzerland

Published in 1972 by The Viking Press, Inc.
625 Madison Avenue, New York, N.Y. 10022

Published simultaneously in Canada by
The Macmillan Company of Canada Limited

SBN 670-55319-0

Library of Congress catalog card number: 72-79156

Printed and bound in Switzerland

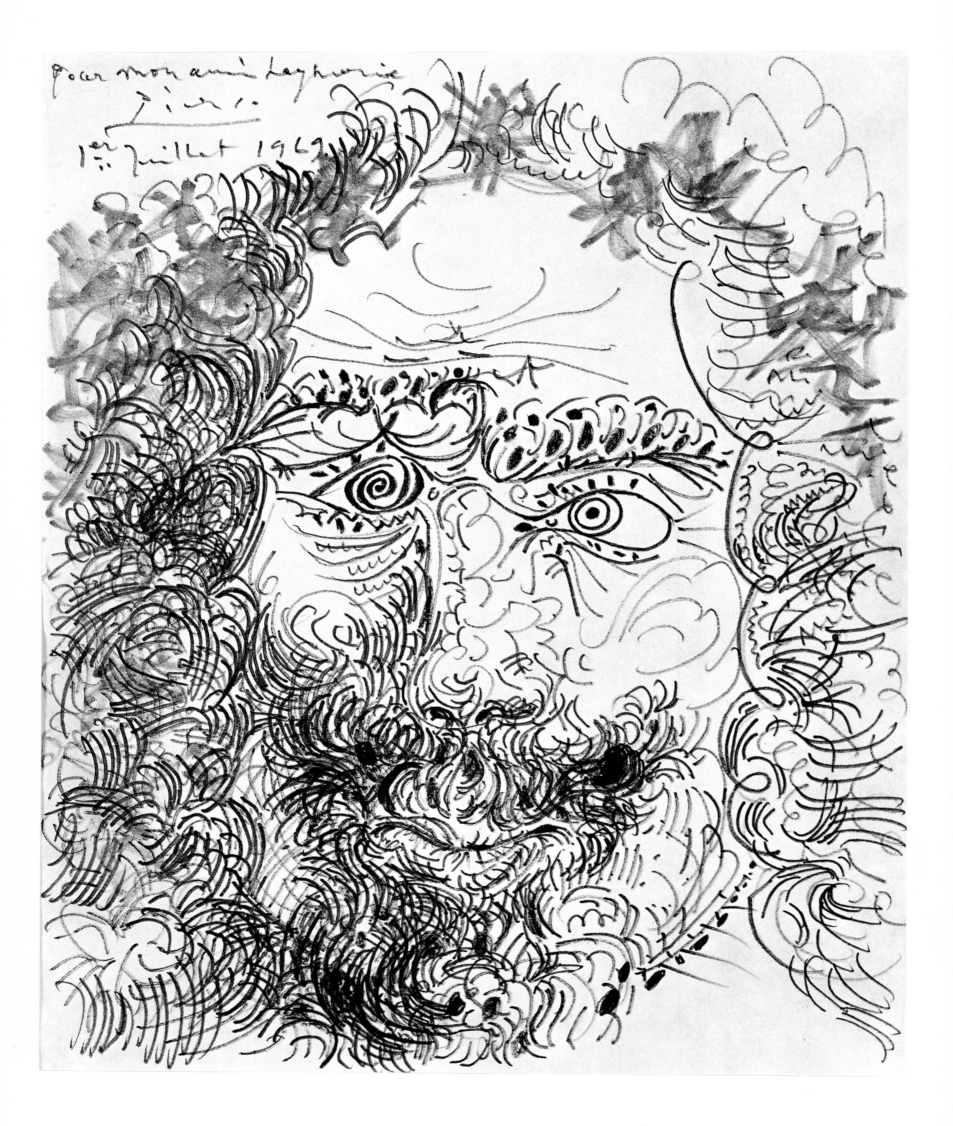

Introduction

Picasso once told me that I would never write a book on him, because a new one would have to be written every day. That, indeed, would be the only way to keep abreast of this rare courser who prevails over time by living and working constantly in the ardor of the *present*. His unexampled fecundity, kept up to the most demanding standards, already spans a working life of some thirty thousand days. "Picasso," declared Albert Einstein, "fully justifies the saying which has it that man and the world are daily created by man."

While circumstances have led me to take part in this book, which is intended for a wide public and not for specialists, my written contribution to it remains voluntarily limited, for its essential value lies in the orchestration of pictures and accompanying texts—statements by the artist himself and poems and appreciations by his friends.

"It is not what the artist does that counts, but what he is," says Picasso. How then is one to speak of the man and how is one to *identify* the demiurge? Some six years ago, after a dizzying sweep through the Egypt of his memories and his old homes, as he helped me to draw up the program of the Paris exhibition commemorating his 85th birthday, he made this remark: "In short, this is the inventory of someone with the same name as myself."

His first French friend, Max Jacob, who shared his early poverty and believed in his star, might perhaps have had some revelations to make, but he refrained from doing so. In a letter of 11 January 1917 to Jacques Doucet, the collector who, acting on the advice of André Breton, acquired *Les Demoiselles d'Avignon*, he stated his reasons frankly: "I have written nothing on Picasso. He dislikes being written about. He abhors incomprehension and indiscretion, and I feel so much respect and gratitude towards him that I would not want to do anything to displease him. I have seen how pained he has been by the behavior of our best friends, and I will not imitate it. Certain friends have lived on his name, making the most of gossip, tittle-tattle and idle fancies. Later perhaps... we'll see... but much later and in fact, I do believe, never. Our common memories are something very sweet, very holy and often so very sad." Ten years later, however, Max Jacob summed up his memories in three pages in which all the chronological references are inaccurate, but whose inimitable tone is absolutely right. He recalled, in the days of poverty, their love of mimicry and the need they felt to run over the human keyboard with a light and humorous touch. "In the evening, since we could not afford to go to the theater, we would make up plays of our own under the oil lamp. We would take all the roles in turn, including the stage manager, the electricians and the stage-hands, all of whom we brought into the play." A little later he referred to the ascetic diet which Picasso imposed on himself and which he has never ceased to observe, for the sake of his health—in other words, to preserve his powers of work. "His magnificent stoicism is the image of his whole life, indeed of a character and spirit of which I have never seen the like."

Picasso sometimes keeps whole sections of his work secret if, as it seems to him, the time is not ripe to disclose them, but he gladly encourages any steps in the direction of a serious approach to his creative work. On 6 December 1943, to

Brassaï who was taking photographs in his Paris studio, he said: "That will be an amusing photo to see, but it won't be a 'document'. And do you know why? Because you have moved my slippers. You have put them in a place where I never put them. That is your arrangement, not mine. Now the way an artist disposes things around him is as revealing as his works. I like your photos precisely because they are truthful. The ones you took in Rue La Boétie were like a blood test from which one might analyze and diagnose what I was like at that time... Why do you think I date everything I do? Because it is not enough to know an artist's works, you also have to know when he made them, why, how, in what circumstances. Some day there will probably exist a science—let's call it the 'science of man'—which will attempt to go more deeply into man by way of the creative individual. I often think of that science and I want to leave posterity as complete a record as possible... That's why I date everything I do." So the real work of exegesis has yet to begin. This book is an overflight of the unknown planet which coming generations of seekers will have to explore. It has been said that the understanding of Rembrandt was one of the great achievements of the nineteenth century. When will Picasso be fully understood?

If I take leave to reproduce as frontispiece one of his marvelous recent drawings bearing date and dedication, the reason is that he made this drawing before my eyes, in definite circumstances which I could relate, for the express purpose of showing me one of his personal working methods—a method distinct from that of other artists with whom he knew I was comparing him as I watched him at work in all his singularity. Matisse would rework his initial drawing several times in separate drawings, sifting it down to essentials, whereas Picasso proceeds by a progressive accumulation within the same drawing. In the geology of this face with its stratified layers lie the shifting, immemorial depths of the human condition, and in the eyes is the specific intensity of a searching gaze checking to see whether it is rightly seen. Since my attention never flagged during the eager concentration of its execution, what I felt then is also recorded in the drawing, not in terms of any particular likeness but metaphorically, through the emotion conveyed by the eyes of an outsider on whom, at a privileged moment, impinged the eyes of a seer. Thus the singular gaze enclosed in this Rembrandtesque face is the twofold gaze essential to the life of forms. Throughout his work Picasso is haunted by the image of the couple, paired for love or fighting, paired in an artistic relationship or in contemplative fervor—man and woman, horse and bull, painter and model, waking man and sleeping woman. But the motif of the isolated head has assumed increasing prominence of late years. No other structure of the visible world offers so reactive a variety of form or material within so imperious a unity of meaning. "All faces are as old as the world," he remarked to Gertrude Stein, who noted that "in his way Picasso knows faces as a child knows them": he knows them, in other words, in all their spellbinding and redoubtable *nearness*. And if most of the men's faces which he depicts are bearded faces, the reason is, by his own admission, that he involuntarily depicts them with the memory of his father's face at the back of his mind.

The state of trance-like concentration in which he works has not changed since the Blue Period when Sabartès described it: "His attention is torn between canvas and palette but it never leaves either: both stand in his line of sight and he discerns them together. He gives himself body and soul to the work which is the justification of his existence. With a loving gesture he dips the silk bristles of the brush into the oily color pigments to blend and spread them on the canvas, all his senses focused on the sole object before him, as if in the grip of a spell... One can follow by ear the sweep of the brush on the canvas."

His blood and origins are Andalusian, the background and stimuli of his youth are Catalan. Malaga, his native city, overswept at times by the wind and smell of the desert, resonant with Arab chants and the gipsy flamenco, gave him the sense of rhythm and the dark power of the *duende*, the inner demon celebrated by his fellow Andalusian Lorca. "He once told me, as a characteristic mark of his home-town," wrote Cocteau, "that he saw a local streetcar conductor singing at his work,

and slowing down or speeding up his machine according to whether the tune was lively or lilting, while he kept ringing the bell to the rhythm of the song." In Barcelona he joined the anarchist-minded, modernist group which resuscitated El Greco; he combined humanitarian sympathies with the Nietzschean cult of the ego. In 1901 he tried to extend the movement to Madrid and founded there a "sincere" art magazine, *Arte Joven*, in which, alongside impassioned declarations, appeared Goethe's luminous profession of faith in universal harmony and the realm of mothers, together with a significant study of the "psychology of the guitar," "symbol of the popular soul and symbol of emotions, which may be why it has the shape of a woman."

But the three essential moments of his youth were the summer stay of 1906 at Gosol in Andorra, where he achieved a style of his own ("A tenor who reaches a higher note than any in the score. Such was I!"); the early years at Corunna in Galicia, where he attained puberty and asserted his personality, without external influences; and, after the strains of city life in Barcelona and Madrid, the withdrawal of several months to Horta de Ebro, a mountain village on the confines of Aragon. It was at Corunna that he first became aware of his gifts, of his need and power to probe reality, and there, on the death of his sister Conchita, he sealed, with the forces within him, the inviolable pact which set the course of his life. His father, a painter and art teacher, deferred to his irrefragable mastery, handed over his palette and brushes to him and, in the language of the *aficionado*, gave him the *alternativa*. Picasso takes after his father in his fondness for pigeons and his passion for bulls. In June 1898 Manuel Pallarés, a slightly older friend with whom he maintained ties of affection for many years to come, took Picasso with him to his family home at Horta de Ebro. There he recruited his energies, sleeping in caves, bathing in mountain streams, leading the rugged outdoor life of the muleteers and the rude local craftsmen with their age-old technical secrets. "Everything I know," he later declared, "I learned in the village of Pallarés." Having known in my own childhood a peasant way of life not very different, in rural France, I may perhaps claim some insight in this respect. When in November 1966, after the triumphal inauguration of the Homage to Picasso exhibition in Paris, I paid him a visit at Mougins, at a time when he was troubled by personal cares, we dined alone one evening in the kitchen, his wife Jacqueline being unwell, and exchanged memories of peasant life. "We look like Cézanne's card players, " he remarked. Late at night the conversation turned again to artistic matters. "How difficult it is," he said, "to get something of the absolute into the frog pond."

After having measured his strength in Spain, he confronted Paris for the first time in the autumn of 1900. "Here you stand at the gate of the century," wrote the poet Vicente Huidobro, "and in your hand you hold the key to that gate"—what Eluard called so aptly, since it may so easily be warped, "the frail key to the problem of reality." Cubism is a poetics of reality, of the underlying but unconcealable tension between art and reality, worked out through a system of evocative signs or pictorial metaphors. Picasso revolutionized the arts at the beginning of his century, just as Masaccio, Giorgione and Caravaggio did at the beginning of theirs; but they died young, while he has outlived his revolution and goes on marking the century with his inexhaustible powers of self-renewal and the sovereignty of his genius, in the solitary and authoritative manner of Michelangelo.

His vast body of work may be said to fall, first, into stylistic periods defined by reference to color (Blue and Rose periods), to internal exigencies (analytical and synthetic Cubism), to external models (Negro and Cézannesque phases, Ingrism, antique classicism). Then, the syntax and essential repertory being established, it was freely developed in sequences and cycles bound up with the subject (mythology, bullfighting, painter and model, variations on old masters), with technique (engraving, ceramics, drawing, sculpture), with places (Antibes, Vallauris, Cannes, Vauvenargues, Mougins). The coexistence over several years of synthetic Cubism and naturalistic classicism may then have seemed the mark of a versatile temperament torn between its own revolutionary momentum and the call of tradition. In fact, the motivation behind it was different. With him there is neither conflict nor

rupture, but a fruitful dichotomy, a branching out in two parallel directions, one of which is only apparently conventional. In an age of aesthetic relativism, when all the arts of the past have again become contemporary, an age which recognizes the self-justification and autonomy of every style, without giving precedence to any, Picasso feels free to choose the most suitable mode of expression according to the impulse of the moment and the nature of the subject; in a word, he feels free to destroy style in the interests of truthful expression. "Whenever I had something to say, I have said it in the manner in which I have felt it ought to be said. Different motifs inevitably require different methods of expression. This does not imply either evolution or progress, but an adaptation of the idea one wants to express and the means to express that idea." Historical circumstances have made possible the simultaneous use of several registers hitherto mutually exclusive; but they could only be mastered without incurring the reproach of eclecticism or schizophrenia (which Jung misguidedly charged him with) by a personality of such formidable coherence within its inexhaustible diversity. The principle governing his creative powers, acting day in, day out, on a few constant, deeply rooted themes of universal appeal, is not the principle of evolution but the principle of *metamorphosis* and perhaps, on the hillside of Notre-Dame-de-Vie, even that of eternal return.

In 1943, at one of the darkest periods of the war, while making the preparatory designs for the *Man carrying a Sheep*, that simple, solemn shepherd of hope, Picasso also made his famous bull's head by joining together with breathtaking simplicity a bicycle seat and handlebars. "That is all very well," he said. "But the bull's head should have been thrown away immediately afterwards. Thrown into the street, into the gutter, anywhere, but thrown away. Then a working man would come along and pick it up. And he would find that out of this bull's head he might be able to make a bicycle seat and handlebars. And he does so... Now that would have been wonderful. That is the gift of metamorphosis." In the same spirit of illuminating, two-way metamorphosis, André Breton quotes this Zen fable: "Out of Buddhistic kindness, Bashō one day made an ingenious change in a cruel haikai composed by his humorous disciple Kikaku. The latter having written: 'A red dragonfly—tear off its wings—a red pepper', Bashō altered it to: 'A red pepper—put wings on it— a red dragonfly'."

Schopenhauer was struck by Goethe's gaze, by the power of his eyes to expand and express wonder. Poets have celebrated Picasso's gaze, the black diamonds of his matchless eyes which "perhaps never close" (Eluard); which "never wink, for his are the transfigured eyes of faith" (Cendrars); which are "as watchful as flowers always wanting to look at the sun" (Apollinaire). Roland Penrose tells how on a spring evening at Vauvenargues, in 1960, Jacqueline exclaimed with surprise that Picasso was looking straight at the sun. "I have always looked the sun in the face ever since childhood," he calmly replied. In 1932, in an arresting essay in a special Picasso issue of the review *Documents*, which he edited, Georges Bataille established a direct connection between looking straight at the sun and certain Mediterranean rites or myths, the Mithraic cult of the bull, the solar cry of the cock ("always close to the cry of an animal whose throat is being cut"), and the fall of Icarus. And he concluded: "The myth of Icarus... clearly divides the sun in two: the one that shone in the course of his upward flight and the one that melted the wax... when he went too close to it. This distinction between two suns depending on the human attitude is especially important because, in this case, the psychological workings concerned are not devious impulses, attenuated by secondary elements. But it would be pointless to try and trace exact equivalents of such workings in so complex an activity as painting. One may say, however, that academic painting roughly corresponded to a flight of the spirit not carried to excess. Present-day painting, on the contrary, is concerned to break off that flight with a vengeance, in one blinding flash—a concern which has its part in the elaboration or the disintegration of forms. But, strictly speaking, this can only be said to occur in Picasso's painting."

Jean LEYMARIE

On the farthest verge of life, on the confines of art...
Guillaume APOLLINAIRE

The Mystery of Life

The *Woman with a Fan*, which for many years occupied a prominent place in Gertrude Stein's Paris apartment in Rue de Fleurus, has both the vibration of real life (for it is a direct recording of visual reality) and the hieratic stylization of an Egyptian bas-relief. In 1905, as the wave of Fauvism and Expressionism was breaking over European art, Picasso recovered his serenity, after the moodiness of the Blue Period, and painted in all its classical nobility this strange figure suggestive of an Annunciation. Like an emblem of his work, it stands expectantly on the threshold of the unknown world which it is the purpose of art to disclose. The lowered left hand holds the fan, the right is raised in a gesture at once of welcome and farewell. The painter takes leave of the brooding, spectral world which he had been picturing, and which one of his poet friends, André Salmon, evocatively summed up as follows:

The Blue Period.
The cripples and vagrants making their home in a church porch; the mothers without milk; the hundred-year-old Crow.
All the sorrow and all the prayer. The Tumblers. The fat man in red, the slim adolescent acrobats, the wizard Harlequin, the doleful bells and the dismal drum, the girl with a shawl and the White Horse of the never-ending mill, twice again celebrated by Max Jacob.

The Rose Period.
All the mirrors, all the springs, all the window panes, all the nudes. Do you remember, Pablo? Do you remember, Guillaume?... "On the farthest verge of life, on the confines of art... on the farthest verge of art, on the confines of life."
Auto-da-fé. Resurrection.

Art and life meet, their utmost boundaries join, in an atmosphere at first of overwhelming sadness, then of nostalgic evasion. This monochrome, almost uniform background whose motivations have been so much inquired into has a symbolic radiation as simple as it is immeasurable—the sky at twilight and the earth at dawn, the cold blue of limbo and the tender pink of deliverance. He aimed at creating a spiritual space necessary to the mystical resonance of his themes, and its neutrality permits the miraculous line to attain its required deployment. After a phase of chromatic violence and often sarcastic observation of outward scenes, in the streets and cafés, there was a change of mood and he began raising those unanswerable questions which are called forth by the mystery of existence and the fatality of destiny. Familiar with the romantic but often cruel hardships of Bohemian life, traveling up to Paris three times before finally settling there, and having tried in vain to stir up interest in Madrid for the modernist art in which he had been schooled in Barcelona, he reserved his sympathies for the lonely, wandering outcasts who, like himself, lived on the fringe of society. "He believes," wrote his confidant Jaime Sabartès, "that sadness lends itself to

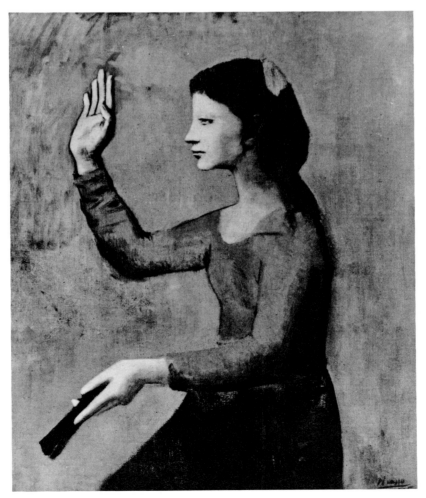

Woman with a Fan, oil. *1905*

meditation and that sorrow is the stuff of life." *The Tragedy* represents three poor folk by the sea: in their mute despair, the hands of the child beating the air, they stand perhaps for the three ages of life, and on the shore fringed with the eternal foam of the sea they embody simply and directly the harrowing universality of the human condition.

The main themes that appear now and will reappear continually throughout his subsequent work—relations between the sexes, motherhood—call for no particular comment, except for the ritual dignity with which they are treated, for they deal with the primordial instincts and constants of human experience.

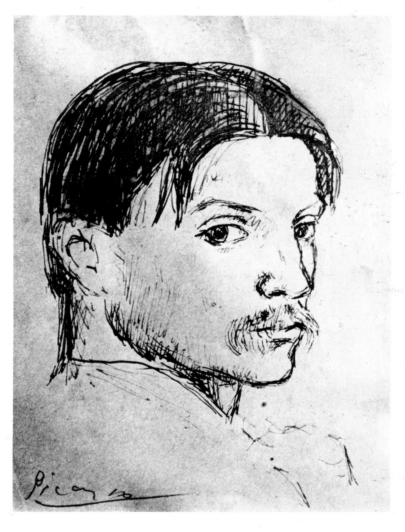

Self-Portrait, pen and ink. 1903

One must note, however, the fear and fascination exerted on Picasso by the figure he so often portrayed of the blind man, whose knowledge of things is tremblingly concentrated in the sense of touch; also his clearly personal identification with the mythical figure of Harlequin who under his fancy costume and jester's cap harbors supernatural secrets bound up with his mercurial agility, his overriding boldness, his collusion in subterranean forces and the kingdom of death. Already present in the Blue Period, and suggested perhaps by Cézanne's painting *Mardi Gras*, which could then be seen in Vollard's Paris gallery, Harlequin dominates the Rose Period, or Circus Period, seen, though, not on the boards but backstage, either alone or among his compeers and pet animals more human than men, the compassionate spectator of sentimental nativities or the protagonist of funeral rites. Harlequin discreetly animates a few cubist pictures and comes into his own again, in the most various forms, in the years of Picasso's collaboration with the Russian Ballet; then, after a long eclipse, he has again come mysteriously to the fore in recent canvases and drawings.

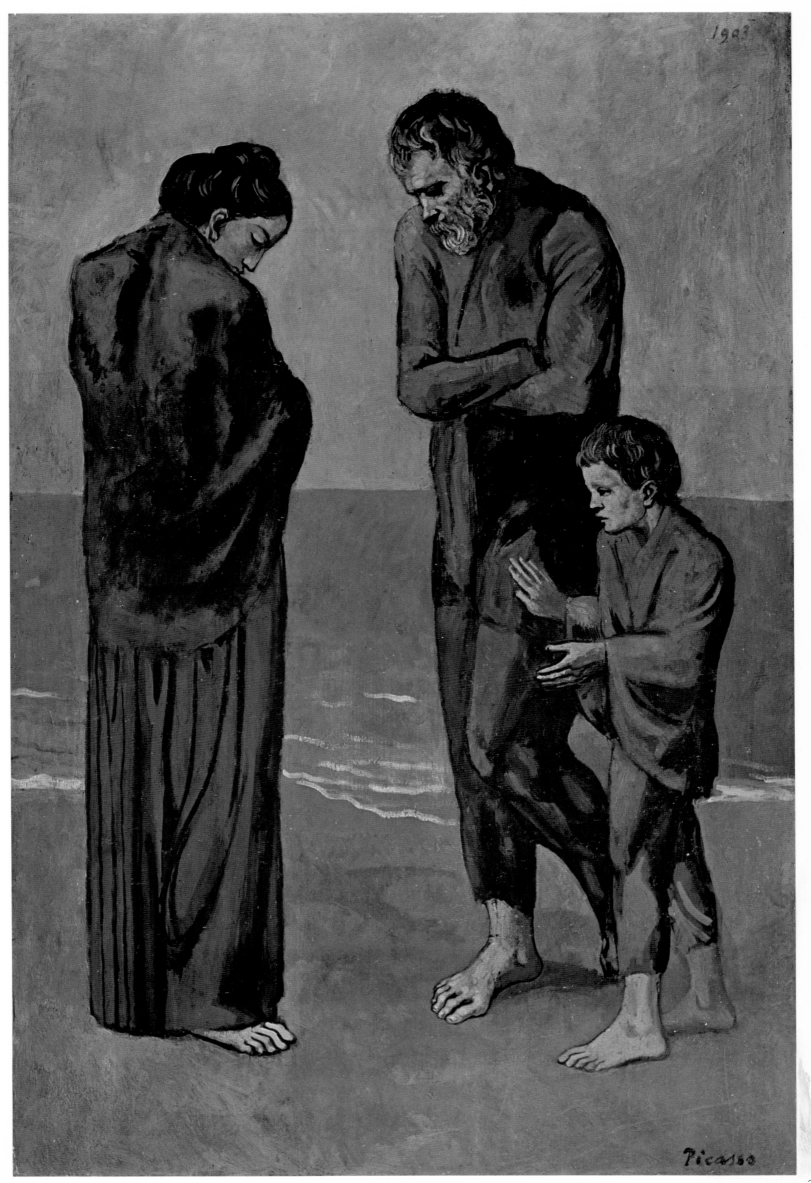

The Tragedy, oil. 1903

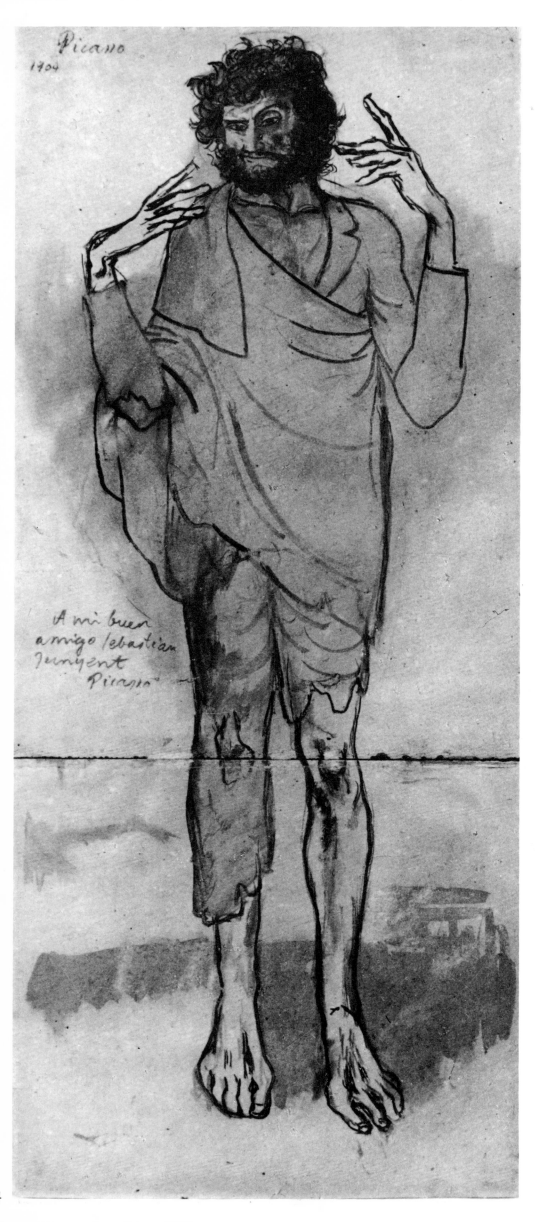

This drawing, grandiose both in its unusual size and its dramatic expressiveness, is one of the last and most arresting of those done in Barcelona in 1904 prior to his move to Paris. Heightened with the light blue watercolor characteristic of this period, it is drawn on two sheets of yellow paper joined together, and dedicated to one of the painter's Catalan friends. Before achieving this monumental synthesis, Picasso had treated several times, in 1902 and 1903, the figure of the idiot *(el tonto)* or the madman *(el loco)* which recurs so often in the Spanish repertory and answers to Picasso's own concern with the most intense and varied exploration of physiognomy and psychology. The mannerist elongation and the angular style reflect something of El Greco, just then being rediscovered with enthusiastic appreciation by the Spanish modernists and directly studied by Picasso himself during a visit to Toledo in 1901.

A preparatory chalk and colored crayon drawing shows *Celestina* under a picaresque aspect and in the traditional guise of a procuress. Every anecdotal reference, however, has disappeared from the corresponding oil painting, which reveals at once the singular individuality of a portrait and the universality of a human type. The old woman, so soberly draped, with the terrible cast in her eye and the long gash of the avid mouth, remains unforgettable in the masterly control of the line and the muted simplicity of the coloring.

The Madman, watercolor. 1904
Celestina or Woman with a Cast, oil. 1903 ▷

I remember the phrases that came to me when for the first time I saw the canvases of the Blue Period:

"Picasso has looked at the human images floating in the blue of our memories... How unearthly they are, these skies all astir with soaring, these lights as heavy and low-lying as those in caves!"

Guillaume APOLLINAIRE, 1912

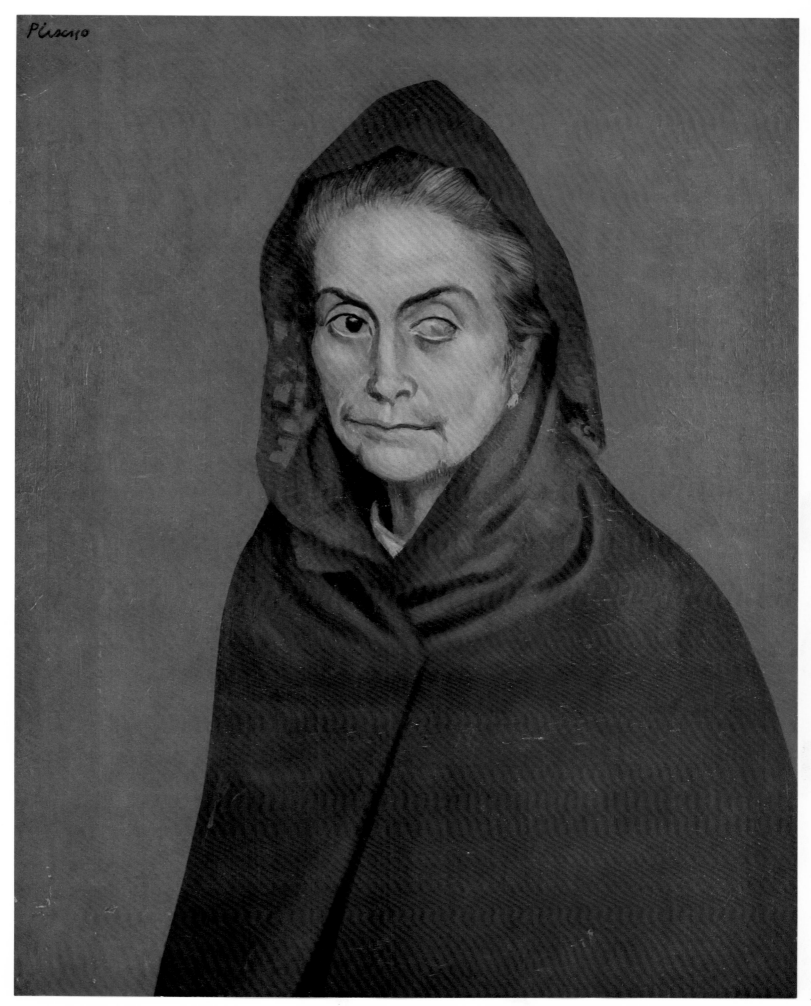

5

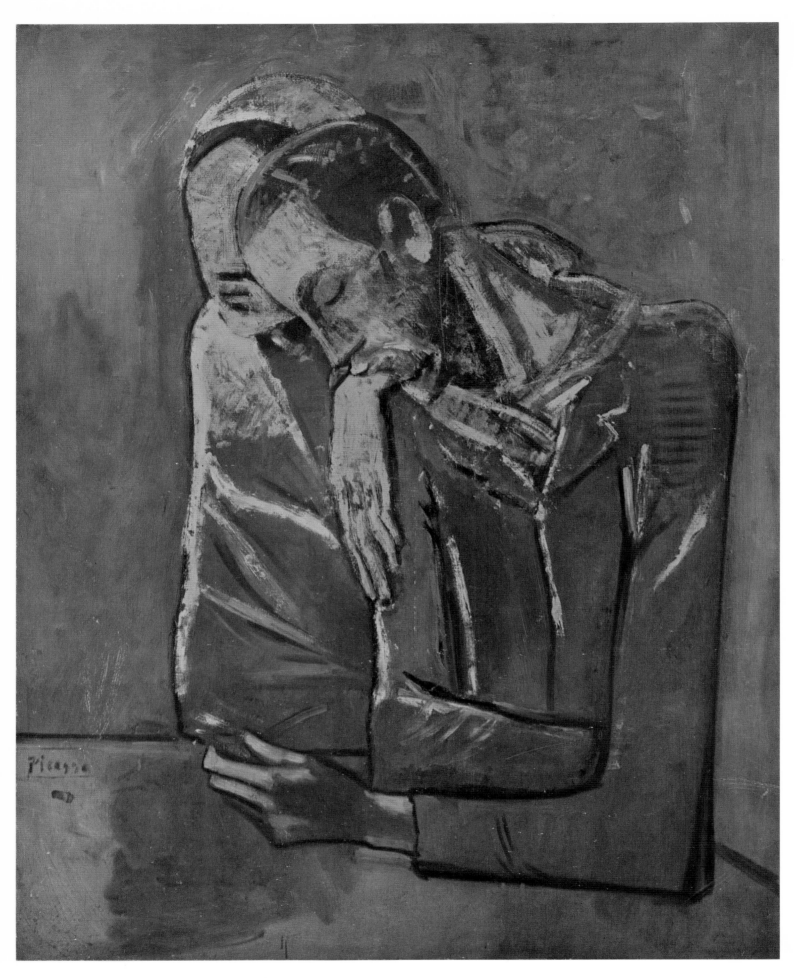

The Couple, oil. *1904*

Everyone was then under the spell of his somewhat fascinating personality—subdued by the prestige of his prodigious gifts, of his so appealingly human art—so cruelly expressive an art, which seemed already to move on a plane of such vast expanse.

Gaunt figures sitting in bars—lean acrobats conveying the sadness of their pathetic attitudes—Rose Period, Blue Period—finally the different qualities begin to merge and something infinitely human and tender arises alongside the Spanish sense of tragedy.

Pierre REVERDY, 1924

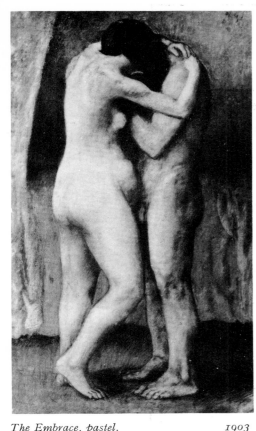

The Embrace, pastel. *1903*

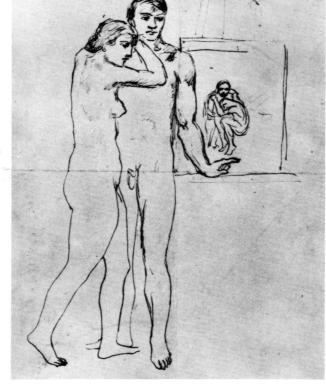

Sketch for "La Vie", pencil. *1903*

Sketch for "La Vie", pen and ink. *1903*

The themes of The Embrace and Mother and Child, to which he often returned, are combined and synthesized in the major canvas of the Blue Period, entitled *La Vie* (Life). Two preliminary sketches, one of them dated "Barcelona, 2 May 1903", reveal its genesis, transformations and personal implications. The standing male nude, with enigmatic gestures, to whom the pregnant woman clings (the same woman represented in *The Embrace*), has at first the features of Picasso himself. In the painted version, however, Picasso substitutes the clearly recognizable features of his friend Carlos Casagemas, who in a fit of despair brought on by an unhappy love affair had committed suicide on 17 February 1901; his mind at that time was haunted by this tragic episode. The picture is an example of those allegorical works treating of human destiny and prompted by sexual obsession which were so frequent at that period; grandiose compositions in a similar vein were painted by Gauguin and Munch. Searching questions arise here from the confrontation between the anguished, denuded couple representing free love and the mother with flowing drapery and swollen feet holding a child in her arms. The mysterious dramatic resonance of the scene is further amplified by the presence of two pictures within the picture: the seated, embracing couple, plainly inspired by Gauguin (whose death occurred at the very time this picture was painted), and the woman below, a crouching figure in forlorn solitude, who brings to mind a famous lithograph by Van Gogh.

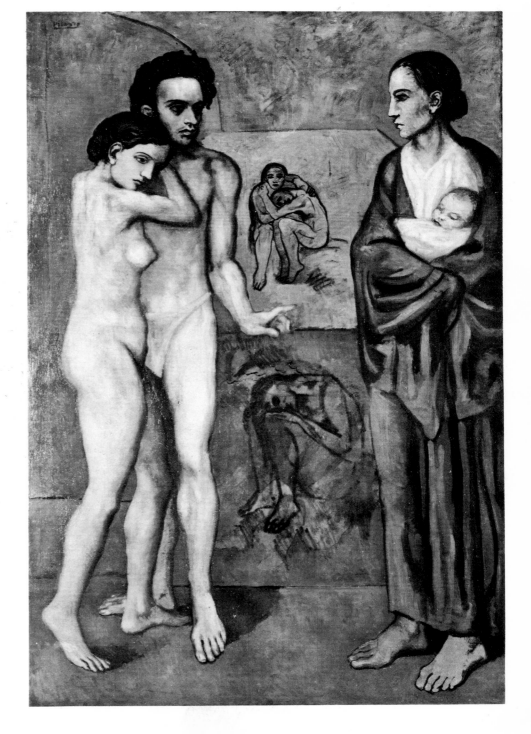

"La Vie", oil. 1903

7

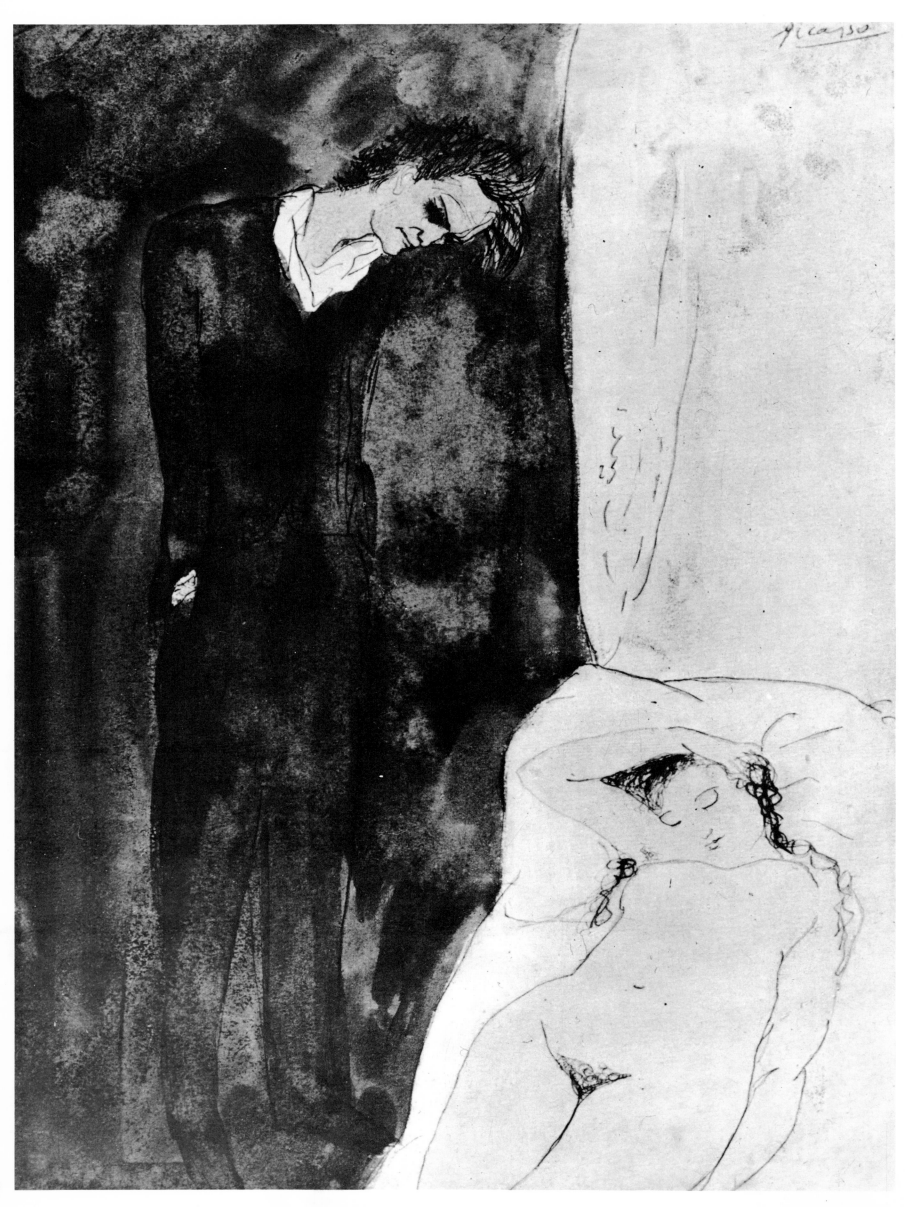

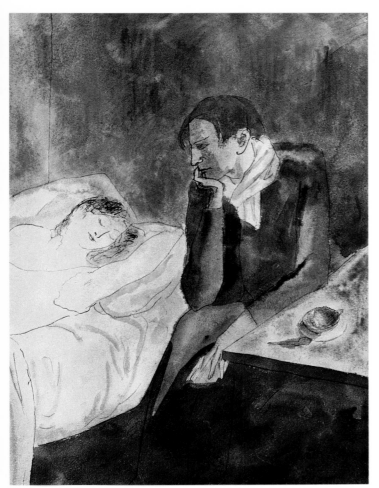

Meditation, watercolor. *1904*

This pen drawing heightened with watercolors was done in Paris in 1904, shortly after Picasso had settled in the Bateau-Lavoir in Montmartre. It is a moving autobiographical document on a theme that obsessed the artist. The man with a lock of dark hair slipping over his forehead, seated in profile between the table and bed, beside a cup of coffee, his aggressive chin cupped in his delicate hand, gazing intently at the splendid young woman, all but nude, sleeping beside him in the peace of her satisfied senses, is clearly a self-portrait; and after the melancholy broodings of the Blue Period, it is the very image of single-minded strength and concentration. Seeing beyond the fascinating and radiant vision before him, Picasso seems to have turned his mind's eye upon himself, trying to fathom his own destiny and the infinite mystery of human relationships.

Sleeping Woman and Seated Man, pencil. *1931*

The relaxed, naturalistic, classicizing vein abandoned in painting after 1925 was continued for many years thereafter in his graphic work, as for example in this magnificent pencil drawing of 1931. The nude couple, one asleep, the other sitting up motionless and thoughtful, undoubtedly answers to a profound emotional motivation in the artist's life, for it recurs periodically in various forms. Sometimes, as here, the woman lies asleep, her arms folded upwards around her head, baring her armpits and breasts, and the man sits awake and thoughtful, but turned away from her; again, as in the ink wash drawings of 1942, the roles are reversed. In the wash drawings of 1947 both figures are women, one of them awake, crouching down and gazing at her companion. The theme appears again in 1967, when the amplified couple, a man and a woman, achieve an awesome and stupendous grandeur.

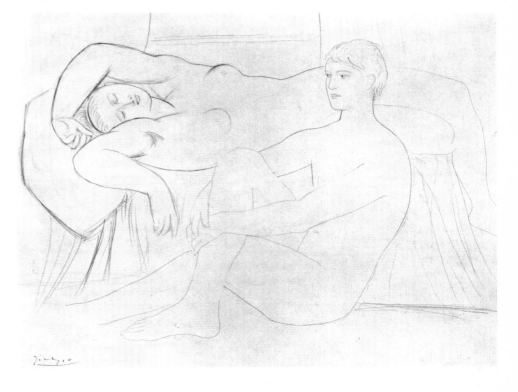

Sleeping Nude, ink and watercolor. 1904
Sleeping Man and Seated Woman, ink. *13 December 1942*

Couple in a Meadow, ink, pencil and gouache. *18 August 1967 II*

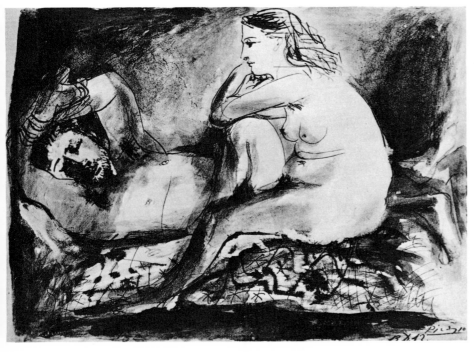

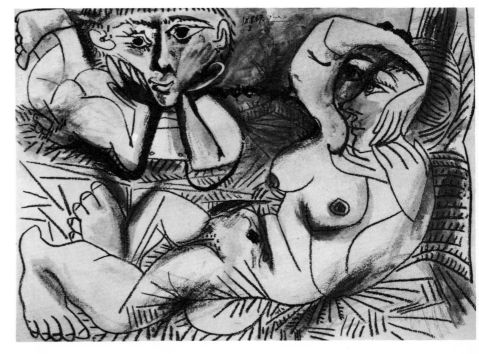

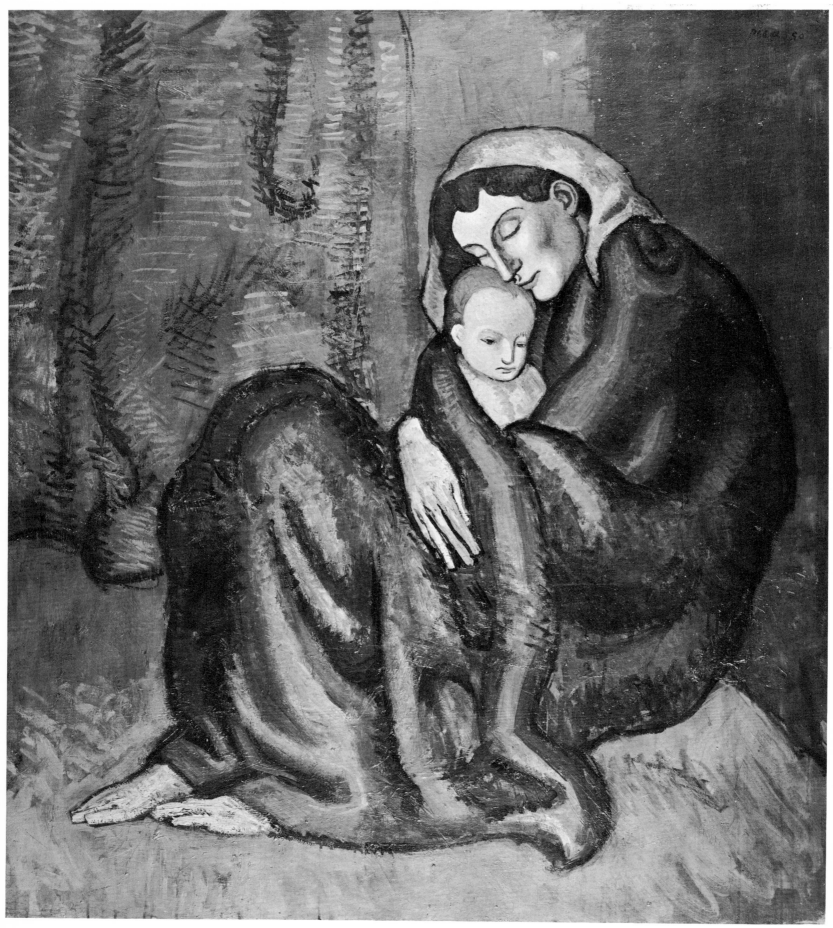

Mother and Child (Maternity), oil.

1901

Wrapped in icy mist, the old men wait unthinkingly, for only the children are lost in thought. Prompted by distant lands, wrangling beasts and hardened chevelures, these old men can beg without humility.

Other beggars have been worn down by life. They are crippled and helpless. They are surprised at having hit the target which has remained blue and is no longer the horizon. Growing old, they have gone mad like kings with too many herds of elephants carrying small citadels. There are some travelers who confuse flowers and stars.

Aging, as oxen die at about twenty-five, the young have taken suckled nurselings to the moon. In pure daylight, some women fall silent, their bodies are angelic and their gazing eyes tremble.

Guillaume APOLLINAIRE, 1905

Seated Woman, oil. 1902

Among the specters of poverty and loneliness stretched out or hunched up against the nocturnal backdrops of the Blue Period, there are two themes which recur with significant insistence: that of the mother and child, and that of the blind man, sometimes young, usually old. In the nineteenth century artists as different as Daumier, Renoir, Carrière and Maurice Denis had painted many Maternities, treating them as secularized Madonnas. Picasso fell in with this modern trend, but a kind of mystical imprint devoid of religious overtones lingers on in the singular expressiveness of his draped figures and in the elongations and linear interlinkings of his style, marked by the influence of Romanesque and Gothic sculpture. Eight Maternities by Picasso date to the years 1901-1902, one of them painted on a portrait of Max Jacob among his books.

Old Man with a Child, watercolor. 1904

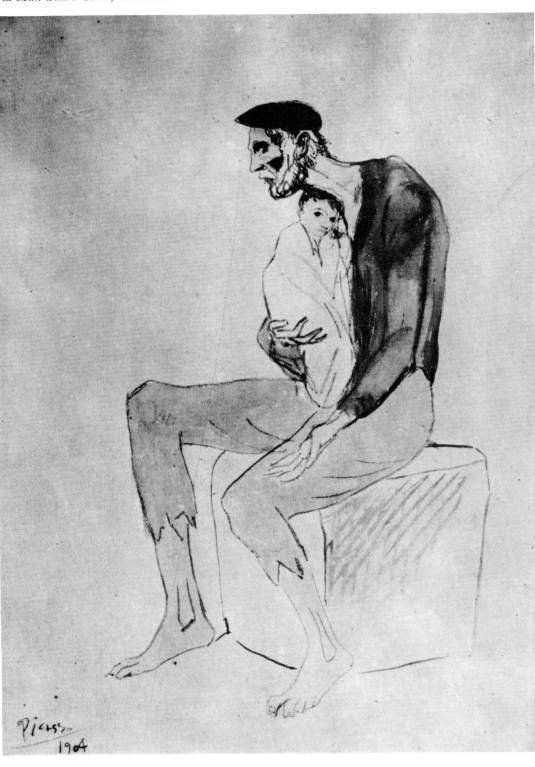

Blindness, so common in Spain, is the physical infirmity naturally feared above all others by a painter, and the thought of it may have haunted Picasso during these years of material worries and illness. Blindness is also a sign of the insight bestowed on poets, especially with the ripe experience of old age, when it may further be compensated by a highly developed sense of touch. The drawing on the following page of two confronted figures, a blind old man with tenderly fostering hand and a young girl looking up with candid gaze, is an image of incomparable tact in which the spareness and purity of the line espouses the delicacy of the sentiment. The figure of the blind man appears at the same period in Picasso's engravings and sculptures.

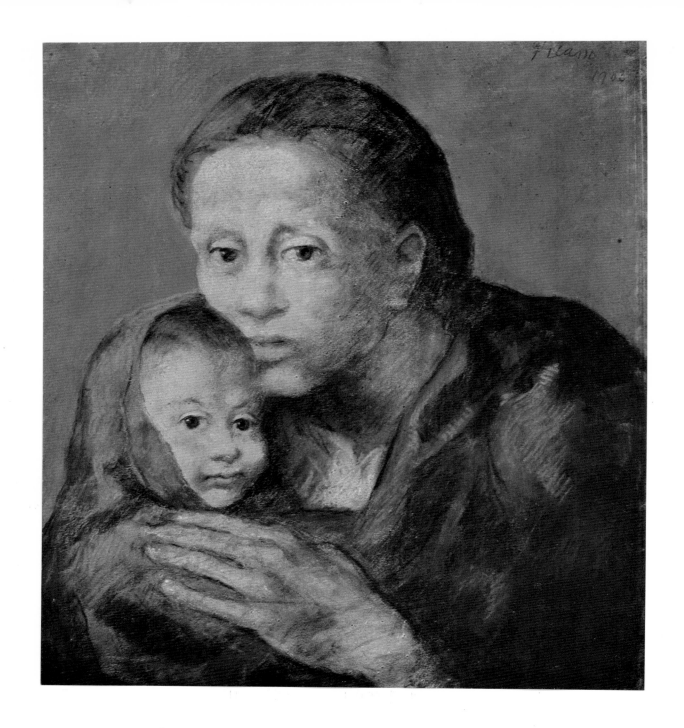

Mother and Child
(The Sick Child), pastel. 1903

Mother holding a Child, pencil. 1904

Though no longer loved, these women remember. They have been going over their brittle ideas too much today. They do not pray; they worship their memories. They crouch in the twilight like an old church. These women have given up and their fingers would stir only to wreathe crowns of straw. With the coming of day they disappear, they have consoled themselves in silence. They have passed through many doors; the mothers protected the cradles to see that the new-born babes were not ill-gifted; when they leaned over them the infants smiled, knowing what good mothers they had.

These women have often returned thanks and the movements of their forearms trembled like their eyelids.

Guillaume APOLLINAIRE, 1905

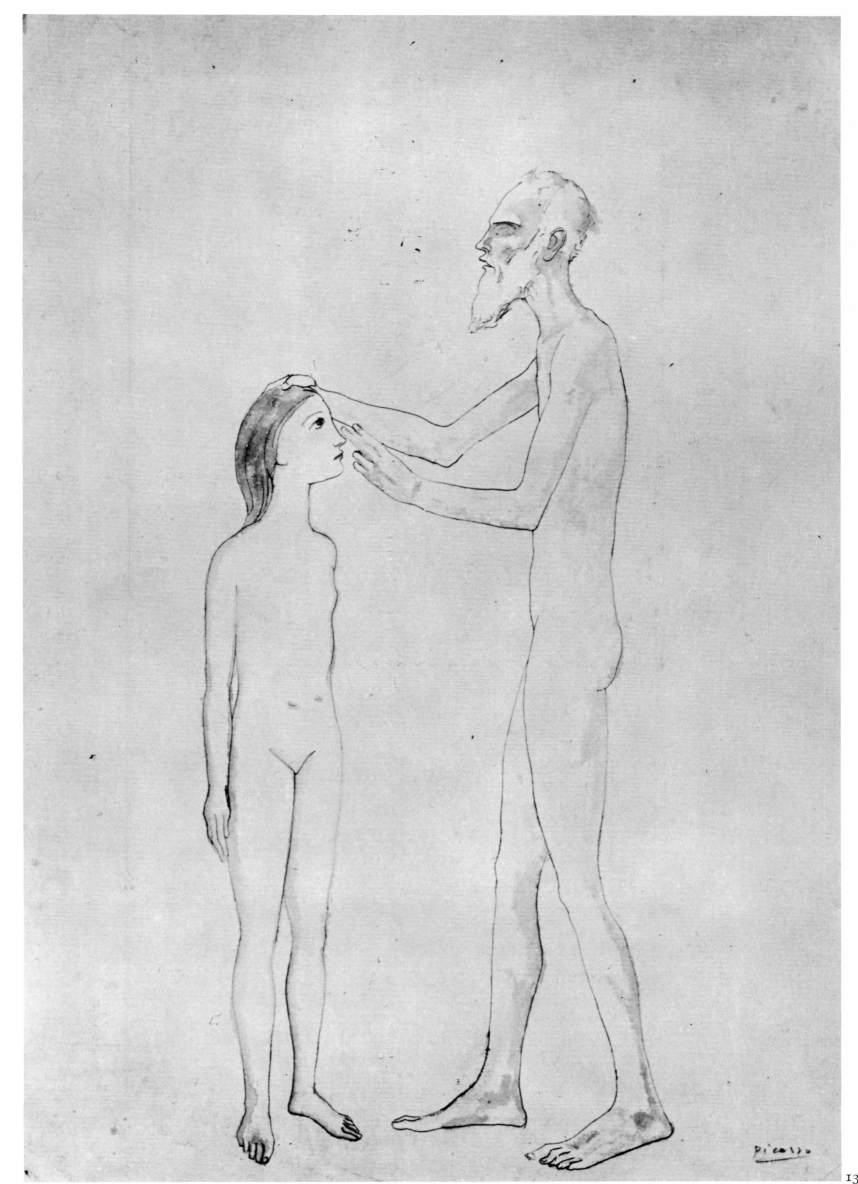

*Old Man
and Young Girl
(The Blind Man),
ink and watercolor.
1904*

13

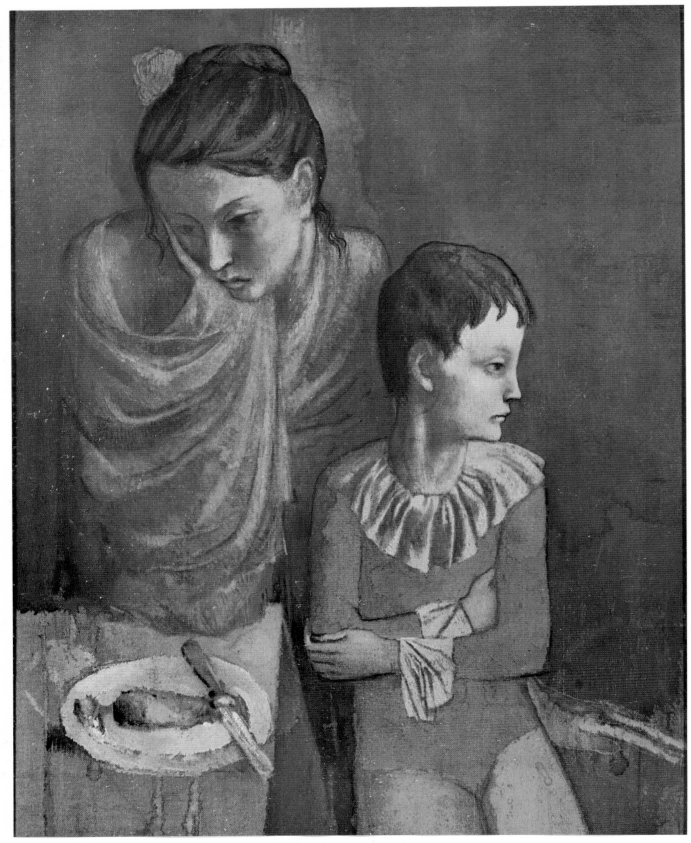

Tumblers (Mother and Son), gouache. *1905*

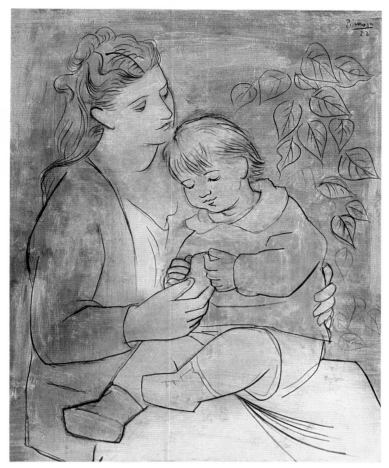

Mother and Child, oil. 1922

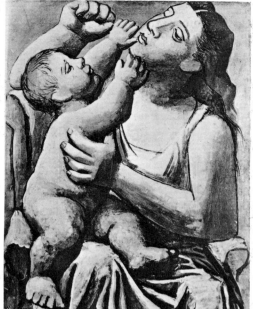

1921

Mother and Child, oil.

1936

Family Group, India ink.

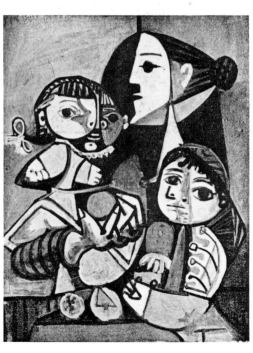

25 January 1951

Mother and Children with an Orange, oil.

The birth on 4 February 1921 of his eldest son Paul, who began to appear in drawings two weeks later, marks the beginning of a new cycle of Maternities very different in mood from the nostalgic Maternities of the Blue and Rose periods. A dozen or so painted versions followed each other in the space of a few months, in the neoclassical style of the moment. A few are treated with a flawless linear naturalism; others, with their fluted draperies, their stone and brick-colored tones, and their powerful build-up of full-bodied volumes, stand before us like enduring, universal monuments.

In 1935, while in the midst of a grave domestic crisis, Picasso became the father of a little girl, Maia, whose mother could not share his home. This is why, in several magnificent wash drawings of February 1936, the family group centering on the child is represented in mythological guise. After the Second World War Picasso settled at Vallauris on the French Riviera and two children were born of his liaison with Françoise Gilot: Claude in 1947, Paloma in 1949. There followed a new sequence of Maternities. The most remarkable of them is the *Mother and Children with an Orange* of 25 January 1951. The mother hugs her two children to her and holds in her hand the fruit of the Mediterranean light and the symbol of joyful fertility.

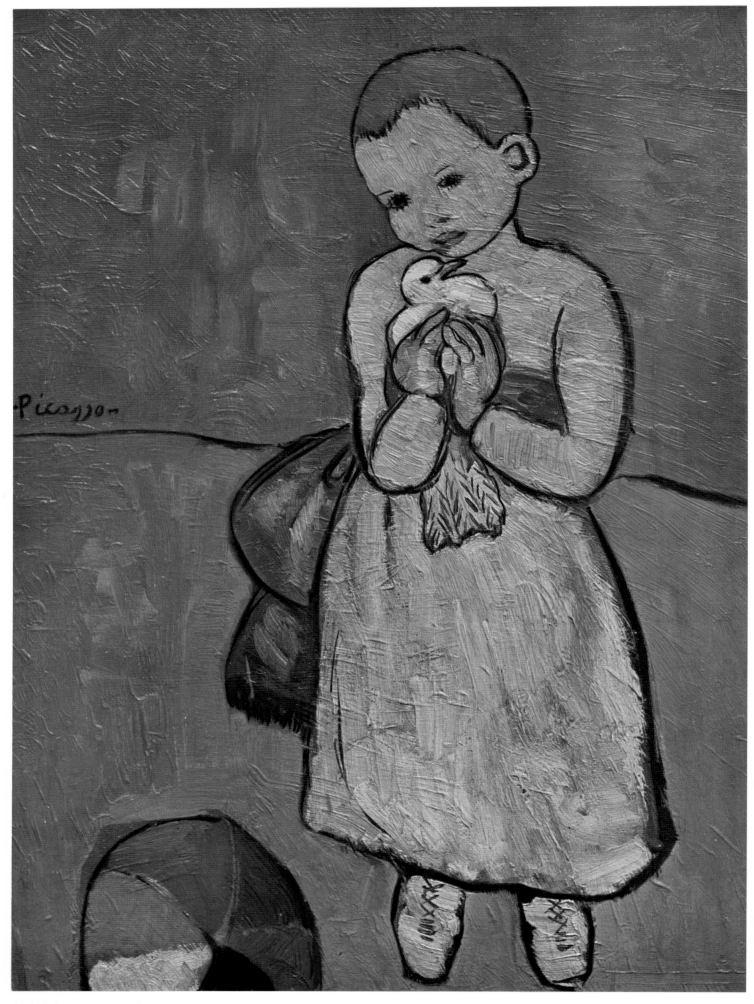

Child holding a Dove, oil.

1901

How can I help thinking of that lighter multicolored ball abandoned at his feet by the "Child holding a Dove" of 1901, which in itself is almost an allegory of the painter's mood at that time? In favor of what or rather of whom is the ball abandoned? Why, in favor of the humble little cluster of gray feathers snuggling in the hands of the child, with his large wide-open eyes, who presses it tenderly to his breast.

Here is a true image of tenderness.

Francis PONGE, 1960

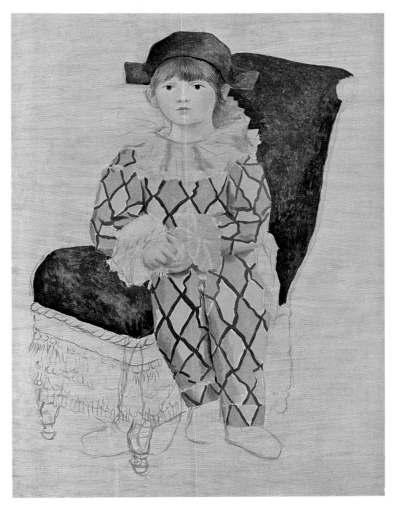

Harlequin (Paul at the Age of Three), oil. *1924*

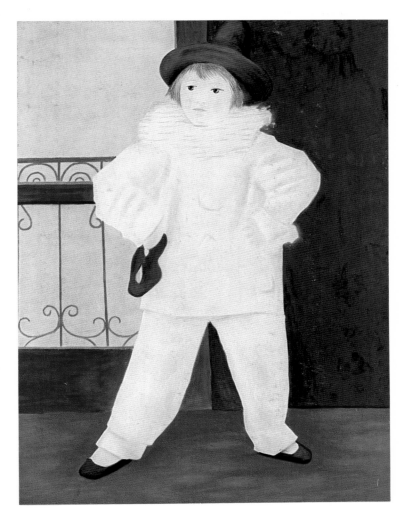

Pierrot (Paul at the Age of Four), oil. *1925*

THE BETROTHAL

<div align="center">To Picasso</div>

Spring lets the perjured lovers roam
And lets blue plumes drift slowly down
From the cypress where the bluebird nests

A dawn Madonna took the eglantine
She'll come tomorrow picking gilly-flowers
To put in nests of doves she destines for
The pigeon which tonight was like the Paraclete

In the lemon grove the last girls to come
Were smitten with the love we love
Distant villages are like their eyelids
And among the lemons their hearts are hung

<div align="center">Guillaume APOLLINAIRE, Alcools, 1913</div>

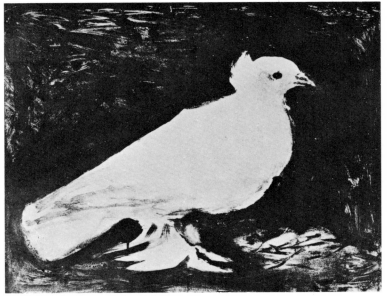

Dove, lithograph. *9 January 1949*

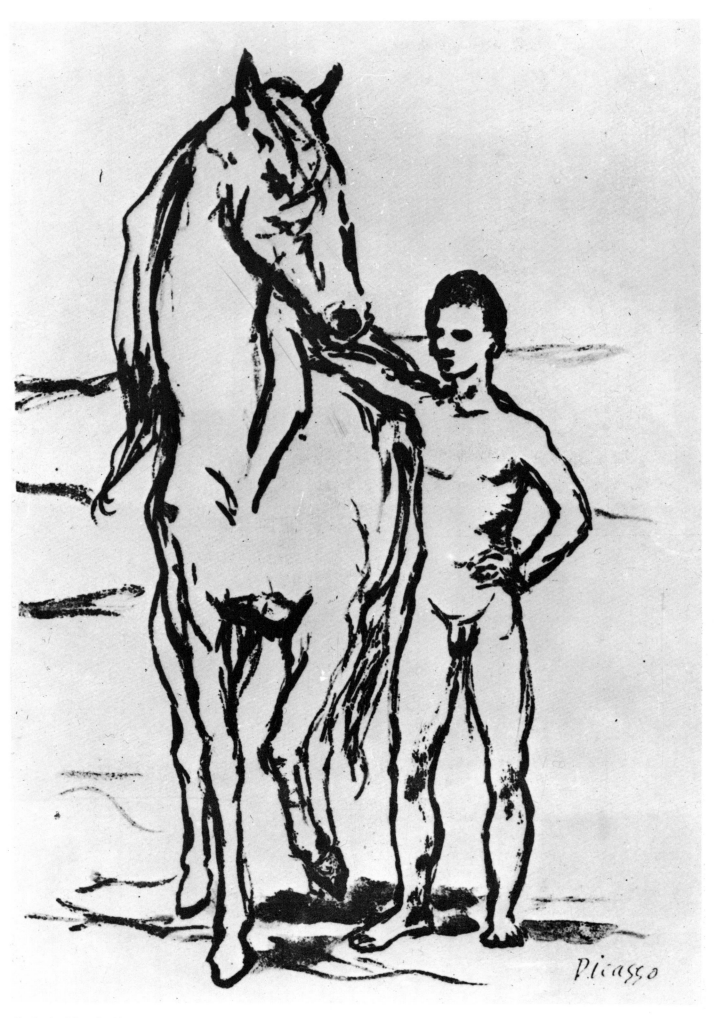

Study for "Boy leading a Horse", brush drawing and sepia wash. *1905–1906*

Maia with a Doll, oil. 22 January 1938

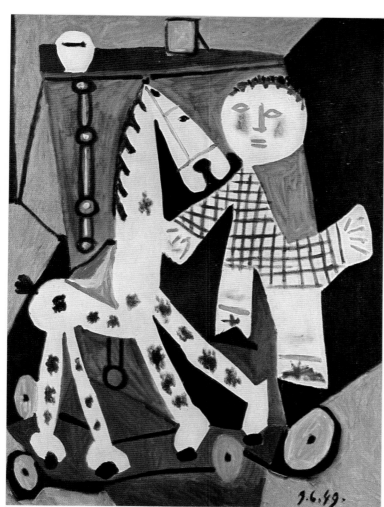

Claude with his Hobbyhorse, oil. 9 June 1949

The children of the Blue Period have no playthings, and indeed hardly seem to be in the mood for playing, while there are no children at all in the strict iconography of Cubism. Later Picasso shows his own children at play; this he does with a father's tender fervor and an instinctive understanding of their magic world of make-believe. Nothing is more serious than the games children play, consisting for the most part of miming the mystery of life and the occupations of adults; in their play-acting there is an undoubted analogy with the act of artistic creation. On the previous page Paul is portrayed in the costume of Harlequin and Pierrot, in small paintings which are marvels of freshness and accuracy. Here Maia holds her horse and doll in her arms, her large glowing eyes turned toward us from her profiled face. In representing little Claude with his hobby horse, Picasso amuses himself in imitating with supreme mastery the naïve colors and lines of children's drawings. Several pictures and drawings show Claude and Paloma separately, in their games and characteristic expressions, but the most charming sequence of all is the one that shows them together, making drawings. In such works as these, done on the spur of the moment in the privacy of his own home, Picasso reveals the superior economy and purity of his means.

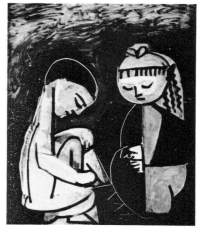

1952

Claude drawing with Paloma, oil.

1954

Claude drawing with Paloma, oil.

1954

Claude drawing with Paloma, oil.

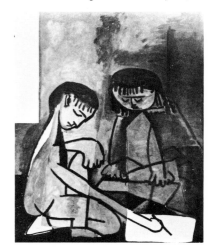

1954

Claude and Paloma Drawing, oil.

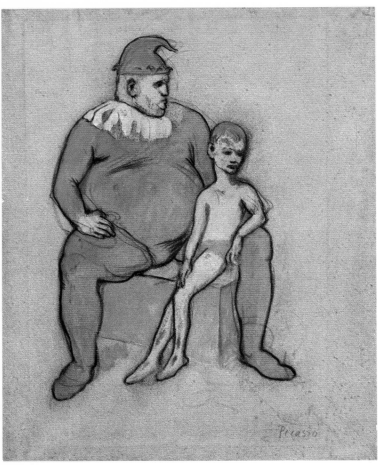

Study for "The Tumblers", watercolor.　　　　　　　　1905

THE DUINO ELEGIES

But tell me, who are *they, these acrobats, even a little
more fleeting than we ourselves,—so urgently, ever since childhood,
wrung by an (oh, for the sake of whom?)
never-contented will? That keeps on wringing them,
bending them, slinging them, swinging them,
throwing them and catching them back: as though from an oily,
smoother air, they come down on the threadbare
carpet, thinned by their everlasting
upspringing, this carpet forlornly
lost in the cosmos.
Laid on there like a plaster, as though the suburban
sky had injured the earth.*

Rainer Maria RILKE, Fifth Elegy, 1922

Translated by J.B. Leishman and Stephen Spender

The Tumblers (Family of Saltimbanques), oil.

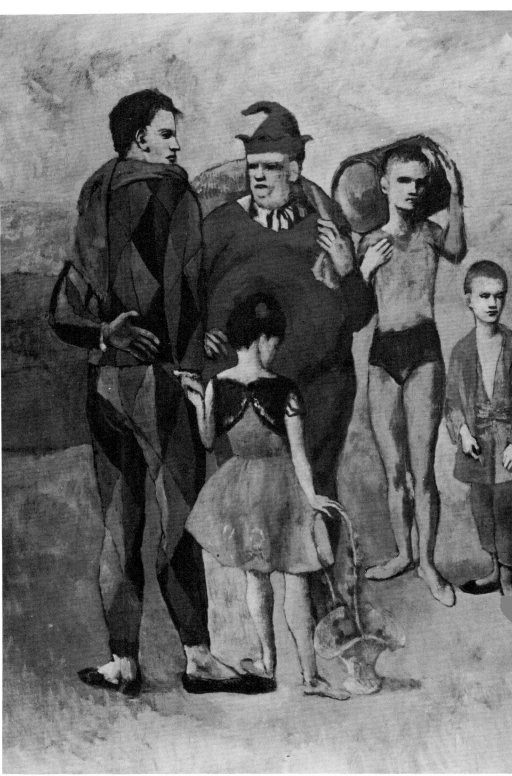

THE TUMBLERS

*In the plain the tumblers go
Their way past garden plots
By the door of dingy inns
Through churchless villages*

*The children stroll ahead
The rest come dreaming after
Each fruit tree acquiesces
When they wave from far away*

*They have weights round and square
Some drums some gilded hoops
The bear and monkey tame pets
Beg for pennies on the way*

Guillaume APOLLINAIRE, *Alcools*, 1913

Apollinaire wrote several poems inspired by the vagabond world of Harlequins and circus folk. This is the central theme of the Rose Period, summed up in *The Tumblers* or *Family of Saltimbanques*. This picture hung in the Munich apartment of Hertha Koenig in 1915, when Rilke, disheartened by the war, lived there for several months, and memories of it inspired him when in 1922 he wrote the fifth of his Duino Elegies.

1905

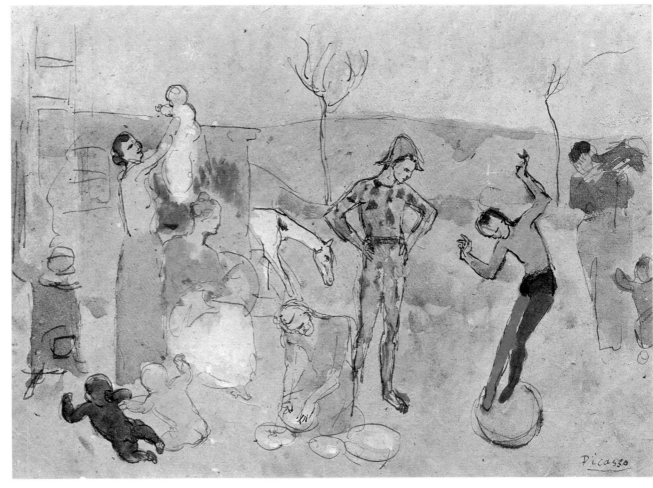

Circus Family (The Tumblers), watercolor and ink.

1905

TWILIGHT

.

Wan harlequin comes on the boards
Salutes the audience and such
Of wizards from Bohemia
And fairies as the house affords

Then having caught a star and pulled it down
He handles it with outstretched arm
While with his feet a hanged man beats
The cymbals presto keeping time

The blind man rocks a bonny child
The doe lopes by beside her fawns
The dwarf looks up with rueful grin
At ever-growing harlequin

Guillaume APOLLINAIRE, *Alcools*, 1913

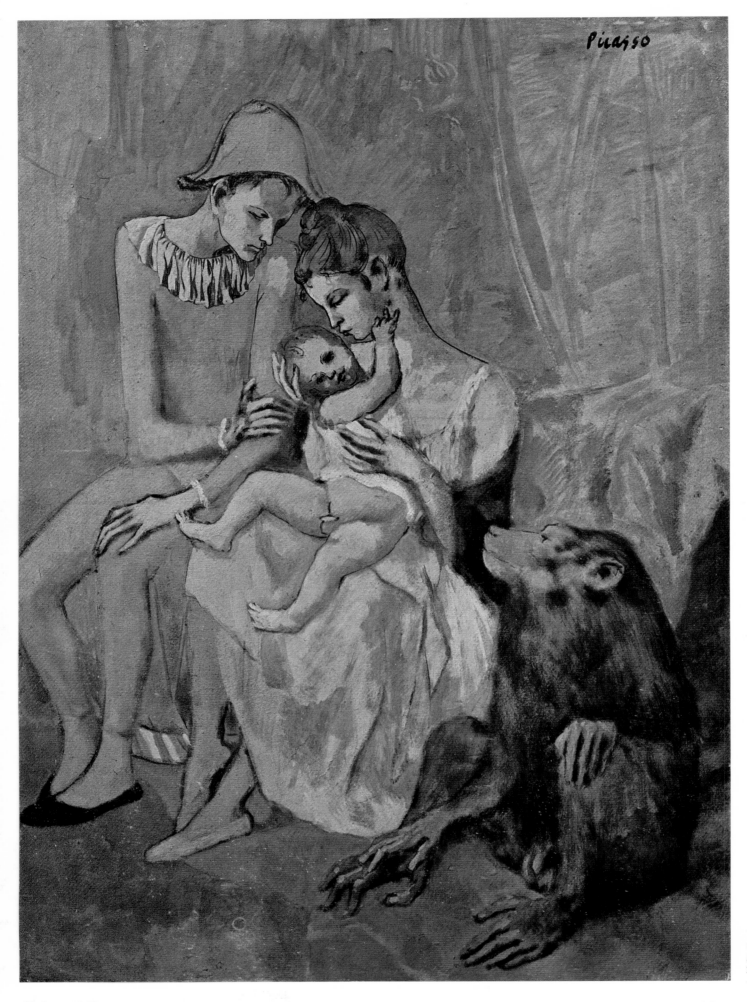

The Acrobat's Family with a Monkey, gouache, watercolor, pastel and ink. 1905

Christmas! The women bred future acrobats among the pet monkeys, white horses and dogs as well as bears. . . These budding adolescent girls have the restlessness of innocence; from animals they learn the religious mystery. Harlequins accompany the glory of the women; and the harlequins resemble them, seeming neither male nor female.

The color has the lusterlessness of frescoes, the lines are firm. But placed at the limit of life, the animals are human and the sexes undefined. Hybrid beasts have the consciousness of Egyptian demi-gods; taciturn harlequins have their cheeks and brow faded by morbid sensibilities.

There is no confusing these circus folk with play actors. Their audience must be religious-minded, for they celebrate mute rites with a difficult agility. This is what distinguishes Picasso from the Greek vase painters whose line his own sometimes approaches. . .

Guillaume APOLLINAIRE, 1905

The "fleeting" acrobats extolled by Rilke and the "wan harlequins" evoked by Apollinaire, to Picasso's mind, called for the lighter texture and sheen of watercolor, pastel and gouache, crisscrossed by the spirited strokes of the pen outlining the slender figures with long sinuous hands. Sometimes the three media are combined and give rise to the major works of this brief period haunted by the backstage figures of circus folk and acrobats. If *The Acrobat's Family with a Monkey*, which gives a glimpse of their private life, illustrates one of the most characteristic themes of modern art and poetry, the composition of the picture keeps, significantly enough, to that of a Holy Family or a Flight into Egypt and even conforms to the canons of Mannerism, in which elegant stylization acts as the vehicle of spirituality. The dog and the crow also accompany Picasso's acrobats, but the monkey, with its expression of superhuman tenderness, belongs to the iconography of the Holy Family; it figures, for example, in one of Dürer's prints on this theme.

The gouache representing the *Death of Harlequin*, lying on his bed with clasped hands, while two young comrades watch over him devotedly, has, in the sobriety of its means, the tragic grandeur of a Pietà. Shortly after its execution, it was bought directly from the artist by the German collector Wilhelm Uhde, who lent it to Rilke. Both Apollinaire and Rilke, each in terms of his personal system of metaphors, divined what is so profoundly implied here by Picasso: that Harlequin's original realm is that of death, whose ferryman he is, and that the "mute rites" of the circus preserve, under their travesty and degradation, a sacred tenor.

Death of Harlequin, gouache. 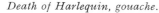 1905

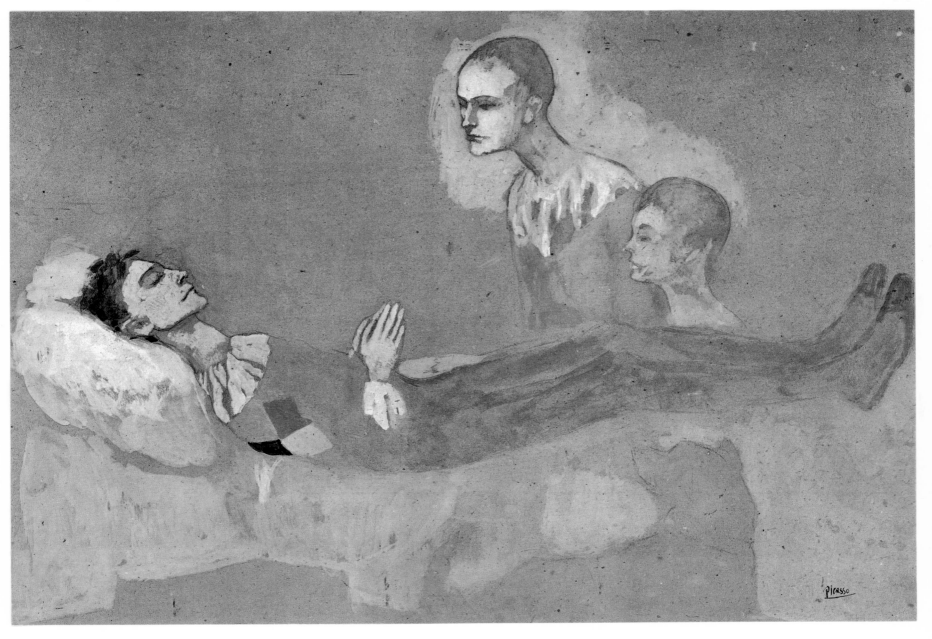

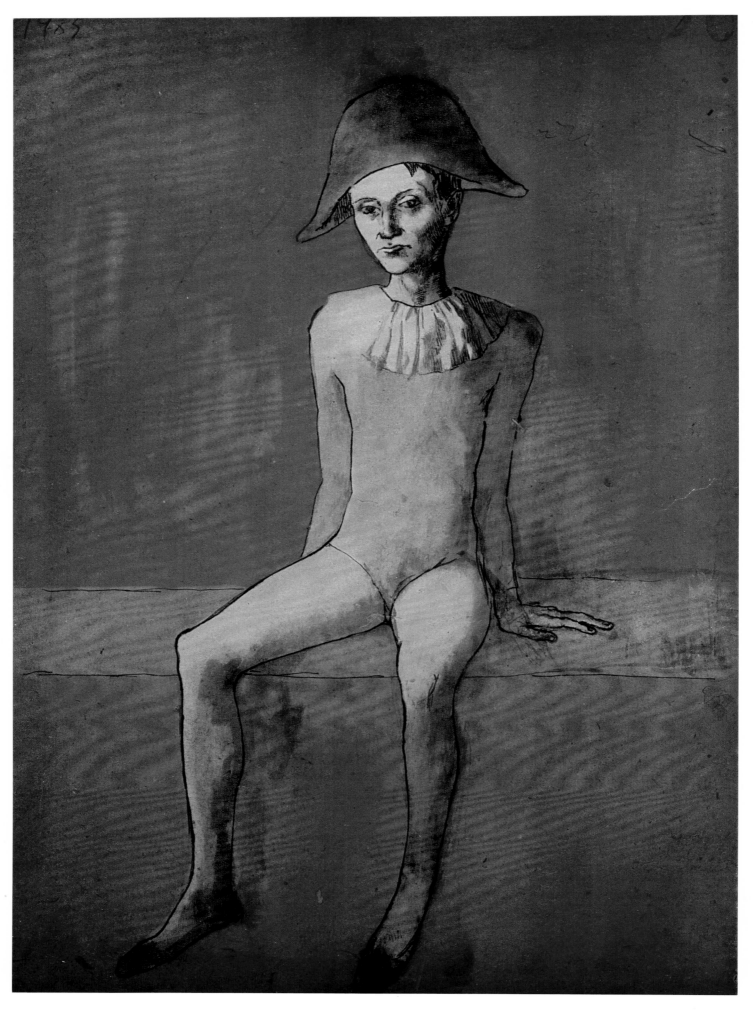

Seated Harlequin, ink and watercolor. 1905

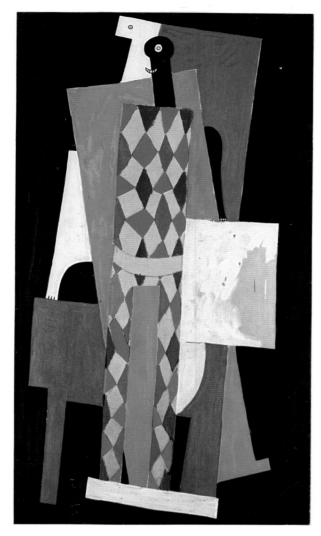

Harlequin, oil *1915*

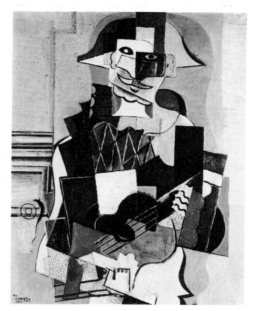

Harlequin with Guitar, oil. *1919*

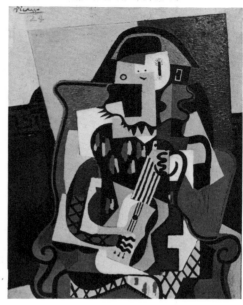

Harlequin with Guitar, oil. *1924*

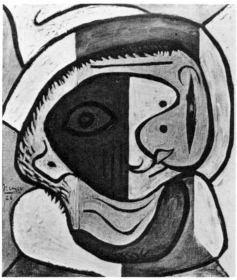

Head, oil. *1926*

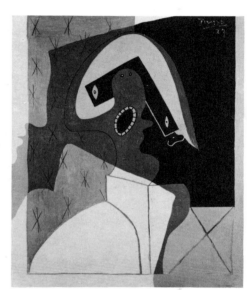

Harlequin, oil. *1927*

Harlequin, with whom Picasso complaisantly identified himself in his early days, disappeared from his work—with rare exceptions—during the phase in which Cubism was being worked out. He reappears in 1915 in a brilliant and startling picture and becomes a stock figure during the period in which the artist worked on stage productions inspired by the Commedia dell'Arte. To his young son Paul, Picasso transferred the costume and attributes of Harlequin, whose figure again disappeared in strange contortions in 1927. The most important of the folded metal cutouts executed in 1961 is a Pierrot Lunaire deriving from Watteau, while Harlequin, brandishing a club, has made an enigmatic and blustering comeback in his painting since 1969.

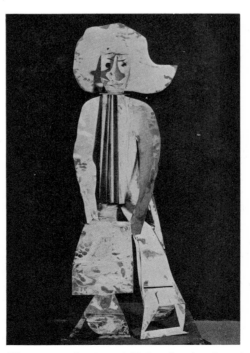

Pierrot, metal cutout, folded and painted. 1961

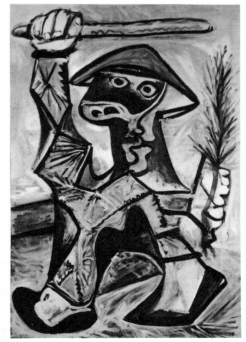

Harlequin, oil. *1969*

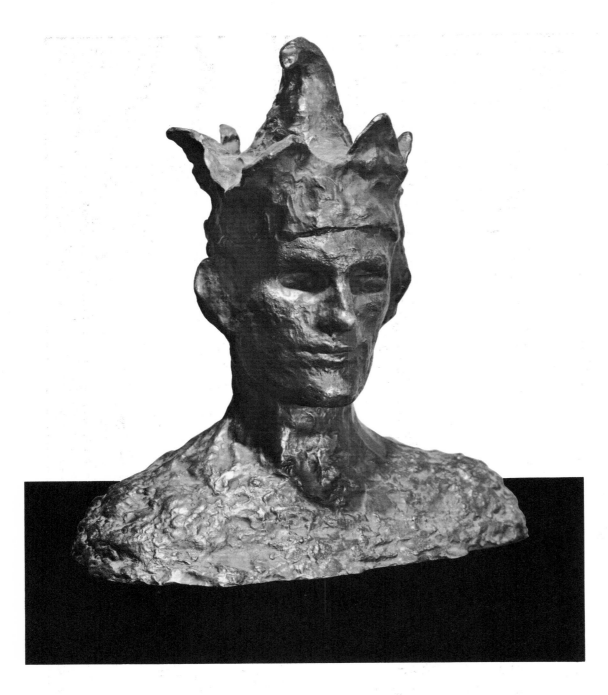

Head of a Jester, bronze. 1905

Picasso's first notable sculpture, cast in bronze by Vollard in 1905, was a bust of a jester or Harlequin wearing a pointed cap; it is connected with many analogous subjects treated in paintings and drawings during that same year. Picasso modeled it in plaster one day on his return from the circus with Max Jacob, who served as the model at the start, but in the end the poet's features were only retained in the lower half of the face. The whole bust was reworked in order to accentuate the vibration of light after the manner of Rodin, but also to impart to the deep eye-sockets that inward gaze which contrasts with the tremulous surface effects and gives the dream-laden figure an air of timeless suspense.

The year 1923, which in the ease and fecundity of his output seemed to her comparable to 1905, was described by Gertrude Stein as the second rose period or adult rose period. In the simplicity and plenitude of his classical style, Picasso then produced his grandest, most intensely meditative Harlequins, with a mirror or with clasped hands. A real model posed for this melancholy, motionless figure, which nevertheless takes on the value of both a self-portrait and a universal symbol. The face has the timeless, synthetic quality of a mask, and the eyes are fixed on the mystery and nothingness of the human condition.

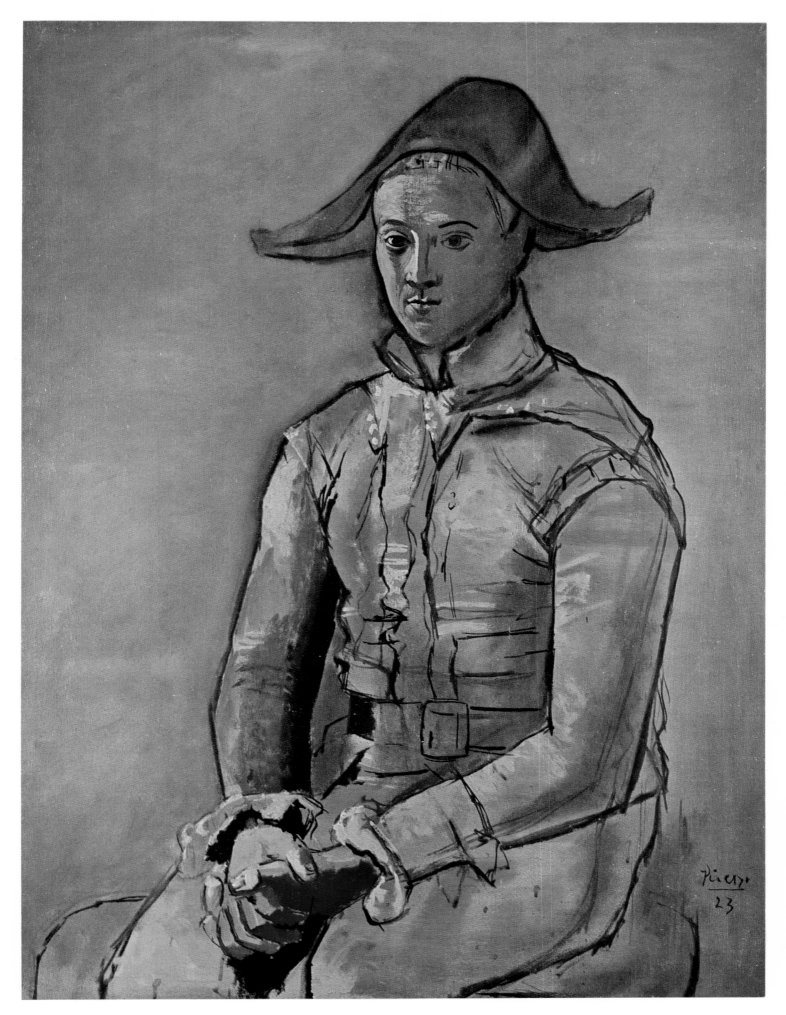

Seated Harlequin, oil.

This painting is to the other painting what poetry is to prose.

Juan GRIS

The Revolution of Form

The *Demoiselles d'Avignon*, whose heroic genesis and legendary destiny are well known, set the new course of modern art by shifting the center of gravity to the picture itself and its creative tension. All previous values of the work of art as illustration or as vehicle of sentiment were dissolved and converted into plastic energy. With its intrinsic discontinuities and the very incompleteness inherent in its paroxysmal handling, this crucial work broke away from the perspective convention of the Renaissance and from the classical norm of the human body of which Picasso himself, only a few months before, had been one of the purest interpreters. Hinging on an oblique axis, it is built up in a shallow space in which forms are shattered and reassembled in angular design. Five female nudes (ostensibly the inmates of a brothel in the Carrer d'Avinyó—Avignon Street—in Barcelona), with hallucinating eyes and rough-hewn forms, loom up against a backdrop of curtains with which they are almost interwoven by the geometrization of volumes and the overlapping of warm and cold colors, some advancing, some receding. The tall girl on the left with long dark hair and a grave Egyptian profile raises the curtain to reveal the terror and fascination of this spectacle. The two central figures stare straight at the spectator, who is thus caught in the hypnotic spell of the picture; they bear the imprint of Catalan frescoes and Iberian reliefs. But it is the two superimposed figures on the right, chronologically and stylistically distinct, because subsequently reworked under the shock of African statuary, that undergo the most virulent distortions: animalized facial masks, folding back of the nose indicated by bold streaks of color, break-up and barbaric reorganization of the whole body according to rhythmic requirements and the multiplicity of viewpoints. Picasso discovered, integrated and imperiously combined the most varied artistic ferments by subjecting them to his own propulsions and to the formal and expressive virtualities which he released in course of execution.

Braque was among the few bewildered visitors admitted to his studio while he was at work on this revolutionary picture. Brought by Apollinaire late in 1907, Braque was the one, of all Picasso's friends, who at first protested most vehemently and who very soon most clearly divined the momentous implications of the work. The friendship struck up then and there between the two painters became closer still in 1909 when they realized that they had been following independently two parallel lines of research. From then until 1914 they worked in ardent cooperation, a veritable marriage of artists which gave birth to Cubism, the new system of figuration keyed to modern reality. The coherence

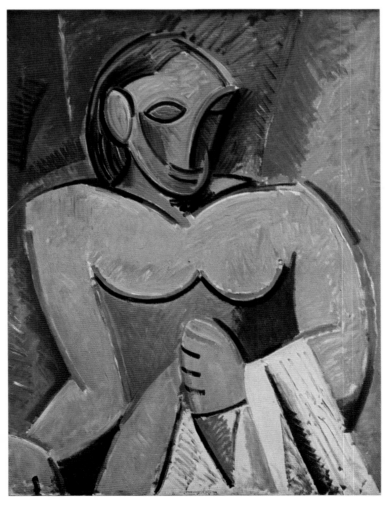

Nude with a Towel, oil. *1907*

and fecundity of this movement sprang from the happy conjunction of these two outstandingly gifted men, and from the mutual enrichment of their opposing temperaments. Their meeting is inseparable from the prodigious creative seedbed which Paris constituted in the early 1900's, and the radical mutation which they brought about in the arts was accompanied by a parallel mutation in science, technics and thought. In all fields of endeavor, reality ceased to be a matter of transferable data and came to be seen as an operatory process. In art, the old unitary, fixed perspective gave way to a dynamic, polyvalent articulation rich in unforeseeable combinations.

Sheet with Studies for a Self-Portrait (detail), pencil. 1906

Intuitive in its approach and Cartesian in its rigor, Cubism was aptly described by Pierre Reverdy as "a methodical adventure". The problem was: how, without illusionism or any other dodge, to solve the key problem and paradox of painting, the insertion of volume into the plane surface of the canvas. The answer was: by dissociating the motif from its imitative conventions, by reducing it phenomenologically to its essential qualities, and by reconstituting it ideally on the two-dimensional surface of the picture. The structure of the external world may possibly coincide with the architectonic rhythm of the picture, because there exists a universal geometry of form. The turning space in which the human figure and the tangible objects of daily life loom up, like patterned concretions, offers at first the compact, volumetric aspect of an embossed relief. Then the whole mass is broken up and crystallizes into facets, opens out and develops over the plane of the canvas in thin, transparent, echeloned layers. Absolute and concrete frontalization came with the discovery of pasted papers, which permitted the return to color (momentarily sacrificed to form), the direct notation of texture, and the use of condensed signs evoking reality by metaphorical allusion, not by representational illusionism. A pictorial tradition of several centuries thus came to an end, superseded by a new poetics of creation as complex in its aims as it was simple in its means.

Then a more downright movement impinges sharply on all the backdrops, on all the displays of skill, and that is the beginning —though no one yet suspects it—of the disconcerting discovery that will overthrow everything.

And so we come to that moment when Picasso, possessing all the resources, all the virtuoso powers that an artist can possibly master, yet tormented by all sorts of misgivings, decided to dismiss from his mind the enormous mass of knowledge and experience he had acquired and set out to learn everything all over again, to start from scratch.

Pierre REVERDY, 1924

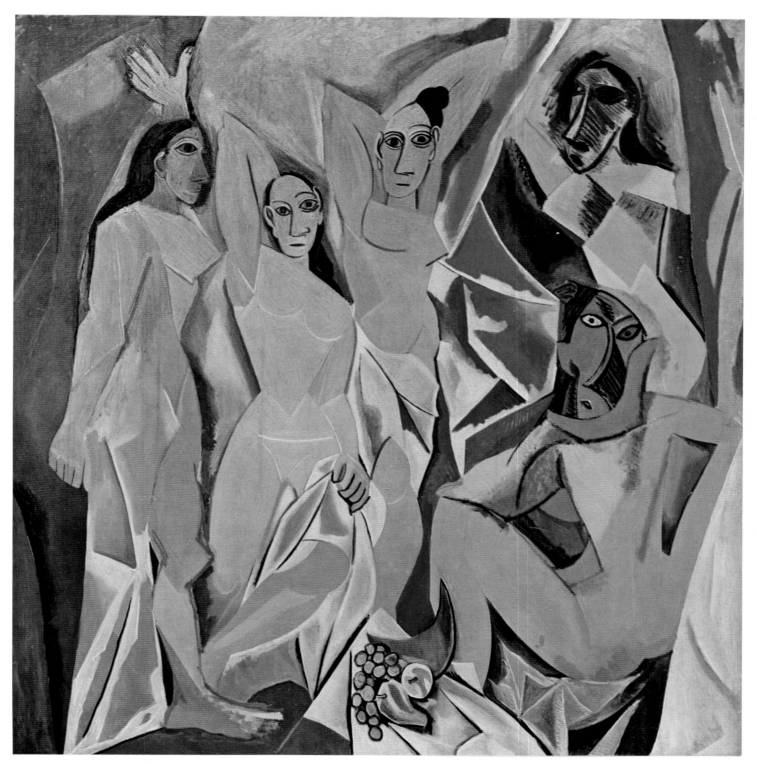

Les Demoiselles d'Avignon, oil. *1907*

This large picture which Uhde had been telling me about, this large picture since called "Les Demoiselles d'Avignon", which constitutes the starting point of Cubism. What I should like to make you feel at once is the incredible heroism of a man like Picasso, whose moral solitude at that time was something terrifying, for not one of his painter friends had followed his lead. The picture he had painted now struck them all as something crazy or monstrous. Braque, who had met Picasso through Apollinaire, declared that to him it seemed as if someone had drunk kerosene and started spitting fire, and I myself was told by Derain that Picasso would end up by hanging himself behind his big picture, so hopeless did the undertaking seem. Everyone who knows the picture now sees it in exactly the state in which it was then: Picasso regarded it as unfinished, but it has remained exactly as it was, with the two halves rather different from each other.

D. H. KAHNWEILER, 1961

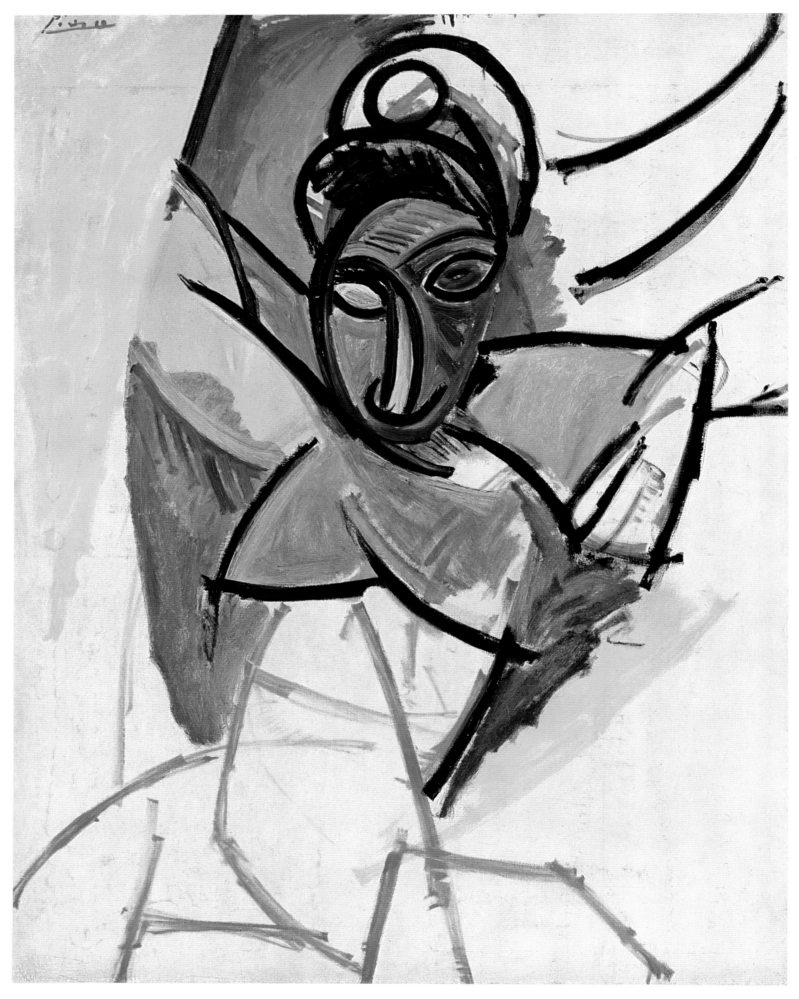

Sketch for "Les Demoiselles d'Avignon", oil. 1907

As Picasso so aptly said to me one day (I find this comment altogether admirable): "At that time they used to say I painted crooked noses, and had already done so in 'Les Demoiselles d'Avignon'. But it had to be painted crooked for them to see that it was a nose. I was sure that later on they would see that it was not crooked."

D. H. KAHNWEILER

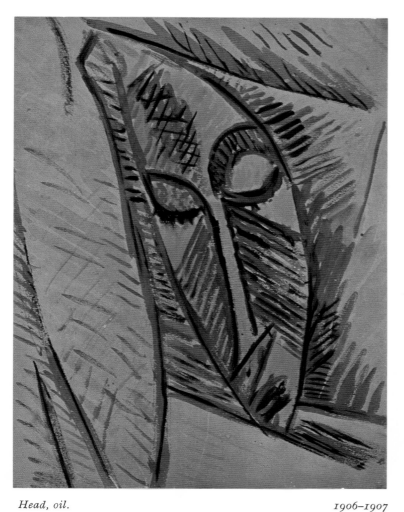

Head, oil. 1906–1907

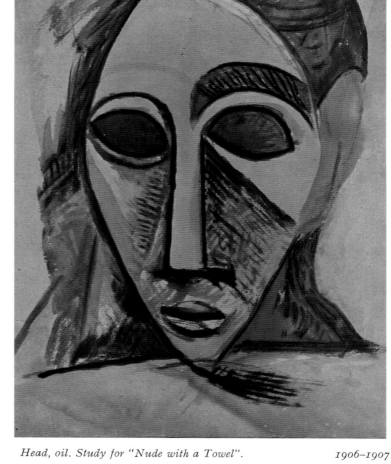

Head, oil. Study for "Nude with a Towel". 1906–1907

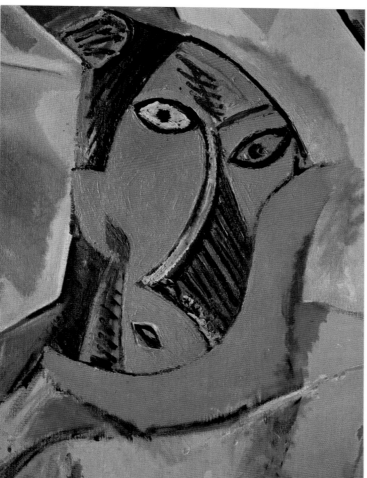

Les Demoiselles d'Avignon (detail), oil. 1907

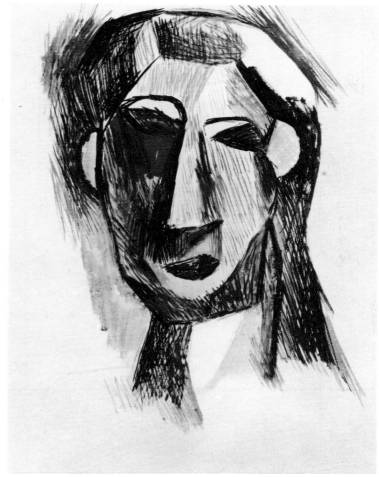

Head of a Woman, watercolor. 1908

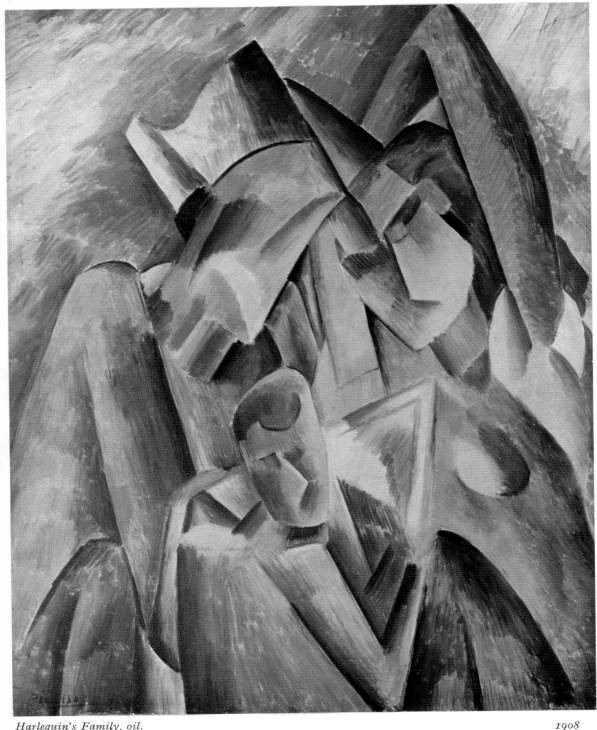

Harlequin's Family, oil. 1908

The Reservoir at Horta de Ebro, oil. 1909

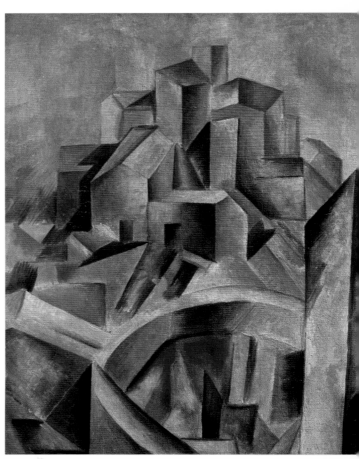

Painted late in 1908, *Harlequin's Family* reverts to a familiar theme and exemplifies the Cézannesque simplification of form and its homogeneous reorganization on the level of the plane surface of the canvas, in terms of sharp-edged sections alternately light and dark. In the summer of 1909 Picasso returned to the Spanish village of Horta de Ebro (or Horta de San Juan) in the province of Tarragona, where he had made a long, rewarding stay ten years before. In the four months he spent there now, he produced a series of architectonic figures and landscapes which fully reveal the cubist process of analysis and reconstruction: shattering and crystallization of volume by a system of oriented facets, reduction of color to almost monochrome tones, simultaneous combination of several different points of view. The *Reservoir at Horta de Ebro* was bought by Gertrude Stein, and Picasso gave her photographs of Horta, taken by himself on the spot, which confirm the accuracy of his painted transposition.

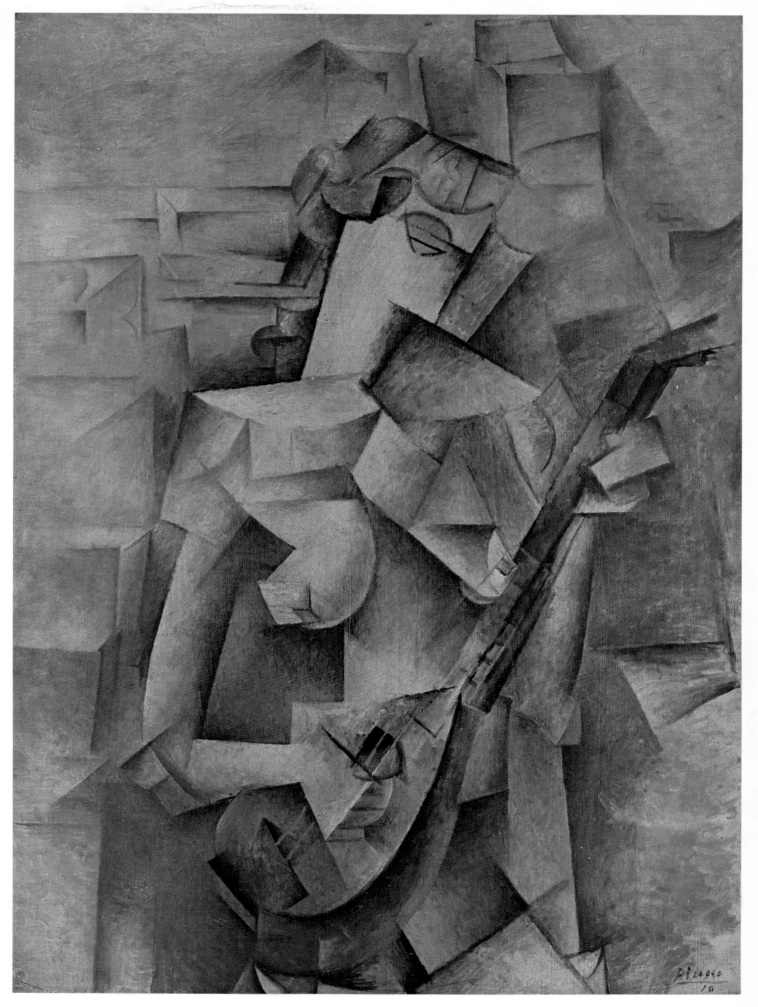

Girl with a Mandolin, oil. 1910

In reality one works with few colors. What gives the illusion of many colors is simply the fact that they are put in the right place... There is no such thing as abstract art. You have always got to start with something. Afterwards you can remove any appearance of reality; there is no danger then, for the idea of the object has left an indelible imprint. It is the object which prompted the artist, aroused his ideas, set his feelings in motion. Those ideas and feelings will be permanently imprisoned in his picture; whatever they may do, they cannot now escape from it; they are an integral part of it, even though their presence may no longer be discernible.

PICASSO, 1935

It would be absurd to say to the public: this picture represents such and such an object. To say that is to create around the picture a convention which stifles it, which arrests its radiation. The work of art is neither static nor limited. Its interest today is quite different from what it may be tomorrow.

Georges BRAQUE, 1935

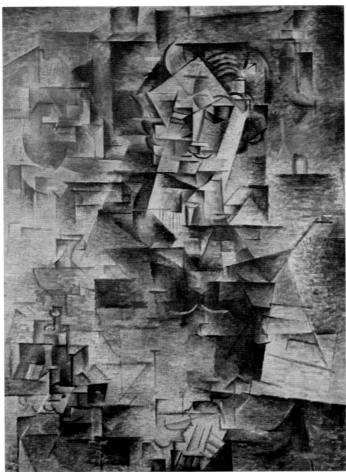

1910

Portrait of D. H. Kahnweiler, oil.

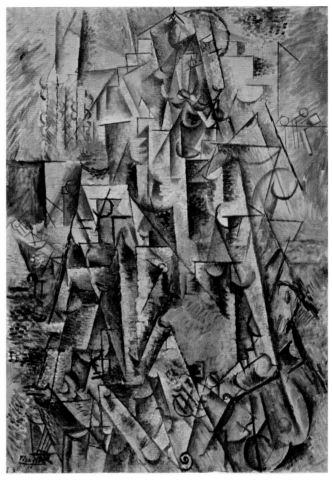

1911

The Poet, oil.

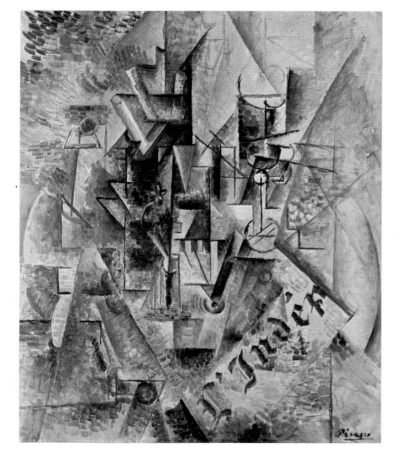

1911

L'Indépendant, oil.

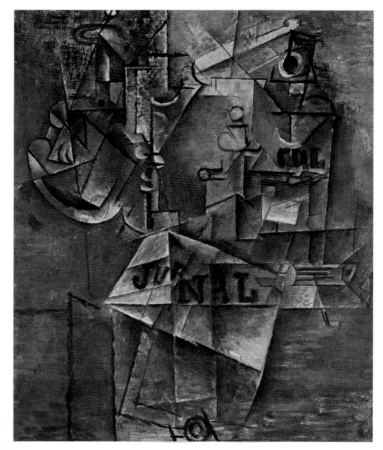

1912

Le Journal, oil and charcoal.

From the open-air laboratory there will continue to escape at nightfall beings divinely unexpected, dancers sweeping along with them shreds of marble mantelpieces, tables adorably laden, beside which your own are turning tables, and everything that hangs on the immemorial newspaper "Le Jour...". It has been said that there cannot be any surrealist painting. Painting and literature, what is that, O Picasso, you who have carried to its highest pitch the spirit, not of contradiction, but of escape!

André BRETON, 1928

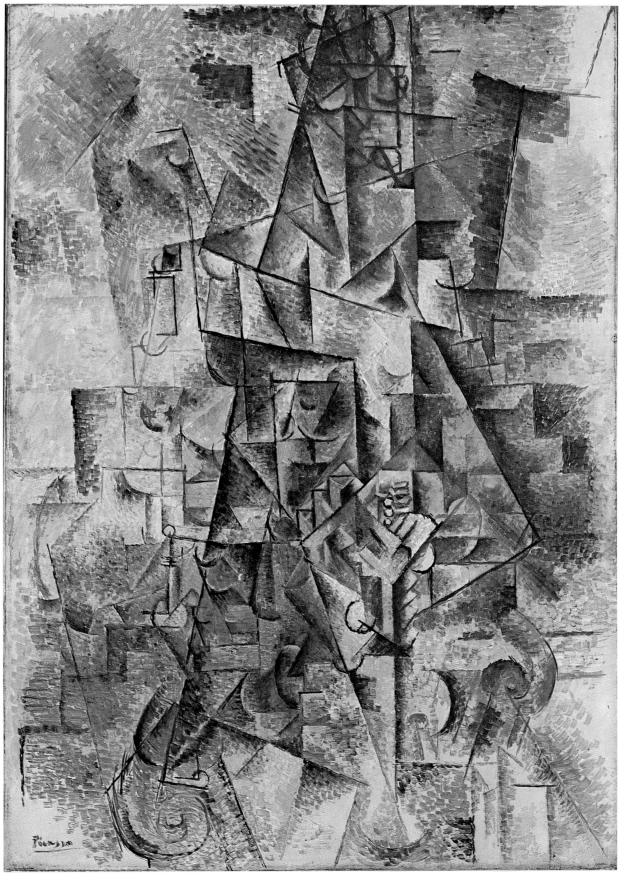

By what miracle does this man, whom I have the amazement and happiness to know, find himself in possession of what was needed to give shape to what, before him, had remained within the sphere of the purest fantasy? What a revolution must have occurred within him for him to enter that sphere! Impassioned seekers will one day try to find out what impulse roused Picasso toward the end of the year 1909. Where was he? What kind of life was he living? "Cubism"—can this ridiculous term rob me of the prodigious sense of discovery which, to my mind, took place in his output between the "Horta de Ebro Factory" and the portrait of Kahnweiler? Nor, for me, can the self-important accounts of onlookers or the feeble exegeses of a few scribes contrive to reduce such a venture to the proportions of a mere news item or a local artistic phenomenon. It takes so keen an awareness of the treachery of visual appearances for a man to break with them, and *a fortiori* with the familiar aspect of things, that one cannot help acknowledging Picasso's immense responsibility. A failure of will on the part of this one man, and the matter that concerns us would at the very least have hung fire and might never have been realized at all. His admirable perseverance is a precious enough pledge for us to do without an appeal to any other authority. What lay at the end of that anguishing journey? Will we ever know?

André BRETON, 1928

Accordionist (Pierrot), oil.　　　　　　*1911*

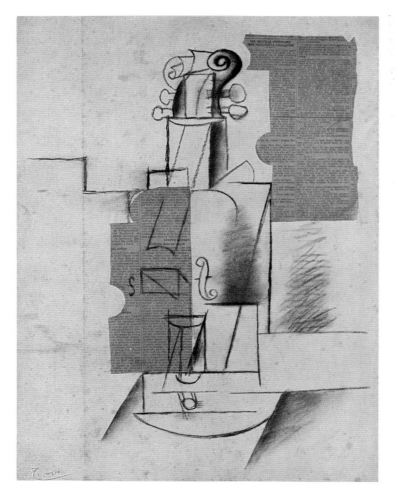

Violin, charcoal and pasted paper. *1914*

Is there clay more barren than all these torn newspapers
With which you went forth to the conquest of the dawn
Of the dawn of a humble object
You lovingly draw what was waiting to exist
You draw in the void
As no one draws
Generously you carved out the form of a chicken
Your hands played with your packet of tobacco
With a glass with a bottle which won

The infant world issued from a dream

Good wind for the guitar and for the bird
A single passion for the bed and the boat
For fresh greenery and new wine

 Paul ELUARD, *To Pablo Picasso*, 1938

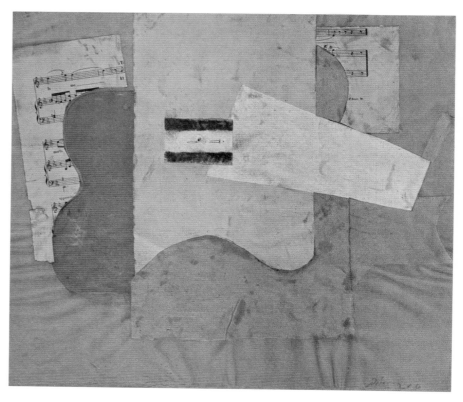

Sheet of Music and Guitar, pasted paper. *1912–1913*

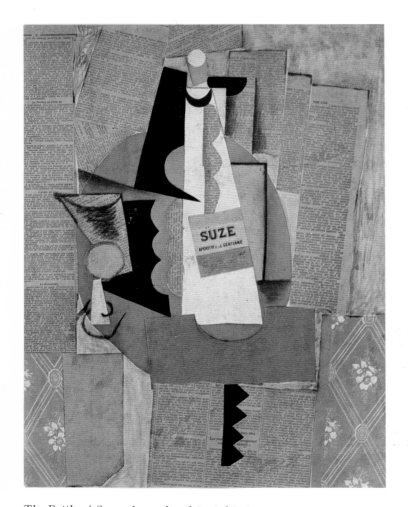

The Bottle of Suze, charcoal and pasted paper. *1913*

At that time I was in close touch with Picasso. Our temperaments were very different, but we were guided by a common idea. Picasso is a Spaniard, I am a Frenchman, that became quite obvious later on; everyone knows the differences that involves. But in those early years the differences didn't matter... We lived in Montmartre, we saw each other every day, we talked a lot... Things were said between us in those years that will not be said again, things that cannot be said again, that no one now would understand, things that would be incomprehensible and that so much elated us... and all that will die with us.

We were like two mountain climbers roped together. We both of us worked very hard... The museums had no more interest for us. We went to some exhibitions, but not so many as all that. Above all we were wholly wrapped up in our work.

 Georges BRAQUE, 1954

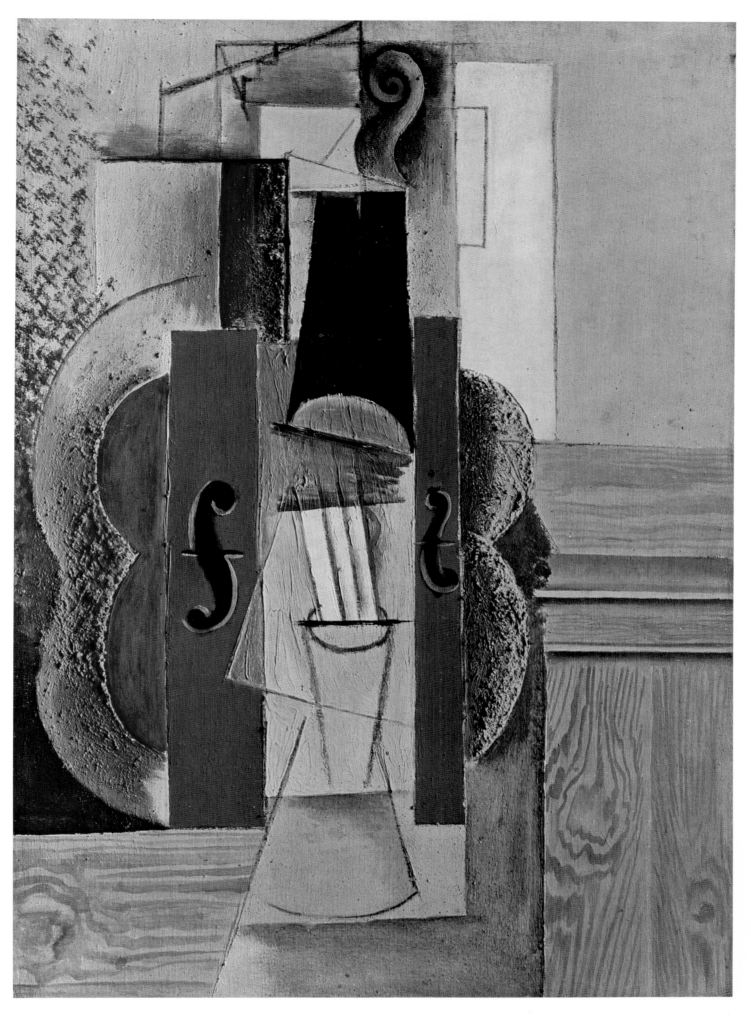

Violin hanging on the Wall, oil and sand.

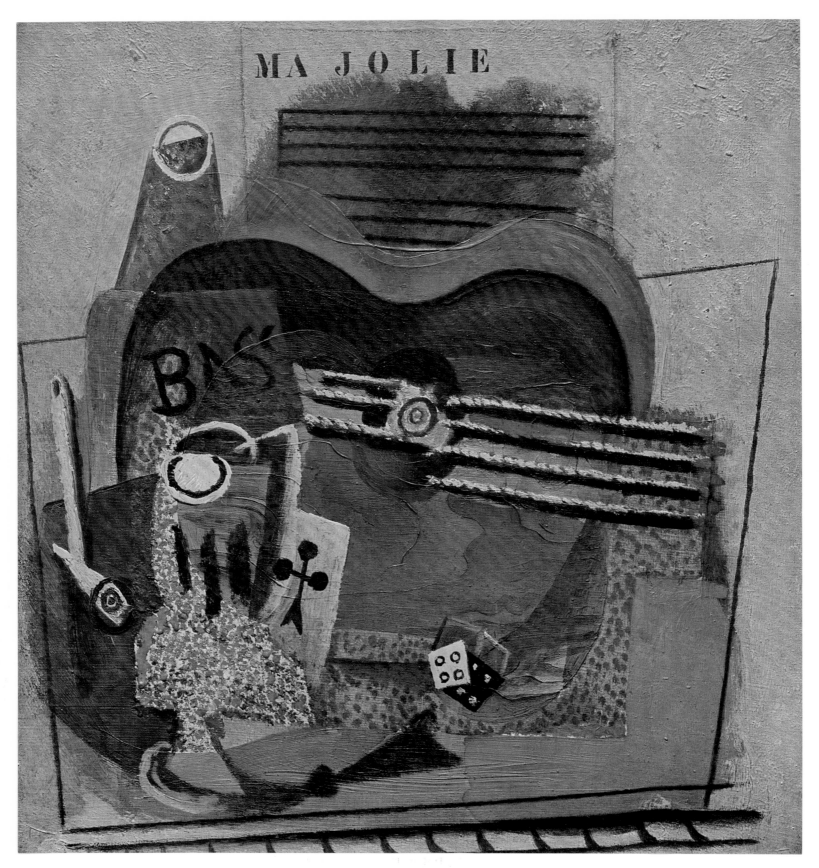

Ma Jolie, oil. *1914*

It is only when objects get complicated that they cease to be indescribable. Picasso was able to paint the simplest objects in such a way that anyone in front of them not only became capable of describing them, but desirous of describing them. For the artist as for the most untutored of men, there is no such thing as concrete forms or abstract forms. There is only communication between what sees and what is seen, an effort to comprehend and relate things—sometimes to determine and create. To see is to understand, to judge, to distort, to imagine, to forget or to forget oneself, to be or to disappear.

I think of the pictures called "Ma Jolie", as bare of colors as what one is accustomed to see, as what one is familiar with. The colors do not arise from the space, they are space itself, contained as they are by the limits of the picture, like the spirals of smoke filling up a whole room, unlimited and precise. Neither the limits of the picture nor those of the room stop me, anyone is thus who is composed, discomposed, recomposed. O vague but essential memory, I know what, outside, contains the night, what is grouped by the invisible, what forms it envelopes; the invisible is within me, buoyant or peremptory. I see within me. Picasso has removed the crystal from its gangue.

Paul ELUARD, 1935

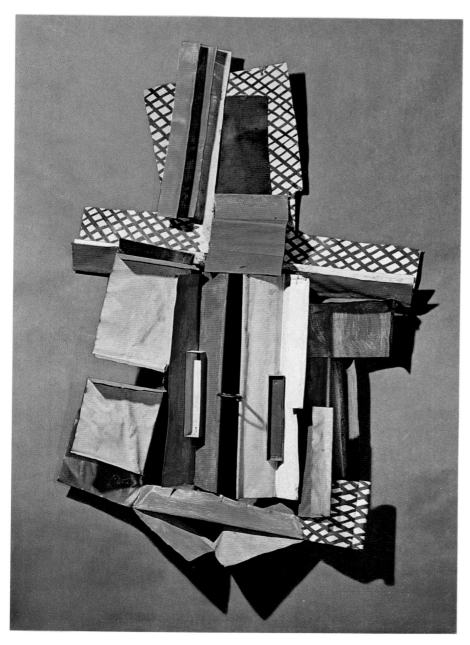

Guitar, painted metal cutout. 1914

I am one of those who will never forget how many times he has made me rejoice... All by himself and again and again, he has set off the fireworks before my dazzled gaze. I see again with youthful eyes when I recall my first encounter with Picasso's work in an issue of "Les Soirées de Paris", edited by Apollinaire, which contained illustrations—rather hazy ones—of five of his recent still lifes (that was in 1913). Four of them consisted of assembled materials of a residual character, such as small boards, spools, strips of linoleum and string, taken from daily life. The shock caused by the never-seen was followed by a sense of the sovereign equilibrium of the work achieved, work promoted—whether one likes it or not—to the realm of organic life and thereby justifying the necessity for it. Nearly half a century has passed since then. From what Picasso told me one day, I gather these constructions of long ago have been dismantled, but the surviving picture of them is enough to show to what extent they anticipate what are allegedly the most daring forms of expression today. To what extent too, for the most part, they dominate them through the authority which they display, and which at once rules out any suspicion of gratuitousness.

André BRETON, 1961

Head, charcoal and pasted paper. 1914

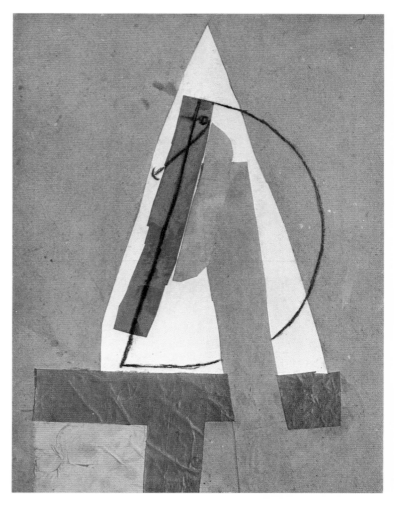

One can imagine a time when painters, who even now no longer grind their own colors, will find it childish and unworthy of them to apply their own paints, and will come to see in that personal brushstroke which still today gives the value to their pictures, no more than the documentary interest of handwriting or an autograph. One can imagine a time when painters will not even have the colors applied by others, will not even do any drawing. The collage gives us a foretaste of that time.

ARAGON, 1930

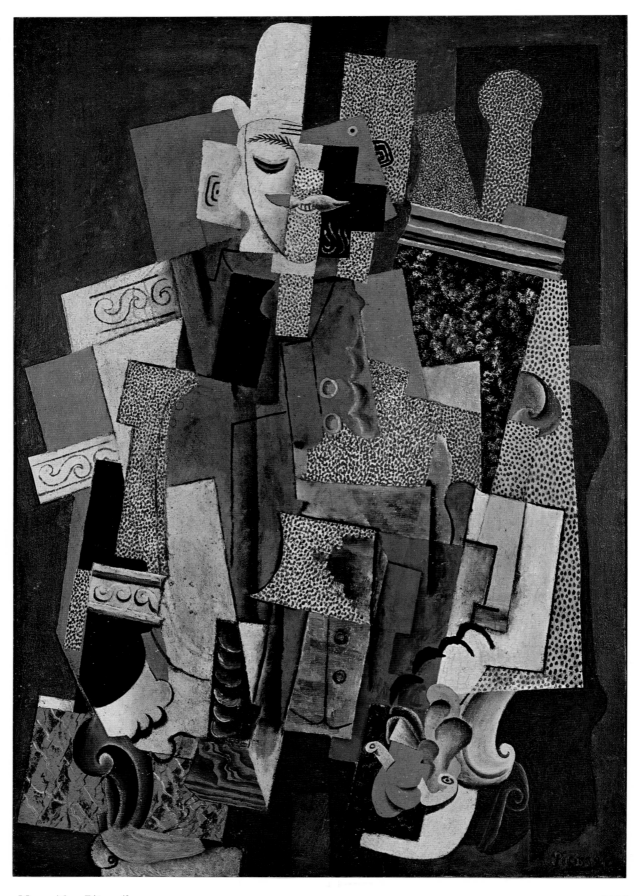

Man with a Pipe, oil. *1915*

Cubism is not a seed or an art in gestation but a stage in the development of primary forms, and once these forms have been worked out they are entitled to live a life of their own... Cubism has its own pictorial ends. We see it only as a means of expressing what our eyes and minds perceive, with all the possibilities possessed by line and color thanks to their own peculiar qualities. For us it proved a source of unexpected pleasures and discoveries.

PICASSO

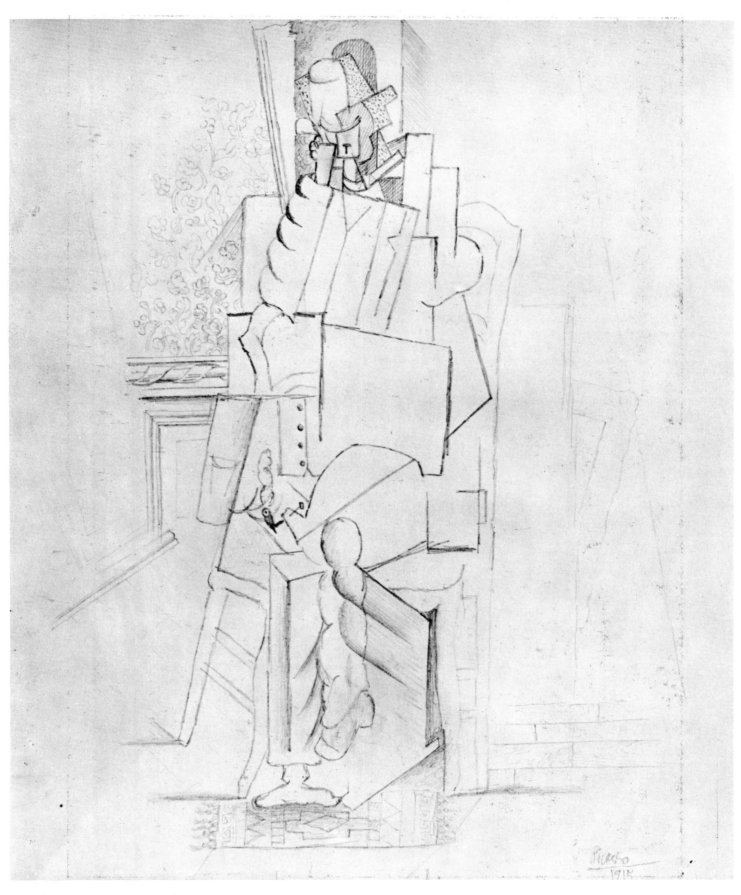

Seated Man with a Pipe, pencil. *1915*

The work often conveys more than its maker desired or intended, indeed he is often astonished at results which he had by no means foreseen. The birth of a work of art is sometimes a manner of spontaneous generation. Now the line gives rise to the object, now the color suggests forms which determine the subject.

<div align="right">PICASSO</div>

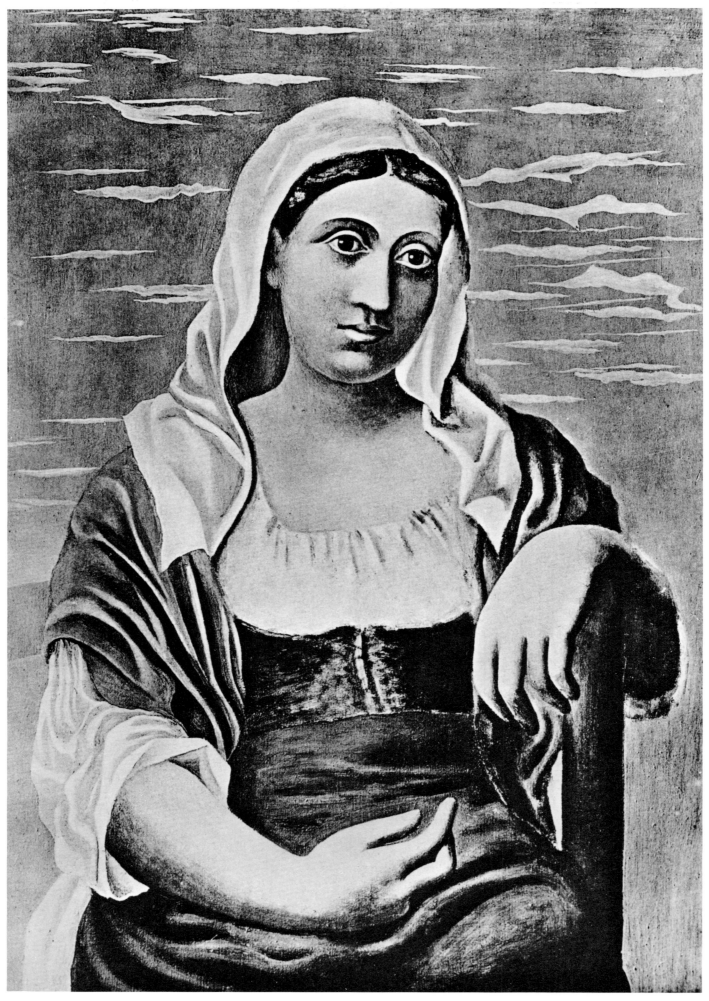

Seated Italian Woman, oil.

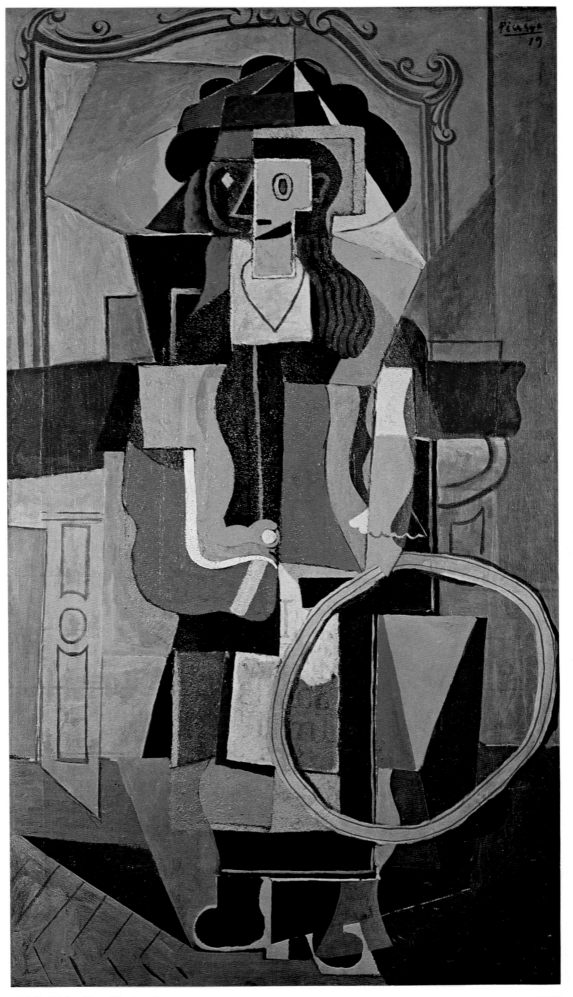

Little Girl with a Hoop, oil. *1919*

Study for the Final Version of the Drop Curtain for "The Three-Cornered Hat", pencil.

1919

Definitions of "Parade" are blossoming out on all sides like branches of lilac in this belated spring.

It is a stage poem which the innovating musician Erik Satie has transposed into astonishingly expressive music, so clear-cut and simple that the marvelously lucid spirit of France herself can be recognized in it.

The cubist painter Picasso and the boldest of choreographers, Léonide Massine, have brought it off by achieving for the first time that alliance of painting and dancing, sculpture and miming, which plainly betokens the advent of a more complete art.

Guillaume APOLLINAIRE, 1917

Study for the Drop Curtain for "Parade", pencil.
1916–1917

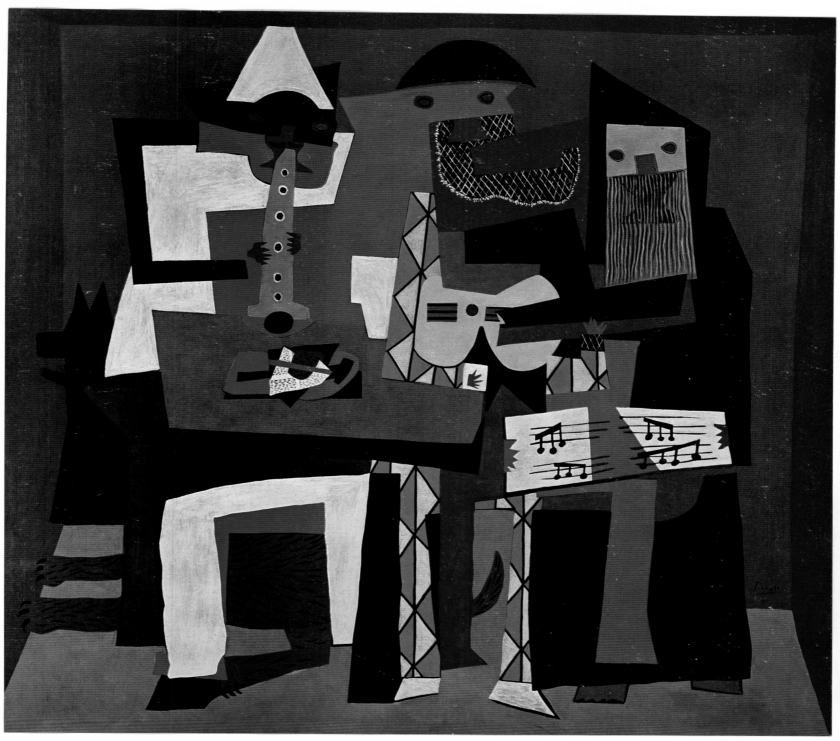

Three Musicians, oil.

In 1916 Picasso met the young and brilliant poet Jean Cocteau, who introduced him to the world of the Russian ballet presided over by the impresario Sergei Diaghilev and the choreographer Léonide Massine, with the participation of the best contemporary composers. Picasso, who had always been fascinated by the stage, collaborated all the more eagerly since he married one of Diaghilev's dancers and found renewed inspiration in the work. His initial and at once decisive contribution was scenery and costumes for *Parade ;* it was the occasion too, for his first trip to Italy in 1917. Two years later, *The Three-Cornered Hat,* produced in London with music by Manuel de Falla, provided him with a Spanish theme and he designed a drop curtain showing the bullring with women in mantillas, men in cape and sombrero.

In the summer of 1921, at Fontainebleau, Picasso painted at the same time two masterly versions of *Three Musicians,* which represent the final working out of Synthetic Cubism and the condensation of his recent experience as a stage designer. Three masked figures over lifesize, suggested by broad simple planes or allusive signs, stand in line in front of the little table under which, in the version reproduced here, crouches a black dog no less fanciful than the musicians themselves: Pierrot playing the clarinet, Harlequin playing the guitar, and a Capuchin friar in black robe and cowl holding the music on his knees. The vivid colors of the costumes stand out against a dark brown background, and the hieratic majesty of the scene is set off by visual rhymes and puns full of wit and poetry.

Still Life on a Table in front of an Open Window, India ink. 1924

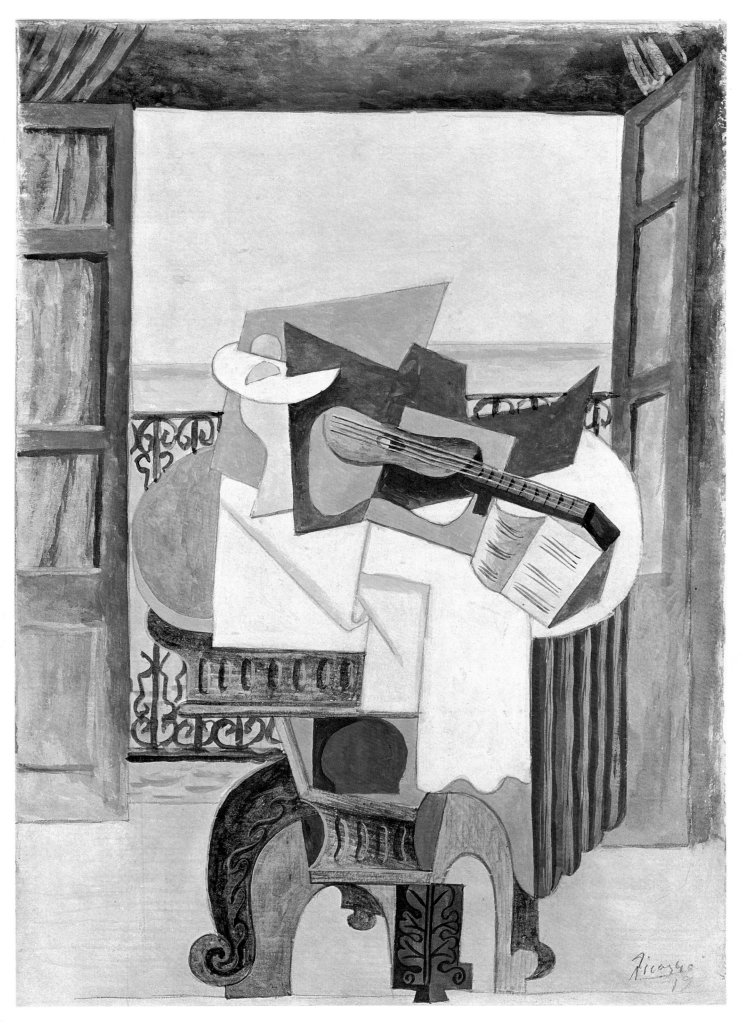

Still Life with Guitar on a Table in front of an Open Window, gouache. 1919

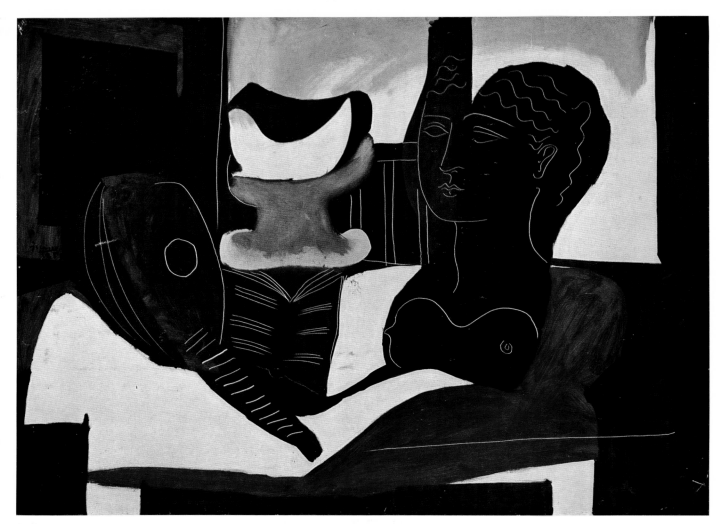

Still Life with an Antique Head, oil. 1925

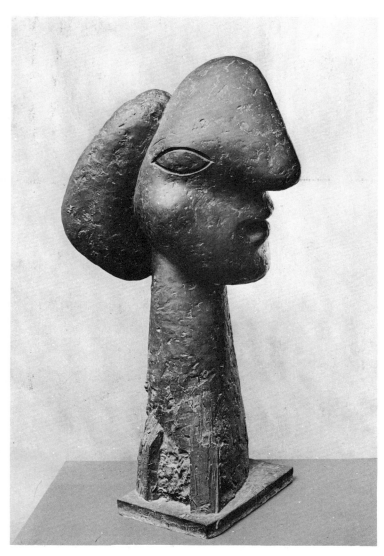

Head of a Woman, bronze. 1932

Picasso has created fetishes, but these fetishes have a life of their own. They are not only interceding signs, but signs in movement. This movement makes them concrete. Between all the men, these geometric figures, these cabalistic signs: man, woman, statue, table, guitar again become men, women, statues, tables, guitars, more familiar than before because comprehensible and tangible to both mind and senses. What may be called the magic of line and colors again begins to nourish everything around us and ourselves as well.

Paul ELUARD, 1935

About that time it happened that Picasso did a very serious thing. He took a soiled shirt and fixed it to a canvas with needle and thread. And since with him everything was apt to turn into a guitar, this too was a guitar for example. He made a collage with some nails that were sticking out of the picture. He had a craze, two years ago, a real craze for collages. I heard him complaining at that time, because everybody who came to see him and found him using old scraps of cloth and cardboard, string and corrugated iron, and rags picked up in the ashcan, thought they were being helpful in bringing him lengths of magnificent cloth "to make pictures with". He wouldn't touch them, he wanted the actual waste products of human life, something mean, soiled, despised.

ARAGON, 1930

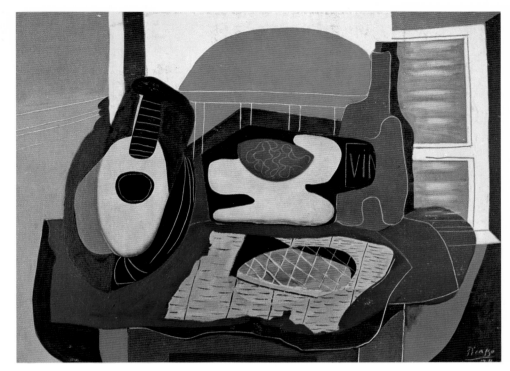

Still Life with a Cake, oil.　　　*1924*

Guitar, collage.　　　*1926*

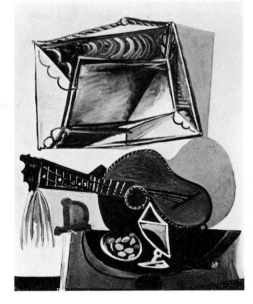

Still Life with Guitar, oil.　　　*1942*

Aragon foresaw the inventive resources in store for the artist in the deliberate choice of extra-pictorial materials, of scrapped or discarded materials. While in the sumptuous still lifes of 1924 and 1925 the guitar is still the privileged form, attuned to the other objects by a bland arabesque, in 1926 it is dramatically intimated by a fragment of newsprint and an old rag bristling with aggressive nails. During the war it regained its recognizable aspect and its feminine curves, but the long dagger and darkened mirror that accompany it are still ominous. Years elapsed and the old familiar instrument reappeared in 1959 beside the jug and glass, in glowing colors, fixed to the wall by a huge nail. "My dream in music," said Cocteau, "is to hear the tunes of Picasso's guitars."

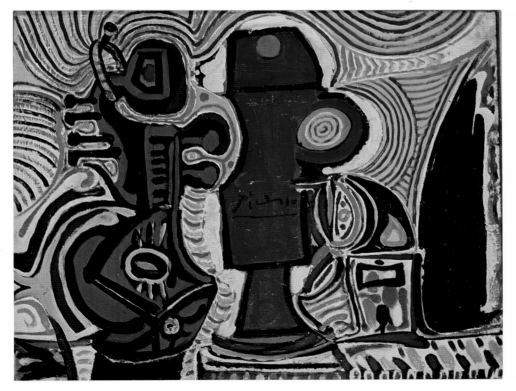

Mandolin, Jug and Glass, oil.　　　*1959*

I recognize the variable image of woman
Double star shifting mirror
Negating desert and oblivion
Source with breasts of heather spark trust
Giving day to day and her blood to blood

I hear you sing her song
Her thousand fancied forms
Her colors which make the bed of the countryside
Then go to tinge nocturnal mirages

And when caresses flee
Huge violence remains

Remains the weary-winged wrong
Dark metamorphosis a lonely people
Devoured by misfortune

Dismay of seeing that there is nothing to see
But self and what is like the self

You cannot do away with self
It stirs to life again
Before your righteous eyes

And on bedrock of present memories
Unordered undisordered simply stands
The towering prestige of making men see

Paul ELUARD, *To Pablo Picasso*, 1938

The World of Woman

Renoir is the painter of the female body, Matisse the master of "sublimated sensuousness". Picasso, like Goethe and Rembrandt (whom he resembles in having given the central place in his life and work to woman and in having imparted to her most intimate reactions a universal value), is the interpreter of the world of woman in all its shifting complexity. Capable of drawing, on his own account, better than Raphael, of unfolding with sovereign perfection the arabesque of the female nude, the ideal motif of eternal classicism, he has also made this supreme form, and the veneration surrounding it, the object of what some have thought his most outrageous assaults. The attitude of this manhandling worshipper of woman reflects the fundamental ambivalence of sex and relations between the sexes. An ambivalence moreover which, when primordial woman is made the symbol of all nature, leads the artist to immerse her in the flux of passions and events, to subject her, like any other element of nature, though in privileged fashion, to the most drastic stylistic manipulations.

The *Two Standing Nudes* of 1906 are massive, columnar figures surmounted by dazed, masklike faces. With the *Demoiselles d'Avignon* a year later, the revolution of form was carried through amidst the eruptive uprush of instincts. Cubism was a conquest of freedom which permitted a metamorphic reorganization of the human figure without changing the sum of its parts. Picasso was thereby enabled to express the fullness of love and physical sensations as no artist before him had been able to do; to body forth objectively, without recourse to fantastic art or surrealism, the mental reveries, the unconscious obsessions, the wonderings and panic terrors of which woman and her nakedness are the vehicle. The equivalence or permutation between the signs representing the face and the signs representing the genital organs, common practice in Neolithic and above all in Oceanian art, is applied to the large bronze *Head of a Woman* made at Boisgeloup in 1932, with its phallic nose, vaginal mouth, and eyes incised in full, thigh-like rotundities. Hence the mysterious radiance added to its technical mastery and archetypal power. A fascination of the same order is exerted by the famous painting of 1913, *Woman in a Chemise*, so much admired by Eluard and Breton. Without departing from her easy, familiar pose, her truth to life and her intransigent architecture, she is also the fabulous emblem of her race, the poetic embodiment of desire and its accomplishment. Twenty years in advance, she heralds the luxuriant series of Women in Armchairs, relaxed in sleep, quiescent as the plant life that often grows beside them, and an unwitting object of erotic pleasure. To this traditional theme of Woman in an Armchair Picasso has reverted again and again: it records the partner and the mood of the moment, like a barometer of his emotional life, registering calm or storm, raptures or clouded spirits.

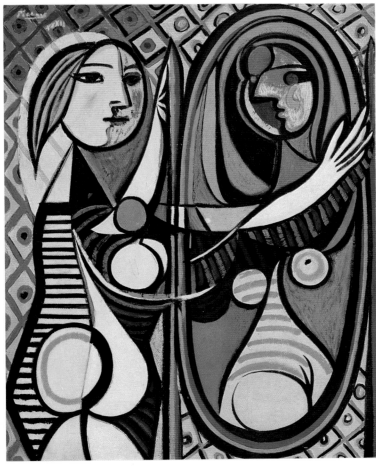

Girl before a Mirror, oil. *14 March 1932*

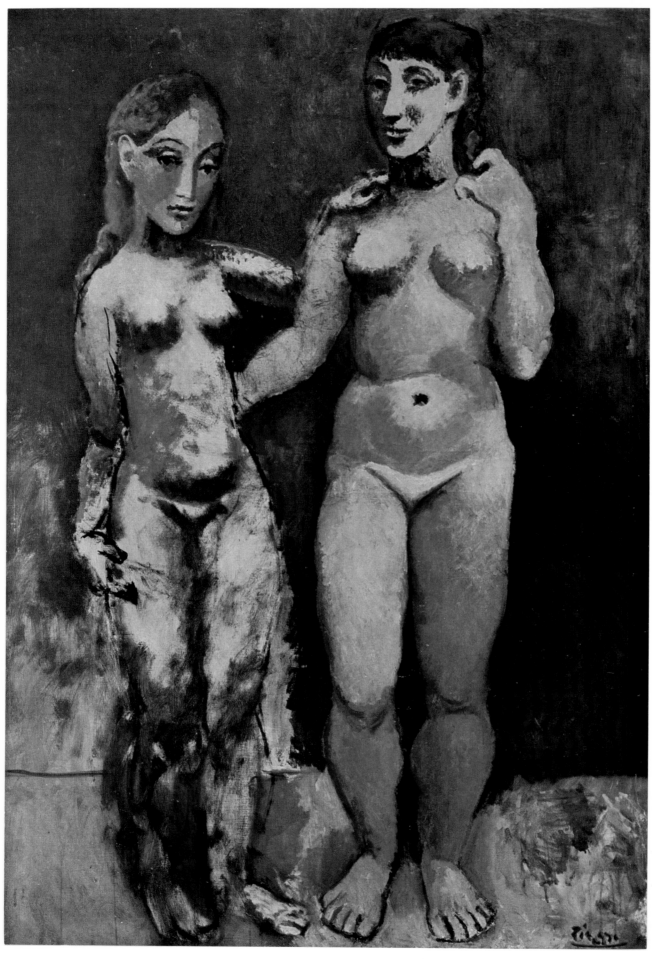

Two Standing Nudes, oil. *1906*

His figures are magnificently motionless, peculiarly pictorial, and these are the higher qualities of his entire art. No attitude or gesture but what is the pictorial outcome of the means set in motion. Not a head, body or hand but what, by its form and position, is an element peculiarly serviceable to the overall expression. No other meaning but what lies in the pictorial make-up of the picture.

Pierre REVERDY, 1924

Herself the mirror of man and the world, woman is forever gazing into the mirror, indulging the demands of coquetry or searching for deeper, more disturbing answers. When the mirror slants and takes on the so-called "psyche" shape in the famous synoptic picture of 1932, it exceeds (like all modern art) its role of mimesis and gives rise to an awe-inspiring anamorphosis revelatory of the eternal Eve under her ternary aspect, in her cyclical destiny. Visible simultaneously in side and front view, dressed and undressed, in light and darkness, in her transparent candor and her unconscious evasions, the girl with the lavender and lunar face witnesses her gradual ripening, her sensual blooming, her burgeoning fecundity. In the oval, womb-like mirror looms the embryo and her own spellbinding specter: it is the focus of infinite biological forces of which she herself is but the transitory receptacle.

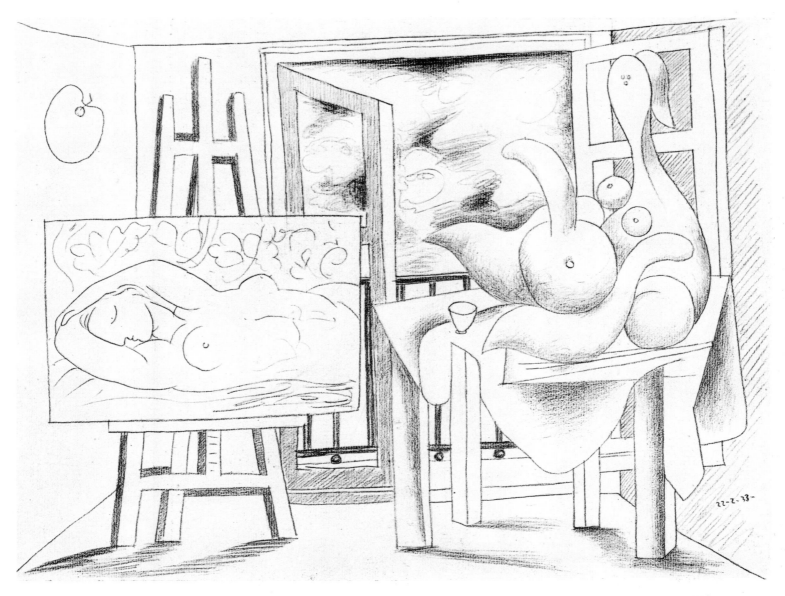

The Studio, lead pencil. *22 February 1933*

A drawing of the following year is entitled *The Studio*: on an easel stands the normal, perishable image of a nude female voluptuously asleep, a figure very much in the Venetian tradition; on a table, like an ordinary object or a tribal idol, stands its timeless counterpart, a strange, functional megalith. These two types of figure, stemming from opposite artistic sources, one civilized, the other barbarous, necessarily coexist in his work like the two poles of the human psyche. In the *Seated Bather* of 1930 or the *Woman dressing her Hair* of 1940, Picasso restored its mythical dimension to the monster, under the shock of personal emotions or international events: it is not the negation of beauty, but its complementary fatality. For a Faustian creator there is no rapture without terror, no goddess without the corresponding succuba.

ONE AND SEVERAL

In the mad tranquillity of her sleep
It snowed and the sky which played the tortoise
Gray as a blind lynx and sly as a hole
Judged the earth by its silence and winter

In the mad tranquillity of her sleep
There was the sea bonneted like a bee
There was the blue the warmest brightest glow
Of blood and fire and gold and kissing on eyes

In the mad tranquillity of her sleep
There were hands and eyes contending
Beautiful hands deft alive and trusting
And eyes in the past present and future
Serving life and pleasure and hope

Paul ELUARD, *To Pablo Picasso*, 1938

Reclining Bather, pencil. *1920*

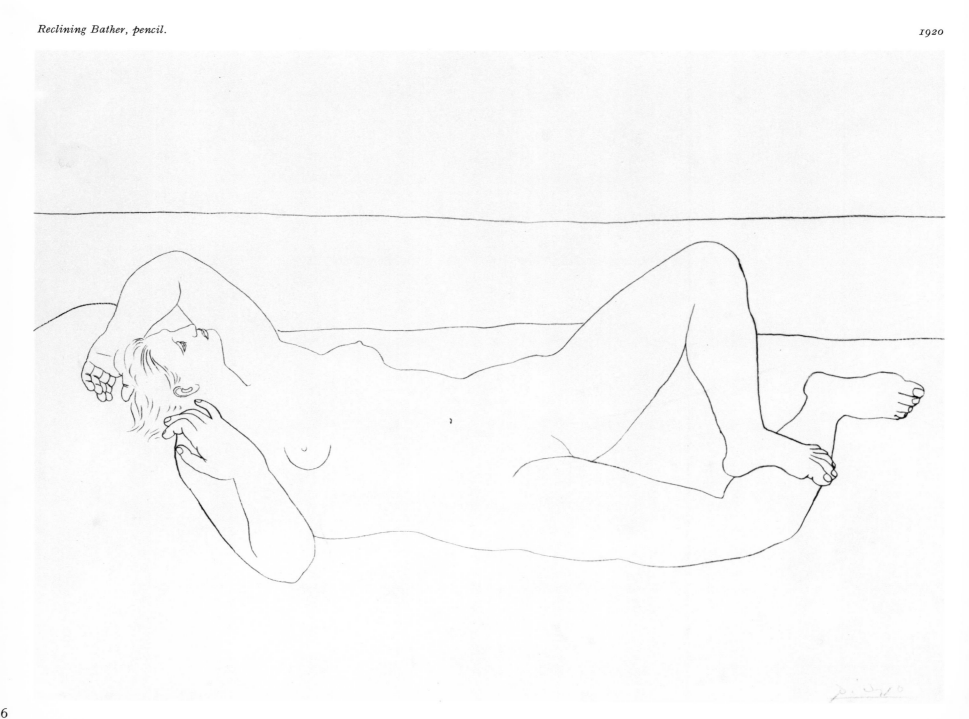

The bathers' legs denude wave and beach
Morning your blue shutters close over night
In the trailing streaks the quail smells of hazel-nuts
Of old months of August and Thursdays
Sounding peasant harvests many-hued
Scales of fens and dryness of nests

Face like bitter swallows in raucous sunset

The morning lights an unripe fruit
Glistens on wheat on cheeks on hearts
You hold the flame between your fingers
And you paint away like a fire

At last the flame unites at last it saves

Paul ELUARD, *To Pablo Picasso*, 1938

Standing Bather, ink. About 1925

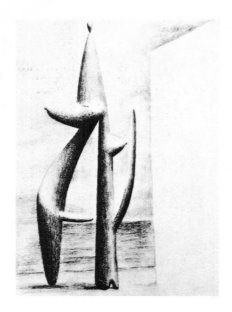

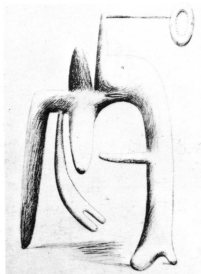

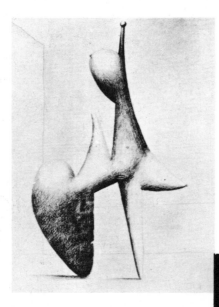

The bleak splendor of the setting—summer sky, burning sand and blue sea—and the refinement of the color scheme, with mauve gray shadows and warm ochre lights, render even more terrifying the image of this female Sphinx stranded on the beach with the bone-crushing pincers of her head, her hook-like arms and her robot body whose cartilaginous parts have been mechanically dismantled and organically reassembled.

Moreover, the perfect corpse of truth is trompe-l'œil, the eye-fooling illusionism of art. Truth can only be brought back to life through the synthesis of style: the stylization of the fetish is the truthfulness of art. But even truth itself can be dissected, and I cannot help feeling a sense of gratitude toward a painter who, like Picasso, takes the human mechanism apart before our eyes.

Maurice HEINE, 1930

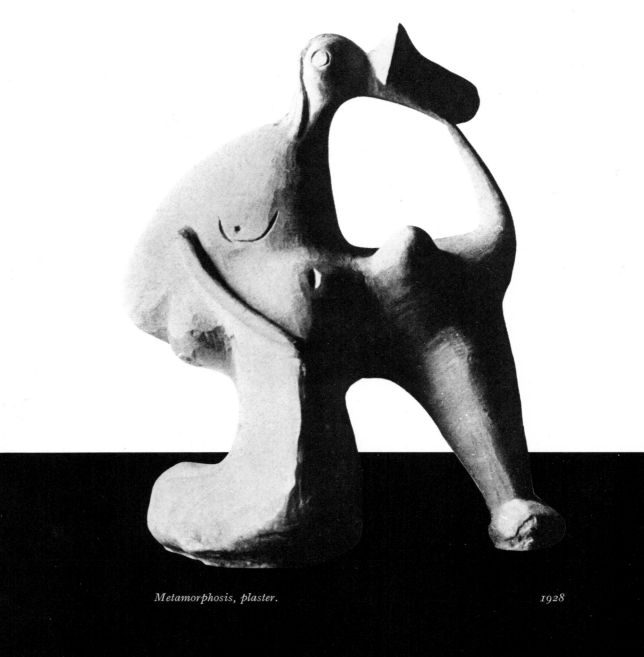

Metamorphosis, plaster. *1928*

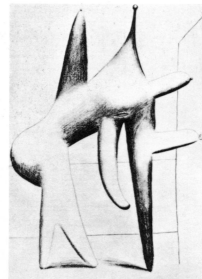

Study Sheets with Charcoal Drawings. Summer 1927

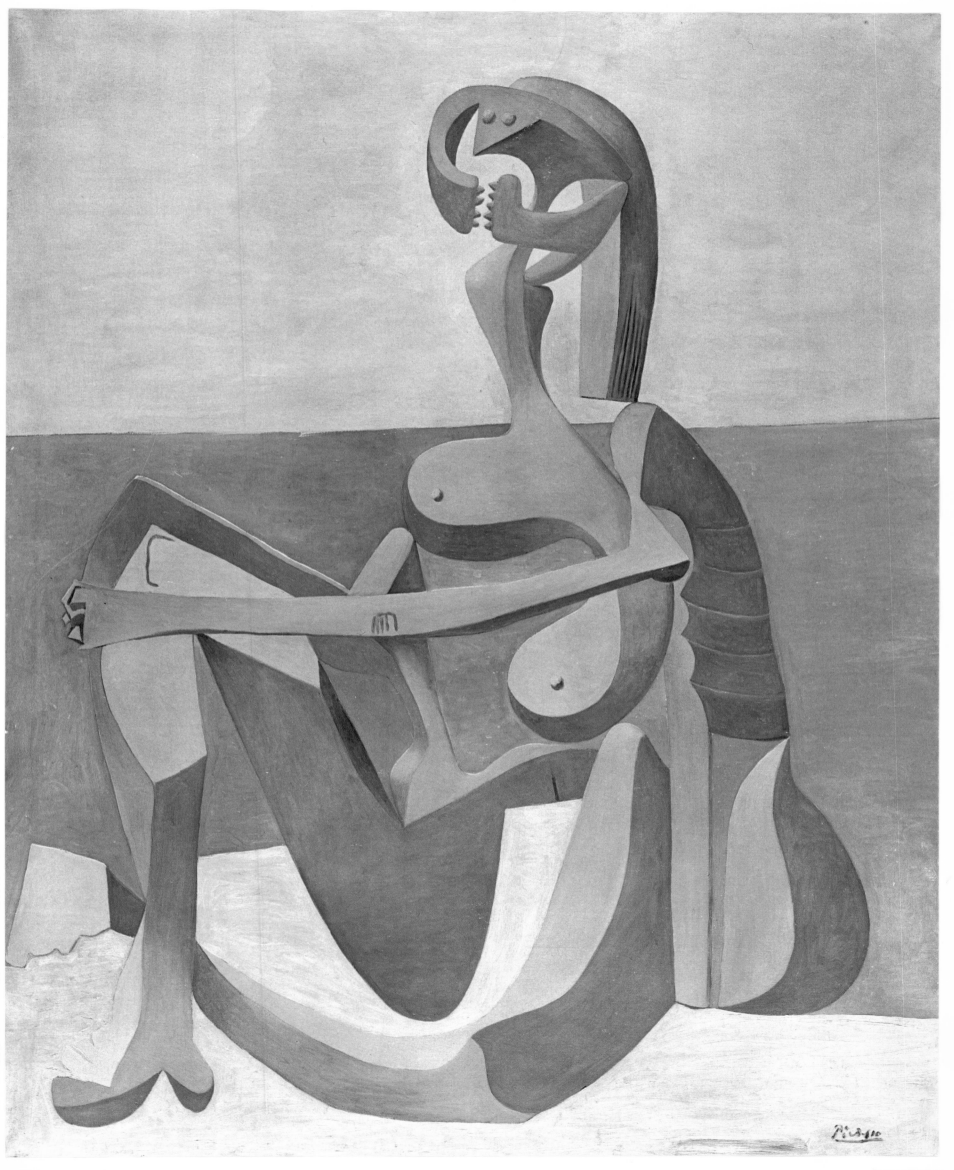

Seated Bather, oil.

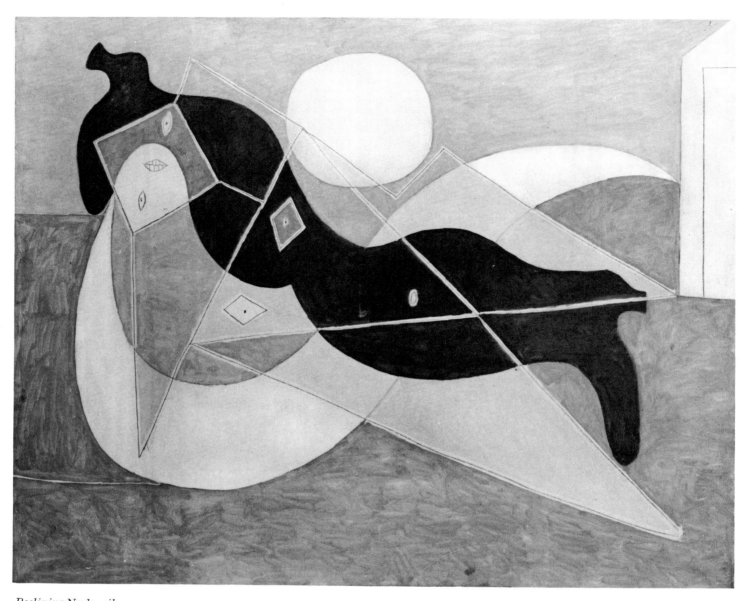

Reclining Nude, oil. *25 March 1932*

Reclining Nude, lead pencil. *28 July 1932*

His meeting at the end of 1931 with a young blonde beauty of easygoing temper and opulent charms, Marie-Thérèse Walter, dispelled the monsters and nightmarish visions of previous years, and in the various techniques he now actively practised—painting, drawing, engraving and sculpture—she soon inspired a cycle of female nudes of the most harmonious and complete sensuality. Picasso fell under the spell of his new model with her round, moonlike face, her full breasts and the splendid swing of her hips, whose shapely, plantlike curves animate the characteristic style of this happy period, sometimes referred to by French critics under the name of "graphisme courbe". The sleeping figure of Marie-Thérèse is seen stretched out or curled up in a welter of voluptuous rippling curves which her nude body sets up with natural innocence; or she sits in an armchair, cupping her face in her hands with a delightful movement of surprise and expectation. A single continuous line marks out the axis of the brow and the bridge of the nose, and this firm classical profile, acting as the identifying link between a multiplicity of images, sets off the dreamy sweetness of the face with its large, elongated eyes, the small mouth, the fleshy chin.

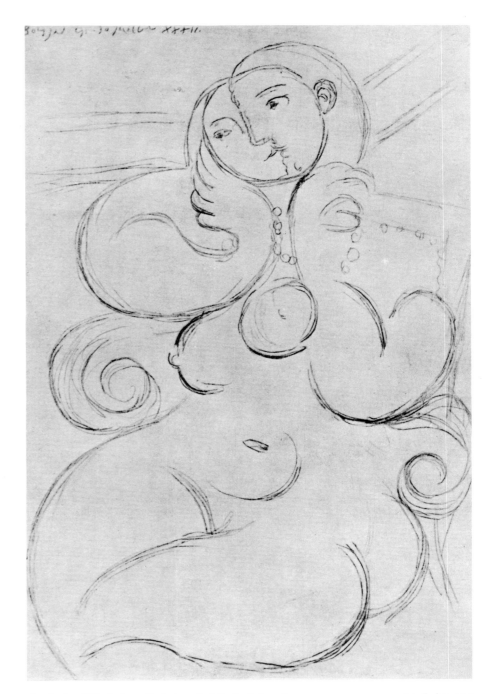

Study for "Nude in a Red Armchair", lead pencil. *30 July 1932*

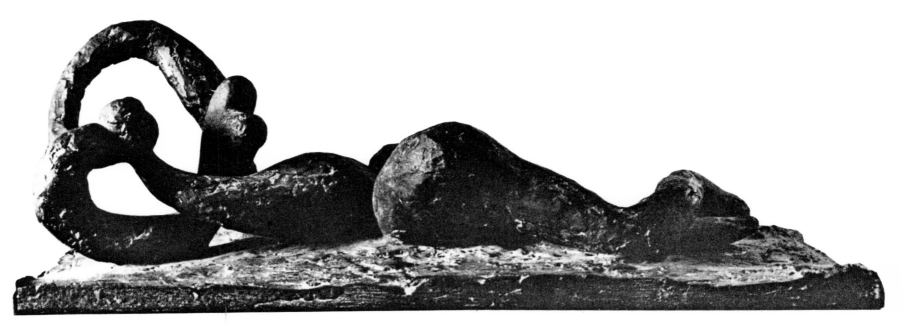

Reclining Woman, bronze. *1932*

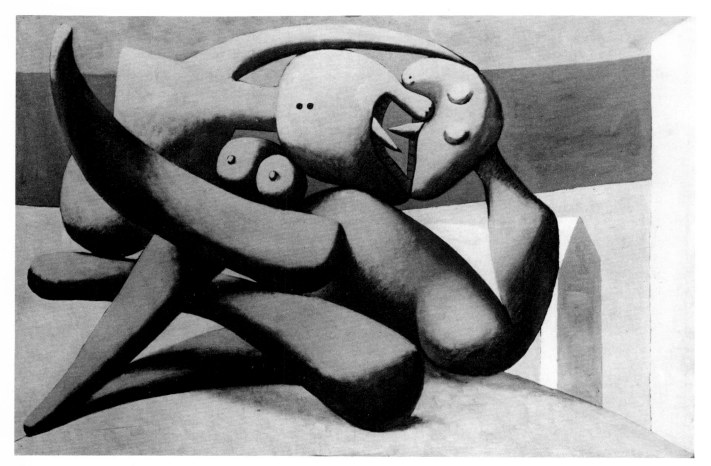

Figures by the Sea, oil. *12 January 1931*

These female figures organized like sexual constructions in eager movement stand on the borderline between painting and sculpture, and their plastic equivalents can be seen in the Boisgeloup studio photographed by Brassaï or, as here, by the collector A. E. Gallatin. "He opened the door of one of the great boxlike structures, revealing its multitude of sculptures, dazzling in their whiteness," says Brassaï. Remembering the colossal heads inspired by Marie-Thérèse Walter, which had just appeared in the famous series of etchings significantly entitled *The Sculptor's Studio*, Brassaï adds: "So they were not imaginary! I was greatly surprised to rediscover them here in the flesh, by which, of course, I mean in the round; all curving lines, the nose becoming more and more prominent, the eyes like globes, resembling some barbarian goddess."

Now that certain pictures by Picasso are solemnly taking their place in all the museums of the world, what I admire most of all is the generosity with which he thus shares everything that must never be allowed to become a focus of feigned admiration or an object of speculation other than intellectual. In this, too, the view he takes of his own work may be described as being absolutely dialectical. The time has come to emphasize the point, on the occasion of this presentation, in the first issue of "Minotaure", of a substantial part of his recent "extra-pictorial" production.

André BRETON, 1933

Woman throwing a Stone, oil. *8 March 1931*

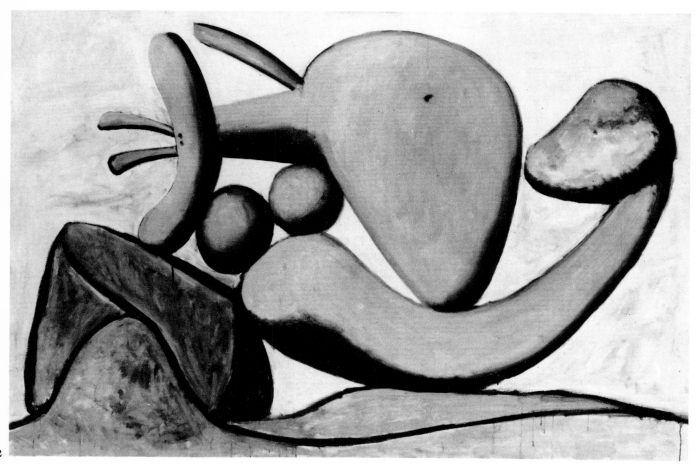

Much more noteworthy, it seems to me, because this alone is really suggestive of the power given to man to act on the world in order to fit it to himself (and thereby fully revolutionary), is the unremitting temptation he feels, throughout his work, to confront all that exists with all that might exist, to call forth from the never-seen whatever may caution the already-seen to make itself less often and foolishly seen.

André BRETON, 1933

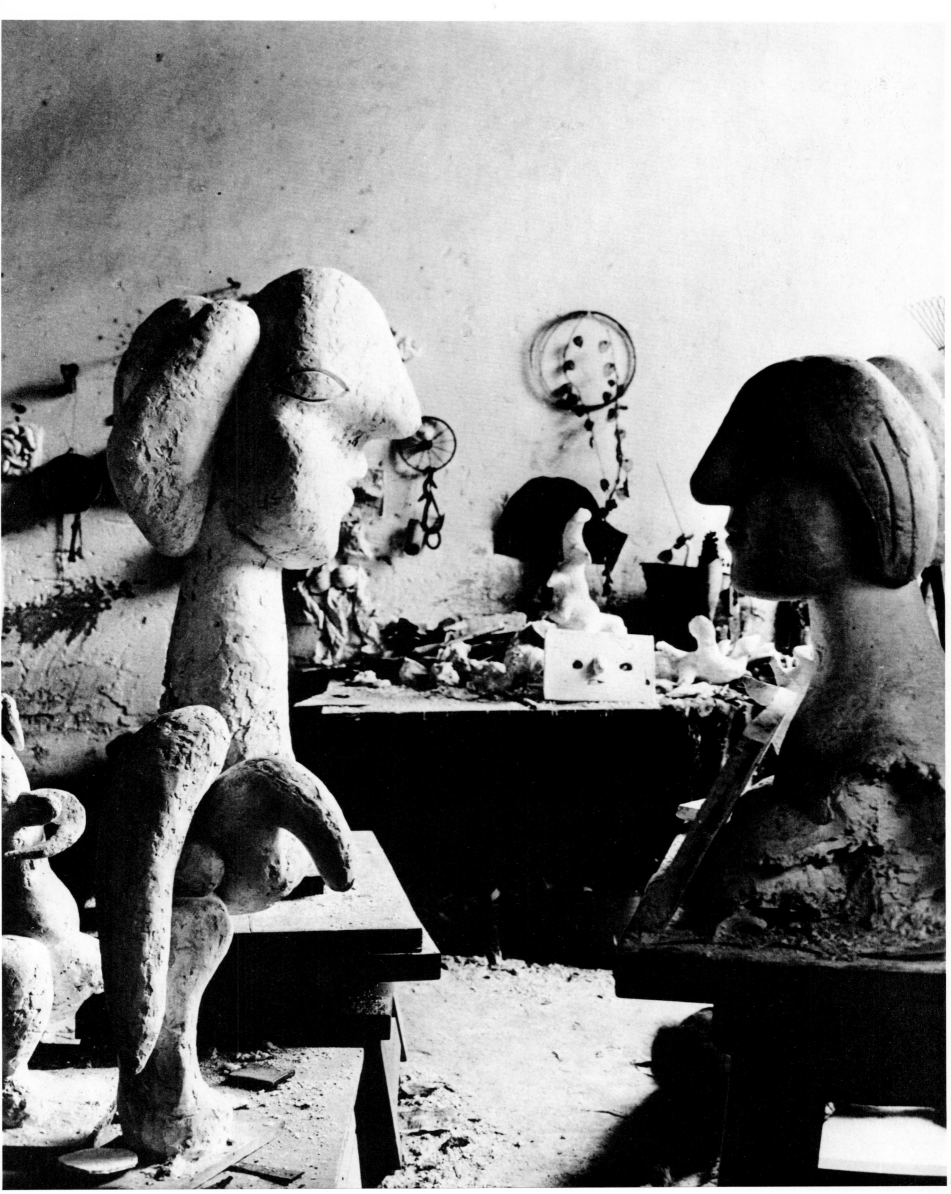

63

Sculpture in Picasso's Studio at Boisgeloup (1933), photograph by A. E. Gallatin.

Two bathers anatomically reconstructed, with a calculated exaggeration of their sensual forms, play on the beach with a toy boat in the blue calm of midsummer, but a huge staring head looms on the horizon like a menacing omen. Disasters were soon to follow, barbarism was unleashed over Europe and Picasso took refuge during the early months of the war at Royan, on the Atlantic coast about seventy-five miles north of Bordeaux. There, taking the traditional theme of the nude dressing her hair, he raised a monument of horror transcending his personal anxieties and embodying the bestiality of the period and the darkest forebodings of men everywhere. The monster, organically viable, is crouching in a sort of narrow box which heightens the impact of its enormity and bathes it in a lurid atmosphere of mauve and green.

Girls with a Toy Boat, charcoal and pastel.

12 February 1937

Nude dressing her Hair, oil.

6 March 1940

Seated Nude, oil.

11 December 1961 II

Standing, seated, reclining, crouching, sometimes grouped in couples whose angular or curving masses stand in contrast or equilibrium, but usually shown singly in splendid isolation, female nudes proliferate in the artist's recent work and invade every one of the different media in which he works. Since the place accorded to landscape, long a minor one, has also grown more prominent with the passing years, he has taken more and more to installing them out of doors, in the freedom of the open air, in order to show them lifesize in their most natural setting. *Nude under a Pine Tree* of January 1959 confronts us in close-up with full-bodied interlocking forms bound up with the rhythm of the earth and the passiveness of repose. The subtle monochromy emphasizes the architectonic size of this prodigious monument, one more responsive however than any other object to the patterned play of shadows through the leafage. The artist's Afghan hound Kaboul moved so freely and nobly through the studios where the nudes were painted that its long muzzle is combined with the woman's startled eyes in several composite nudes done late in 1961. Early in 1964, while walking in the garden of their house, Jacqueline and Picasso came upon a stray black kitten which they took home with them, and its appealing presence at once embellished a series of pensive or strenuous nudes. All trace of style goes by the board and the *Seated Nude* of January 1965 looms up in radiant light punctuated by a few magic signs which intriguingly enhance its charm. The skillful play of the crayon in the *Sleeping Nude* of August 1969 conveys the essence of woman in all her candid naturalness.

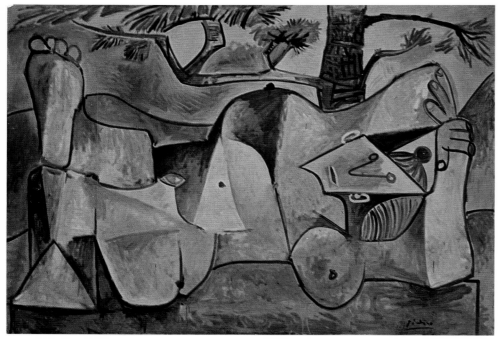

Nude under a Pine Tree, oil.

20 January 1959

Woman with a Cat, oil.

THE NUDE AS IT IS

Picasso muses as he looks at his canvases: painters in their studios painting nudes.

He says he must find a way of doing the nude as it is. *That is, the spectator must be given the means of doing the nude himself when he looks at the canvas.*

(He speaks to a painter.)

You know, it's like the hawker of fruits and vegetables. You want two breasts? Well, here are two breasts.

What is required is for the man looking at the picture to have at hand all the things he needs, and these things have to be given to him. Then he will put them in their place himself with his own eyes.

Hélène PARMELIN, *Les Dames de Mougins*, 1964

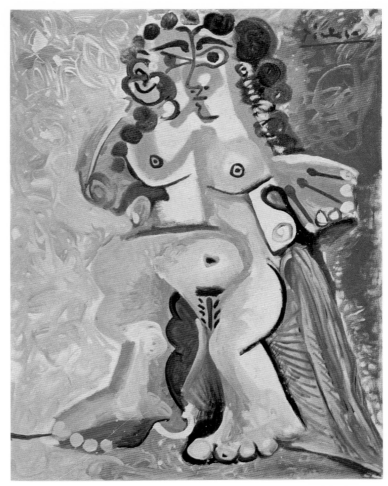

Seated Nude, oil. *7 January 1965 II*

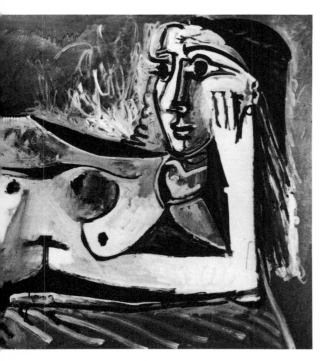

1964

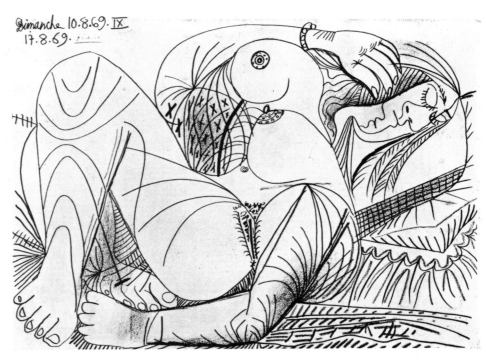

Sleeping Nude, colored crayon. *10–17 August 1969*

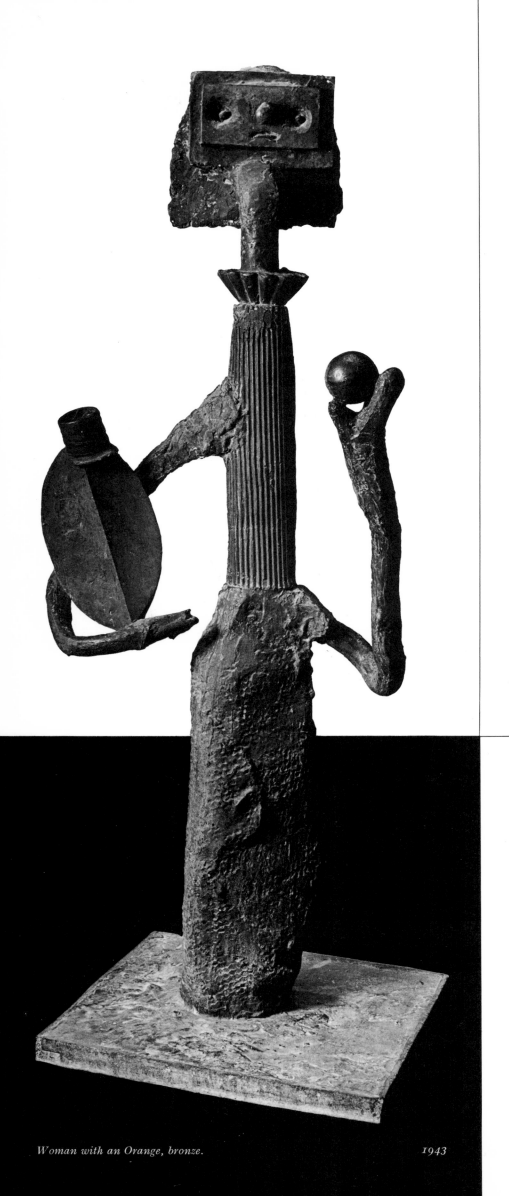

"Since I couldn't leave Paris [during the occupation], I made my bathroom into a sculpture studio,"

Picasso told Brassaï who, coming to pay him a visit, was astonished to discover in a group of normal figures a stranger construction which revealed, not without humor, an extraordinary inventive power and, in the use of unexpected materials, an infallible but realistic sense of metamorphosis:

"A tubular statue, very long and thin, attracts my attention, because of its novelty. The body is a slender shaft—some kind of corrugated paper must have been used to impress its grooved pattern—the neck, a wooden roller emerging from a dessert mold, transformed into a little fluted ruff. As for the head, it is a square slab, doubtless the cover of a box. The left arm is crooked, holding a sort of vase; the right arm, lifted vertically, holds a ball in its hand. Picasso has named it *Femme à l'Orange.*"

BRASSAI, 1942

The *Woman Reclining and Reading,* with its suggestive mood of introspection, is a small bronze painted like a ceramic and built up by the same technique of assembled materials as the tall, standing, hieratic figure of the *Woman with an Orange.* Picasso combines the most disparate and often grotesque elements not for fanciful purposes but with a view to recreating the mysterious truth of life by endlessly varying the image of woman.

Woman with an Orange, bronze. *1943*

During his stay at Vallauris, Picasso, Mediterranean wizard that he is, initiated himself into pottery making and passionately explored its possibilities, recreating the unity of form and design which constitutes the centuries-old secret of an art which magically combines painting and sculpture. Georges Ramié, the master potter with whom he worked, tells of the genesis and outcome of an admirable series of female figurines:

The story of these statuettes is in itself quite as interesting as the conception and the remarkable success which they represent.

Most of them began, a long time ago, as pieces thrown in the form of stop-necked bottles. While still fresh, they were shaped by a squeeze of the thumb which modified the cylindrical contour of the bottle. Thus molded before it had set, the clay possessed a plasticity all the more perfect since the resistance of the air imprisoned in the body of the piece enabled him to rework a particular detail and prevented the whole from losing shape.

He had no other intention but that of evoking an attitude; they were simple studies of volumes with a view to the play of light and shadows. As such, they were fired in their original simplicity and so they remained. Quite recently, this state being judged too rudimentary, it was enhanced by coloring added with the brush and by several refirings. So now the starkness of the pure form, for a time self-sufficing, was brought to a refined conclusion by its alliance with the seductive subtlety of these colors.

The extraordinary power of life which emanates from these figurines undoubtedly makes them the most incomparably human and most deeply felt works in Picasso's ceramic output.

Georges RAMIÉ, 1951

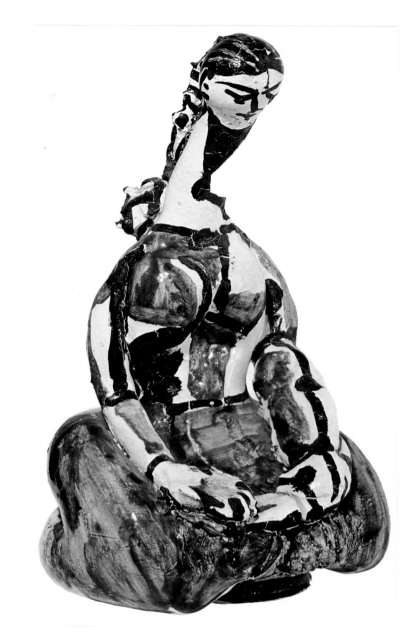

Seated Woman, painted terracotta. *1953*

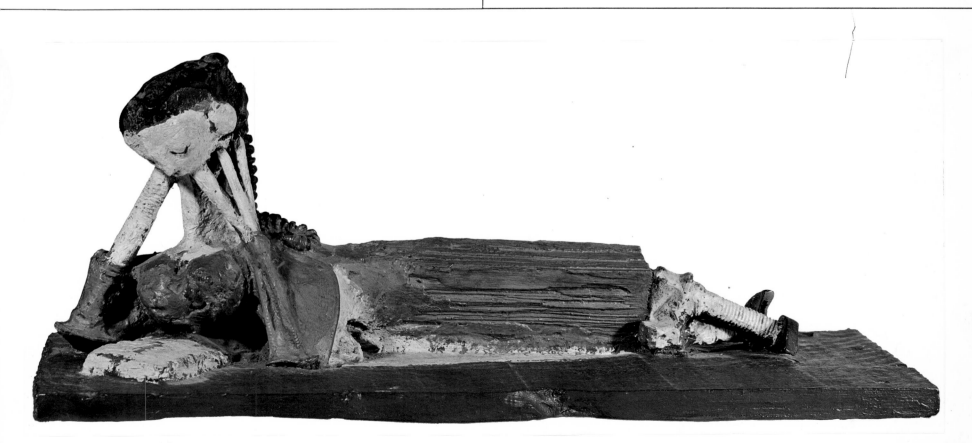

Woman Reading, painted bronze. *1952-1953*

A seated nude woman reading on the beach and a crouching nude woman washing her feet in an interior—these two anatomical studies, exactly dated, are separated by an interval of seven years. Despite the time lag and the difference in style (metamorphic construction, naturalistic figuration), in technique (oil and pastel, lead pencil) and setting, these two monumental nudes have an arresting kinship and the same impress of true and total humanity. Breaking away completely from illusionist conventions and traditional rectilinear coordinates, they occupy and define a curving space arising from tactile and dynamic perceptions. Picasso renders tangibly the muscular strain and movement of the human body engaged in a specific action, recording all its aspects simultaneously. This characteristic attitude of woman as she leans forward to read, to pick flowers, to take up her child or more prosaically to examine or wash her feet, recurs periodically in his work and finds its fullest expression during the year 1944, in a series of pencil studies in May, of ink wash drawings in July. She reappears again in this characteristic pose in July 1960 in a series of seven drawings connected with the variations on Manet's *Déjeuner sur l'Herbe*. She is taken up and integrated into group compositions, drawn or painted. We find her thus in 1956—a year of many nudes of exceptional plastic density—in the righthand figure of *Two Women on the Beach*, a picture which revives and extends, on a monumental scale, the cubist system of articulation. Her characteristic inward curve contrasts with the verticality of the lefthand figure straining toward the mirror.

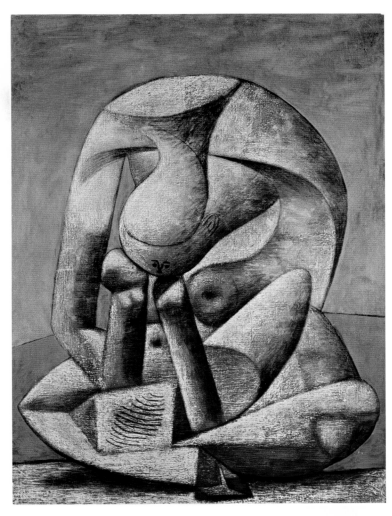

Seated Woman with a Book, oil and pastel. *18 February 1937*

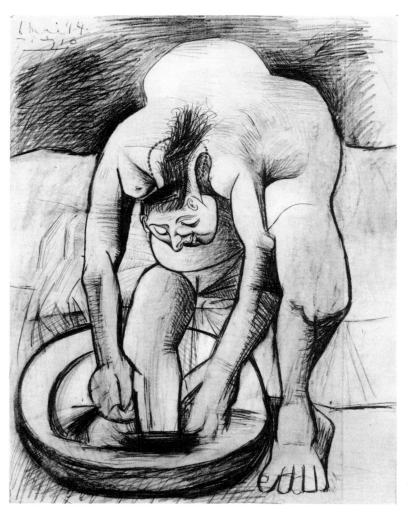

Woman bathing her Right Foot, lead pencil. *6 May 1944*

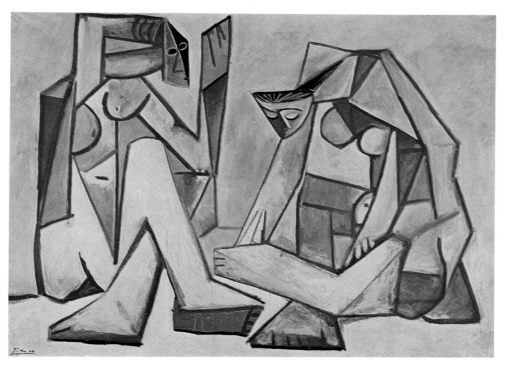

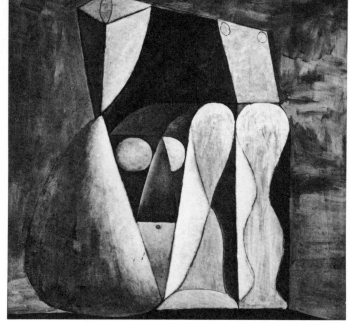

Two Women on the Beach, oil. *16 February 1956*

Crouching Woman, oil on plywood. *1946*

Picasso's pictures often suggest sculptures, just as his sculptures answer to pictorial representations. The interconnection between the problems of plane surfaces and volumes in space lies at the heart of Picasso's preoccupations, for they are the very substance of the problem of structures. It was by grappling with those problems that Cubism was able to contribute one of the most staggering solutions ever seen in the history of the developments of pictorial knowledge, a veritable overhauling of everything that concerns the art of seeing.

Tristan TZARA, 1948

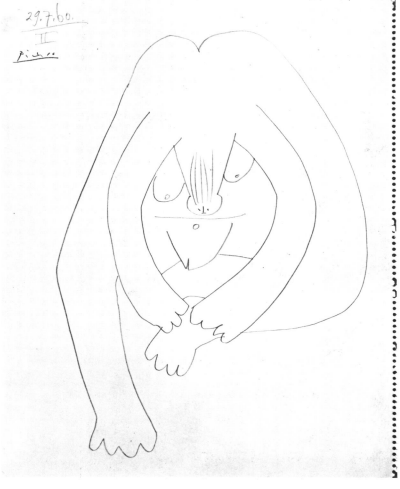

Two Studies for the "Déjeuner sur l'Herbe", drawings. *29–30 July 1960*

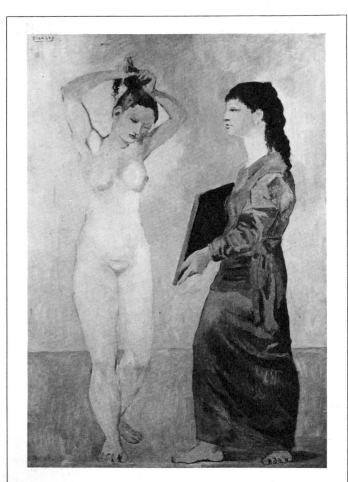

La Toilette, oil. *Summer 1906*

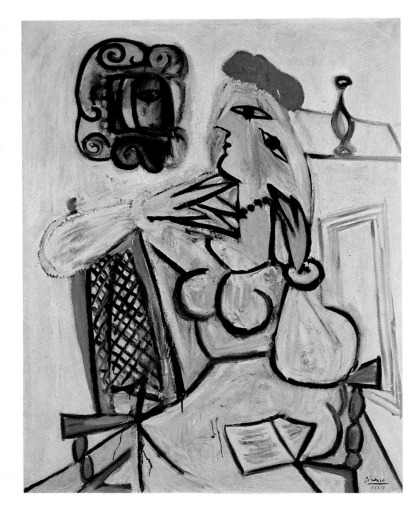

Woman in a Red Hat, oil. *1934*

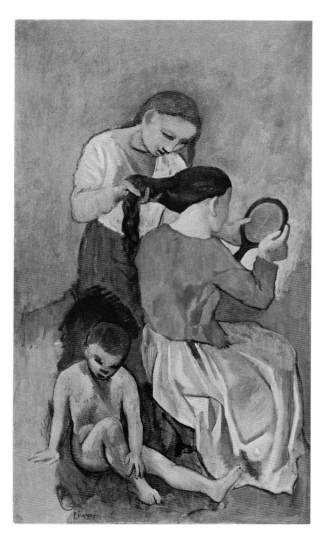

La Coiffure, oil. *1906*

Unchanging themes, changing interpretations. An oval form or a simple rectangle, to which a pair of eyes is turned at the heart of the picture, is enough to convey a haunting suggestion of inquiry or scrutiny. For a woman doing her hair or having it done, the mirror held up before her or held by herself is a necessary instrument, and her manner of using it is part of the ceremonial connected with her coiffure and her toilette. The two compositions of 1906 inspired by these traditional motifs pass suddenly from the purest classical grace to the massive dignity of primitive forms. When a woman made up with sensual coquetry and wearing a provocative red hat sits down and unexpectedly meets her own gaze in a Baroque looking glass, the effect of surprise is of a different order. The similarity, not to say duplication, of the nude woman and the draped maidservant gazing at her adds to the mirror effect of *La Toilette*. Sometimes it is a naked boy who holds up the mirror and his upright figure contrasts with the woman's contortions. *Woman seated before a Mirror* of 1937 is the end-result of an extensive series begun in 1934, representing young women reading, writing, drawing or sleeping in a quiet interior with a large looking glass. In this composition, with its marvelous balance between voids and solids, the motionless model is engrossed in the contemplation of her voluptuous beauty; but what the mirror reflects are not her opulent curves but the iridescent triangles patterned by light streaming in from the open window.

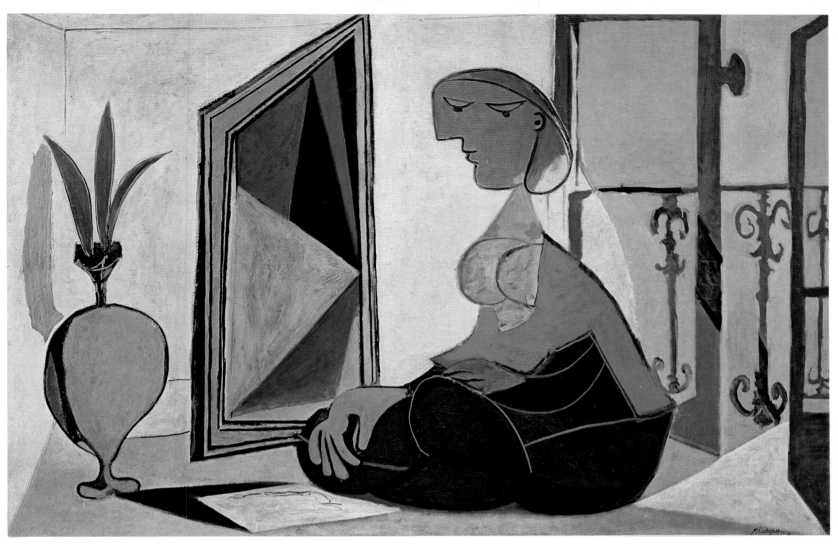

Woman before a Mirror, oil. 1937

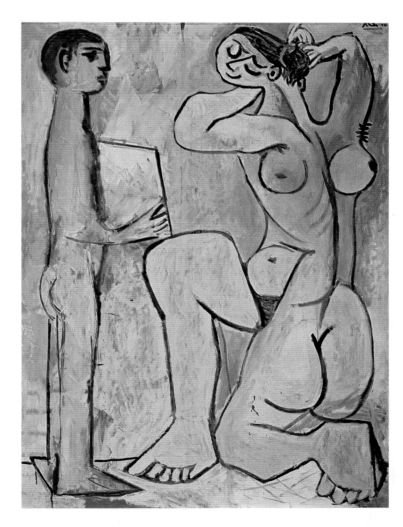

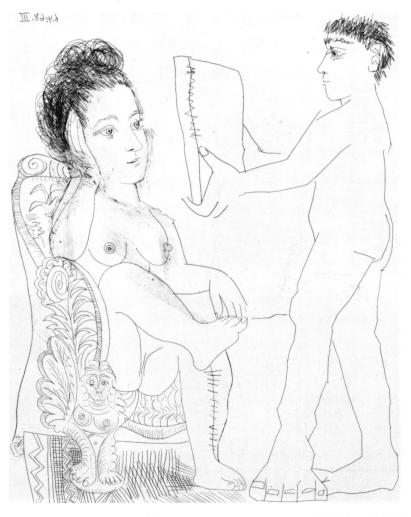

La Coiffure, oil. 7 *March* 1954 *Woman before a Mirror, drypoint.* 6 *April* 1968 *III*

73

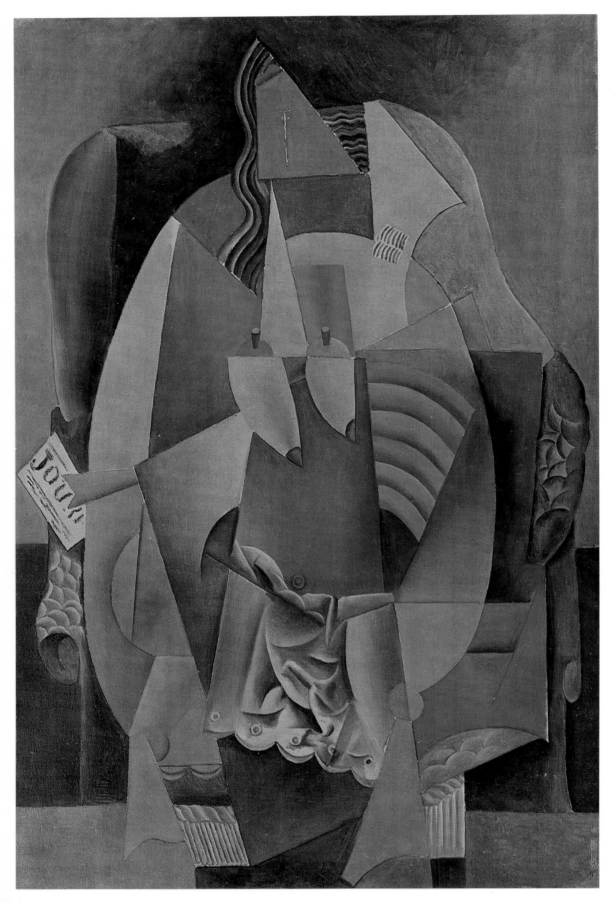

Woman in a Chemise seated in an Armchair, oil. *1913*

I speak of what helps me to live, of what is good. I am not one of those who try to go astray and forget themselves by loving nothing, by reducing their needs, tastes and desires, by guiding their life—that is, life itself—to the repugnant conclusion of their death. I do not seek to subdue the world solely by the virtual power of the intelligence, I want to be responsive to everything, I want everything to be real and useful to me, for only on that basis can I conceive of my existence. Man can have his being only in his own reality. And he must be aware of that reality. Otherwise, he exists for others only as a dead man, no more alive than a stone or a heap of manure.

Paul ELUARD, 1935

I think of that famous picture by Picasso, the Woman in a Chemise, which I have been familiar with for nearly twenty years and which has always seemed to me at once so elementary and so extraordinary. The huge, sculptural mass of this woman in her armchair, the head as big as that of the Sphinx, the breasts nailed to her chest, contrast wonderfully—and that is something neither the Egyptians nor the Greeks nor any artist before Picasso had been able to achieve—with the delicate features of the face, the waving hair, the delicious armpit, the salient ribs, the vaporous petticoat, the soft, comfortable armchair, the daily paper.

Paul ELUARD, 1935

Woman in an Armchair, pencil or charcoal. 1914

Cubism is neither the seed nor the germination of a new art: it represents a stage in the development of original pictorial forms. Once worked out, these forms are entitled to an independent existence.

If at present Cubism is still in a primitive state, a new form of Cubism will have to arise later. Attempts have been made to explain Cubism in terms of mathematics, geometry, psychoanalysis, etc. All this is mere literature. Cubism pursues self-sufficing pictorial ends. These we may define as the means of expressing everything that our reason and our eyes perceive within the limits of the possibilities allowed of by line and color. What an inexhaustible source of unexpected joys and discoveries!

PICASSO, 1930

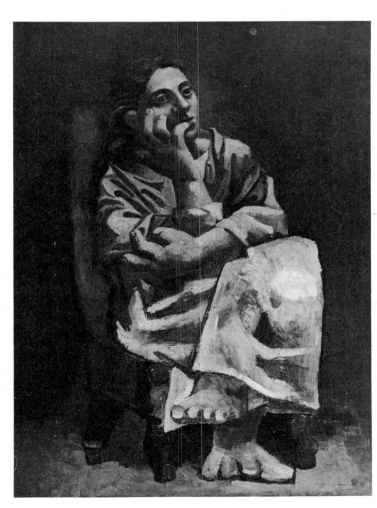

Seated Woman, oil. 1920

Art has neither past nor future. Any art powerless to assert itself in the present will never come to anything. Greek art or Egyptian art do not belong to the past: they are more alive today than they were yesterday. Change is not evolution. If the artist modifies his means of expression, that does not mean that he has changed his state of mind. Everyone is entitled to change, even painters.

I have always worked for my own time. I never trouble myself about the spirit of research. I express what I see.

I do not concern myself with "meditation". I do not indulge in "experimentation". If I have something to say, I say it in the way that seems to me most natural.

PICASSO, 1930

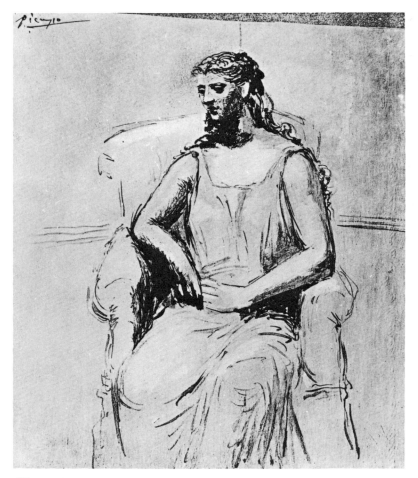

Woman in an Armchair, oil. *Winter 1921–1922*

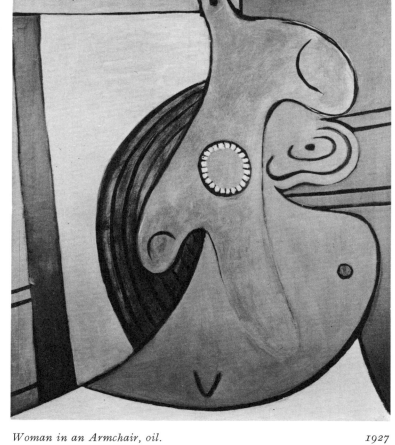

Woman in an Armchair, oil. 1927

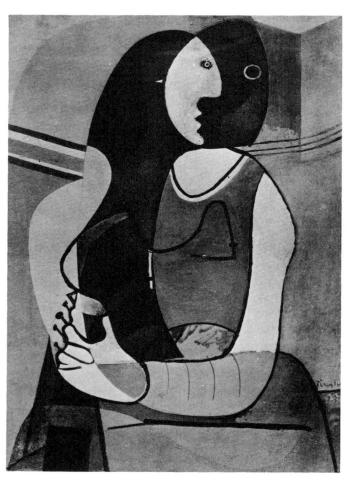

Seated Woman, oil. 1927

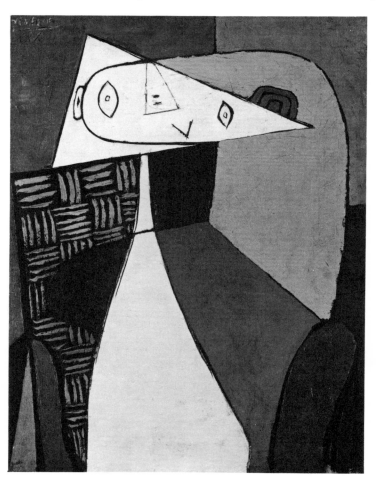

Seated Woman, oil. 1930

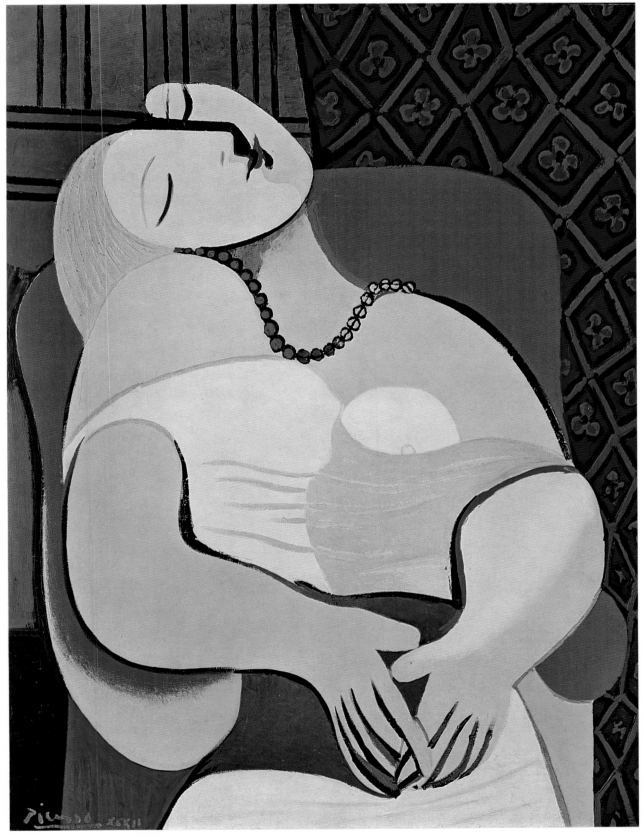

Woman asleep in a Red Armchair (The Dream), oil. *1932*

The picture is not thought out and fixed in advance; while it is being made it follows the mobility of one's thoughts. When it is finished, it changes even more, according to the state of the person looking at it. A picture lives its own life, like a living creature; it undergoes the changes that daily life imposes on us. This is natural enough, since a picture lives only through him who looks at it.

PICASSO, 1935

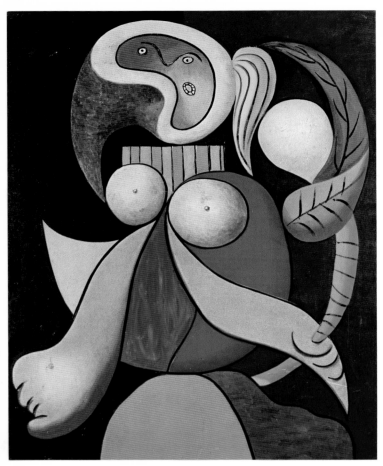

Woman with a Flower, oil. *1932*

Girl with a Guitar, oil. *10 January 1932*

Girl with a Book, oil. *January 1932*

A crowd of portraits
One is disdain another is conquest
Another clear, lapping water
Another bell of dew.

Paul ELUARD, 1944

Flower, book, guitar, armchair and window have given their titles to these pictures; they might also be designated according to the waking or sleeping state of the subject, according as the model is shown full face or in profile, nude or clad, or according to the suppleness or violence of the line. But thereby only the accessory or the accidental would be evoked, and not that essential confrontation with the perpetually living and diversified presence of the motionless woman in her chair which fixes her in our gaze and memory. Each of the works brought together here as examples of a common and quite traditional theme contains in itself the reference to many others often similar and yet different. "If there were only one truth," says Picasso, "one would not be able to paint a hundred pictures on the same theme." As a group, they represent the stylistic and emotional variations of a creative adventure in which, as he reacts to the unforeseen solicitations of the moment and the reality of his daily surroundings, the painter unites art and life.

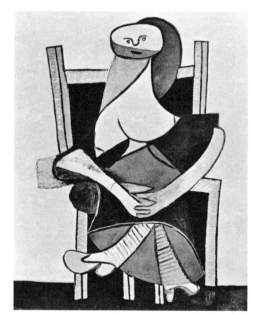

Woman in an Armchair, oil. *1937–1938*

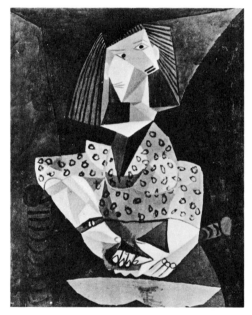

Woman in an Armchair, oil. *5 October 1941*

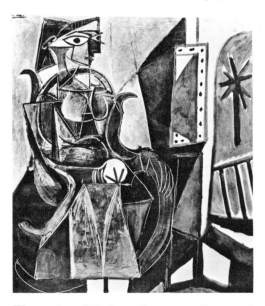

Woman by a Window, oil. *11 June 1956*

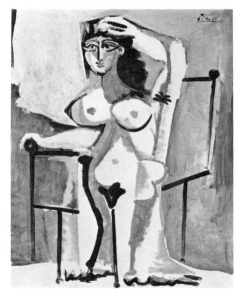

The Model, oil. *24 April/8 May 1963*

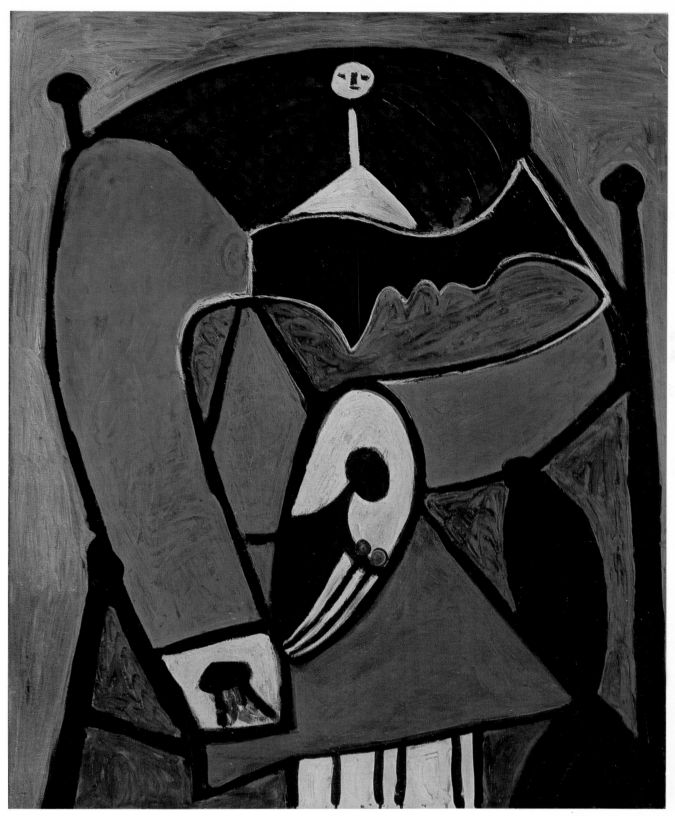

Woman in an Armchair, oil. *1948*

It would be very curious to record photographically, not the stages of a picture, but its metamorphoses. Then perhaps one would see the path by which a brain has advanced toward the final shaping of its dream. But what is really very odd is to observe that in actual fact the picture does not change, that despite appearances the initial vision remains almost intact. I often see a light and a shadow; when I have put them into my picture, I do my best to "break them up" by adding a color that creates a contrary effect. When the work is photographed, I realize that what I introduced to correct my initial vision has disappeared, and that in fact the image given by the photograph corresponds to my initial vision, before the transformation wrought by my will.

PICASSO, 1935

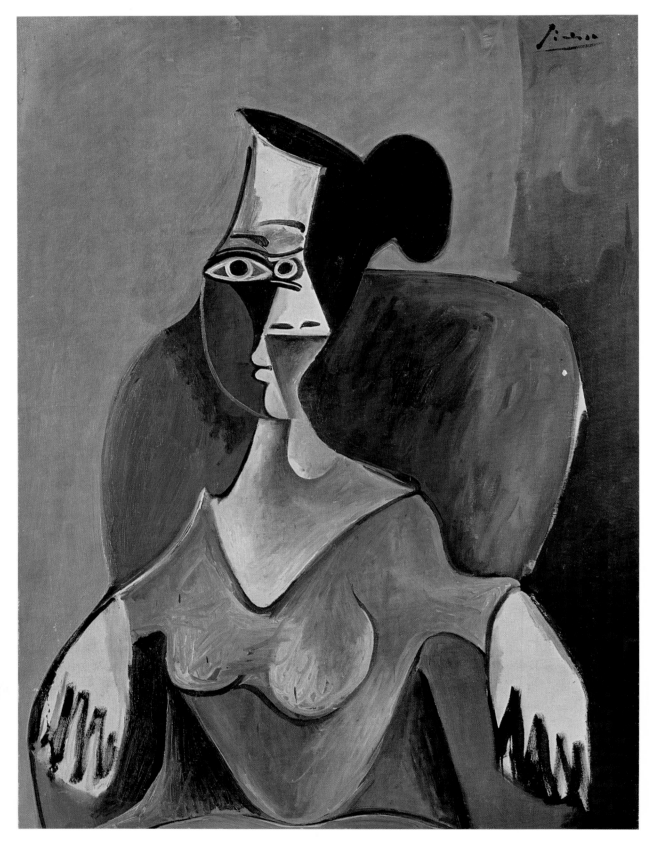

Woman in an Armchair, oil *20 November/13 December 1962*

After all, everything depends on oneself. It is a sun in one's belly glowing with a thousand rays. The rest is nothing.

PICASSO, 1932

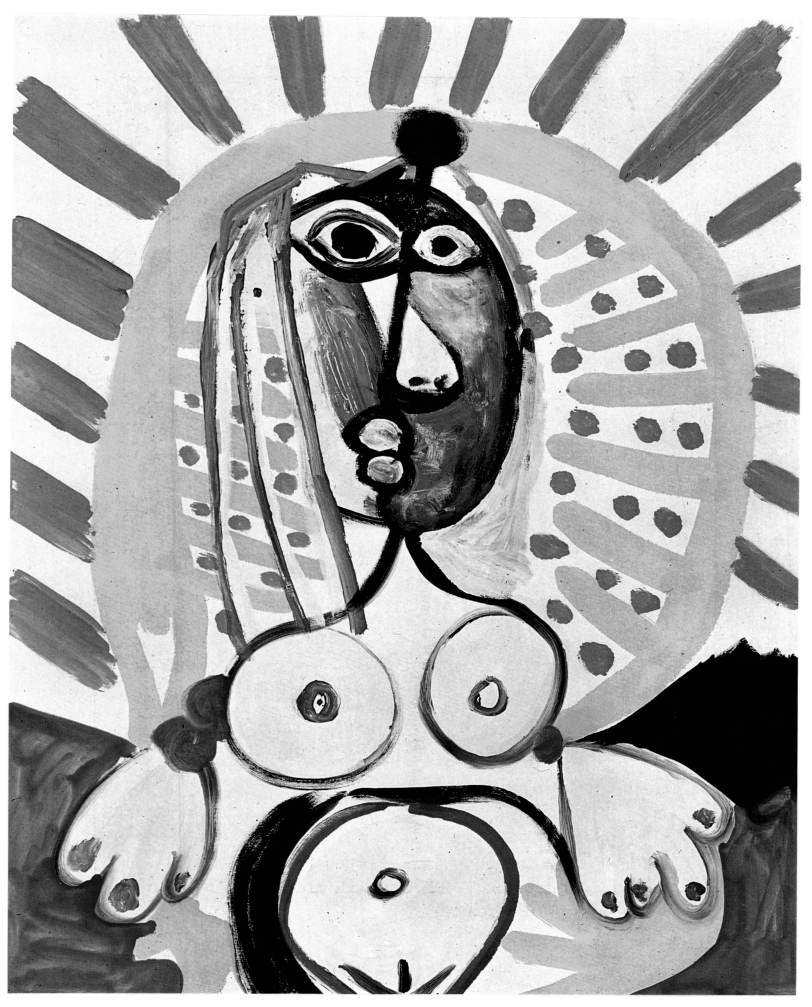

Woman in an Armchair, oil.

7 January 1970 II

History and poetry, all may be one.
LOPE DE VEGA

Drama and History

Echoes and repercussions of *Guernica* made themselves felt on a motif taken over from it and treated separately in several different media, the *Weeping Woman*. The watercolor in livid tonalities of 28 October 1937 is one of the final versions of this poignant series. Although the angular face with its Spanish headdress is portrayed in side view, the two swollen nostrils are visible, and so are both eyes, starting out of the head, with copious tears streaming down the cheeks. The grace of the model, with the delicate turn of her neck, is ravaged by the torment her features undergo, and overwrought despair is conveyed by the pathetic gesture of the handkerchief bitten by the woman to stifle her cry of horror and grief, a cry that even so cannot go unheard. If the suffering expressed by this image transcends time and place, its paroxysmal style betrays our time and marks a characteristic stage in the artist's development.

Contemporaneous with the heyday of jazz and Surrealism, the *Three Dancers* of 1925 is a key picture of the same importance as the *Demoiselles d'Avignon*, but the reversal of values which it achieves goes in the opposite direction, from form towards expression, from plastic structures towards psychic tensions. The zones of flat, strident color and the contrasting blacks and whites go hand in hand with the wild dislocation of the figures and the heterogeneous electrification of space. In the course of the work Picasso learned of the death of his early friend, the Catalan painter Ramon Pichot. This news had its impact on the work at various levels. The dark, motionless man outlined on the right is the ghost of his friend Pichot. Added to the three female protagonists, he seems to preside over this strange scene in which the ritual of the dance, frenzied on one side, majestic on the other, falls into the pattern of a crucifixion. The middle dancer with uplifted arms gliding by the window forms the sacrificatory axis and the convulsive bacchante on the left represents the weeping maenad of Italian iconography. Her demoniacal fury is the reverse of her sacred violence. The distortions of her body and face prefigure the nightmarish creatures who were to follow, the succubi on the beaches and the predatory mantises, one of whom directly menaces the painter in the self-portrait of 1929.

The conflicts, anguish and obsessions of his emotional life found release in the metaphorical language of the unconscious. A journey to Spain in 1934 rekindled the smoldering native embers of his passionate temperament. In the work of this period actual scenes of Spanish bullfighting are dramatically combined with the antique, legendary cycle of the Minotaur with its personal implications. The synthesis culminates in the etching of the *Minotauromachy*, a work as irreducibly dense as Dürer's *Melancolia*.

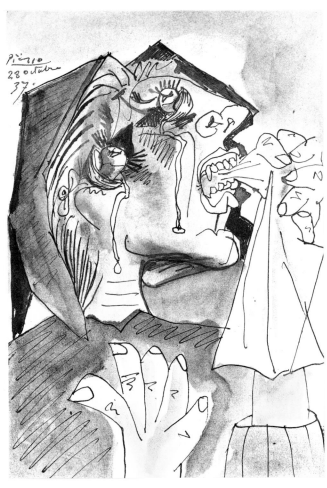

Guernica Postscript: *28 October 1937*
Weeping Woman, watercolor and ink.

In January 1937, with no particular subject in mind, he agreed to decorate the pavilion of the Spanish Republic at the Paris World's Fair. The merciless bombardment in broad daylight, on April 26, of the undefended Basque town of Guernica at once aroused his creative anger and set him to work with such energy that in less than two months he finished the vast, unsigned, undated mural canvas which remains his most famous work, bearing witness unforgettably to the meaning of war in this century. The essential motifs which then haunted him, each of them rooted in his innermost being and in the previous history of forms, are uplifted and crystallized in an epic whole.

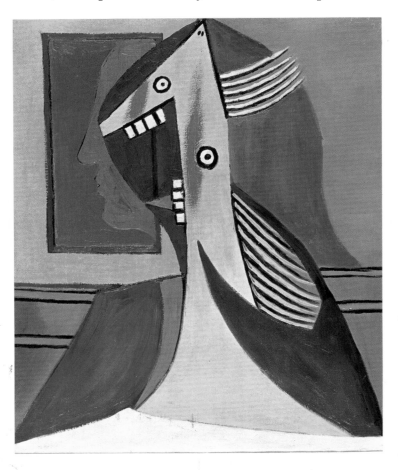

Woman's Head and Self-Portrait, oil. 1929

Its genesis and progression is recorded in the many preliminary studies and the series of photographs taken during its eight successive phases. In the center, in contrasting glare and gloom, the major, symbolically antagonistic confrontation is that of the corrida: the dying horse pierced with a spear—surrogate of the crucifixion—and the unshakable bull whose artistic and mythical origins go back to the Minoan age. Between the two, a bird warbles on the table. Under the horse lies a soldier—or the torero—its limbs scattered, its fist still clutching a broken sword, beside a flower. From a window on the right, a woman bursts in, a pure, over-lifesize profile, holding out the lamp of justice and truth. Three other women form the tragic chorus: one falls through a burning house, the second is running away, and the third, a mother, screams wildly, holding her dead child in her arms. The monochrome composition has the sturdy triangular design of a pediment. The theme which it harks back to, and which all Picasso's war pictures, down to the *Rape of the Sabine Women*, hark back to, is the classic theme of universal resonance: the Massacre of the Innocents. But the character of the work, intimated by certain stylistic borrowings from the famous Spanish Apocalypse manuscripts, is medieval: it is that of the apocalyptic revelation.

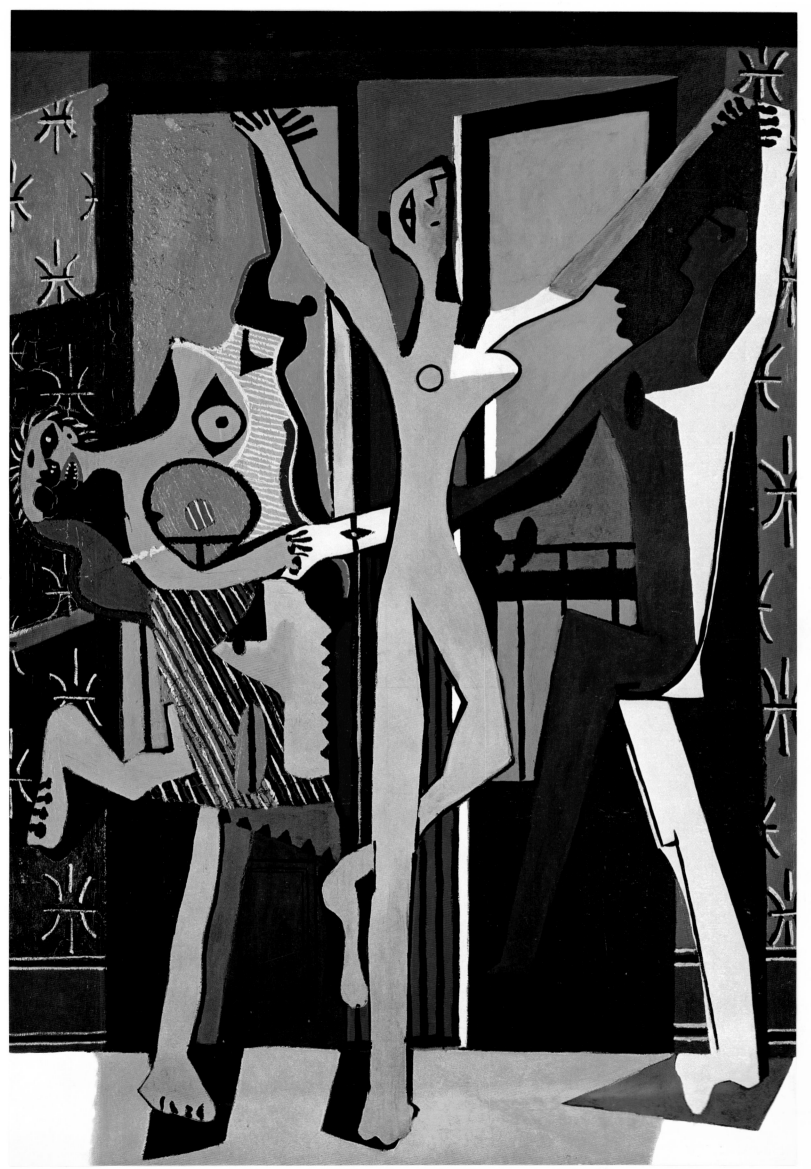

The Three Dancers,
oil. 1925

85

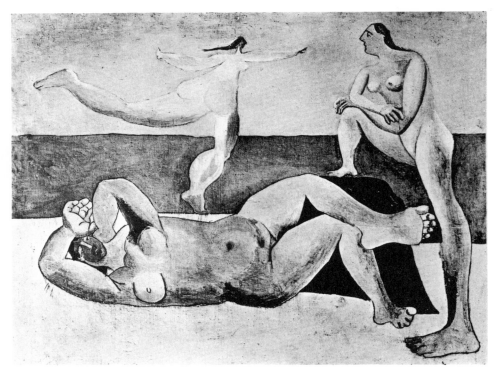

Three Bathers, oil. *1920*

The summer stays he made regularly now on the northern or Mediterranean beaches, among scantily clad bathers, in the relaxed atmosphere that followed the end of the war, together with his close contacts with the world of the dance through his marriage and his continuing collaboration with the Russian Ballet, fortified Picasso's pagan cult of the female body in majestic repose or strenuous movement. The three bathers, with their dynamic elongations and foreshortenings, take full possession of the sea space in which they seem to be very much at home.

Bathers, lead pencil. *12 May 1921*

This figure composition in lead pencil matches, in its linear perfection and rhythmic vivacity, the finest outline drawings on Greek vases. It combines two of the artist's favorite motifs, racing figures on the beach and a tranquil coiffure or toilette scene represented by the kneeling and reclining figures on the right. A few strokes on the white sheet are enough to evoke and differentiate the luminous expanse of sky, sea and sand.

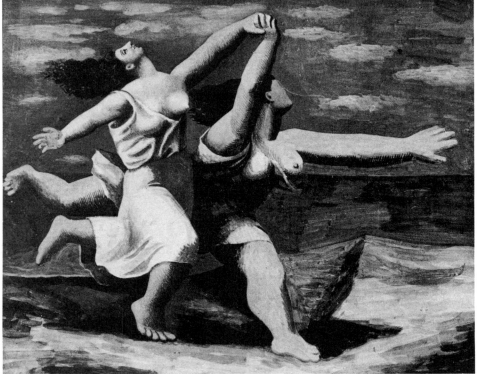

Two Women running on the Beach, distemper. *1922*

The rhythm is speeded up, the classical norm disappears, and the two frenzied bacchantes coursing along the beach with irresistible momentum, hair and breasts in the wind, belong now to the primitive race of giantesses. This distemper painting, small in size, monumental in effect, was used two years later as the design for the curtain of *Le Train bleu*, a ballet-operetta with libretto by Cocteau, music by Darius Milhaud and scenery by Henri Laurens.

On the Beach at Dinard, oil. *24 August 1928*

During the summers of 1928 and 1929 Picasso forsook the Mediterranean for Dinard, a seaside resort in Brittany, where he had stayed in 1922. There he painted a famous series of small beach scenes, usually girls in striped bathing suits playing with a beach ball. With their intense, striated, punctuated, outspreading colors and their acute rhythmic contractions—spheres, triangles and rods—these small pictures, rigorously designed in their Dionysiac paroxysms, carry to an almost frenzied pitch the expression of movement whose course and stylistic variations we have traced.

The bathers of November 1932, with their freely flowing elongations, are also playing with a ball, but they are running on the beach of Juan-les-Pins, on the Riviera, and one feels the difference in the light. They come as a summing up of this dynamic cycle: the ternary grouping recalls the grandiose bathers of 1920; the bold signwork that qualifies and animates them recalls the frenzied bathers of Dinard. The bather on the right, with her head thrown back, expresses an attitude of sexual and sacrificatory surrender to which Picasso often reverted. A study sheet from a notebook, the charcoal drawing of January 1933, in which the angularities of November have given way to curves, is the synthesis of a series of paintings, drawings and engravings on the Rescue theme, sometimes combined with girls playing ball.

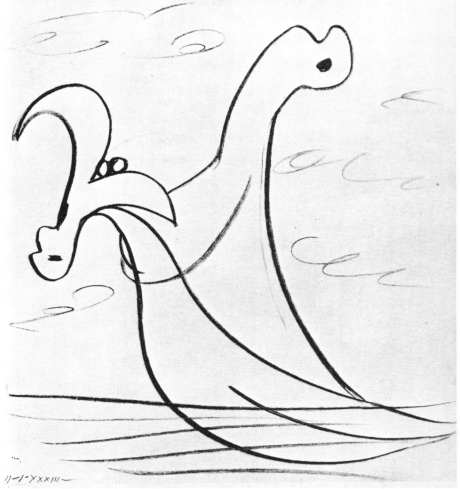

The Rescue, charcoal. *11 January 1933*

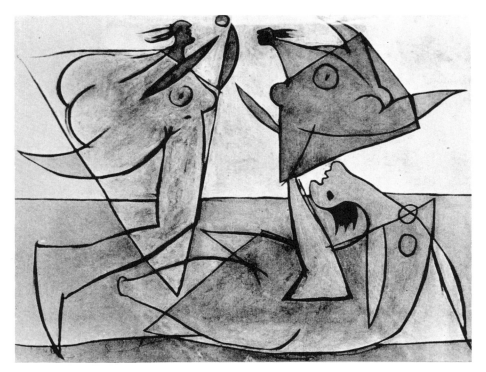

Bathers, oil. *28 November 1932*

In this bounding figure of an isolated bather, triumphant, comic and disturbing all at once, we recognize the features of Marie-Thérèse, obeying her primitive impulses and the metamorphoses which flow from them. By a process of osmosis revelatory of her nature, she first takes on the substance and appearance of the big lunar ball she is playing with, then is transformed into a sea mollusc, a sort of giant squid with spongy, aerodynamic bulbs.

And what if the air we breathe inflated us like balloons? What if our dimensions and proportions were suddenly changed? What would become of Venus then? The most impertinent and burlesque propositions come true, producing images which move us as much as do reproductions of habitual beauty.

Jean CASSOU, 1940

73

Nudes on the Beach, lead pencil.

Bather playing Ball, oil.

30 August 1932

The role of painting, as I see it, is not to paint movement, not to put reality into motion. Its role, as I see it, is rather to stop movement.

You must go beyond movement in order to stop the image. Otherwise you are running along behind.

Only then, as I see it, do you have reality.

PICASSO, 1965

This etching and aquatint on a black ground, unique in character, grandiose both in format and execution, is one of the artist's most arresting prints. Made in the summer or fall of 1938, it sums up, on the eve of war, with inevitably emotional overtones, the long cycle of dancing figures and panic exaltation. This disheveled maenad, whirling to the sound of the tambourine, has the expressionistic horse-face, combining front and side view, which recurs repeatedly after *Guernica*. The cubist system of dislocation and re-assembly, which allows every aspect of the body to be shown simultaneously, from all angles, answers here to a functional necessity, since it expresses the turning movement of the dancer while intensifying her rapturous ardor.

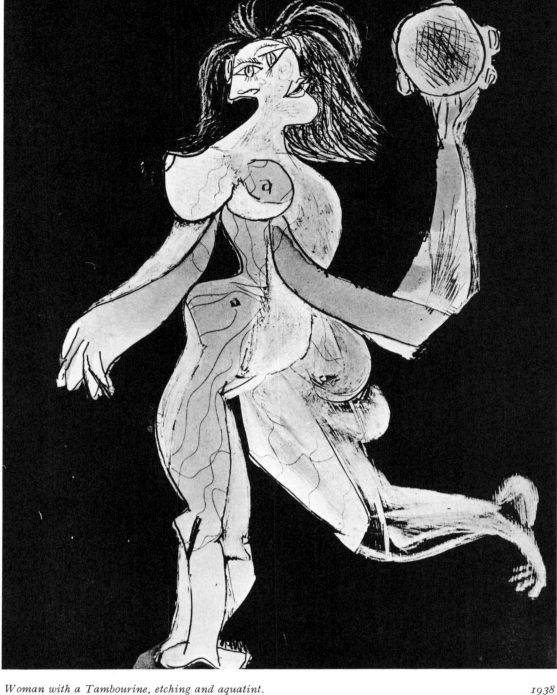

18 April 1933

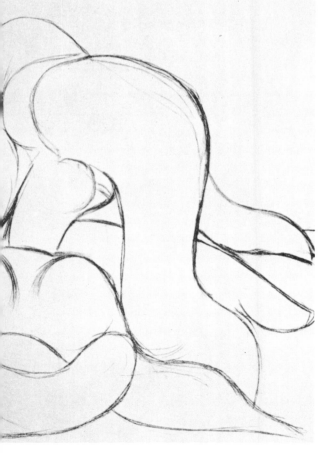

Woman with a Tambourine, etching and aquatint. *1938*

The artist is a repository of emotions, and they may come from anywhere: from heaven or earth, from a scrap of paper, a passing figure, a cobweb. This is why no distinction must be made between things. For them, there are no quarterings of nobility. You must take what you can, wherever you may find it, except in your own works. I have a horror of copying myself, but if I am shown, for example, a portfolio of old drawings, I do not hesitate to take from them what I want.

PICASSO, 1935

The Minotaur theme was inaugurated in 1928 by a large decorative collage (used later as a tapestry cartoon) and a corresponding painting: he was represented running, his head and legs reduced in size by the velocity of his bounding strides. Though already symptomatic in many respects, this initial appearance remained merely incidental, without any immediate aftermath. None of the illustrations made in 1930 for Ovid's *Metamorphoses* has any connection with the legend of Theseus, even though this book is one of the major sources of that legend. Picasso went back to the myth by way of his personal experience and the prompting of circumstances. The true, genuinely graphic incarnation of the Minotaur came in the spring of 1933 when, for the famous surrealist review of the same name, he was asked to design the cover and provide four opening plates showing the fabulous animal brandishing his double-edged phallic dagger or holding it like a scepter. Almost at once, the cycle was

developed to the full in the set of etchings incorporated in the Vollard Suite, where iconographically and technically it occupies an outstanding place. Then the Minotaur proceeded to make its sudden appearance in the sculptor's workshop, carousing with young women and in several episodes revealing the complexity of his hybrid nature, ingenuous or bestial, savage or debonair, terrifying or pathetic, before succumbing in the arena or undergoing the punishment of blindness like a tragic hero.

Several drawings and etchings contemporary with the Minotaur and associated with the corrida represent one of Picasso's strangest creations: the female matador, almost completely nude, with her sword and the wounded horse, being carried on the back of the victorious bull. This singular composition, whose genesis can be traced far back and in which the sexual element is emphasized, reappears in the major, synthetic etching of the *Minotauromachy*.

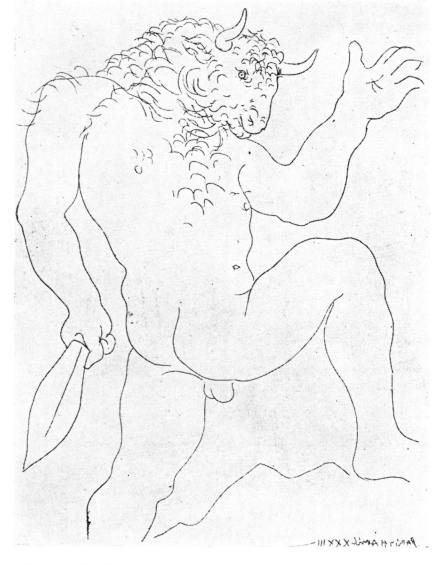

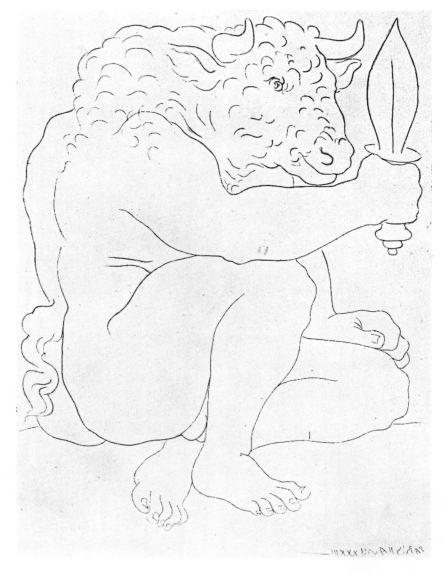

Minotaur with a Dagger, two drypoints.

April 1933

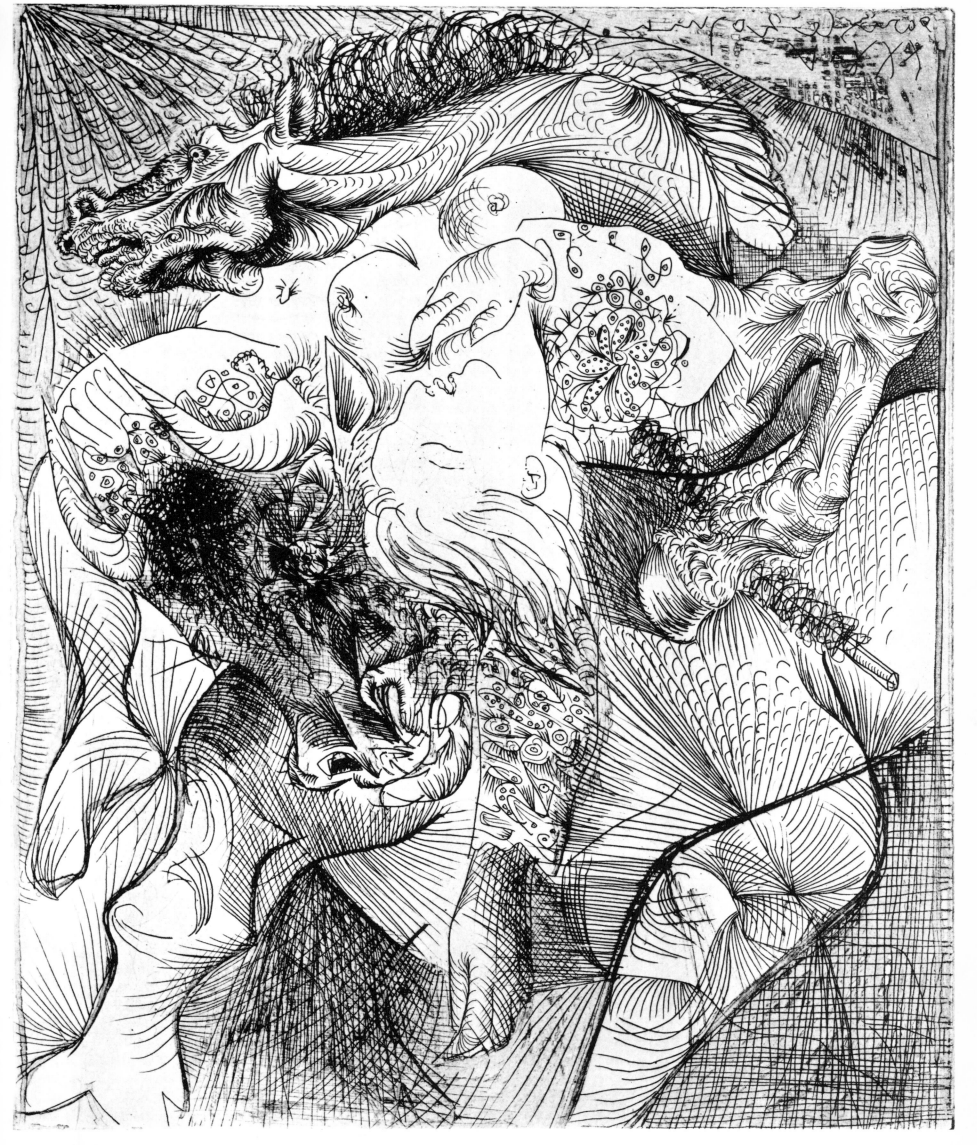

Female Torero II, etching.

20 June 1934

91

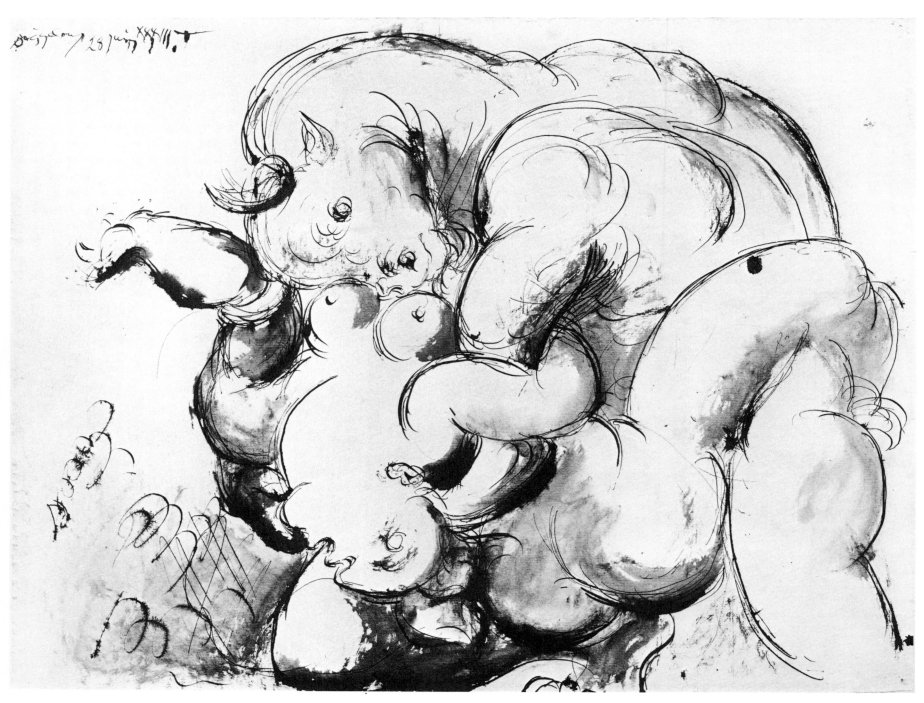

Minotaur attacking an Amazon, India ink.

28 June 1933

In this India ink composition, executed at Boisgeloup on 28 June 1933—a simple variant within a formidable series of engravings and drawings—the savage capture of the woman straining backwards and the irresistible embrace of the bull-headed man are conveyed with a plastic vehemence and a sensual ardor for which one would be hard put to find the equivalent, even in Rubens, the great Baroque master of the genre. The muscular outline setting off the interlocking masses of the two bodies is amplified by the luminist ripples of ink wash.

The drawing on the opposite page, in the same technique but in a different style, with its cross-hatchings characteristic of engraving, is a preparatory study for *Cinesias and Myrrhina*, the fourth of the six etchings and aquatints designed early in 1934 as illustrations for an American edition of *Lysistrata*, Aristophanes' comedy in honor of peace. Picasso kept faithfully to the text, recapturing its truculent irony in the dignity of antique forms and setting. This book was his last venture into the neoclassical style which had lingered on in his graphic work.

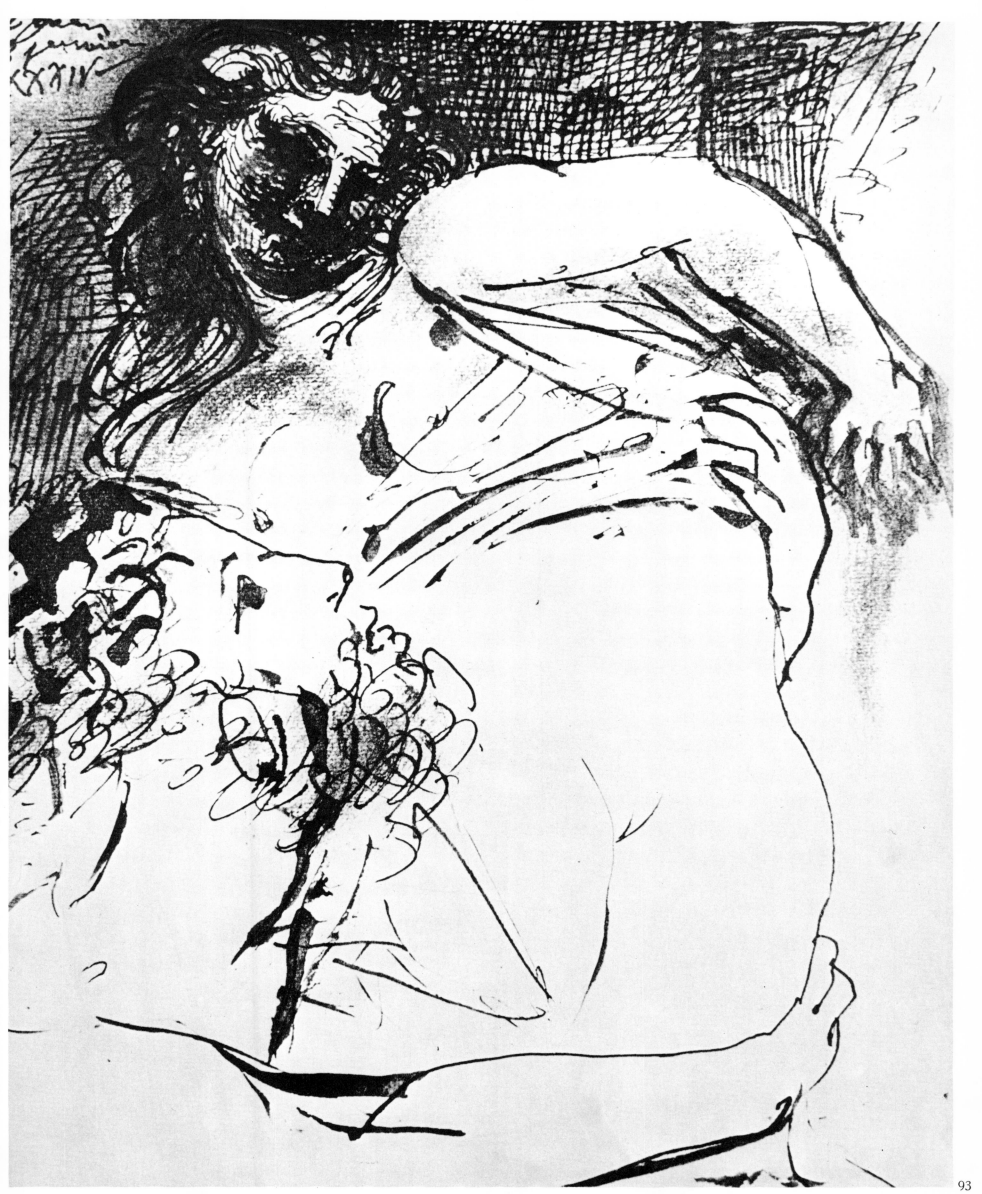

Study for the Illustrations of "Lysistrata", ink.

18 January 1934

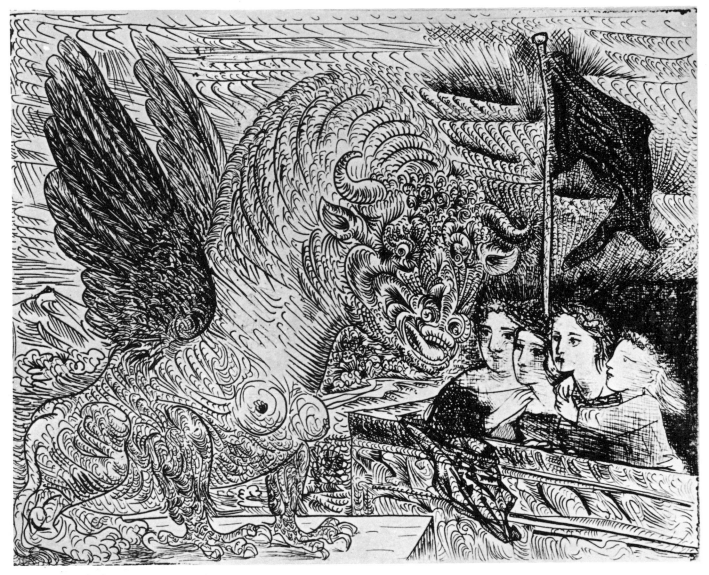

Winged Bull watched by Four Children, etching. *About May 1933*

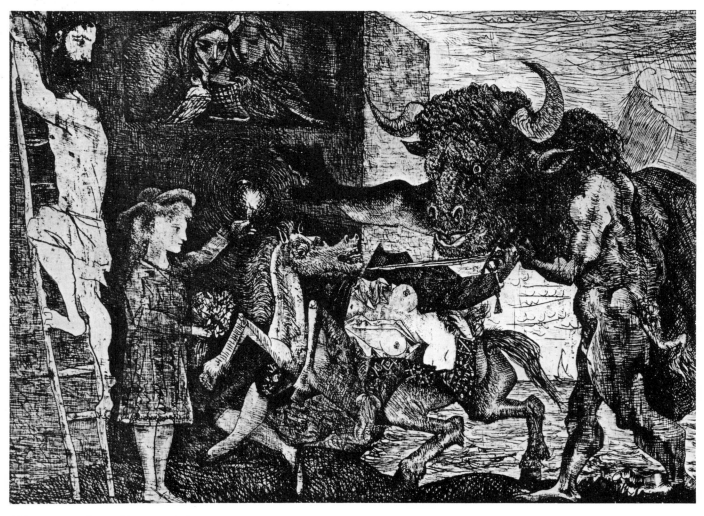

Minotauromachy, etching. *1935*

94

The Minotaur, vanquished in the arena by a youth, dies before the watching eyes of a row of girls, one of whom holds out her hand to him in a gesture of compassion. Several drawings and engravings treat his death in different ways, and in the last of the series, bringing the cycle to an end in December 1937, the monster is seen expiring by the sea in front of the mirror of truth held up to him by a Greek virgin. One of the most splendid and most mysterious prints in the famous Vollard Suite is the one showing four young girls, one of them still a child, gazing at a sort of hermaphroditic sphinx whose body is made up of a lion's paws, a woman's bust, an eagle's wings and a bull's head.

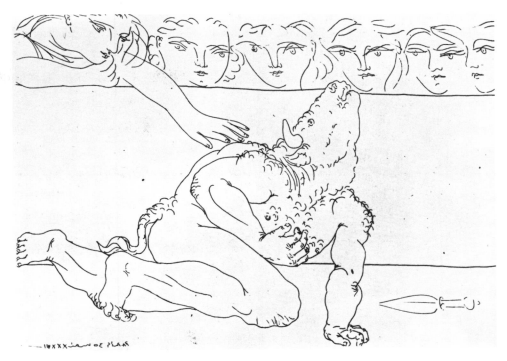

Dying Minotaur, etching. *30 May 1933*

In the hands of a Spanish artist, it was almost inevitable that the themes of the Minotaur and the bull ring should end up by being combined, each setting off the other. Here, to express the violence and ferocity of the combat, Picasso turns to new uses the abbreviated forms and dynamic distortions of the Dinard period. The central drama of the corrida, which he interpreted continually in many variants and which reappears in *Guernica*, is in his eyes the inevitable confrontation of horse and bull, bearers of opposing symbolic values and incarnating both dramatically and sexually the polarity between male and female.

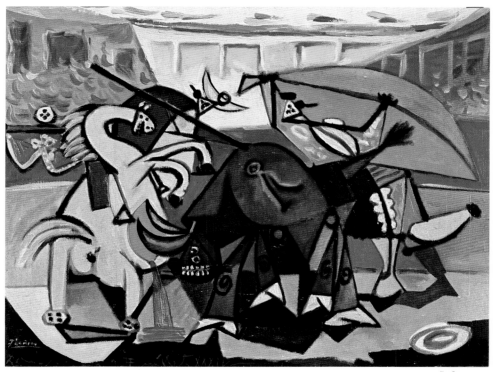

Bullfight, oil. *27 July 1934*

◁ The scene takes place beside the sea, with a motionless sailboat on the horizon. The Minotaur, seen under his most menacing aspect, moves toward the group of the bare-breasted female matador and the wounded horse whose entrails are spilling out. The bearded man clad only in a loincloth escapes by running up a ladder, but looks back with an expression of spellbound anxiety. Two young women look on from the window of a sort of tower, with two doves perched on the sill. Down below, a little girl stands her ground, her feet close together, a strange hat shading her luminous face; in one hand she holds a bunch of flowers, in the other a burning candle toward which the monster extends his huge dark arm. The richest deployment of symbolism and imagination is allied with the most mysterious poetry.

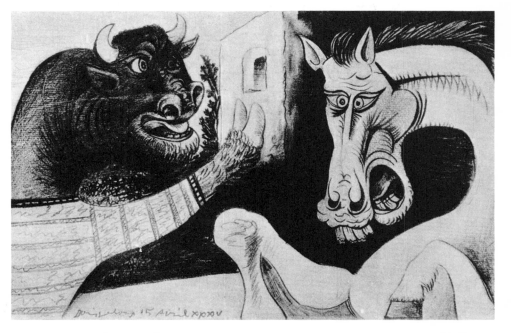

Bull and Horse, lead pencil. *15 April 1935*

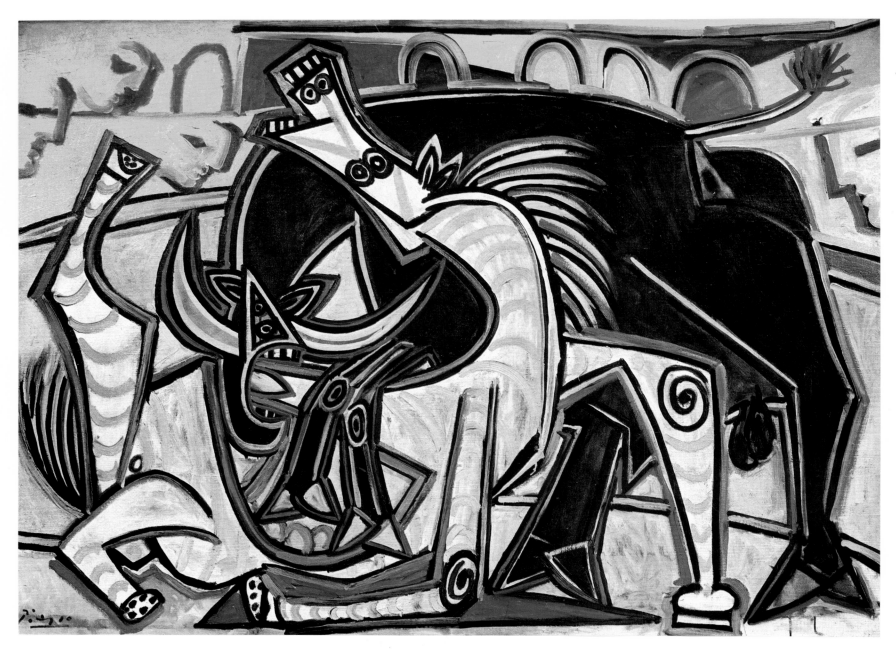

Bullfight, oil. *1934*

We are made to experience in close-up the tragic violence of the shock between the black bull and the white horse going down under the domineering muzzle streaked with barbarous signs. Phosphorescent colors reminiscent of stained-glass windows answer to the partitioned segmentation of the form. On the schematically indicated tiers of the arena four women with the pure classical profile distinctive of this period lean forward and gaze intently at the scene.

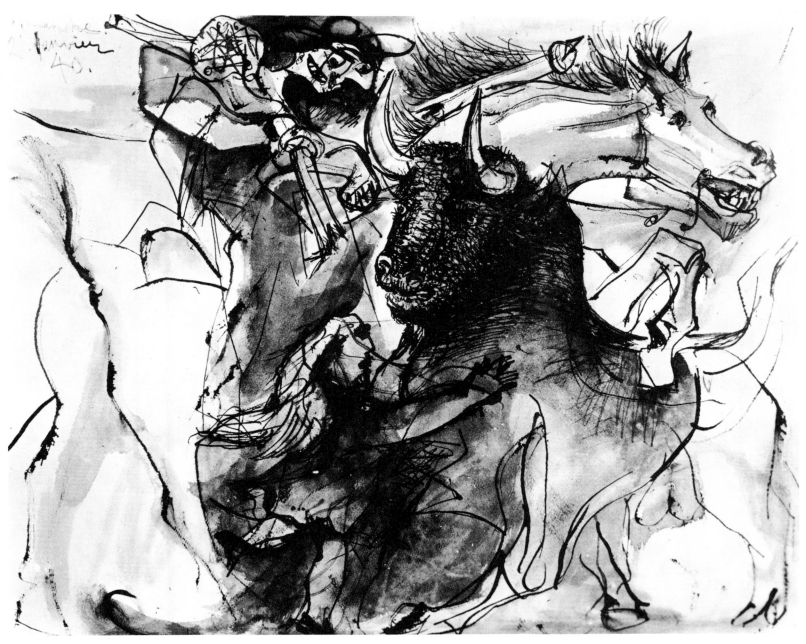

Corrida, ink.

9 January 1940

This ink wash drawing displays the same dramatic power and the same contrasting effect of darker and lighter values as the strongly colored painting of six years before. It represents the stage of the bullfight which Picasso treats most frequently: the bull charging the armed picador. The quality of the animal may be seen from the spiritedness of his attack, and the same is true of the painter in his approach to his subject.

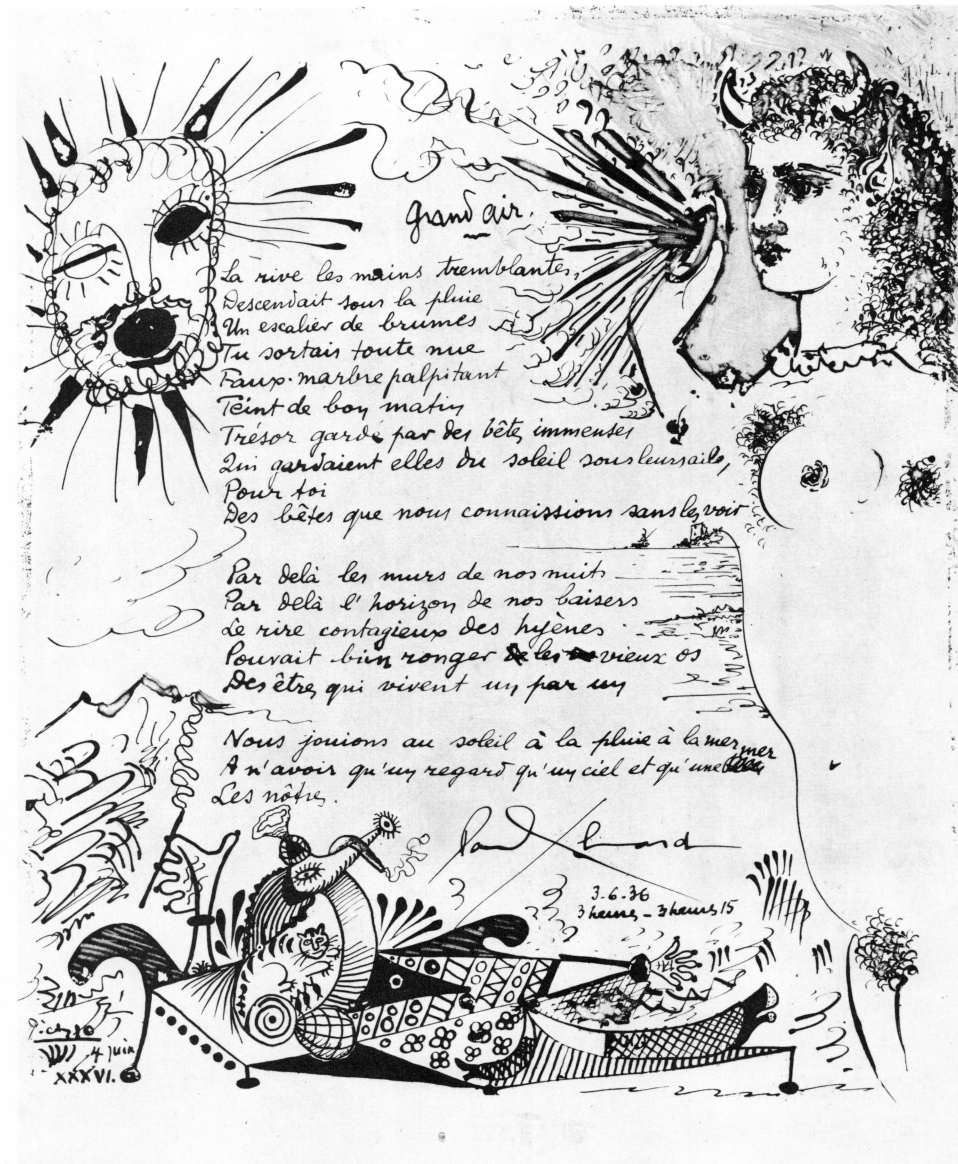

"Grand Air", etching for a poem by Paul Eluard in "Les Yeux fertiles". 3–4 June 1936

Aquatint for "The Dream and Lie of Franco".

8 January 1937

A special technique enabled Paul Eluard to write out his poem *Grand Air* directly on the copper, and it was at once illuminated by the painter, thus sealing the deep friendship of the two men and the union of the two arts. Picasso himself wrote a violent pamphlet against the military dictatorship ravaging his country and reducing it to misery. The illustration of the text was composed of two engraved plates, each divided into several episodes: the story is read from picture to picture like a strip cartoon. The *Dream and Lie of Franco* forms the indispensable satirical-burlesque prelude to the tragedy of *Guernica*; indeed the images of the latter come as a natural sequel to the last plate, reproduced here, beginning with the fifth scene.

Composition Study for "Guernica", pencil. *8 May 1937 I*

Study for "Guernica", pencil. *20 May 1937*

I have always believed and still believe that artists, who live and work according to spiritual values, cannot and must not remain indifferent to the conflict in which the highest values of mankind and civilization are at stake.

PICASSO, May 1937

Study for "Guernica", colored crayon.

Real men for whom despair
Feeds the hope-devouring fire
Let us open together the last bud of the future

Outcasts death earth and the grimness
Of our enemies have the dull
Hue of our night
We will get the better of them

Paul ELUARD, *La Victoire de Guernica*, 1937

The people which this poetry and this painting express as if they were prophesying its history is a whole and genuine, indeed a total and unique people. And alone, completely alone, with its truth. A people that lives and dies truly and fully... The tremulous mystery still smarting with the Spanish people's anger, a mystery caught like the people's fire among its shadows. For the fire appears among the shadows in this truly immortal painting.

This admirable canvas says the simplest thing in the world with unmistakable clarity: it simply says yes and no. It tells us the truth. There can be no further doubt. It leaves no place for doubt. It shows each thing at the full and puts each in its place so well that everything becomes clearly and fully a yes or a no. It is what it is, and does not merely seem so. Or it is what it is even if it doesn't seem so. Realism and classicism join hands in this powerful painting. We might even venture to say that they raise their fist. The clear truths manifested here are like raised fists, and with what pure, powerful, vivid, genuine and true clarity!

José BERGAMIN, 1937

10 May 1937

Study for "Guernica", pencil.

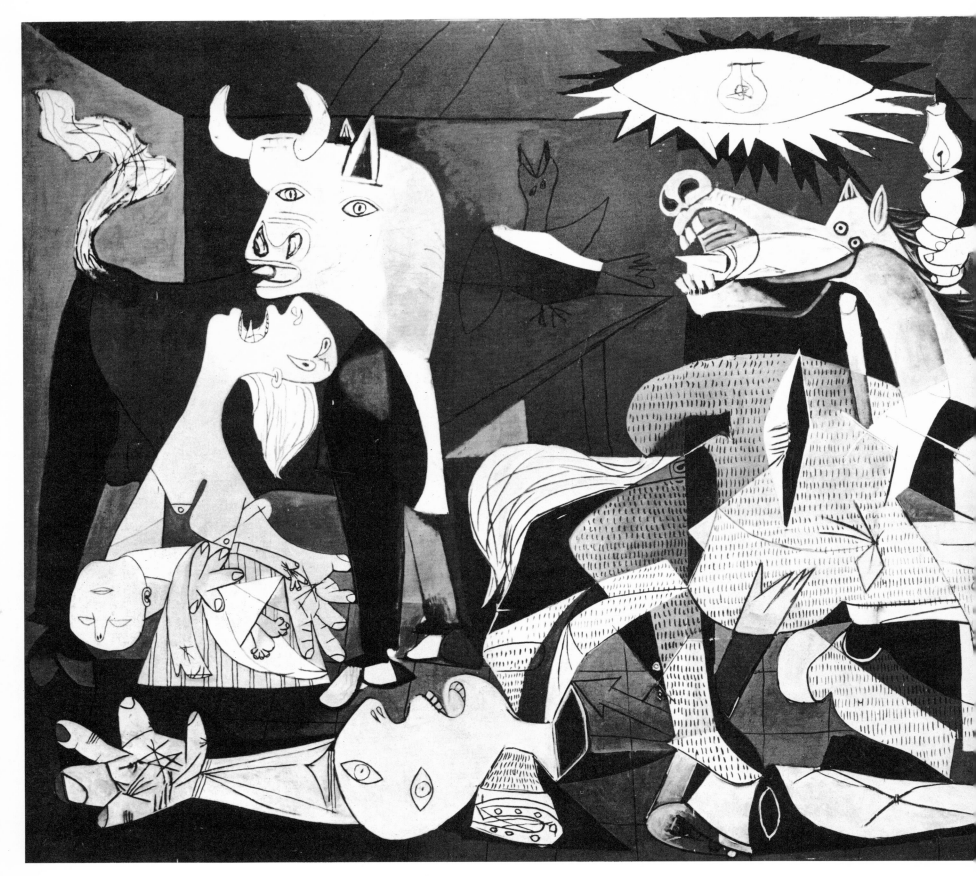

Guernica, oil. 1937

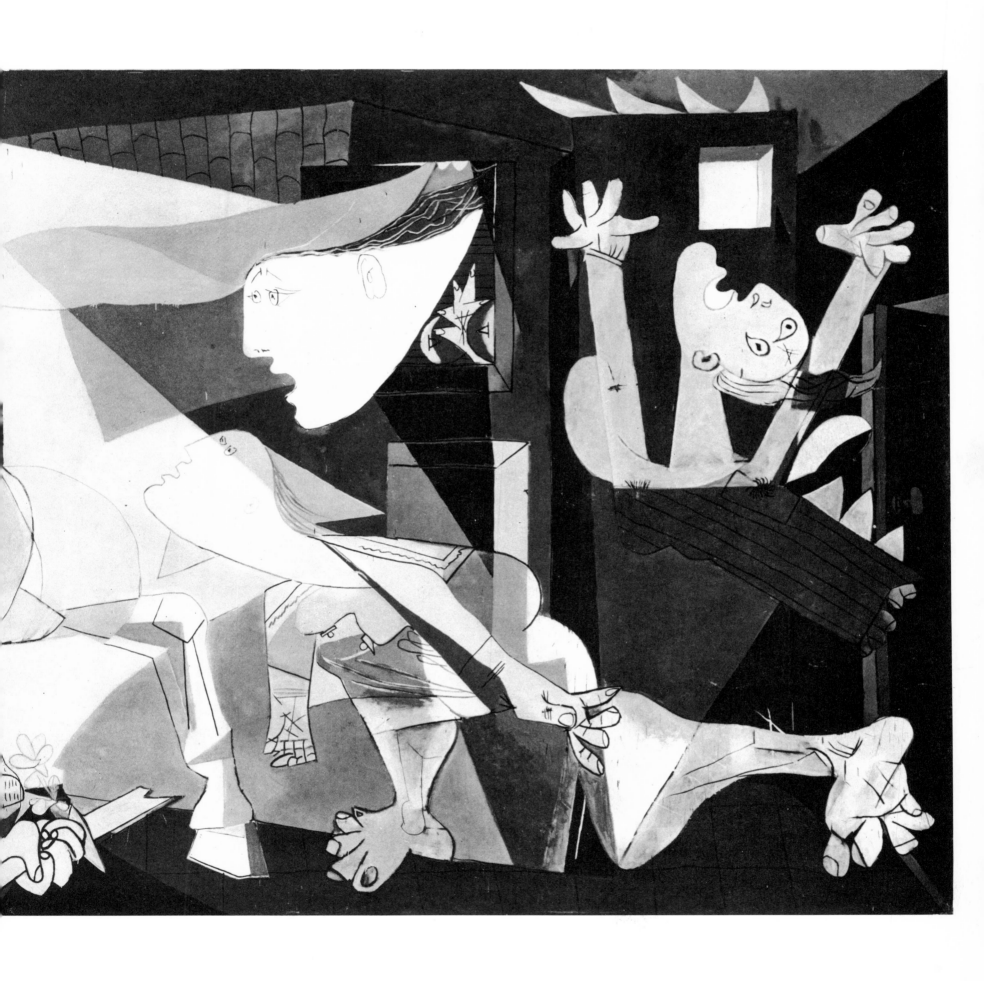

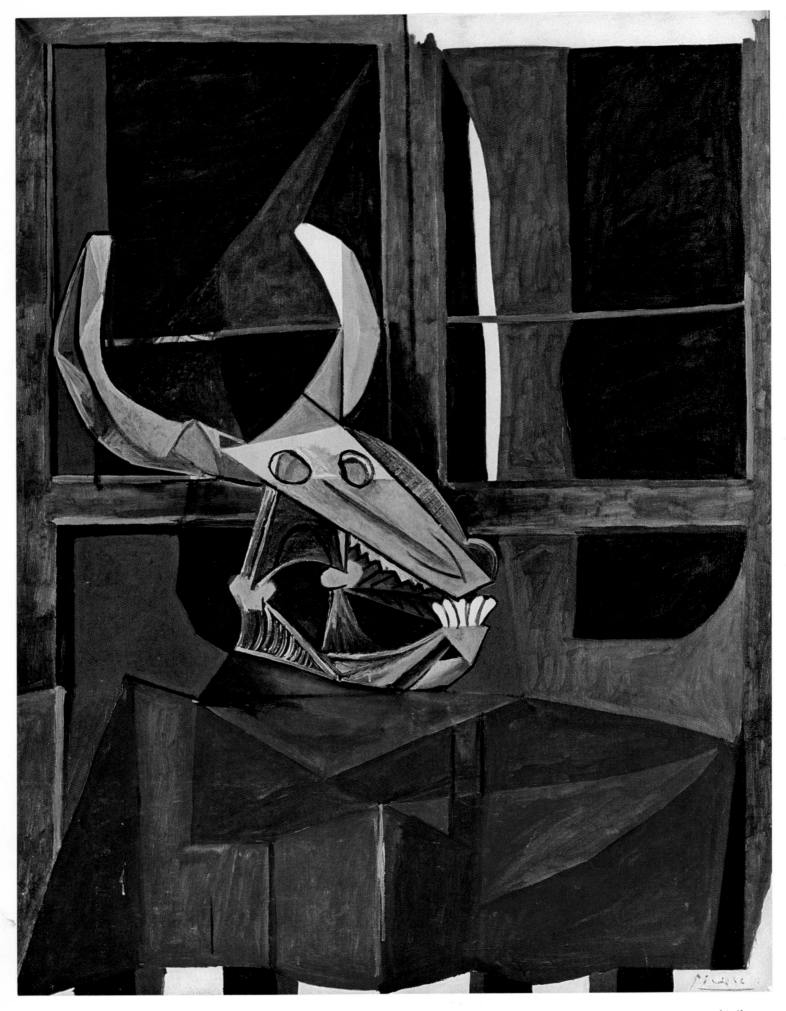

The Bull's Skull, oil.

5 April 1942

My own night lighting is magnificent; I even prefer it to natural light. You must come some night to see it. This light that sets off every object, these deep shadows that surround the canvases and project themselves up to the beams—you'll find them in most of my still lifes, because they are almost all painted at night.

PICASSO, December 1946

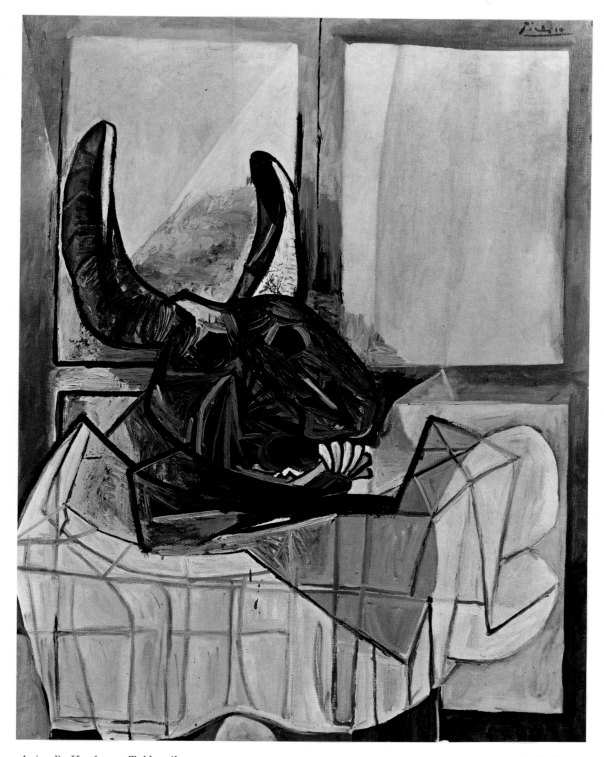

Animal's Head on a Table, oil. *6 April 1942*

In his wartime pictures there frequently appear the human skull and animal skulls, whose structure he scrutinizes. "Have you ever noticed that bones are always modeled not just chipped out?" he said to Brassaï. "And have you noticed how the convex and concave forms of bones fit into each other—how artfully the vertebrae are adjusted to each other?" Flesh, the stuff of tears and joys, has vanished and the skull survives in its incorruptible boniness. Painted on successive days in April 1942, in harmonies of brimstone and bereavement, the two still lifes with a bull's skull on a table in front of a closed window are hallucinating Vanitas pictures in the long-standing Spanish tradition of gripping pathos. They reflect not only the bleak atmosphere of wartime but the deep sorrow felt at the death of Julio Gonzalez, his old friend and collaborator at Boisgeloup: on his friend's coffin, as it stood in the church, Picasso had watched the light peacefully glow, streaming in from the stained-glass window above.

The goat's skull is one of the characteristic motifs of the Vallauris period, and its plastic intensity is conveyed here by a system of linear patterning on a black and white ground.

The bull's ear at the window
Of the wild house where the wounded sun
An inner sun burrows in
Hangings on waking up
The walls of the room
Have vanquished sleep

Paul ELUARD, 1938

I behave with my painting just as I behave with things. I make a window, just as I look out of a window. If this open window does not suit my picture, I draw a curtain and I shut it just as I would have done in my room. With painting, you must act as you do in life, directly. Of course painting has its conventions, which it is indispensable to take into account, since you cannot do otherwise. For this reason you must constantly have the presence of life before your eyes.

PICASSO, 1935

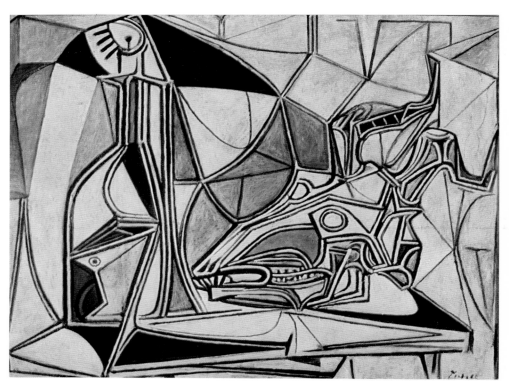

Goat's Skull, Bottle and Candle, oil. *16 April 1952*

105

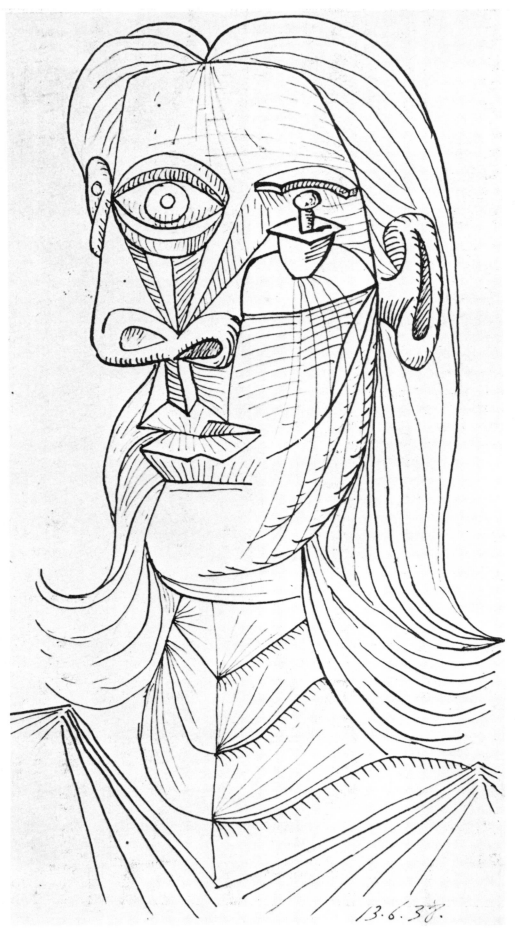

Woman's Head, India ink. *13 June 1938*

The academic teaching of beauty is all wrong. We have been deceived, but so well deceived that we can no longer find out even the shadow of a truth. The beauties of the Parthenon, the Venuses, the Nymphs, the Narcissi, are so many lies. Art is not the application of a canon of beauty, but what instinct and brain may conceive independently of the canon.

PICASSO, 1935

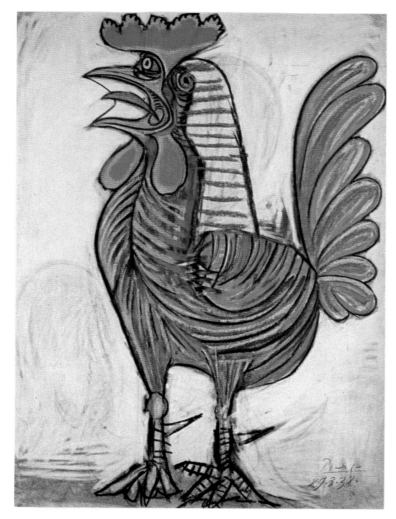

The Cock, pastel. *29 March 1938*

The cock, bound, outstretched and condemned on the merciless knees of his fierce sacrificer, revives and proudly draws himself up a few weeks later in a dazzling series of pastels, with his vivid plumage, his red, flaunted crest, his bristling spurs and full-throated cry. "Cocks," said Picasso to a young American painter who called on him while he was working on them, "there have always been cocks, but like everything else in life we must discover them—just as Corot discovered the morning and Renoir discovered girls."

The cat tearing a bird to pieces conforms to the pitiless, unchanging laws of nature, but this theme, treated twice on the eve of the war, takes on at that time a demoniacal force. With its dark fur and murderous claws, erect against a clear sky, the cat turns upon us its glowing eyes and pointed muzzle, conscious of its crime and reminding us, with an almost human grimace, that man is the cruelest of all animals.

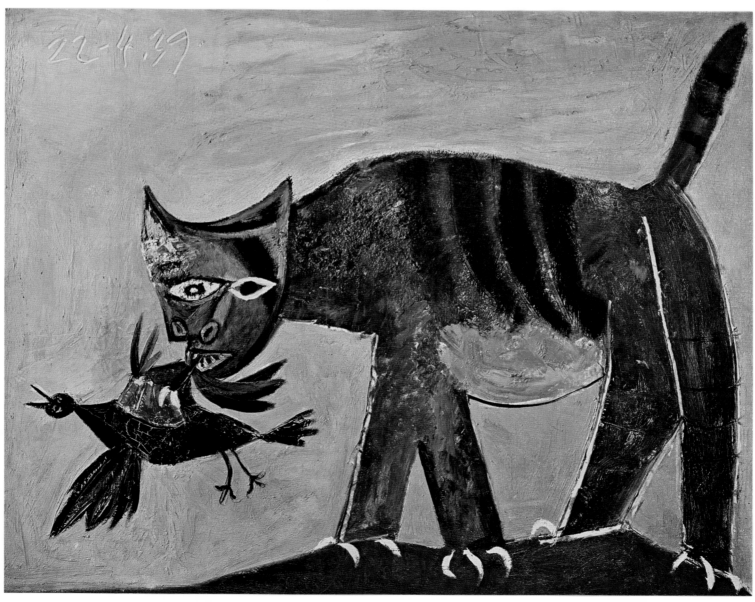

Cat with Bird, oil. *22 April 1939*

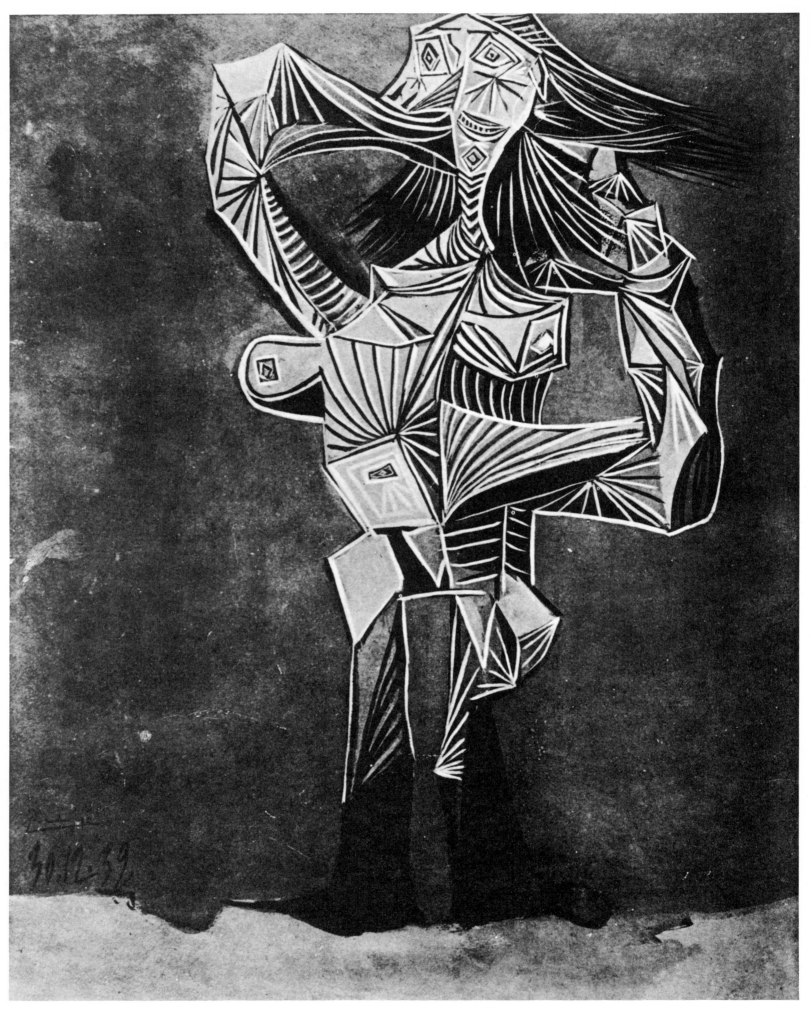

Portrait of D. M., gouache. *30 December 1939*

Through this full-length portrait of Dora Maar doing her hair against a nocturnal background blows a linear hurricane to which it stands up imperiously. The stars and streaks with which it is seamed recall cubist fragmentation and mark an energetic revitalization of the ornamental basketwork patterning developed in 1938.

These faces in which profile and front view are joined in an obvious, human resemblance are the very faces of our contemporaries. We have seen them thus before the great painter showed them as such, and he thereby reveals to us both our fellow men and ourselves. Here the human being accedes to his Olympus, he enjoys the full majesty of creation. Never was mankind so close to the gods as under this total aspect. And thus "art" joins up with science. Stripped of all sentimentality, it sets itself a higher purpose than that of a skin-deep thrill of recognition. But if it speaks to the thinking mind, it speaks too, and how very deeply, to our flesh and viscera, to the whole of that human machinery, only yesterday so unfamiliar and now ready to be better known, in which one can at last predict a harmonious balancing of the many motivations to which it is subject.

Robert DESNOS, *Picasso*, 1943

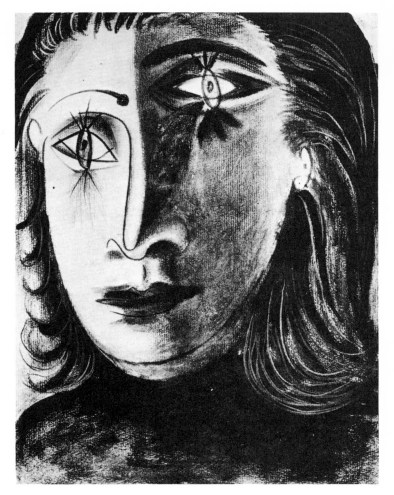

Woman's Head, lead pencil and colored crayons.　　　　*1941*

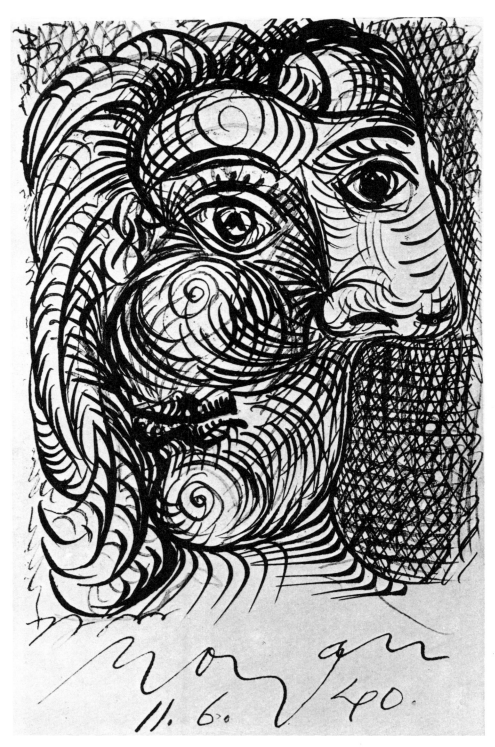

Man's Head, gouache.　　　　*7 January 1940*

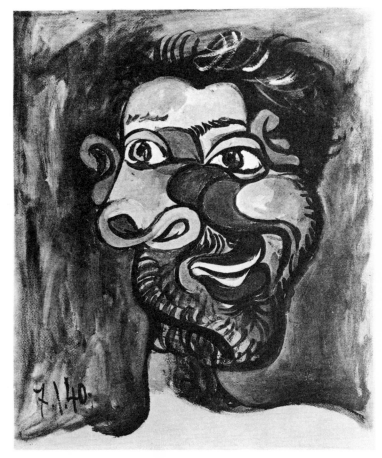

Page from a Sketchbook, India ink.　　　　*11 June 1940*

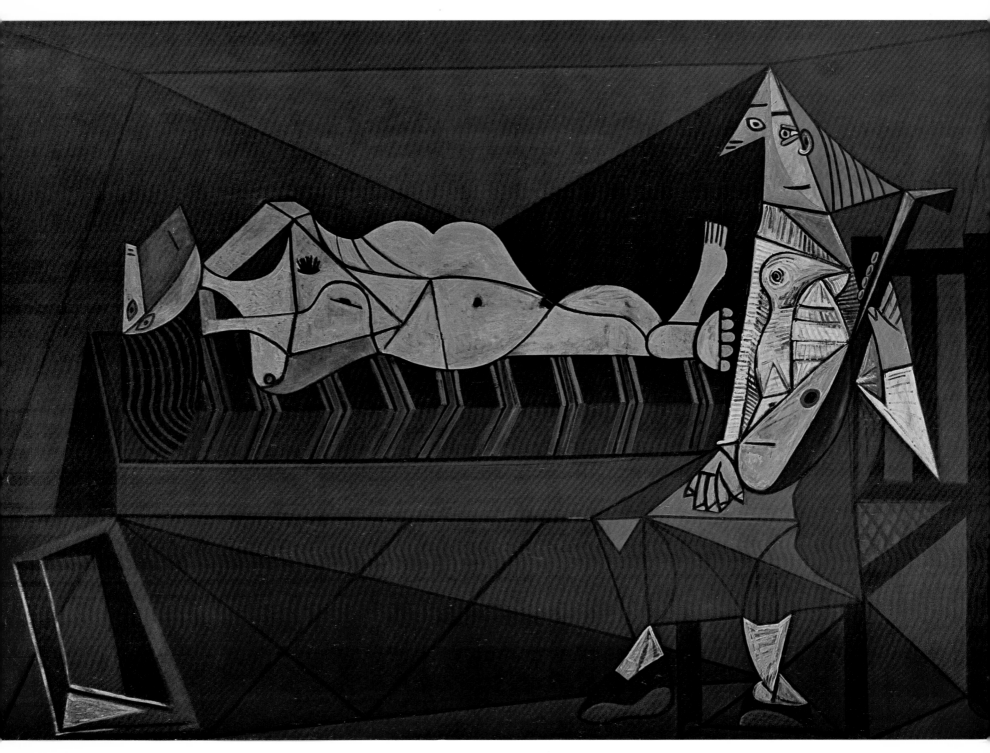

Nude with a Musician ("L'Aubade"), oil. 4 May 1942

How can you expect an outsider to experience my picture as I have experienced it? A picture comes to me from far away; who can say from how far away I have divined it, glimpsed it, made it, and yet the next day I cannot myself see what I have done. How can anyone penetrate into my dreams, my instincts, my desires, my thoughts, which have taken a long time to work themselves out and come to light? Above all, how can anyone grasp what I have added to all that, perhaps involuntarily?

PICASSO, 1935

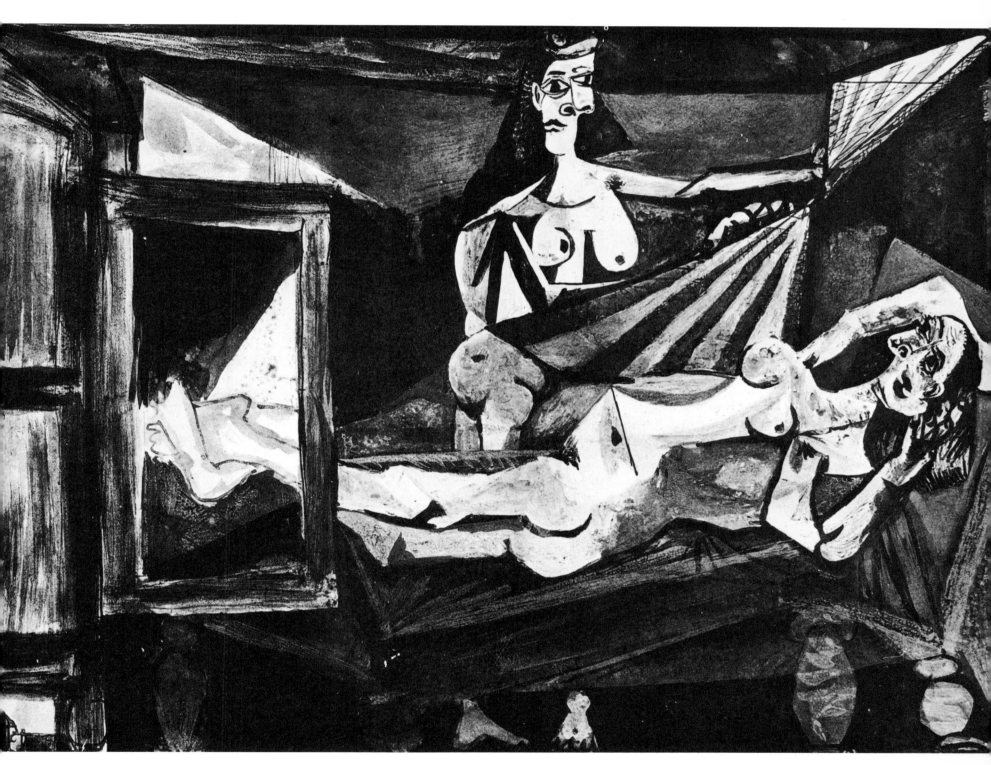

Reclining Nude, gouache. 2 January 1942

I have not painted the war because I am not the kind of painter who goes out, like a photographer, in search of a subject. But there is no doubt that the war is in the pictures I made then. Later perhaps, a historian will show that my painting changed under the influence of the war. Myself, I do not know.

PICASSO, 1945

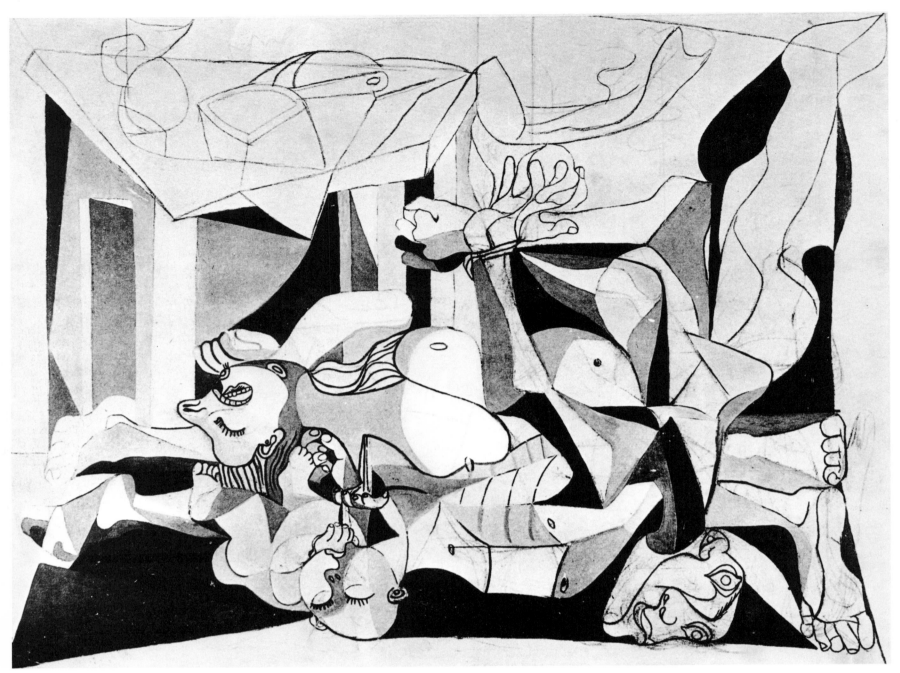

The Charnel House, oil. 1944–1945

Painted at the end of the Second World War under the impact of the newly divulged horrors of the concentration camps, this poignant composition, quite devoid of symbolism, is the stark epilogue to *Guernica*. As in *Guernica*, the palette is drastically reduced to funereal or accusing grays, blacks and whites, thus baring the full force and tension of the linework. Under the kitchen table evocative of everyday life lie the murdered bodies of a man, a woman and a child, the universal triad, with their fists raised and their heads turned upward. For them, writes Alfred H. Barr, "this picture is a 'pietà' without grief, an entombment without mourners, a requiem without pomp."

If today millions of men see in Picasso the maker of the *Dove*, the man of peace, they are infinitely closer to the real Picasso than the stunted aesthetes who delight in certain of his pictures, seeing in them no more than colored surfaces without any objective meaning, but who turn away with disdain and disgust from *Massacre in Korea*.

D. H. KAHNWEILER, 1951

Whether consciously or unwittingly far-sighted, Picasso's work has supplied the mind, long before this terror existed, with a counter-terror which we must lay hold of and which we shall have to use as best we can in the hellish situations in which we shall soon be plunged. Facing up to totalitarian power, Picasso is the master carpenter of a thousand planks for drowning men to cling to.

René CHAR, 1939

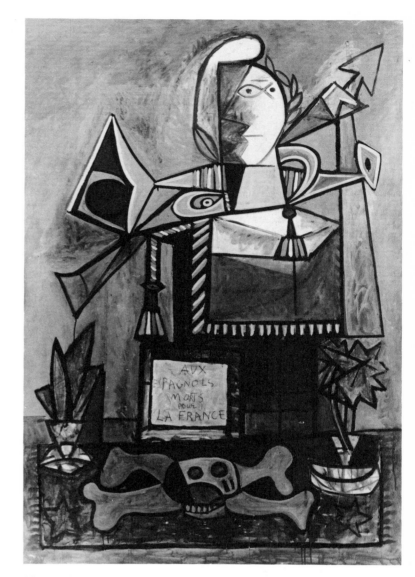

What do you think an artist is? A fool who has only eyes if he's a painter, only ears if he's a musician, or a lyre at every level of his heart if he's a poet, or even nothing but muscles if he's a boxer? On the contrary, he is at the same time a political being, constantly alive to the heart-rending, fiery or happy events of the world, molding himself wholly in their image. How would it be possible for him to take no interest in other men, and with cool indifference detach himself from the life which they bring you so lavishly? No, painting is not done to decorate apartments. It is an instrument of war for attack and defense against the enemy.

PICASSO, March 1945

Monument to the Spaniards who died for France, oil. 31 January 1947

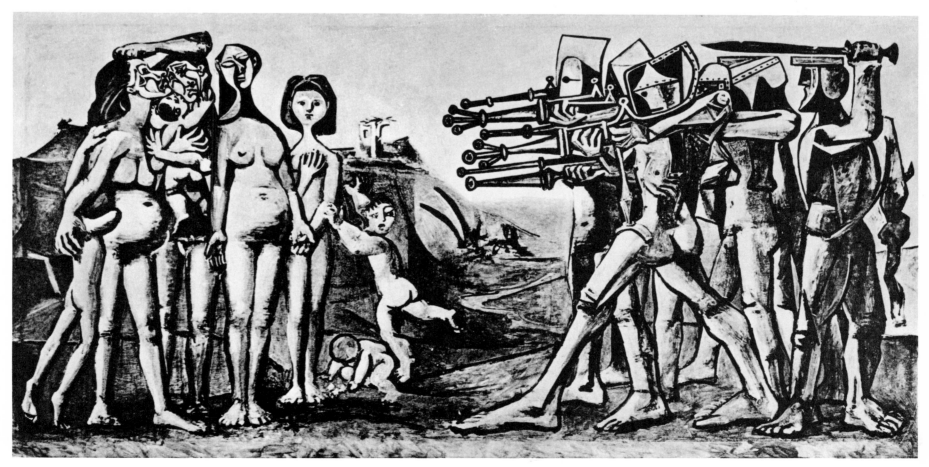

Massacre in Korea, oil.

1951

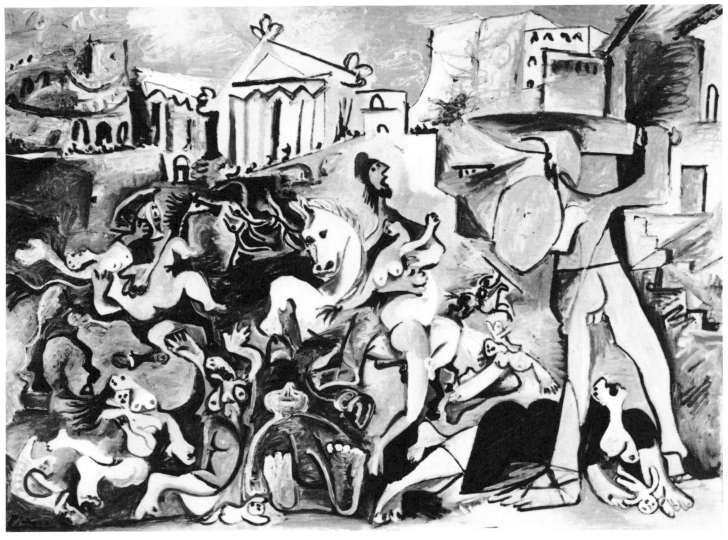

The Rape of the Sabine Women, after David, oil.

4 November 1962

Throughout a whole winter he shut himself up and painted Warriors, battling with a picture of men in strenuous action. Invited, along with the other exhibitors, to show at the Salon de Mai a canvas inspired by Delacroix's battle scenes, he accepted the theme whole-heartedly but turned back from Delacroix to David and Poussin, whose violence, though no less intense, is handled with a classical rigor. He thus composed several versions of David's *Rape of the Sabine Women*, a theme also treated by Poussin, in which murder and sexuality are combined, and innocent women and children are immolated. He preserves and even re-emphasizes the necessary eloquence of gestures, stripping away the anecdote, evoking the past by its emblems (temples, crested helmets, bucklers), does away with illusionist dispersion by bringing the figures forward, and lays stress on the essential moments: the unbridled dynamism of the rape in the version painted horizontally, the fierce duel of horsemen for the possession of the woman in the version concentrated in a vertical format.

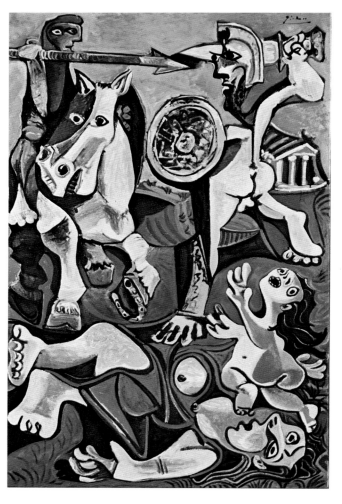

The Rape of the Sabine Women, after David, oil.
9 January/7 February 1963

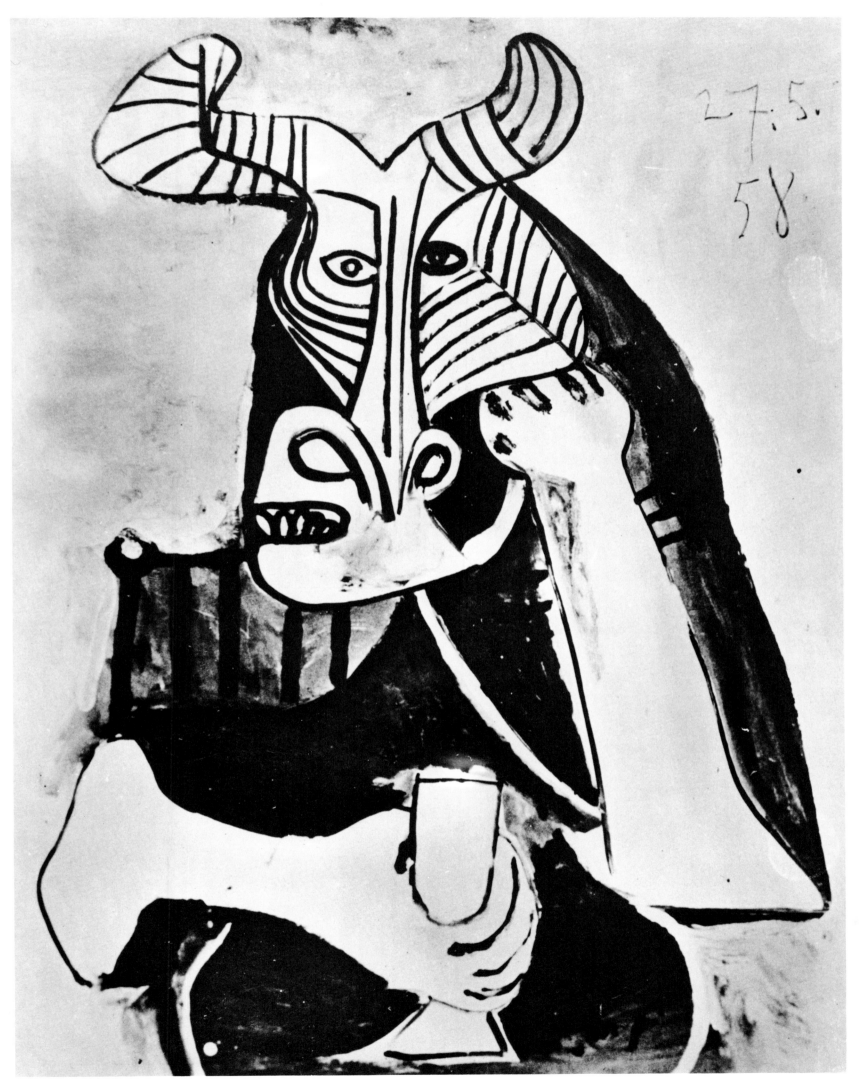

27.5.
58

Horned Figure holding a Glass, oil.

If we knew, all the gods would awake...
Guillaume APOLLINAIRE

Myths and Mediterranean

The drawing reproduced below shows the small and very commonplace villa, the first empty house he could find, where Picasso, caring little for comfort and decor, lived from 1948 to 1954. The villa stands on a hillside and, like many houses on the French Riviera, has its garden, its terrace shaded by mulberry trees, and its water tank. The workshops where he spent his days were located in the neighboring village of Vallauris, *valley of gold*, the pottery-making center whose activities he did so much to revive. Near by, older than man and his infinite mirror, is the sea, where he went bathing every day.

The bay of Cannes, around which he now gravitated, bears an astonishing resemblance to the bay of Malaga, and indeed Picasso is, by birth and innate propensity, a man of the Mediterranean world. That world extends to Egypt, unites Africa and the East, but Greece remains its nostalgic center, Greece which made man the measure of all things and brought the gods down to earth. Picasso's antique or classical period, heralded in 1905 and culminating in the Panpipe players of 1923, marked a moment of equilibrium and wholehearted humanism. As soon as the war was over, in 1945, he returned to the South of France, to the sunny beaches where he had spent nearly every summer from 1919 to 1939. In September 1946, circumstances falling in with his personal needs, he took possession of the Château d'Antibes, the old Grimaldi Palace erected on the Roman castrum, which itself had supplanted the Phocaean acropolis of the ancient Antipolis. There in the space of a few months, working on fibrocement or plywood with a bewildering and infectious verve, as if the spirit of the place were stirring within him, he painted the cycle of bucolic pictures which has remained in the Château and is now in fact an integral part of the setting in which it is displayed and which it spontaneously recreates. Everything then contributed to his pagan exaltation: the return to life and freedom after the long nightmare of the war; the presence at his side of a young and beautiful woman, the "woman-flower" who was to give him two children; membership in the Communist Party, for him at that time a symbol of democratic hope and brotherhood among men; and the radiant influence of a region where Renoir and Matisse had reglimpsed the golden age and where he himself was now to settle. The main panel, aptly entitled the *Joy of Life* in emulation of Matisse's great picture, seems to have been painted to the rhythm of the flutes joyfully played by the faun and the centaur, as the full-breasted dancing maenad and the mischievous bounding goats keep time to the music. The composition unfolds its decorative frieze in terms of simplified planes and linear inflexions, within a color scheme of tender blue and bright yellow. The secret of this naïve limpidity, obtained by skillful reduction, as many preliminary drawings prove, lies in his desire to be accessible to all, to give the widest appeal to this celebration of the Arcadian dream of happiness: "Here I did the best I could, and I did it with pleasure, because this time at least I knew I was working for the people."

On three tall plaques forming a triptych, with decisive black strokes on a white ground, he sketched out on a monumental scale his masculine, Bacchic triad, the cat-faced Satyr blowing on his double flute, the goat-Faun capering to the music, and the jolly, smiling Centaur holding his trident on his shoulder. Executed the following

Villa La Galloise at Vallauris, pencil. *25 November 1949*

year, on the same scale but in a different format, the panel of *Ulysses and the Sirens* evokes in mild tints the union of the sun, the surging sea and the fabled wanderer. These large allegorical paintings were accompanied by many others capturing the smell and tang of the old port of Cannes, picturing sailors, fishermen, fishmongers, and fresh, straightforward still lifes of fruit and fish, and above all sea urchins. Thus reality was blended with mythology, as it has always been in this land of enchantment, where legend is as true as history and the visible more marvelous than dreams.

Plate with Face, ceramic. 1947

To escort the she-goat and the owl, the nurse of Zeus and the bird of Athena, Picasso intended at first to add to his Antipolis cycle the statue of the *Man carrying a Sheep*, but in the end it was set up on the village square in Vallauris. This statue was modeled in clay at the darkest period of the war as an assertion of the perenniality of life. In its rugged and solemn grandeur, it seems to emerge from the depth of the ages, to precede its Greek and Christian counterparts, the lamb bearers and the good shepherds. Among the sculptural masterpieces made at Vallauris, the *She-Goat* and the *Pregnant Woman*, archetypes of fecundity, have the same primordial, timeless weight. Also produced at Vallauris were the mural paintings of *War* and *Peace*, incorporated in the vaulting of the medieval chapel and best seen, as Picasso wished them to be seen, by candlelight. The soldier of justice, with his white shield stamped with the dove, holds in check the sinister chariot of slaughter, so that under an immense sun the Days and their Delights may be freely enjoyed.

Present on all continents, pottery is like the emblem of Mediterranean civilization, combining, like the latter, utility with artistry. In the potters' village, Picasso rediscovered its age-old secret, the unity of form and decoration, and then proceeded to remold form with his infallible touch and sovereign imagination.

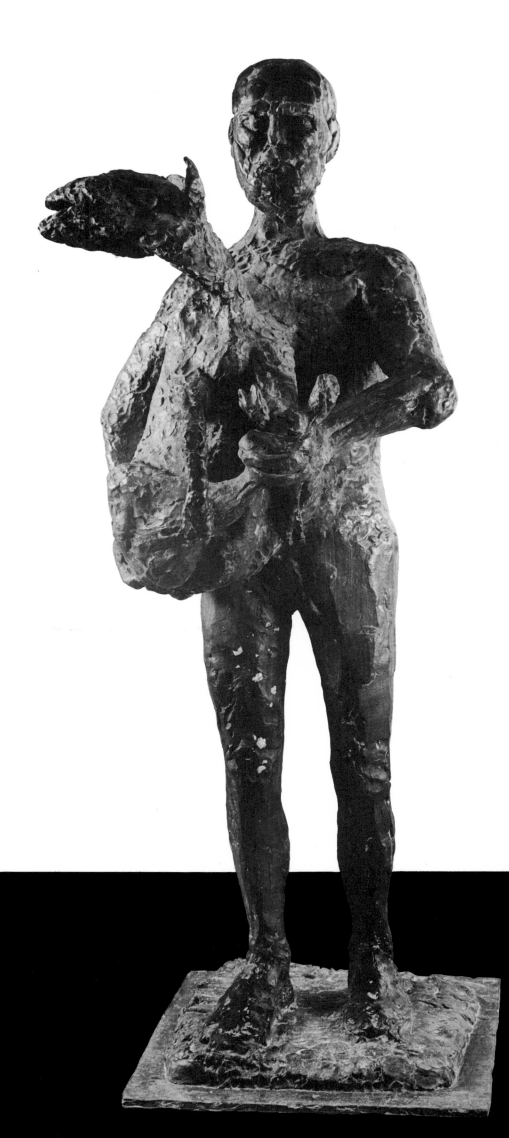

Who will reproach you then
With the immemorial pose
Of any man a prey to shadow
The others are of shadow but the others bear
A burden as heavy as yours
You are one of the branches of the shadow star
Which determines light

Paul ELUARD, *Voir*, 1948

Man carrying a Sheep, bronze. 1942

Ulysses and the Sirens, oil and enamel paint on fibrocement.'

1947

In July 1939, having just lost his mother, Picasso left Paris for Antibes, where a friend lent him an apartment—whose interior decoration he at once neutralized as being too bourgeois. Sabartès, who accompanied him, has related the circumstances in which Picasso painted this large, fanciful composition, the largest since *Guernica*. A whole room had been covered with white canvas, to mask the wallpaper and to leave a free field for improvisation, without any limitation of size. The origin of the resulting canvas is a scene he actually saw, of men fishing by lamplight at night in a corner of the port. In the center are two fishermen in a boat, one bending over to search the water, the other in a striped bathing suit harpooning the fish. Two girls in bright dresses look on from the pier; one holds a bicycle, rendered in dancing curves, and licks a double icecream cone with a sharp-pointed tongue. On the left, above the cubic roofs, rise the mauve, glimmering towers of the Grimaldi Palace, which he decorated seven years later with a bucolic series of pictures concluding with the panel of *Ulysses and the Sirens*, an equivalent vision of marine phantasmagoria. Mobilization orders were posted in France before he finished his *Night Fishing*, a prodigious synthesis of landscape and figures, with shifting lights (moon, stars, lanterns) and phosphorescent colors (blues, greens and violets punctuated with yellow). The result is a disturbing sense of expectation, a poetic vision threatened as soon as it appears by a cruel gesture on the velvet backdrop of night.

You are Ulysses, you are of the family of him who, while refusing to shut his ears, nevertheless made sure of the cords binding his body to the mast and thus contrived to combine the wise precautions of a good sailor with the delicious intoxication produced by the sirens' song.

Eugenio D'ORS to Picasso, 1937

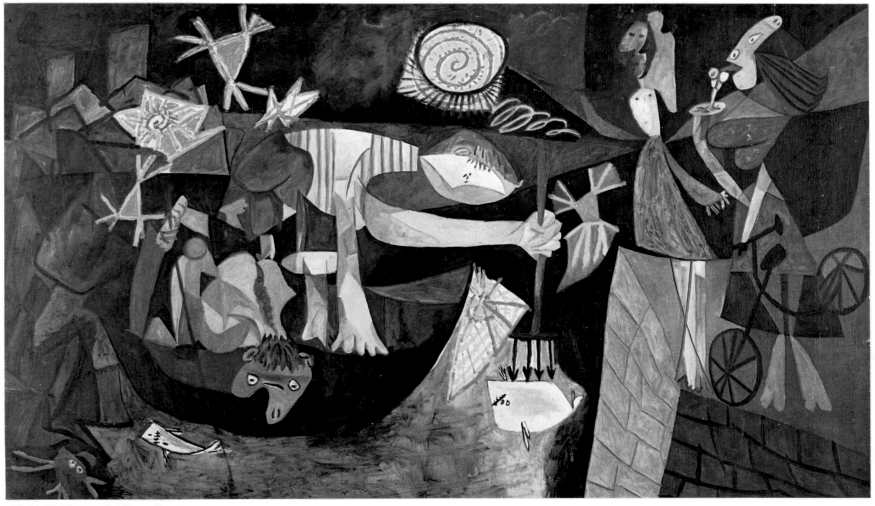

Night Fishing at Antibes, oil.

1939

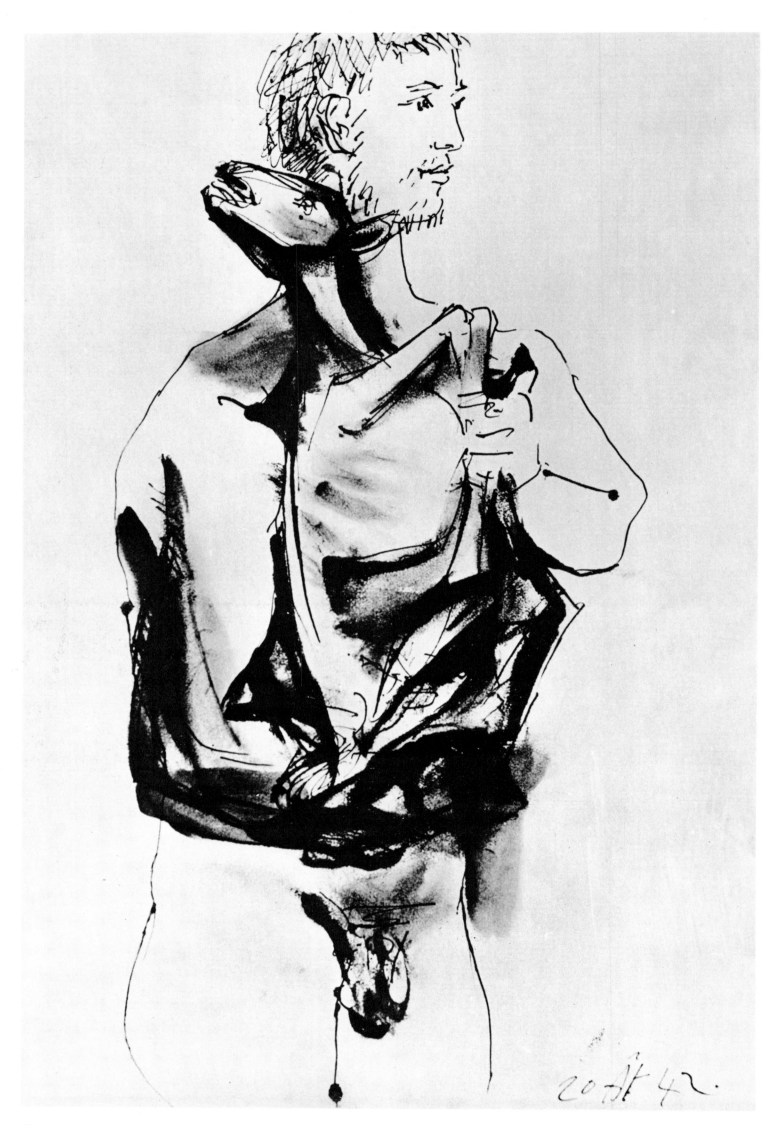

Man carrying a Sheep, ink.

20 August 1942

Sheep, India ink.

26 March 1943

I saw Picasso draw sketches of the *Man carrying a Sheep* on several sheets of paper. These sheets were too small for the whole drawing; so on some he drew the bust, on others he drew the legs. And when he finished I found that I could take any sketch of the legs and it fitted exactly, line for line, with any sketch of the bust. Picasso had done it without thinking.

Paul ELUARD, 1952

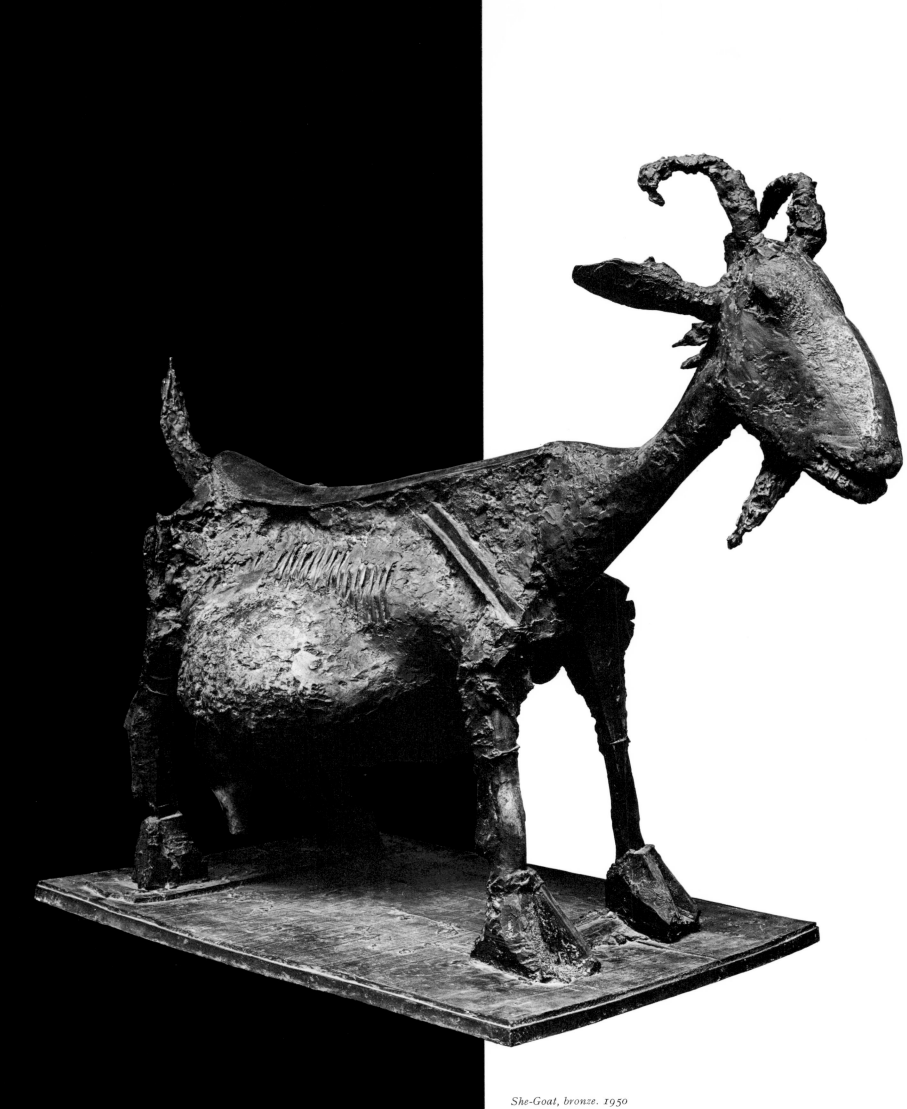

She-Goat, bronze. 1950

No sooner does one enter the cool shade of the Vallauris workshops than one has a sense of being caught up in the same gust of wind which, as is often the case in the Mediterranean, whips up the waters under a fierce sun and fills the deserted shores with all sorts of significant objects: an old basket with a hole knocked in it, a few twigs and boughs, an empty tincan, two half-shattered jugs. I was by no means surprised to find them here, picked up in a careless moment and solidly incorporated in the work, part and parcel of the volumes which the artist's hands had just built up. This gesture, which might have had no more value than that of a game of skill, attained in Picasso the mysterious gravity of a ritual act seemingly imposed on him by some unknown religion. I had never myself been able to define that religion, but it was familiar to me. And suddenly I felt jealous that these great symbols of the South, these archetypes coming down from a remote, immemorial age, had not been created on one of the Aegean islands, where the fingers of man, with that clumsiness that never deceives, once ventured to model matter. No matter, the lesson remains the same: it is enough to say what one loves, and that alone, with the very limited means at one's disposal, but to say it in the most direct way, the way of poetry.

Odysseus ELYTIS, 1951

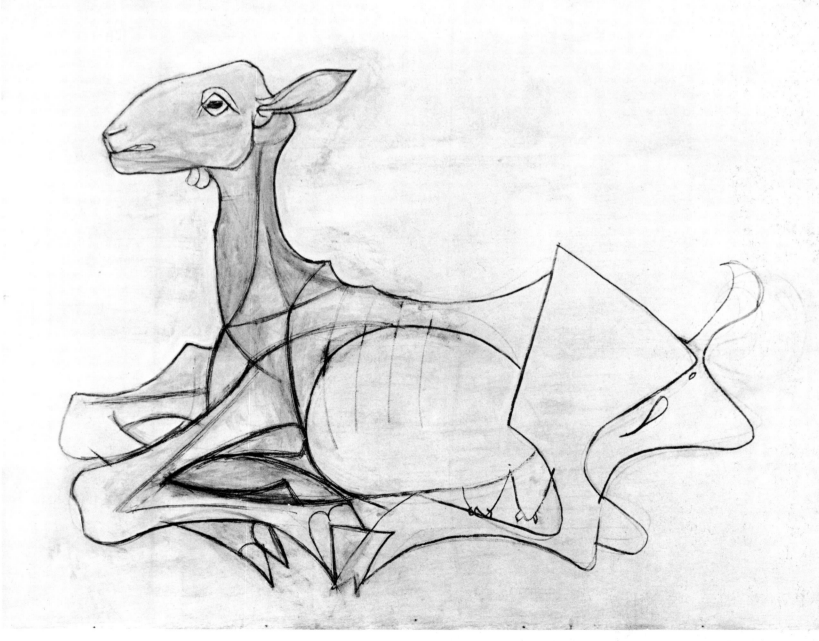

She-Goat, oil on fibrocement.

1946

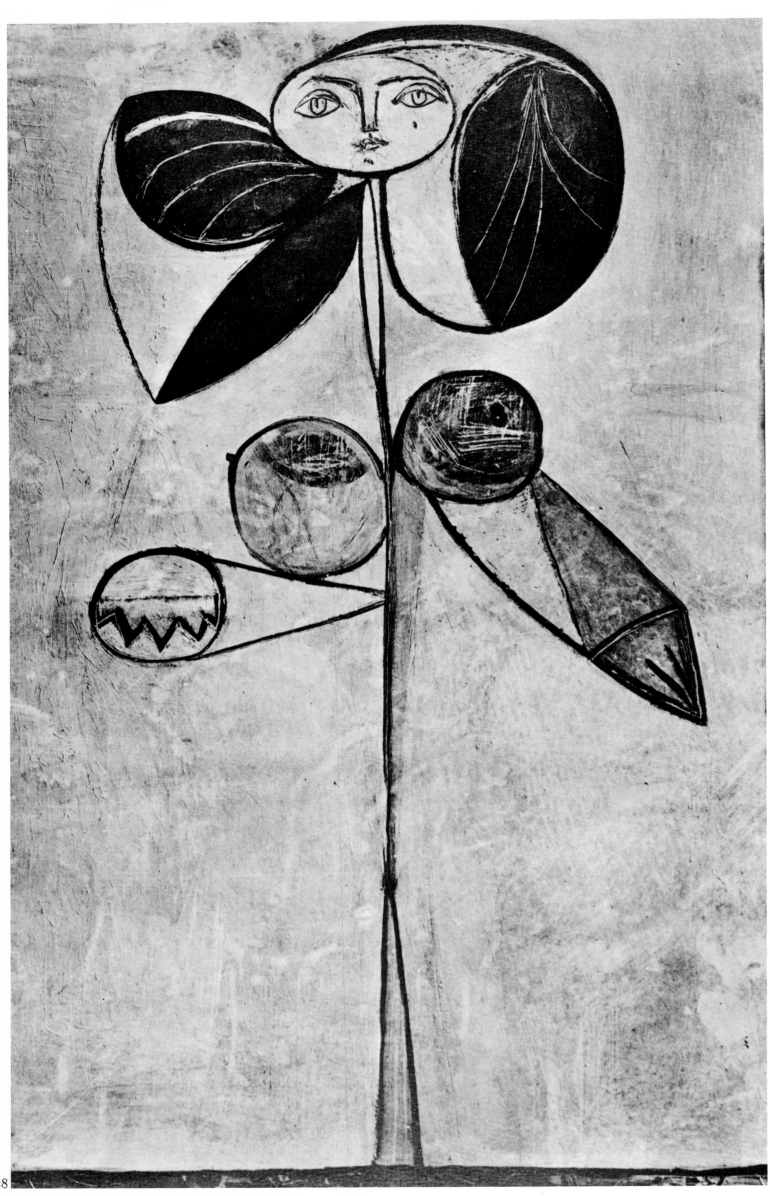

Woman-Flower, oil.
5 May 1946

When you start from a portrait and try by successive eliminations to get down to pure form, to clean, unbroken volume, you inevitably end up with an egg. Likewise, starting out from the egg and working in the opposite direction, you can arrive at the portrait. But art, I think, escapes from that over-simplified motion which consists in going from one extreme to the other. One has to be able to stop in time.

PICASSO, 1932

Owl, drawing. 1946

This is the painting of a new era. It surrenders nothing of previous acquisitions; it stands opposed to niggardliness, opposed to frugality; it is not, as other forms of art are said to be, a window opening on the world, it is the whole world contained in a finite space. A masterly art and at the same time a terse art, it refuses to submit to amputation or restraint, to observe continence, just as it declines to overdo or overstate things. So it is that it both opens the doors of the future and harmoniously takes its place in the long sequence that began, one day in prehistoric times, with the magical engraving of some mammoth on the walls of a cave. And is it not in this union of primitive impulse and refinement that genius lies?

And since I have referred to magic, let us keep this word in its most colorful sense, the sense farthest removed from any narrow doctrine, and so apply it to the whole of Picasso's work.

Robert DESNOS, 1943

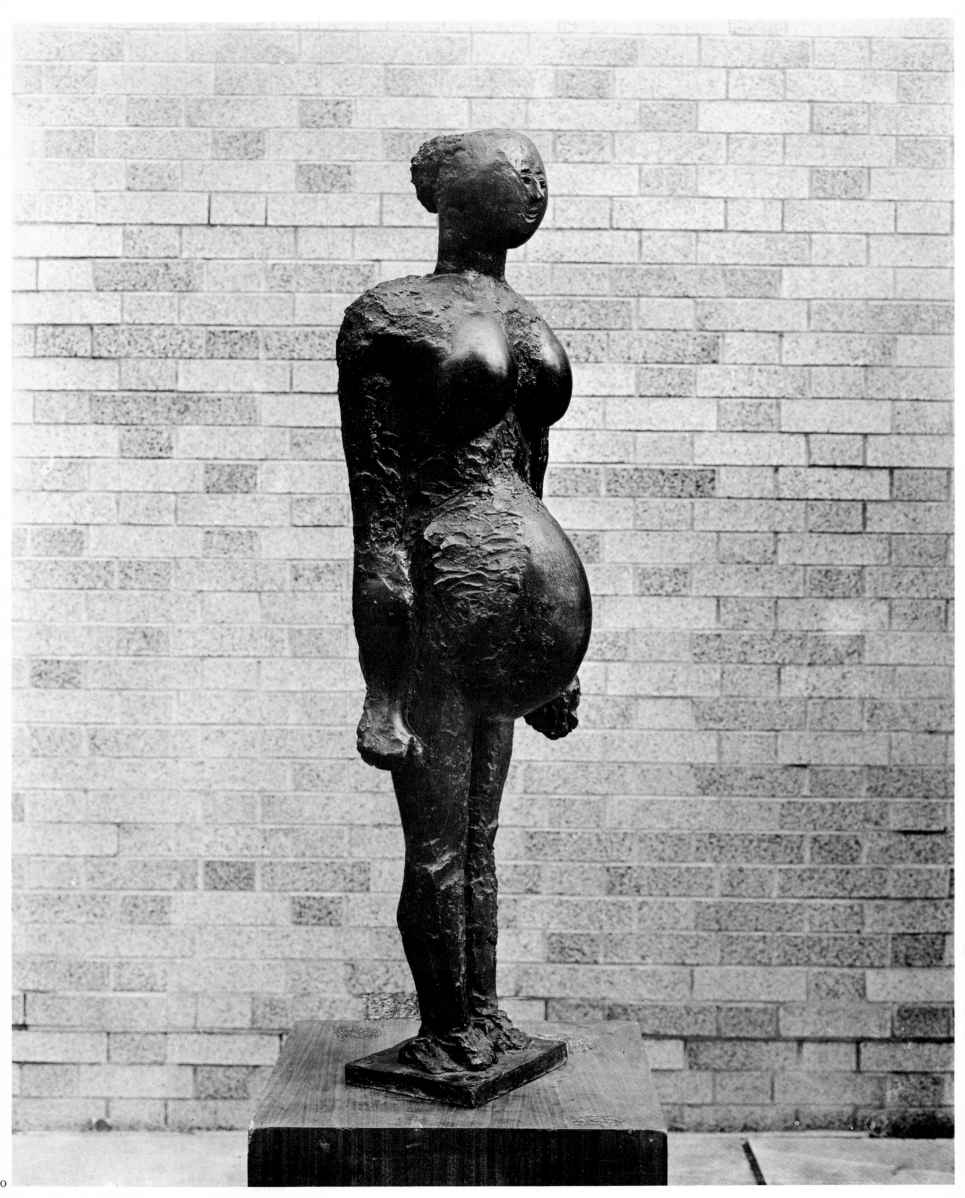

Pregnant Woman, bronze.
1950

Woman with a Pram, bronze.
1950

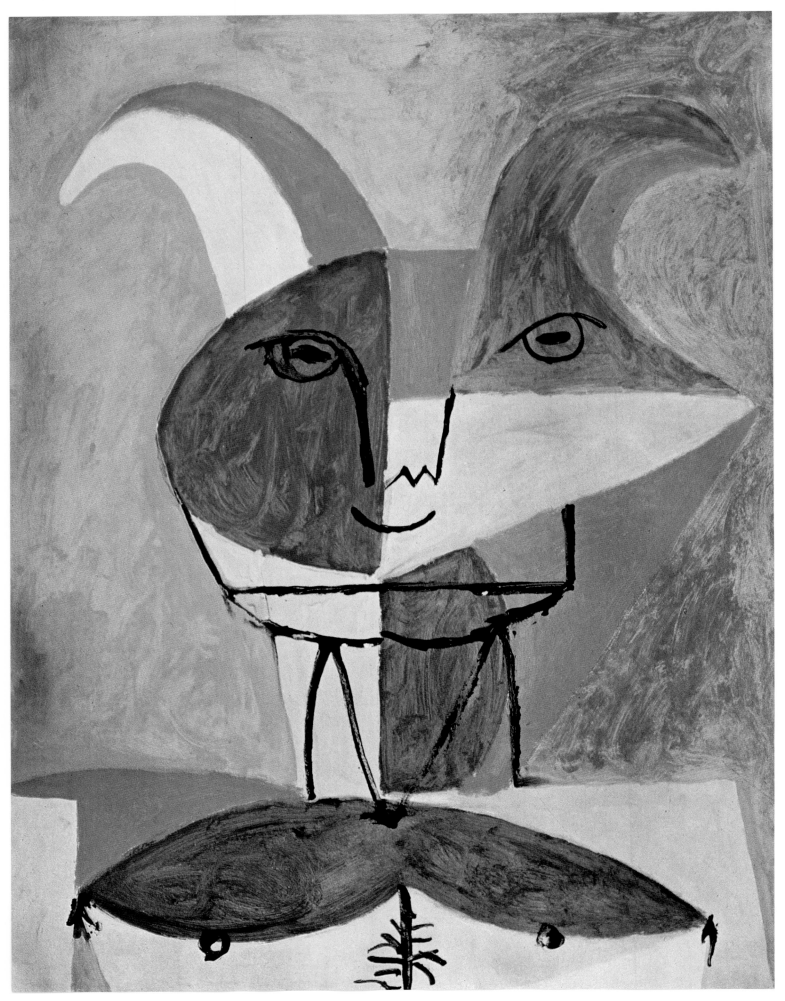

Faun's Head, oil. *1946*

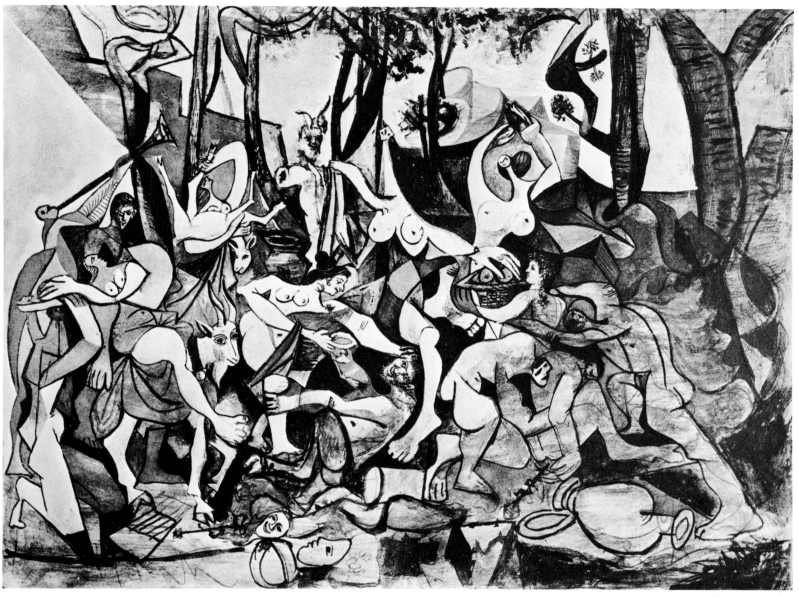

Bacchanal, after Poussin, watercolor and gouache.

24–29 August 1944

Like Cézanne before him, Picasso has always admired Poussin. From the 24th to the 29th of August 1944, while the fight for the liberation of Paris went on in the streets and the windows of his studio shook to the rumble of tanks, Picasso concentrated—as an "exercise of discipline," he says, but also as a symbolic expression of his hope and joy—on making a free copy in watercolors of one of the classical master's bacchanales in the Louvre, the *Triumph of Pan*. This small, vividly interpreted composition is an essential landmark in the development of his work, for it contains the thematic and stylistic source of the joyful cycle soon to cover the walls of the Château d'Antibes, and also of the panel representing *Peace* at Vallauris. Picasso tightens up and dramatizes space, intensifies the headlong exultation of the scene, and emphasizes the sensuality of the forms by a profusion of swelling curves. The main figure is the full-breasted maenad dancing excitely to the beat of the tambourine and galvanizing the Dionysiac train of satyrs and bacchantes, goats and children and music-making faun.

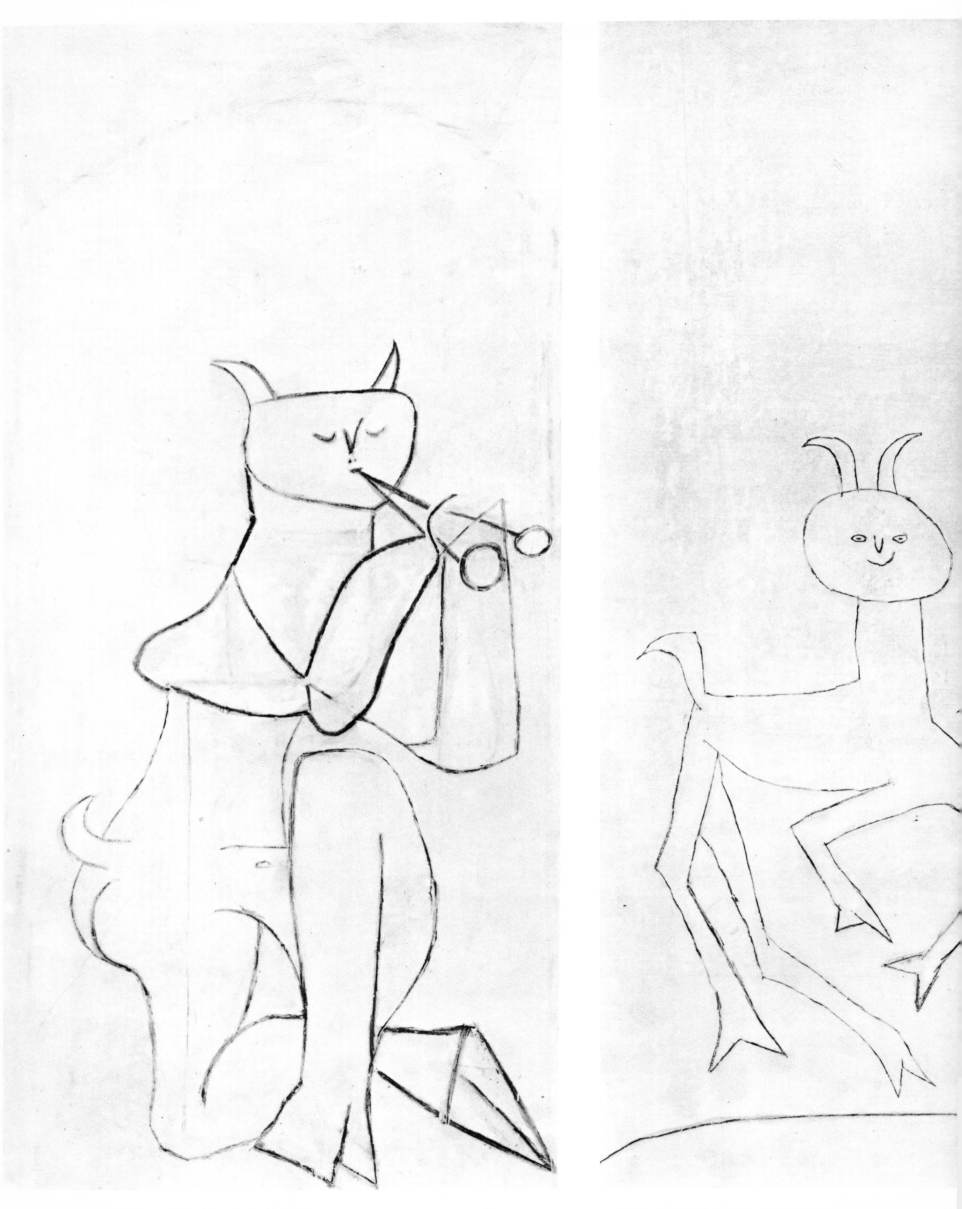

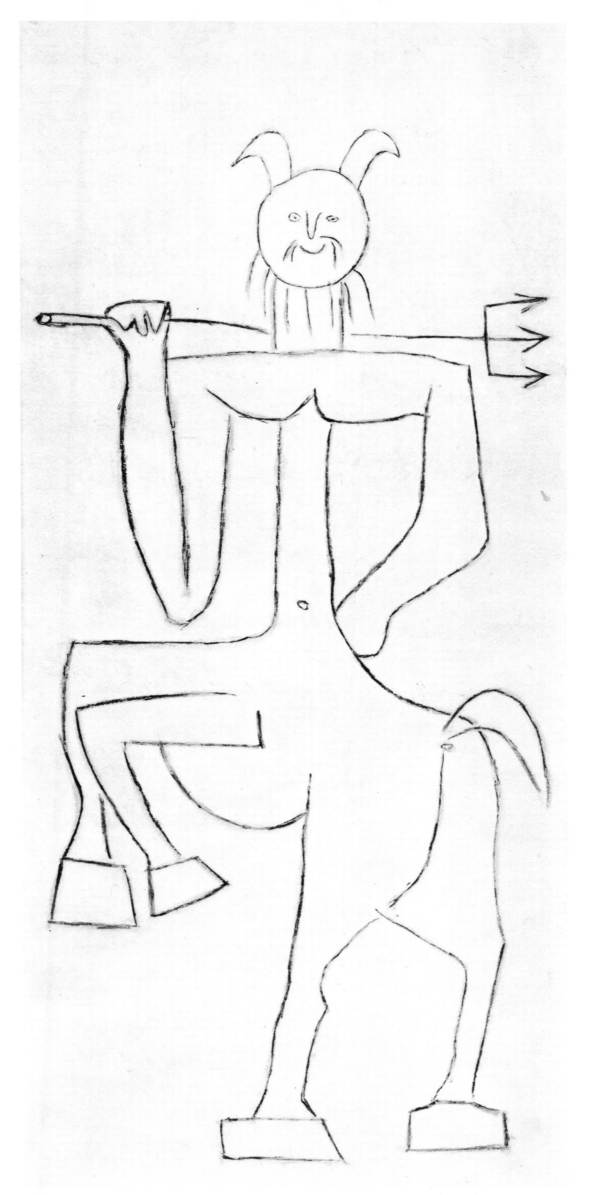

Young Satyr playing
the Double Flute, Young Faun,
and Centaur with a Trident,
oil on fibrocement. 1946

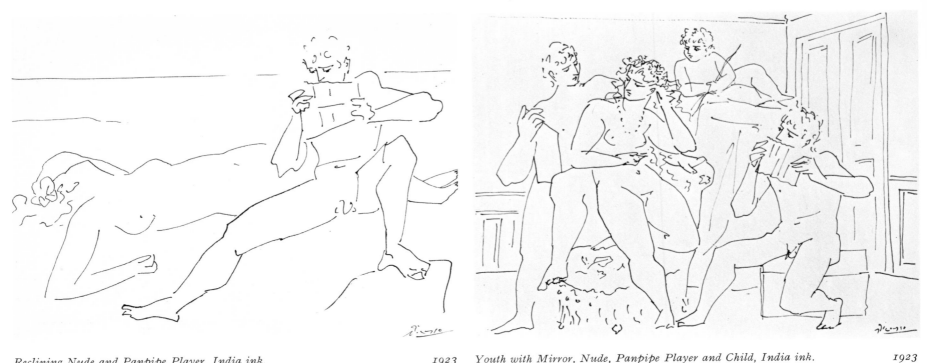

Reclining Nude and Panpipe Player, India ink. *1923* *Youth with Mirror, Nude, Panpipe Player and Child, India ink.* *1923*

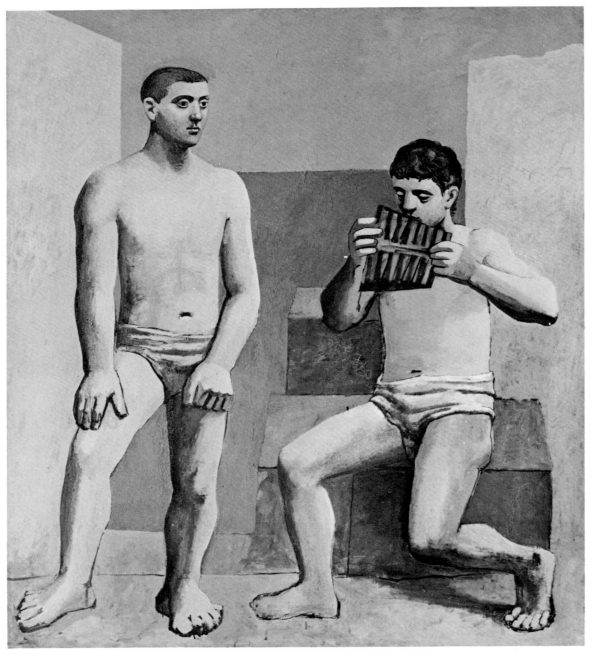

Standing Man and Seated Panpipe Player, oil. *1923*

In the procession of Dionysus, Pan regulates the dance of nymphs with the tune of the pipes, made of reeds of varying length, which bear his name. Several very fine drawings of 1923 show a curly-headed youth playing the pipes, either outdoors beside indolent female nudes or indoors for love-making couples or groups with a mirror. These drawings culminated in the monumental painting which has remained in the artist's possession: it is a masterly summing up of his antique or classical period. Two young shepherds or fishermen with massive, powerfully modeled limbs appear in front of the sea, in an obviously Mediterranean setting. The pipe player is seated, engrossed in his music; his companion stands pensively beside him, his weight resting on one leg. The composition is balanced by the contrast between these two type-postures of Western sculpture. By way of the humanist tradition which from Cézanne to Giotto goes back to the Olympia pediments, Picasso conjures up the world of rustic nobility and harmonious plenitude to which we look back nostalgically.

Faun, Woman and Centaur with Trident, lead pencil. *1 November 1946* *Faun, Woman, Goat and Centaur with Trident, lead pencil.* *1 October 1946*

Dance on the Beach, watercolor. *26 August 1946 IV*

Pastoral, oil on fibrocement. 1946

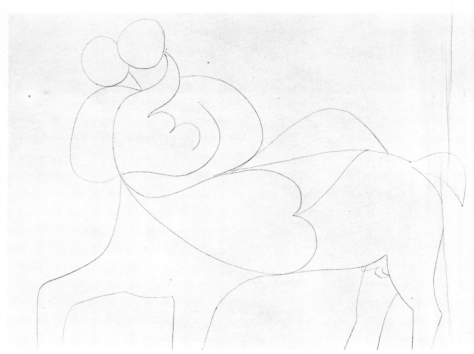

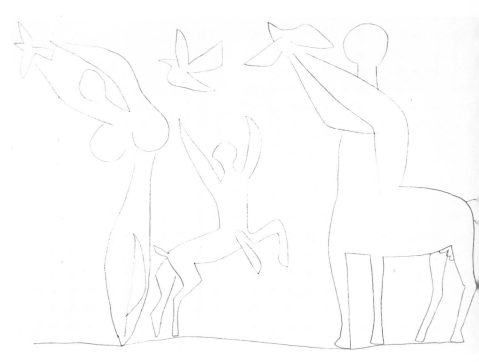

Woman carried off by a Centaur, lead pencil. *1946* *Woman and Two Centaurs with Birds, lead pencil.* *5 November 19*

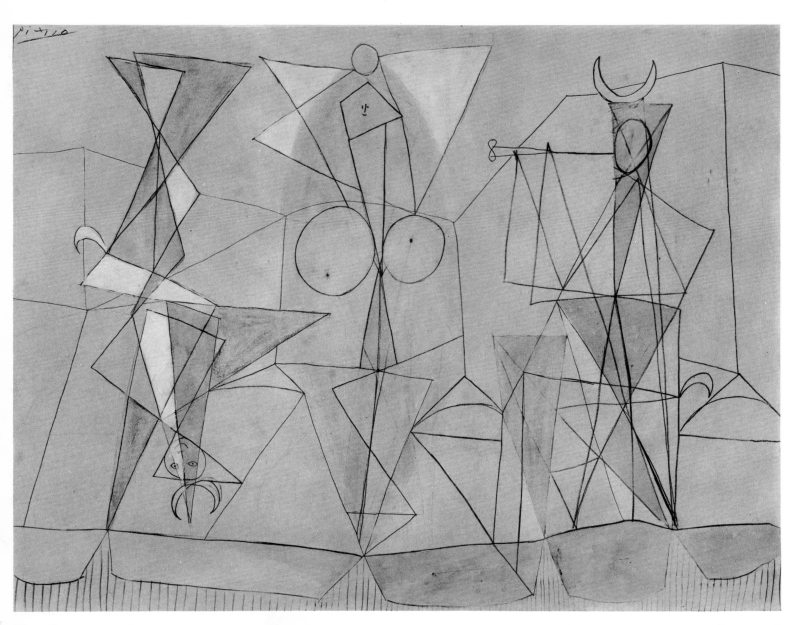

Flute Players, watercolor and India ink. *August 1946*

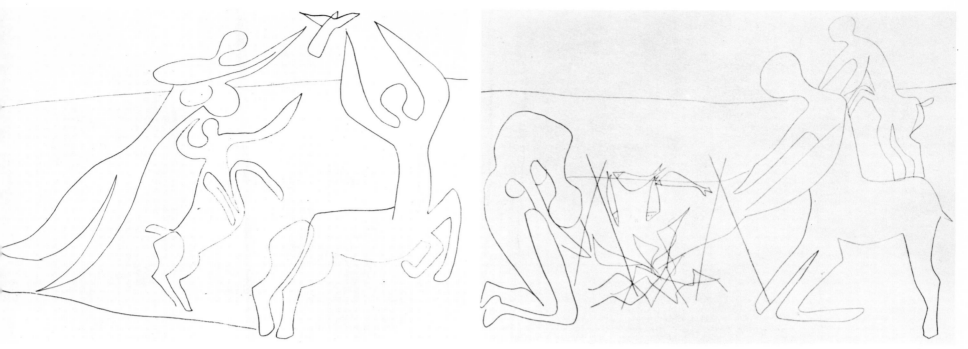

Woman and Two Centaurs with Bird, lead pencil. 5 November 1946 Woman and Two Centaurs roasting Fish, lead pencil. 2 November 1946

It is odd, but in Paris I never draw any fauns, centaurs or mythological heroes like these; it is as if they only lived here.

PICASSO

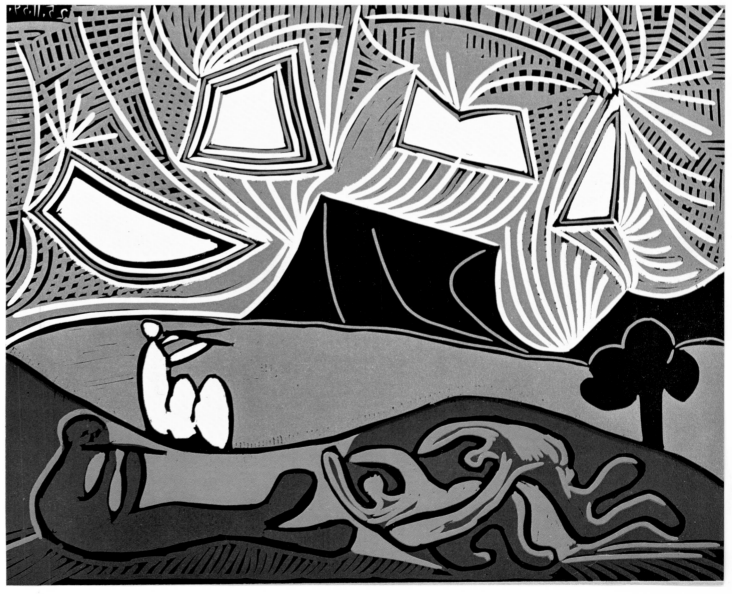

Bacchanal, linocut. 25 November 1959

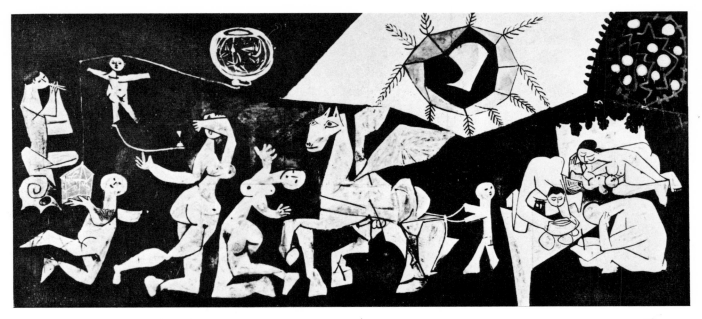

Peace, oil and gouache on plywood. 1952

Peace, detail. 1952

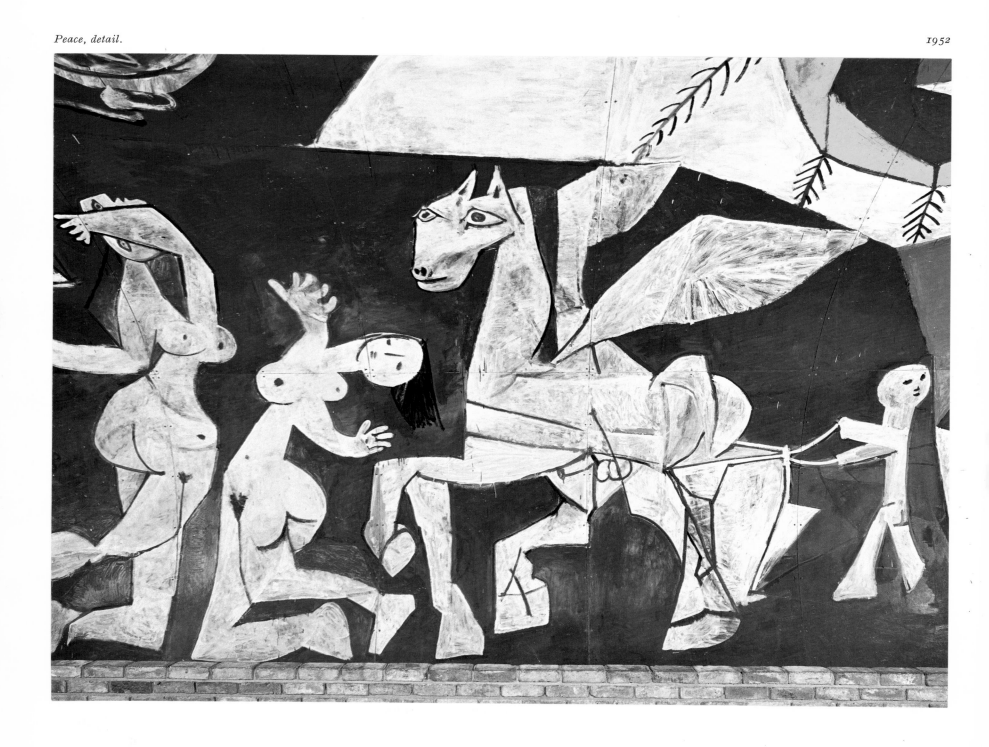

142

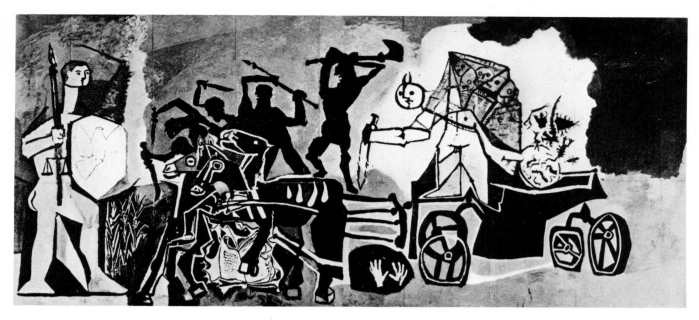

War, oil and gouache on plywood. *1952*

These panels confront us with the bedrock meaning, elemental and profound, of war and peace, of hatred and hope. This art, in which the boldest simplification of the figures and their calculated reduction to the function of signs might run the risk of imparting to it a cerebral, allegorical character, in fact asserts itself first of all with the power of a sensation: this is war, hideous, stupid, unacceptable.

"Peace" contrasts with "War" at first by the favored space of pure tones which it imposes on the eye with its large, smooth, cheerful surfaces. One would have to have the leisure to decipher its meditated meanings, to explore this world of achieved possibilities in which Pegasus driven by a child plows the fields, in which fish fly through the air and birds swim in the water.

—Remember, says Picasso, that the two panels will be fitted to the two sides of the chapel, both of which are vaulted. Thus the "sun" at the top of "Peace" will not be at the top of the "fresco", but over the spectator's head. It is rather dark in this chapel, and I could almost wish for there to be no lighting at all, for visitors to come in with candles in their hand, holding them up to the murals as in prehistoric caves, with the candlelight thus flickering over my paintings.

Claude ROY, December 1952

Dove and Horned Figure covering its Eyes, India ink. 4 December 1953

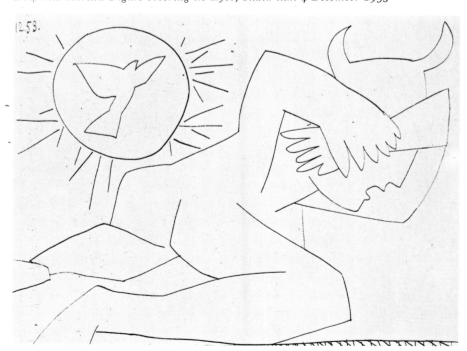

Dove and Figure with Broken Knife, India ink. 4 December 1953

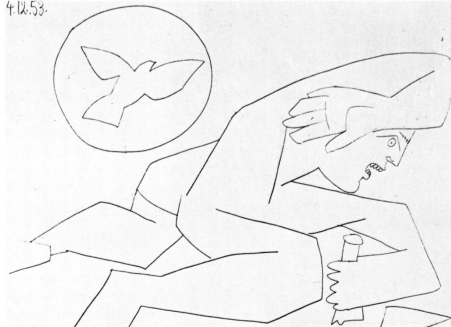

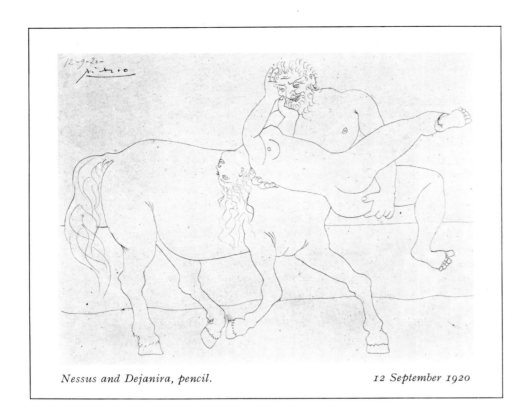

Nessus and Dejanira, pencil. *12 September 1920*

During his summer stay at Juan-les-Pins on the Riviera in 1920, Picasso rediscovered the Mediterranean. In pencil or silverpoint he drew six playful, grave or lyrical versions of the abduction of Dejanira, wife of Heracles, by the centaur Nessus. These are the first examples of that mythological vein which re-emerged periodically, either to throw a veil of irony or decorum over personal disclosures or to celebrate the Arcadian realm of happiness. The motif of the Masked Cupid is a foretaste here of the autobiographical and symbolic sequence developed in the following chapter. The drawing of *Peace* was made a few months after the large mural composition at Vallauris; it takes over the essential elements and the magical rhythm, with a few changes or additions, like the central ring of women and the pensive man standing behind the two seated figures of a woman reading and a man drawing.

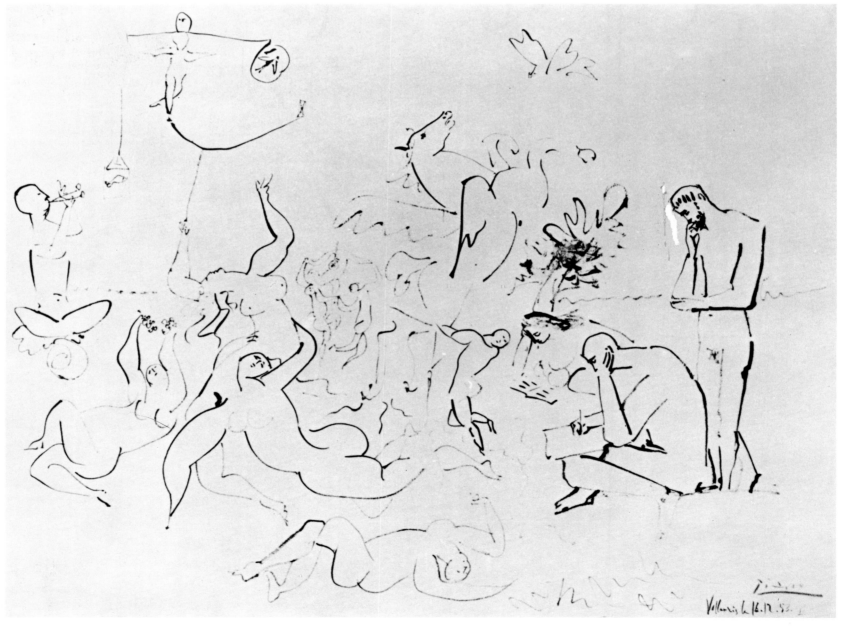

Peace, ink. *16 December 1953 IV*

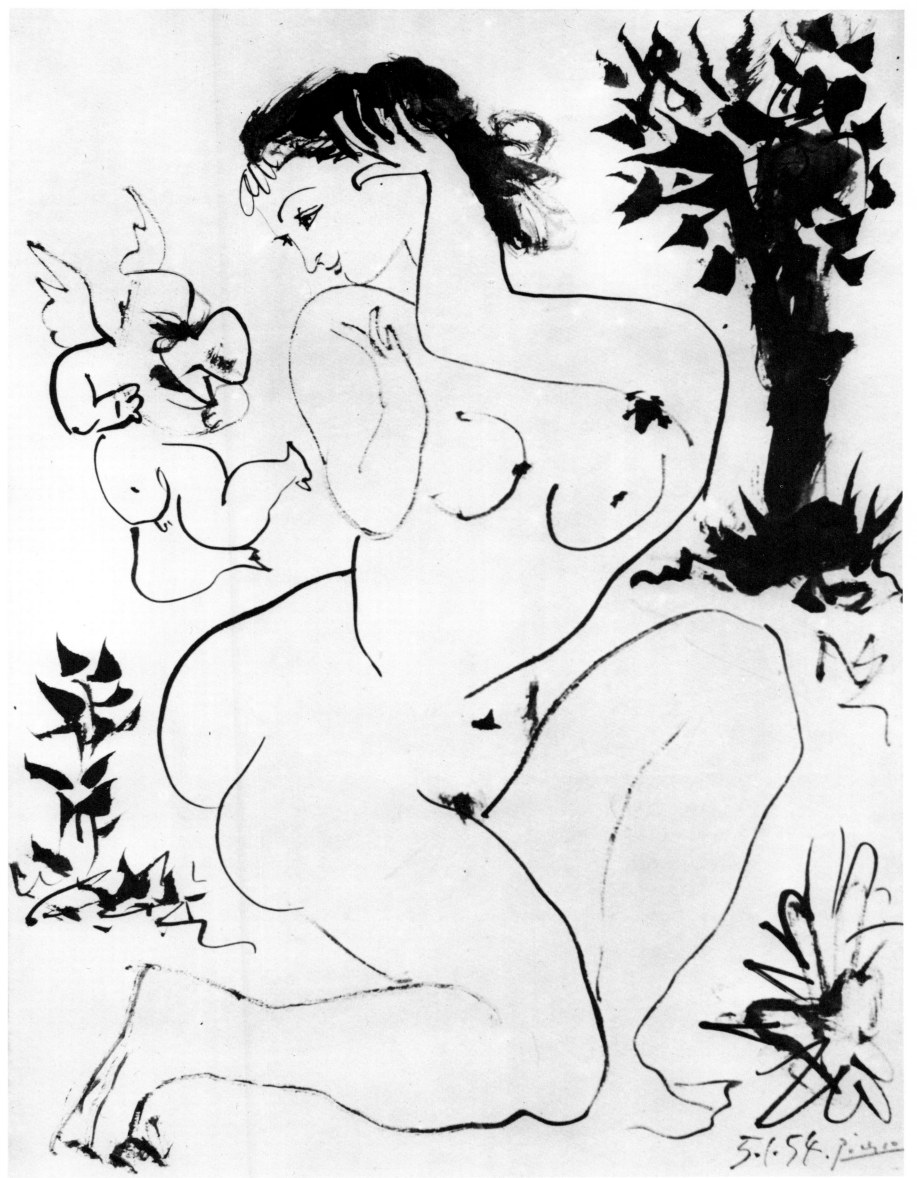

Nude with Masked Cupid, India ink.

5 January 1954

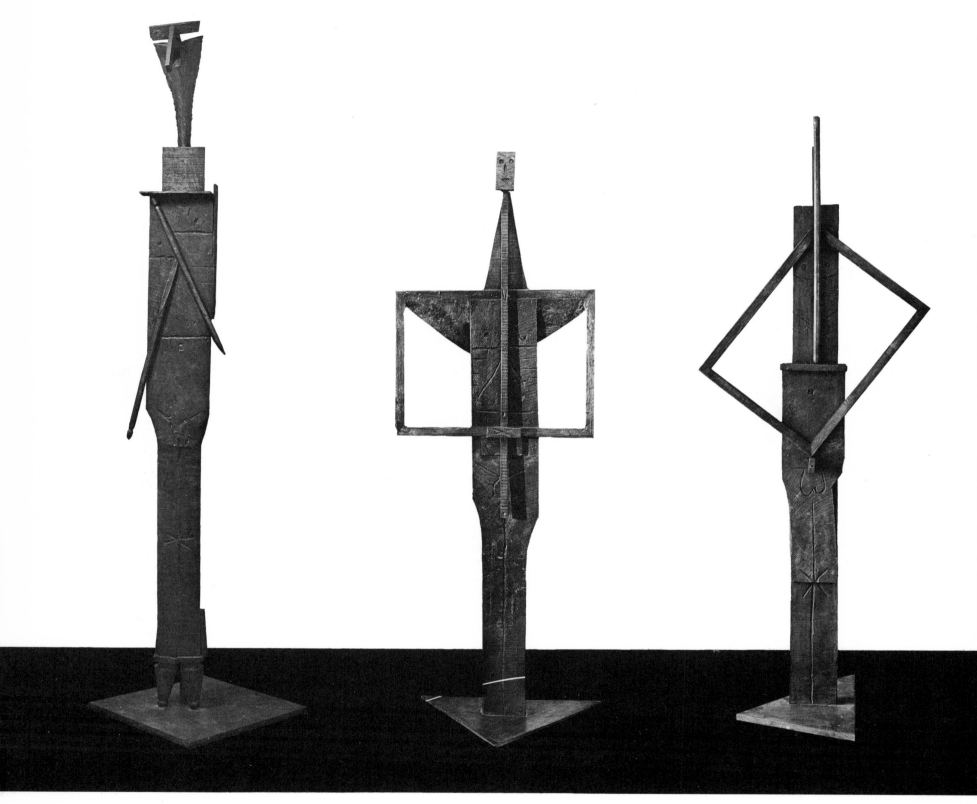

Bathers, bronze. 1956–1957

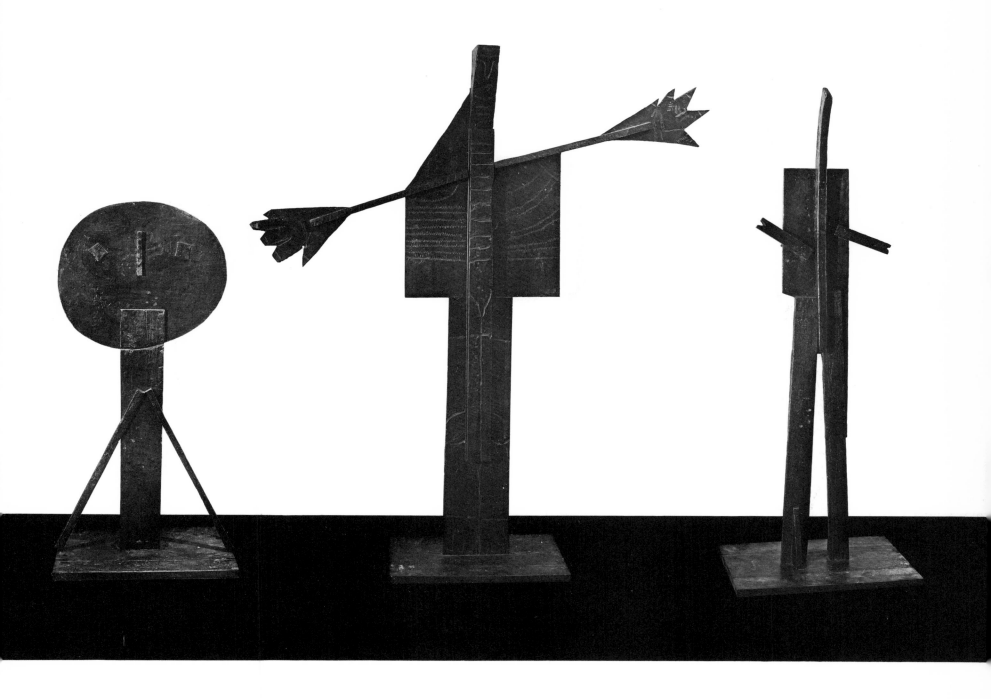

Like a primitive, Picasso fashions engines of magical power. He picks up stray bits of boards, broken sticks, a broom handle, a frame thrown into the refuse bin, useless litter of any kind. He plays about with these odds and ends, assembles them and suddenly finds himself face to face with a monumental figure, charged with a supernatural quality. Through the very shabbiness of its texture, the trash gives rise to a miracle. If one is a genius or a child, one finds a god in random materials more readily than in a block of marble. Fancy hatches a purer brood out of this rag-picker's heap.

Georges SALLES, 1958

Picasso's work is centered on man, and with him, as with most of the great Spanish masters of the past, landscape long remained an infrequent theme. But it does occur, always with telling relevance and usually in direct connection with the circumstances of his life and work. During the Second World War he recorded the essential image of occupied Paris, Notre-Dame and the historic heart of the Cité, in a series of small, geometrically partitioned pictures which convey the spatial complexity of urban structures. After settling on the Riviera after the war, he reverted more often to landscape, in larger formats. At Vallauris he painted several views of his house and the village, some winter landscapes and nightscapes. Also this *Mediterranean Landscape*, whose riot of colors renders the luxuriant and theatrical aspect of Riviera houses: red roofs and green shutters, blue pergola, white or yellow walls, palm trees, trellises, terraces and the glow of the sun on the indigo sea. On it, contrasting with this sophisticated decor, rides a silvery boat with three black figures trimming the sails for a pleasure cruise, or an odyssey.

In September 1958 his immense panel, contemporaneous with the first manned flights into space, was set up in the hall of the Unesco Building in Paris. Its monumental power and mythical radiance quickens its thankless setting of bare concrete traversed by a gangway, and fits into it perfectly. A charred skeleton falls dramatically into the dark blue sea, in the full glare of a southern sun whose white light seems to devour everything. On the left, a metamorphic bather emerges from the water with outspread arms. On the right, three indifferent male bathers stand or lie on the sand; the standing one is of the same family as the sculptured group on the previous page. In a remarkable text in which he paid tribute to Picasso, Georges Bataille identified the Mithraic cult of the bull and the myth of Icarus—which this composition is supposed to illustrate—with the folly of exaltation, the folly of gazing straight at the sun. And the painter's art, which no secondary impediment can deflect from the course of its major impetus, seemed to Bataille to aim at "a rupture of loftiness carried to its highest pitch."

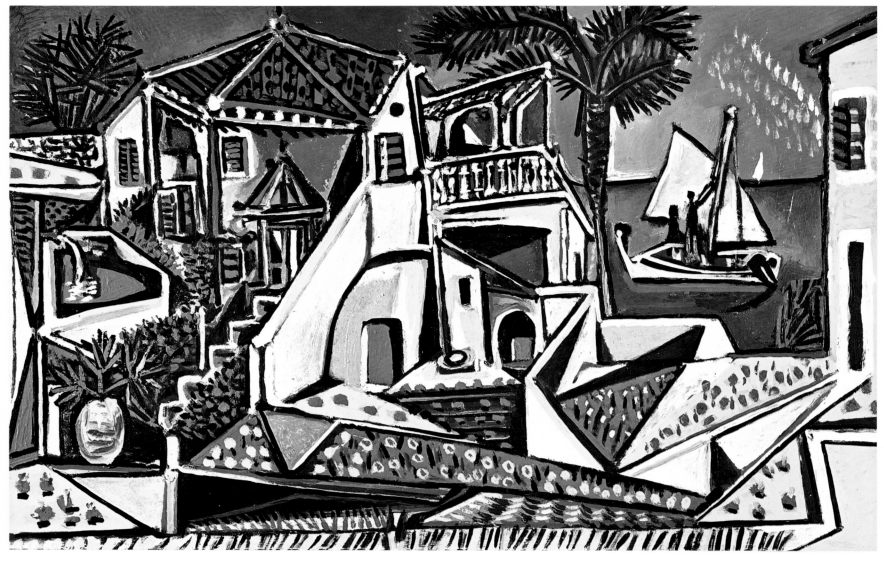

Mediterranean Landscape, enamel paint.

10 September 1952

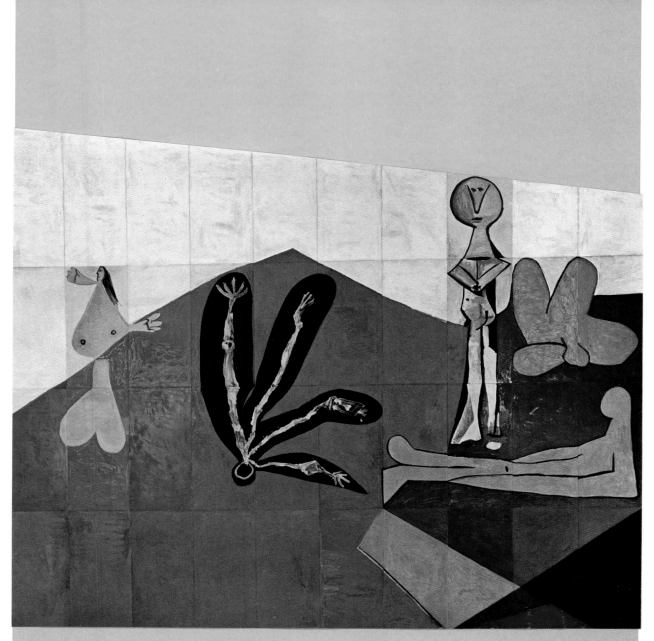

The Fall of Icarus, mural composition for Unesco. *1958*

Swimmer, study for the Unesco mural composition, green crayon. 25 January 1958 XIII.

Picasso's work is a comedy, *in the deepest sense of the term.*

Jean CASSOU

The Human Comedy or "The Caprices"

"A kind of Balzac of painting," said Dufy of Picasso, trying to fit him into a frame of reference. This judgment is increasingly confirmed by an ever more prolific output organized in vast sequences of pictures, above all of drawings and engravings, which must be seen in their entirety, for each element stands not only on its own merits but in relation to the continuous circuit of exchanges and retrospects into which it is integrated. If Balzac's narrative and social fresco, in which from one novel to another the protagonists reappear in fresh situations, is a Human Comedy in the same way that Dante's lyrical and sacred cycle is a Divine Comedy, the reason is that the theater, which pervades all genres, is the central place of revelation, of that vacillation between reality and fiction on which art and life are founded: man reveals his truth beneath outward appearances, but illusion remains inherent in every reality. Picasso's work, rich in contrasts and metamorphoses, but continually returning to the same characters and situations, and Picasso himself, ever prompt to play a part, gifted as he is with unusual powers of mimicry, both maintain a fundamental and often noticed connection with the mode and ritual of the theater, not only in the repertory of themes extending to every kind of show or entertainment—dance, circus, bullfight—but also and above all in the presentation or scenic unfolding of the action. In the engraved sequences multiplied in the course of the last two decades, which can only be interpreted as comedies or tales in the Spanish manner, absurd, truthful, tested by the fires of life and shaped by the caprice of genius, the dramatist of *Guernica* shifts the scene and, even while baring his heart, goes in for masquerading, no less universal in its appeal than tragedy, or launches into the illustrative vein of a spirited story-teller in which the flashing directness of the imagery precedes the recital of events.

From 28 November 1953 to 3 February 1954, under the stress of an emotional conflict which led him to call in question every item in his personal balance sheet, he executed in the space of nine weeks an astounding series of 180 pen drawings, some heightened with wash, in which technical mastery is on a level with human experience. They enlarge on the romantic myth of the "old tumbler" as told by Baudelaire and re-enacted by Charlie Chaplin; they bring out the irremediable inadequacy of old age before the demands of love and the inevitable ridiculousness of art before the demands of life. The situation resulting from the contrast between the foolish old painter pedantically intent on his task and the sovereign splendor of the young model flaunting her sensual charms is exploited through a whole series of variations with a profound and implacable irony. Sometimes the studio scenes shared in by former acolytes or watched by obtuse visitors turn into circus scenes. The play of masks and metaphorical substitutions

Etching. *16–22 March 1968*

intervenes at every level to make even more bitter and grotesque the realization of the truth. The woman needs to be loved as much as the model needs to be painted, but how are these two activities to be fully performed? Finally the monkey, symbol of instinct and usurpatory ruse, takes the painter's place at the easel and the beauty welcomes him or teases him with an apple before the eyes of a pensive clown or a grinning satyr. Each scene extends to several levels of meaning, and the accuracy of the line underscores the innuendoes of the story without losing anything of its calligraphic prestige.

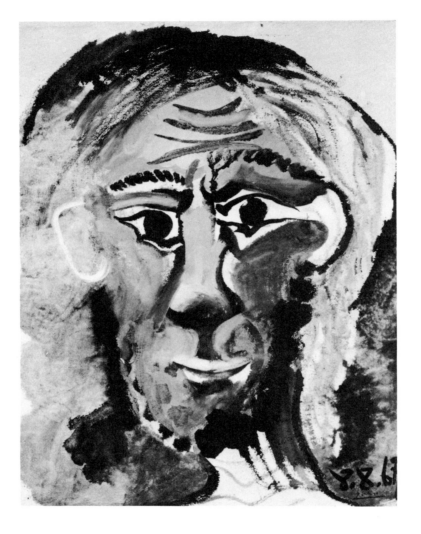

Man's Head, India ink and gouache.
8 August 1967

Nude with Clown, ink wash and gouache. ▷
21 December 1953

Familiar with the bullring from childhood, Picasso has so thorough a knowledge of bullfighting that in the spring of 1957 he was able to engrave in a few hours the twenty-six aquatints of supreme quality illustrating its successive phases, some now abolished, in accordance with the classic manual of the famous matador Pepe Illo, a contemporary of Goya's. Bull-fighting goes back to Crete and the cult of Mithras, but Spain has made it a national rite and regulated its choreography, adding to it in particular the mounted picador, who in repeated encounters goads the bull and tests its mettle. The role of the picador, with his heavy trappings and the sort of sexual and sanguinary charge which he carries out at the moment of the *suerte de picas*, is more interesting pictorially than the matador's role, and on this the artist generally focused his attention. The title *Romancero del picador* has been given to a series of ink wash drawings, *tachiste* in style, executed between 11 July 1959 and 26 June 1960, which with irresistibly epic or picaresque raciness picture the often contested exploits of the plebeian centaur and his backstage pleasures, indoors with girls or outdoors in country settings.

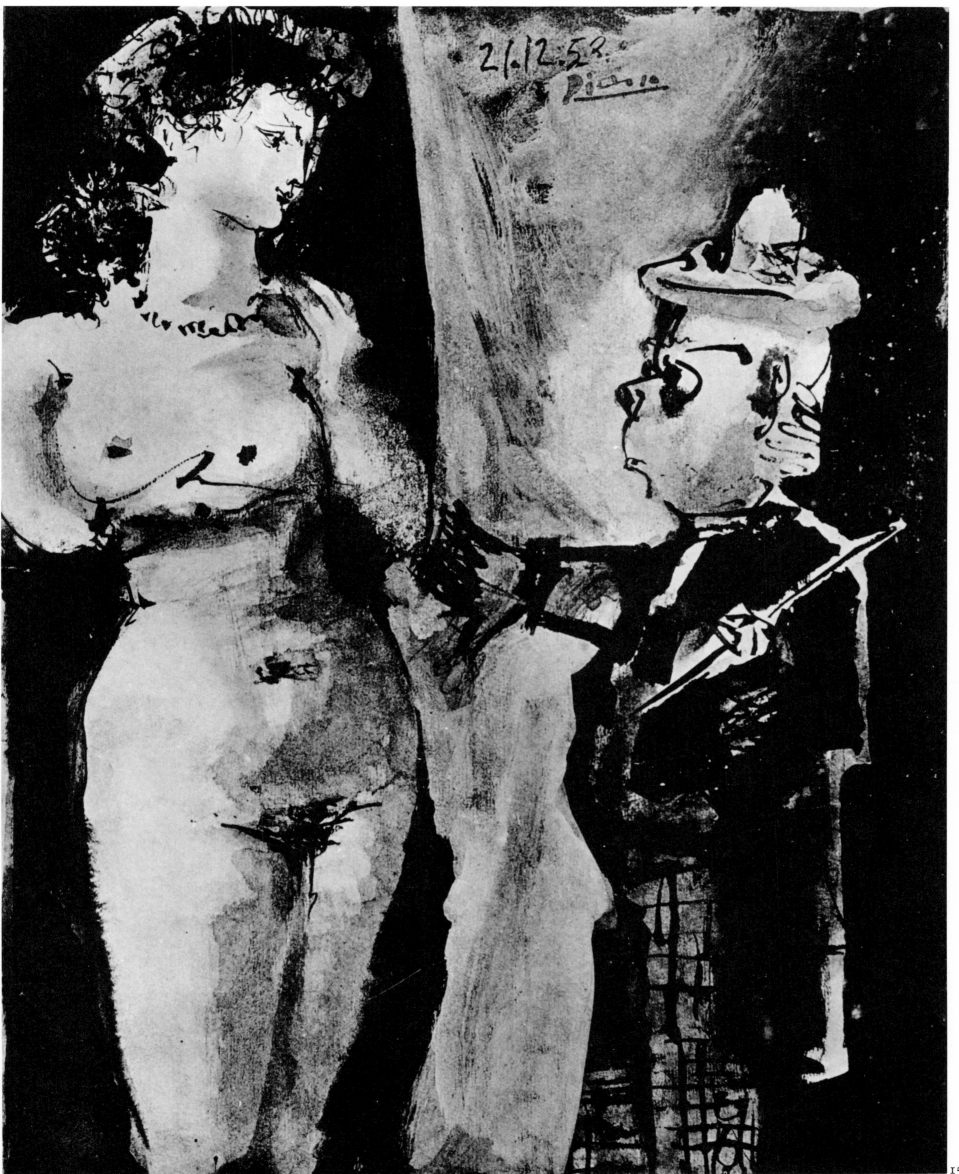

153

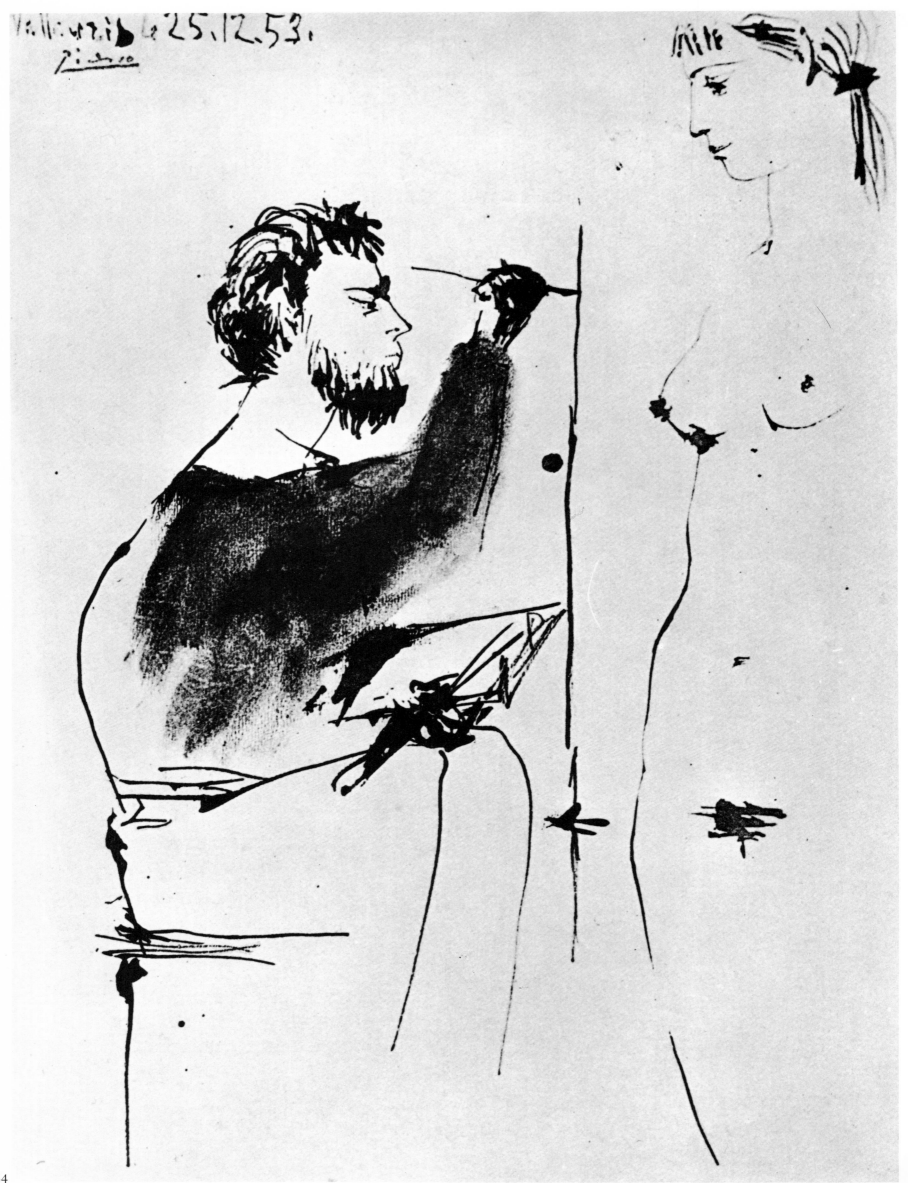

Vallauris le 25.12.53.
Picasso

154

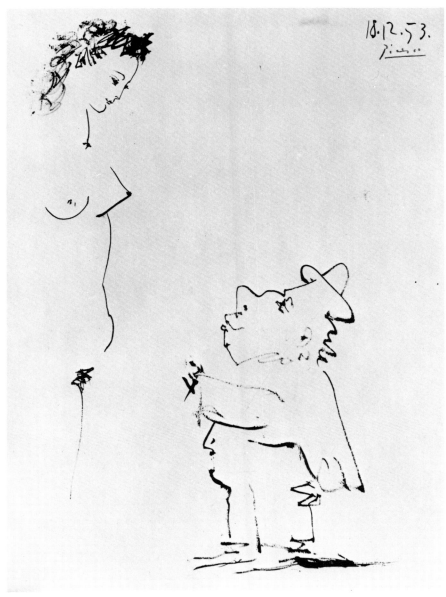

Nude with Dwarf Clown, ink. *18 December 1953*

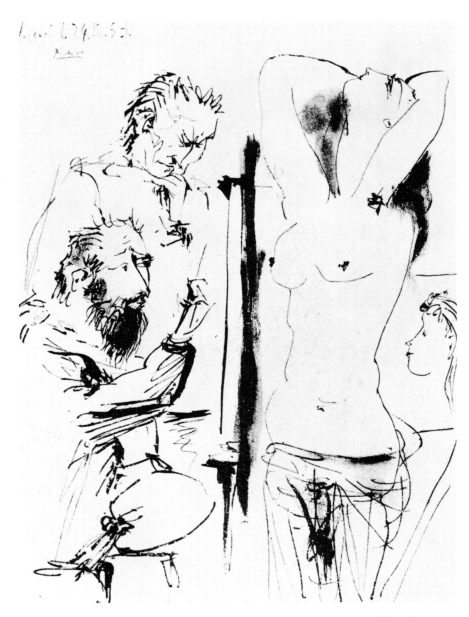

Studio Scene, ink. *24 December 1953*

At bottom, love is all that matters. Any love. And painters should be blinded as goldfinches are to make them sing better.

PICASSO, 1932

The work one does is a way of keeping one's diary.

PICASSO, 1932

◁ *In the Studio, ink. 25 December 1953*

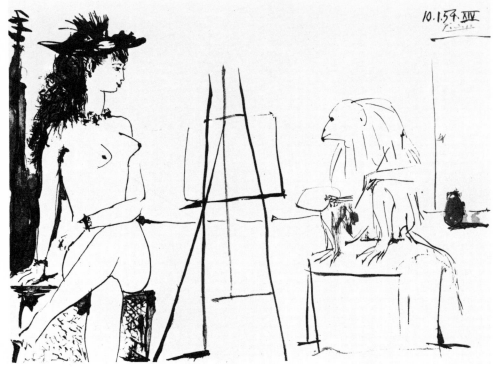

In the Studio, India ink. 10 January 1954 XIV

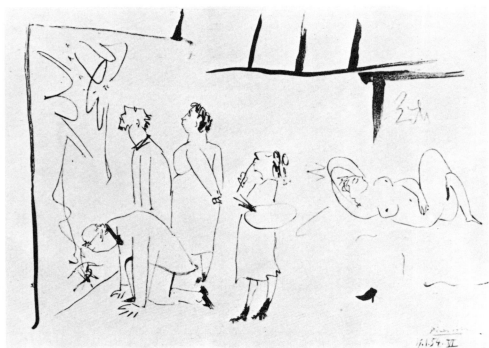

Visiting the Studio, India ink. 19 January 1954 VI

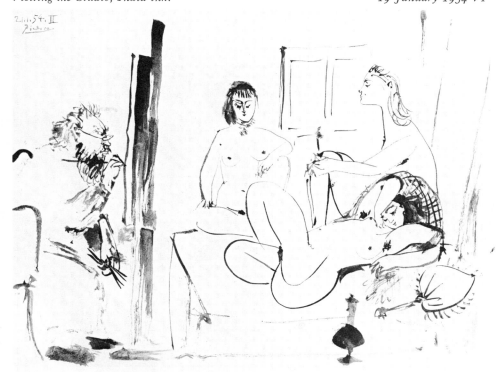

The Studio (The Models), ink. 21 January 1954 III

The Monkey and the Mask, ink wash.

An old, bearded, bespectacled painter, peering intently at his canvas, strives impassively to record the enticing curves of the model. The model falls asleep, a pretentious and unlovely woman painter takes over, and obtuse visitors enter the studio. A monkey seizes the palette and brushes, sits down on the stool in front of the easel, and the model with a plumed hat observes him with a smile of arch encouragement further marked by the insidious similarity between the model's breast and the monkey's muzzle. The play of masks complicates and heightens the absurdity of the situations pictured. A couple reclining in a garden exchange features, the young woman wearing the leering mask of the old man, and the old man

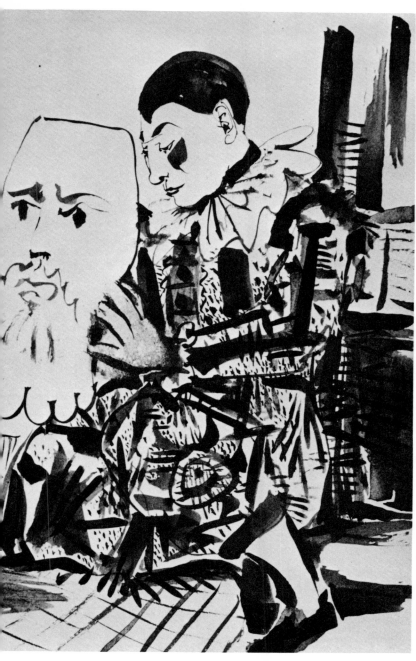

25 January 1954 II

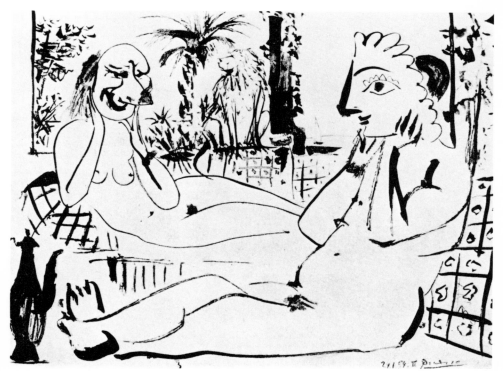

Two Masked Figures with Monkey, ink wash. *24 January 1954 II*

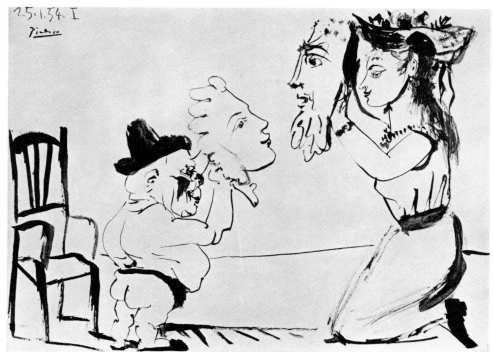

Two Figures with Masks, ink wash. *25 January 1954 I*

assuming the pure profile of his partner; but the disapproving monkey in the background averts his eyes from the sight of these grotesque substitutions. A shapeless dwarf holds out a mask resembling the girl's face, and the latter, kneeling to bring herself down to his level, answers him by holding out the mask of a virile young god. A clown, his face painted like a mask, holds in his hands this same mask of a serene immortal and bows gravely to the girl, in whose lap crouches a watching monkey, bewildered by this show of respect. In an arrestingly beautiful crayon drawing, in green and pink, the Old Man knowing all, a sardonic libertine, and the Girl knowing nothing, a lithe and expectant young animal, eye each other.

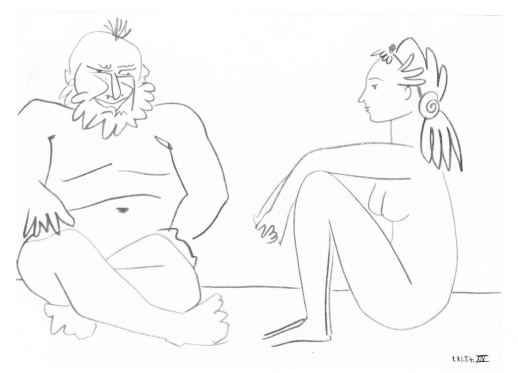

Two Figures, colored crayons. *27 January 1954 XIV* 157

During the Picasso exhibition held in Barcelona in the spring of 1936, where several writers were invited to speak, among them Paul Eluard, Ramón Gómez de la Serna recited some of the poems composed by the man whom he had described as "the toreador of painting."

Goya was well acquainted with the best toreros of his time. Picasso drew the glittering costume of his friend the bullfighter Luis Miguel Dominguin, who, at Picasso's urging, wrote the text of which an extract is given above. Dominguin's elegant silhouette and style inspired the fine aquatints made by Picasso in 1957 to illustrate the classic Spanish manual of bullfighting.

In Malaga, his home town, no less than in Madrid, I have understood what Picasso is and have realized the extent to which he is a toreador—gipsies make the best toreadors—and how much what he does is like bullfighting, like flaunting the *muleta*, tossing it at the critics, blinding them with it, making them put their heads down, drawing them on, "worrying" them and finally finishing them off as one finishes off a weary, flagging bull, touching them home at the most vulnerable point of their aesthetic, to leave them there at the end of their dialectics, with no arguments left, lifeless and spent, and himself to return to the festival of Art with his jaunty, offhand ways, his air of life and death, of authentic danger, of things unseen before and such today as they have never been.

Ramón GÓMEZ DE LA SERNA

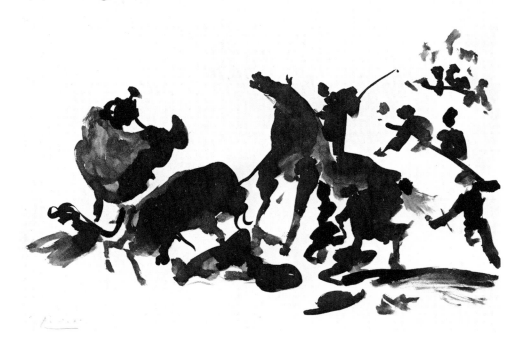

Bullfight, ink wash. 7 *February* 1957 *V*

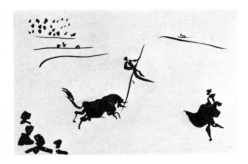

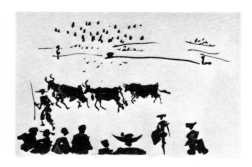

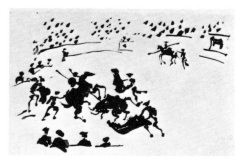

Bullfighting Scenes, aquatints. 1957

Is there such a thing as greatness in the matter of bullfighting? Indeed there is, and a greatness of no mean order. For, to my mind, it is the fruit of that difficult facility, handmaid of a technique which makes us seem natural, in fact makes us seem to improvise. When the bull plays into our hands (or so the public supposes) and we seem to be at our most spontaneous, it may be that we are actually reaping the fruits of many years of experience, of strivings, of insight into these bulls, whose history has been connected with that of mankind ever since its mythological origins; these bulls, runaways from Crete and Rome, who reached the most widely different places in Europe, finally to acclimatize themselves in the marshes of Andalusia, where they found their place of election. The bull, then, an animal that has a history and a greatness of its own, is the chief partner in our "game", in our festival, in the radiation of that Spain which may be identified with Valle Inclan's "esperpento" and also with the Basque drum of the old romances of dead queens.

Luis Miguel DOMINGUIN

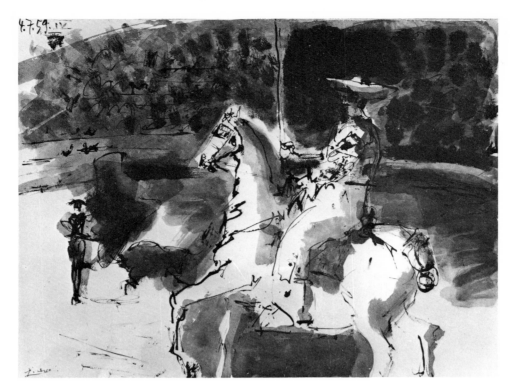

Entry of the Picador, ink wash. *14 July 1959 IV*

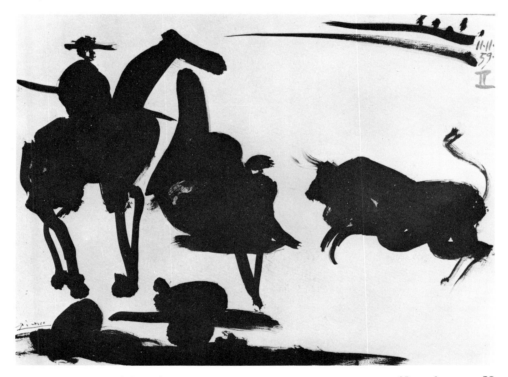

Bullfighting Scene, ink wash. *11 November 1959 II*

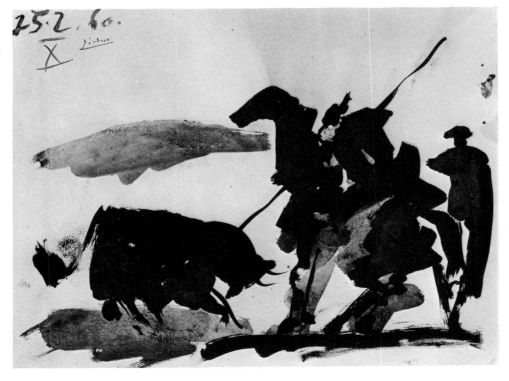

Bullfighting Scene, ink wash. *25 February 1960 X*

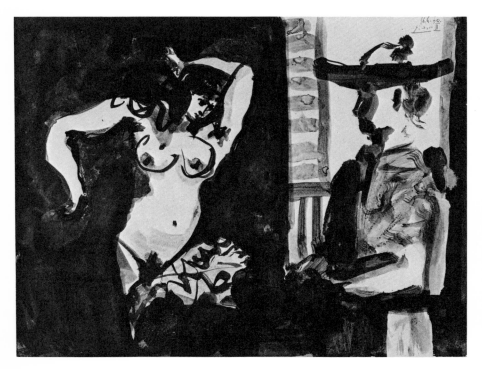

Dancer and Picador, ink wash. *16 June 1960*

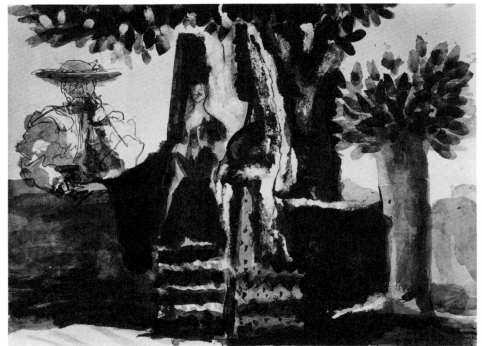

Picador and Two Women, ink wash. *22–23 June 1960*

Scapegoat in the eyes of the public (who often boo him even before he has cheated), the picador is in modern bullfighting the culprit par excellence, the heavyweight who works by main force, for whom no holds are barred and whom, unlike even the trickiest matador, no grace redeems. Perhaps this is why Picasso, in the dazzling series of washes and drawings which he made between 11 July 1959 and 26 June 1960, so often showed the picador in his rascally pleasures and sometimes (it would seem) held him up to accusation.

After 5 June 1960 it is no longer the fighting but the love-making picador who forms the central theme of this series, of which each item is a little world of its own. Then, epic sweep gives way to the picaresque. Now the scene of action is a bawdy house, a street corner, a country nook, instead of the unqualifiable space of the bull ring.

Thus, in the aftermath to the corrida, we have an orgy of hairy armpits, nipples, mantillas, petticoats, sweat and perfume bursting upon us and upon the man with the castoreño—the now visible, now hidden center of saturnalia proceeding to the heady rhythm of guitars, castanets, stamping feet and beating hands. Thus, too, we see the puzzled picador sizing up a beauty (as he would a bull) flanked sometimes by a sordid duenna, or else tacitly enduring (one would say) the silent reproach brought upon him by some escapade worthy of Sancho Panza or the prodigal son.

For it is not only on the open square or in the noble setting of the fiesta that an immemorial drama is played out but everywhere, both in the country and in town, wherever living people are confronted with other living people or with something else besides themselves.

Michel LEIRIS

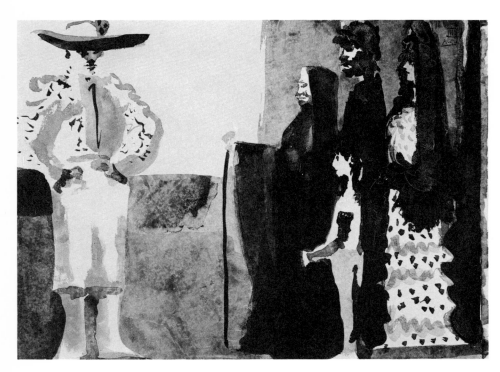

Picador and Figures, ink wash. *11 June 1960 III*

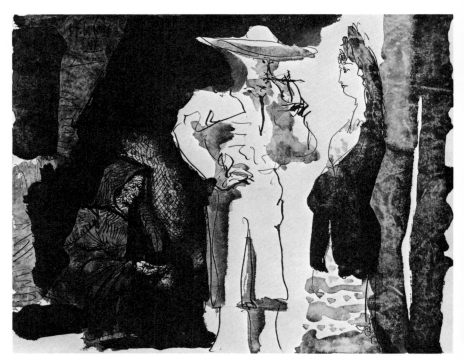

Picador and Two Women, ink wash. *17 June 1960 VI*

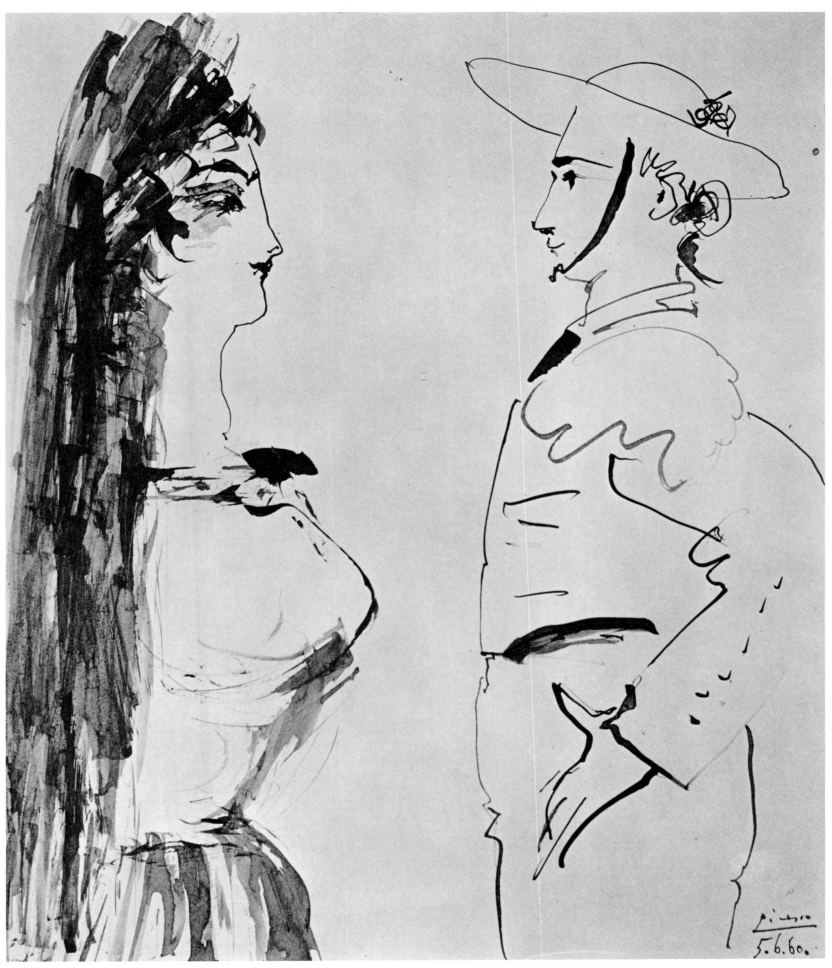

Picador and Woman, ink wash.

21 June 1962 II

Family Portrait, litho crayon.

21 June 1962 I

Family Portrait, lithograph.

During the autumn of 1962 Picasso did a series of drawings in black and in color and also some engravings; these are known as the "family album". Because, very much in the Victorian manner, a family poses on each of these drawings.

Why? As for that...

Where did he get the idea? No idea. But why this family?

Well, why not?

The fact is that this family came into existence. The father seated and stern, with his cravat. The mother and her bonnet. Grandmother and her spectacles. Grandfather and his cane. The long-necked daughter has her graces, the son has his ambitions. There he is with his long hair; he wants to be a poet and live his life, while the fat pug-dog poses full-face at the feet of the cousin who has a job with the government. The daughter looks sad. And what a huge bosom the mother has! Here they have had a family quarrel, but they break it off to sit for the album. They stand up, they sit down, they have their disappointments or ambitions. We know them all right. Picasso comments on them as he turns the leaves; he thinks the poet has talent and the daughter has a future.

Hélène PARMELIN
Notre-Dame de Vie, 1966

6 July 1962 III

Family Portrait, lithograph.

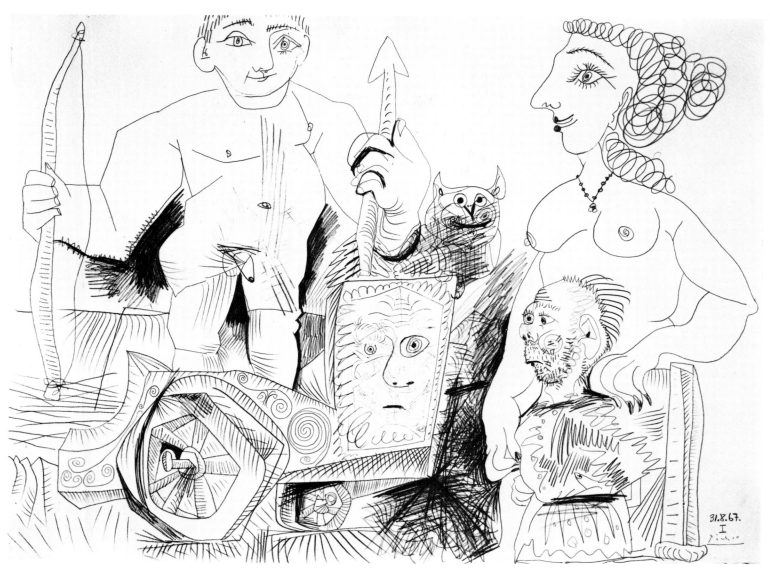

31 August 1967 I

Mythological Scene, pencil.

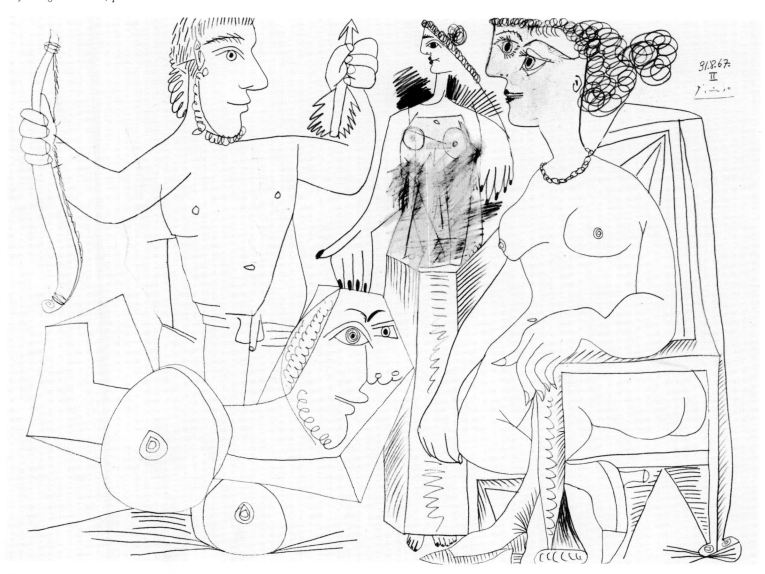

31 August 1967 II

Warrior's Homecoming, pencil.

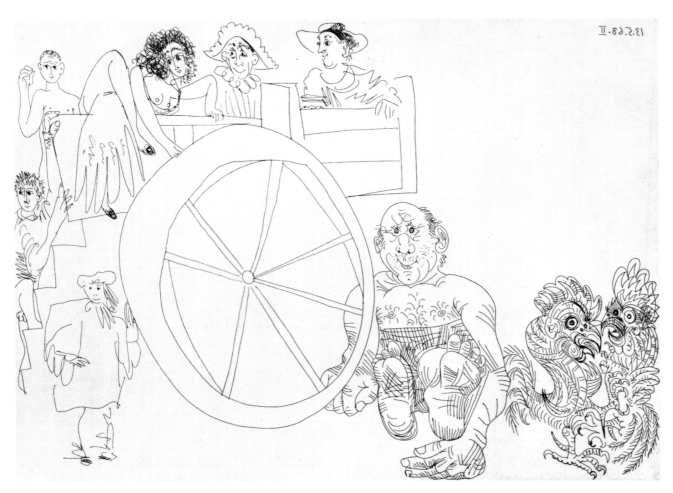

Etching. *13 May 1968 II*

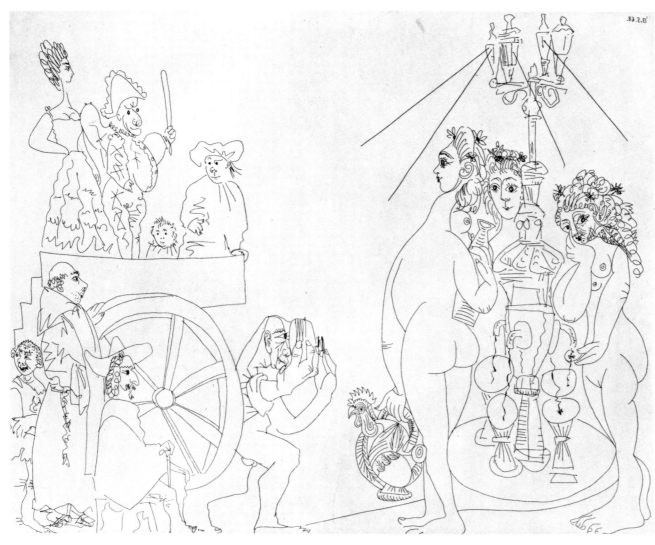

Etching. *13 May 1968*

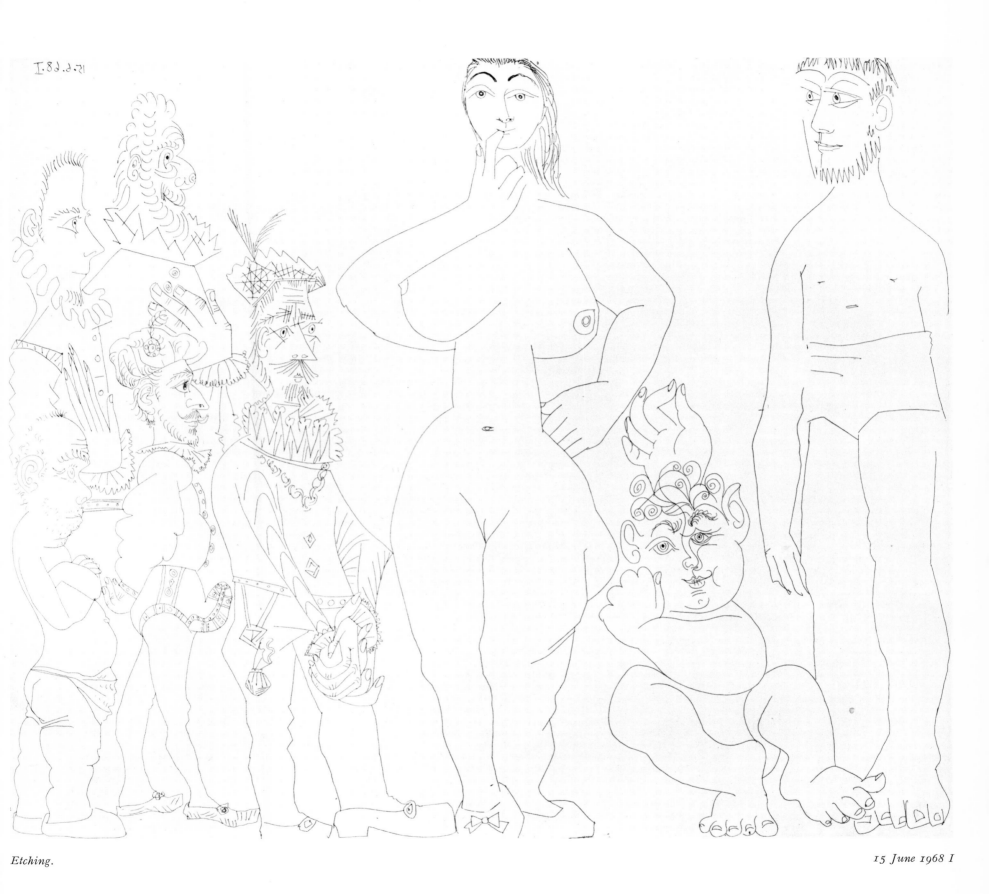

Etching.

15 June 1968 I

When I have something to say, I say it in the way I find most natural.

PICASSO

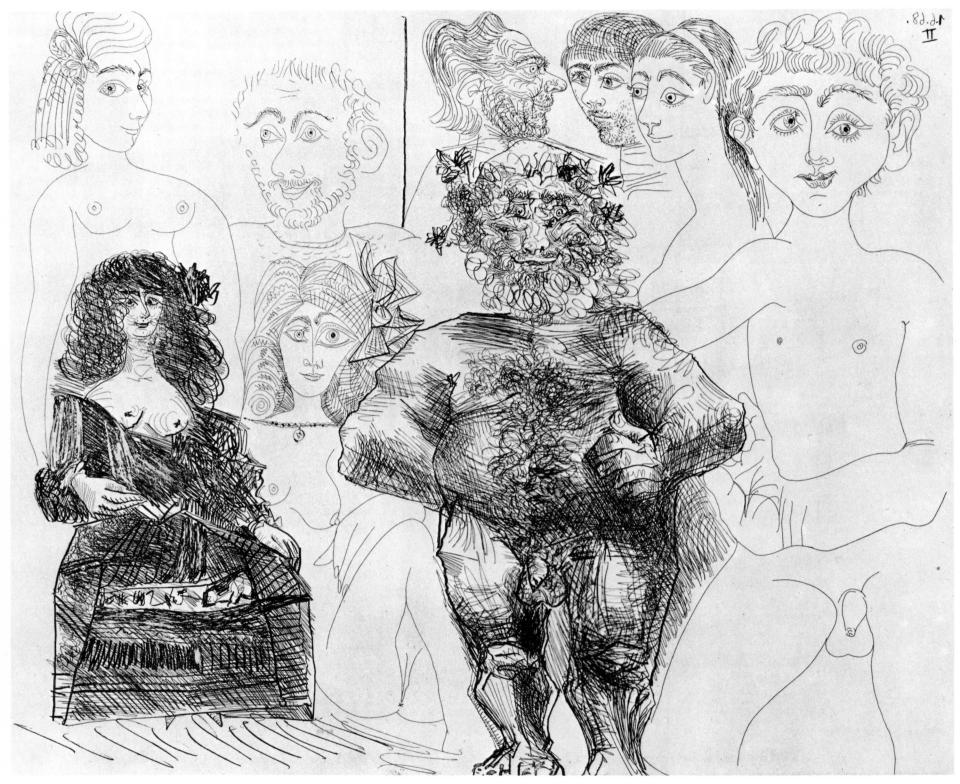

Etching. 1 June 1968 II

That's enough, isn't it? What more can I do? What can I add to that? Everything has been said.

PICASSO

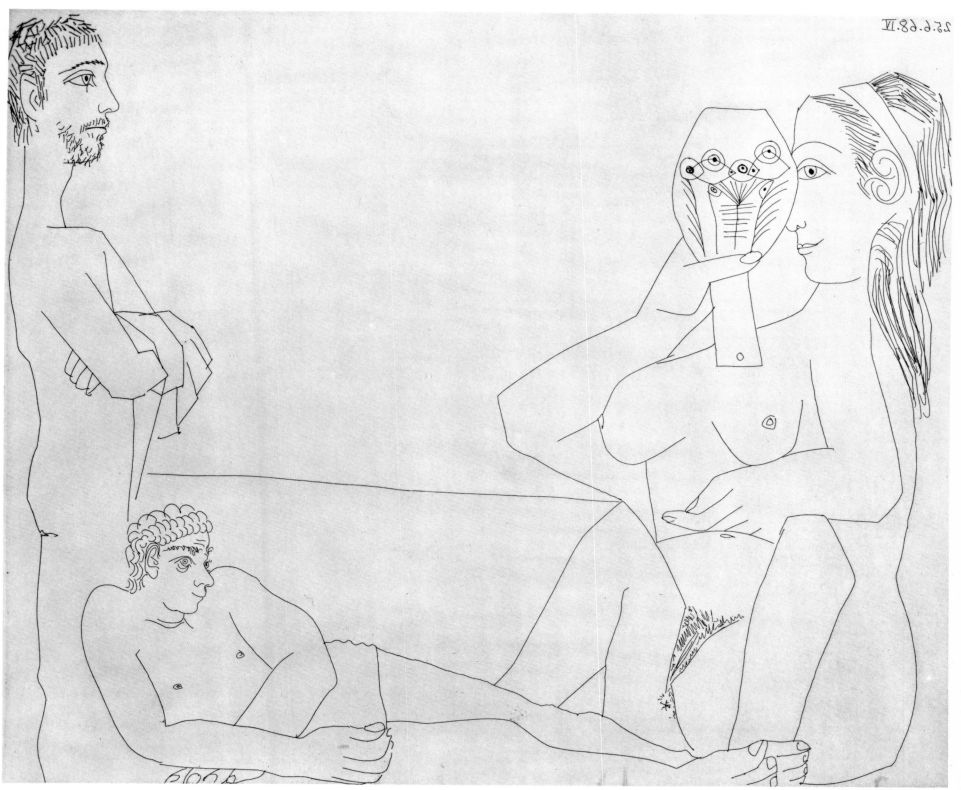

Etching.

25 June 1968 IV

Sometimes there is a head so real that you can have relationships with that head just as you would with a real one.

PICASSO

Everything I do in connection with art gives me great joy.

PICASSO

The Permanent Studio

With his wide-ranging curiosity and inexhaustible resources, dreaming as he does of painting the whole bullfight, the real beach with its bathers or the street as it is, Picasso is not free in the choice of his motifs and reverts obsessively to those imposed upon him. Submissive to what he has mastered and possessed by what gives meaning to his life, he had to confess, on the 27th of March 1963, in the midst of his series on *The Painter and his Model*: "Painting is stronger than I am, it makes me do what it wants." And what it wants above all is an incessant demonstration of its ascendancy.

Since the seventeenth century at least, with Rembrandt, Vermeer and Velazquez, the ritual of the studio and its poetic implications have cast their spell over painters, who treated it in either literal or symbolic terms. The cardinal canvas of the nineteenth century is unquestionably the one in which Courbet assembled around his easel and himself, hard at work on it, the primordial, sustaining forces of life: a naked woman and her child, and the phantasmal society of his time. He thereby signified the end of allegories and extolled creative activity as the true foundation of reality.

Frequently used by Matisse from the outset, the theme of the studio appeared fairly late in Picasso's work. The painted versions of 1925-1928 are variations on the three entities in continually changing relation to each other: the artist, the model and its figuration on the canvas. Then came the etchings in a classical vein on the same subject, illustrating Balzac's *Chef-d'œuvre inconnu* (1927), and the etchings entitled *The Sculptor's Studio* (1933), which coincided with his sculptural activities at Boigesloup: all these works contain allusions to his private life and point up the dilemma between art and sex. Such hints were multiplied in the contemporary drawings of a subjective character in which, under the pressure of domestic discords, painter and model undergo the strange and disturbing metamorphoses characteristic of this period. The cycle of wash drawings of 1953-1954 reflects an equally crucial domestic crisis; it too gravitates around the studio setting, even while proclaiming the vanity of art as compared with the splendors of life.

But painting too has a life of its own, whose depths only the artist can plumb, and works of art like those of nature are integrated into the now unbroken circuit of the studio. The striking resemblance of his new companion, Jacqueline, to one of the models in the *Women of Algiers* and the death of Matisse, whose Oriental heritage fell to him and whose chromatic polarity he took over, spurred him to paint the fifteen variations on Delacroix's luxurious, intimist canvas. He executed them during his last stay in Paris, between December 1954 and February 1955. He transposed its sensual content and rearranged the figures in order to introduce an obsessive motif of his own: the seated woman keeping vigil and the sleeping woman lying beside her. Apart from the decorative or constructive sumptuousness of the color, the signal innovation was the deepening of space and the extension of its structural complexity.

Soon afterwards he settled in a villa above Cannes with a tropical garden and decorations in the 1900 style, which reminded him of his early years in Andalusia and Barcelona and prolonged the exotic atmosphere of Delacroix's painting—an atmosphere that still pervades the portraits of Jacqueline in Turkish costume. For his work he took over one of the rooms whose tall windows looked out over palm trees. The result, in the fall of 1955 and the spring of 1956, was two series of paintings, interspersed with drawings, which show this makeshift studio in its exact reality and in the transmutations it undergoes. The earlier pictures are in a vertical format, lavish and luminous, without figures; the later ones in a horizontal format, stark and monastic, with Jacqueline in side view, her silhouette pure

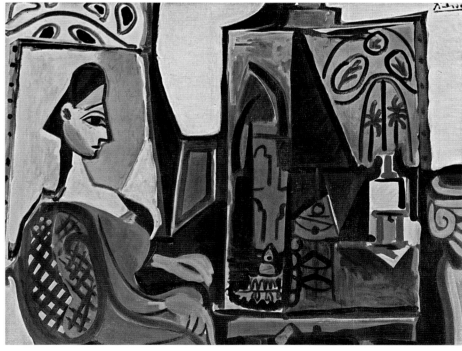

The Studio, oil. *2 April/8 April 1956 III*

and sober. "Nothing provides greater insight into Picasso's method of breaking down and reconstructing reality than these studio scenes. If it were possible to isolate each object and see how it is transformed under his brush one would have penetrated the laws of his plastic vision" (Antonina Vallentin).

A renewed interest in things Spanish grew on him during his short Vauvenargues period and his meditations on that mysterious place where the act of painting is carried out: he was thus led to focus his attention on Velazquez' *Las Meninas*, the studio picture whose subject is precisely the spell created before our eyes when we, as spectators, find ourselves in the

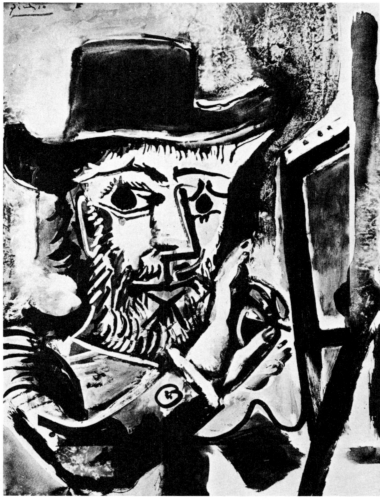

The Painter at Work, gouache. 1964

Portrait of Jacqueline with Clasped Hands, oil. ▷
3 June 1954

place of what it is supposed to represent. To tackle this Spanish masterpiece, he changed studios, going up to the top floor of his villa and shutting himself up there from 17 August to 30 September 1957. He respected and penetrated the organic architecture of the composition, "the stronghold of rectangles" on which rests this "theology of painting," concentrated on the figure of the Infanta brought into close-up, painted the pigeons in the window overlooking the sea, and brushed three autonomous windswept landscapes. The next picture sequence, on Manet's *Déjeuner sur l'Herbe*, was begun at Vauvenargues in 1959 and continued in 1960 and 1961 at Mougins. There took place the transition, heralded by the vast panorama of the *Bay of Cannes* (1958), from interior to exterior space. By way of a difficult and major progression through figures and nature, he arrived at and developed one of his stock personages, the woman leaning forward, and established unexpected and varied relations between the glib painter in fancy costume and the nude bather in majesty. Thus began anew the confrontation between Painter and Model, Man and Woman, Art and Life, brought before us as a real *presence* by an unending act of creation.

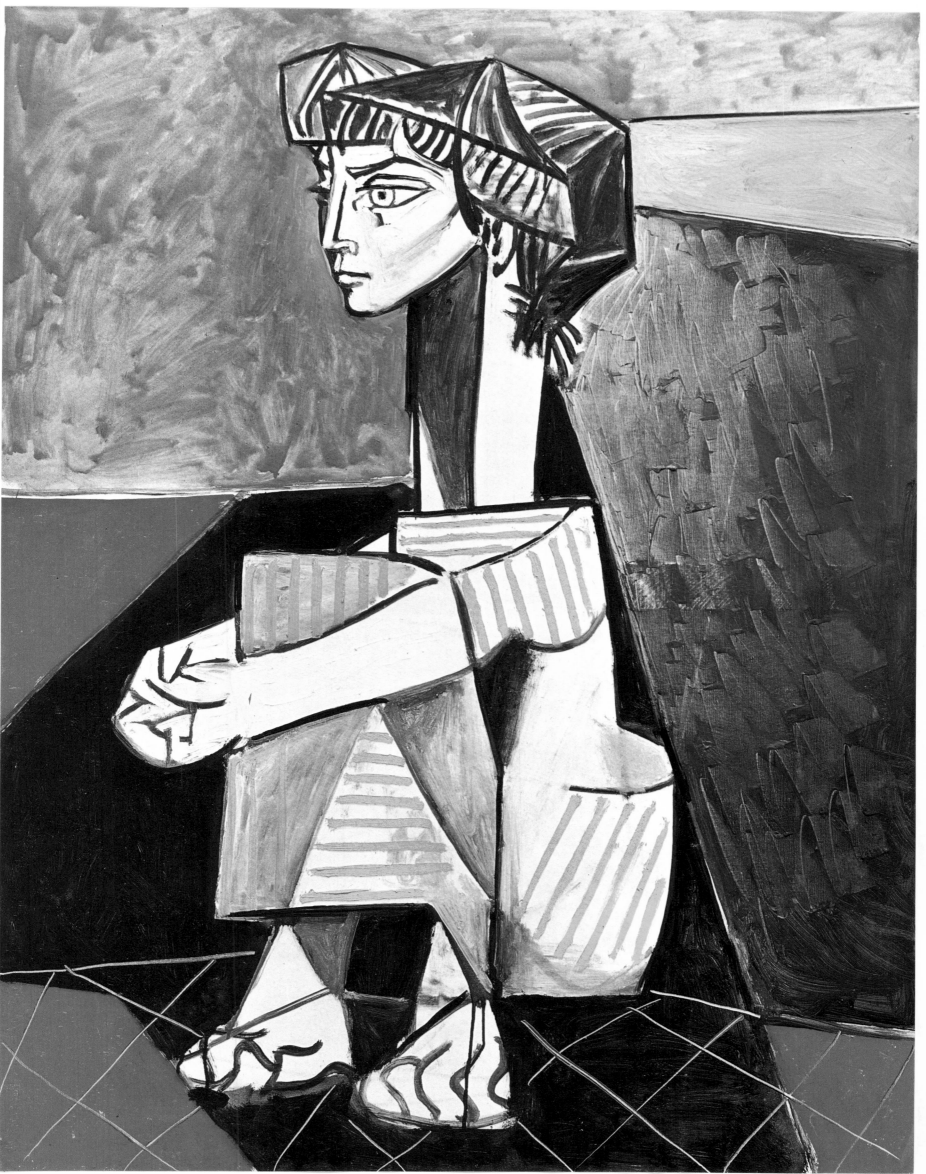

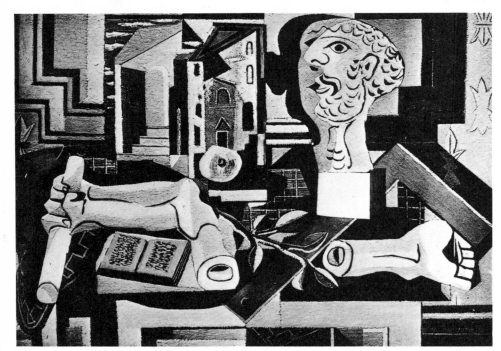

The Studio, oil. Summer 1925

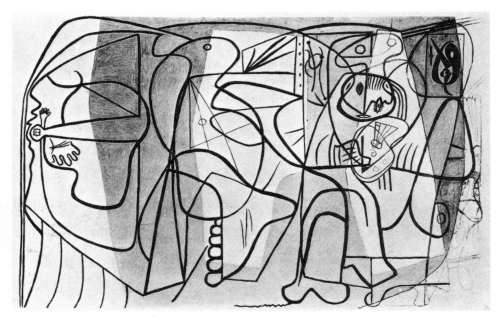

The Painter and his Model, oil. 1926

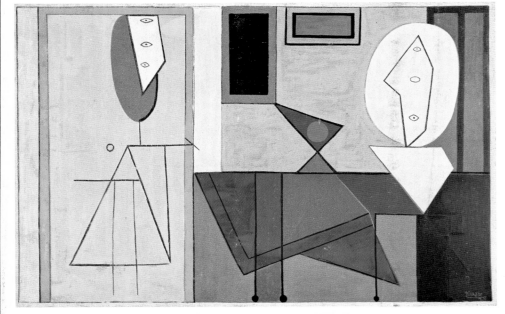

The Studio, oil. 1927-1928

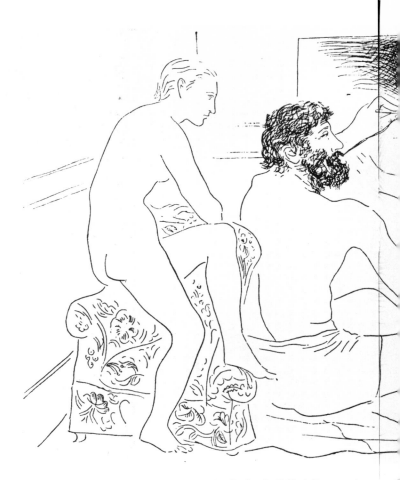

The Painter and his Model, etching for Balzac's "Chef-d'œuvre inconnu"

The *Studio* of 1925 is a still life of unusual design, with its wealth of interlocking forms, colors and textures. It is a revelation not of the creative act of painting, but of the painter's attributes: a stage set, an antique bust, an open book, fragments of arms and hands (due to reappear in *Guernica*), the square and the laurel branch. The dialogue between the Painter and his Model—with the results to date recorded each time on the easel—began the following summer with a large canvas covered with a linear tangle of allusive arabesques. It continued immediately afterwards with the etchings of classical tenor and tension illustrating Balzac's *Chef-d'œuvre inconnu*; the painter projects himself under the Olympian aspect of a bearded god, watched by a lissom young model with short hair. In reaction against curving linearism and monochromy, the major canvas of 1927-1928 is a spare and rigorous pattern with bright expanses of flat color confronting the painter with a still life: fruit dish and plaster bust. The important variant that followed reintroduced a more complex articulation within the geometric patterning: the painter and his model are figured in diagrammatic terms, but by a contrast rich in connotations a regular profile appears on the canvas. The studio of spring 1956, with pictures and easels but without any human presence, has the spareness and serenity that we associate with Spain.

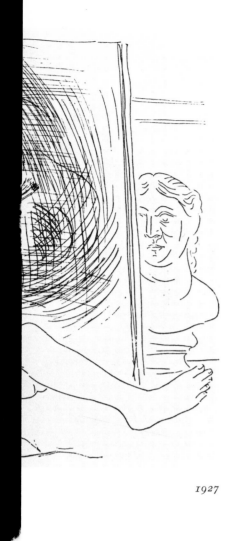

The Painter and his Model, oil. *1928*

The Studio in La Californie, oil. *2 April 1956*

29.10.55.

174

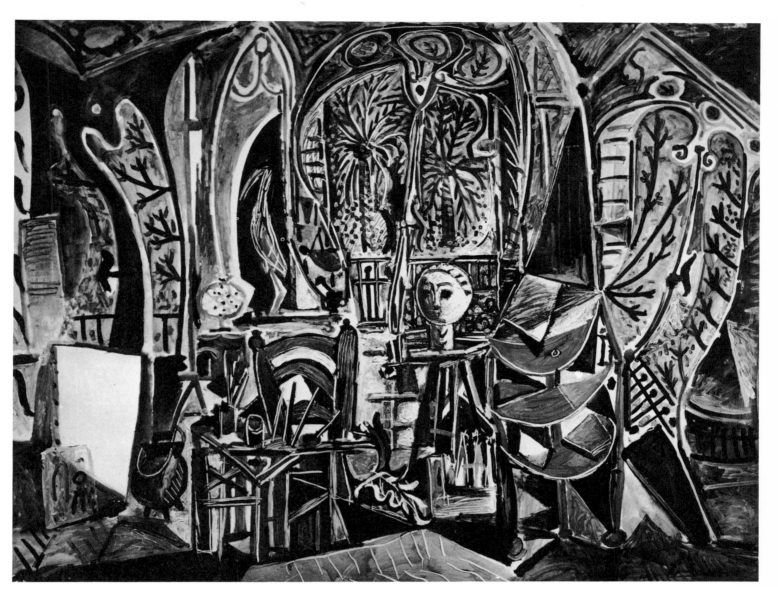

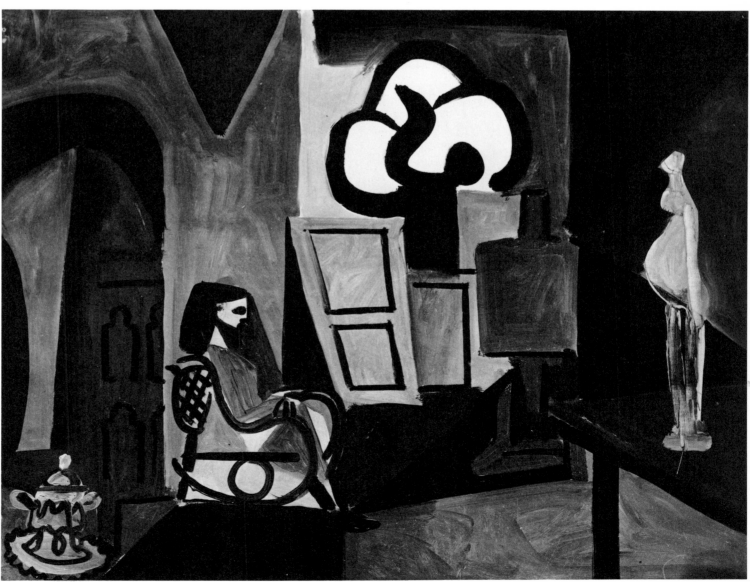

e Studio, oil. 12 November 1955

The Studio in La Californie,
pencil.
9 October 1955

Voman in the Studio, oil.
April 1956

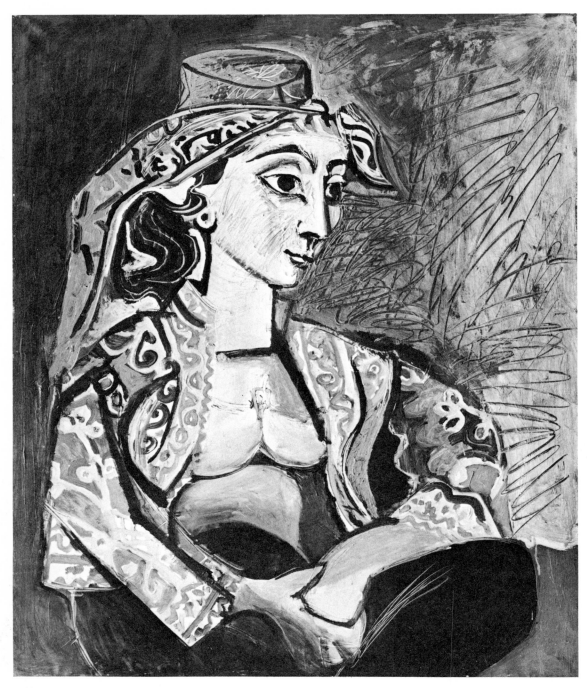

Portrait of Jacqueline in Turkish Costume, oil.　　　　　　　　　　*20 November 1955*

A favorite theme with painters since Carpaccio, the Turkish costume triumphed in the art of the Romantic period and was also taken up by Matisse, then by Picasso. Jacqueline has here put on a red bolero with colorful embroideries given to her by a Japanese lady: there followed a whole series of fine portraits in a sumptuous and sober vein of Orientalism.

These portraits introduce a new note into Picasso's art, a thrill of sensuality expressed in a special subtlety of coloring. In a portrait of 20th November, 1955, painted on a dull red background, the whiteness of the slightly inclined face is rendered by mauve and greenish tones in the flesh and a transparent material barely conceals the satin texture of the breasts. In another portrait of Jacqueline in Turkish costume, where the green-shadowed face is depicted between long flowing hair, the huge eyes drawn in green and black have an extraordinary luminosity conveying the clear candid gaze of the model.

Antonina VALLENTIN

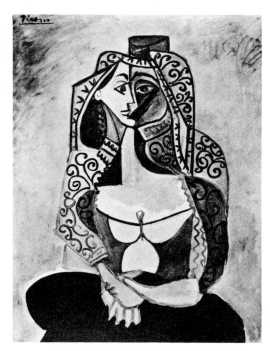

Woman in Turkish Costume, oil.
24 November 1955

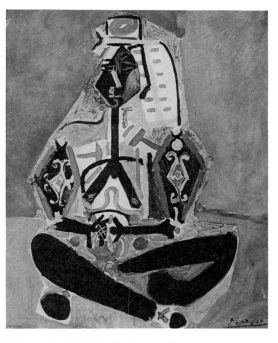

Woman in Turkish Costume, oil.
20 November 1955 II

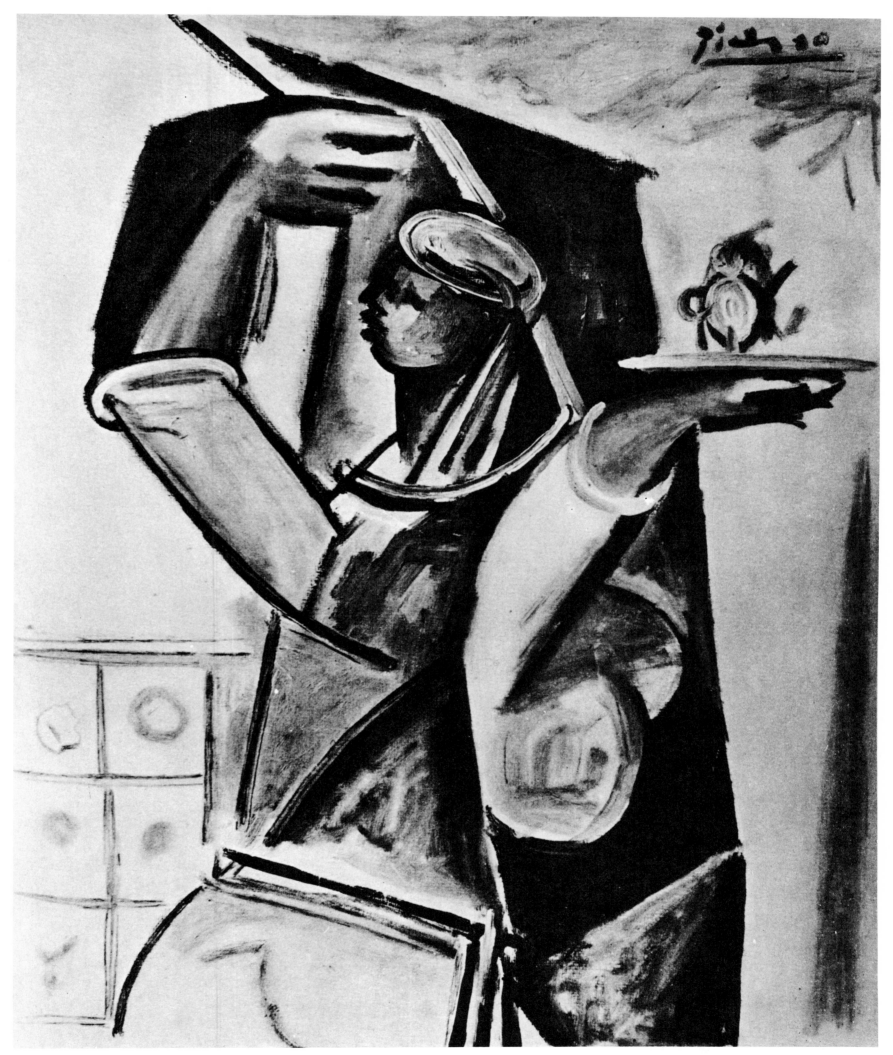

Study for "The Women of Algiers", oil.

18 January 1955

What is a painter after all? A collector who wants to build up a collection by making himself the pictures he has seen and liked elsewhere. That's the way I begin, and then it turns into something else.

PICASSO, 13 February 1934

The Women of Algiers after Delacroix (final version), oil. 12 February 1955

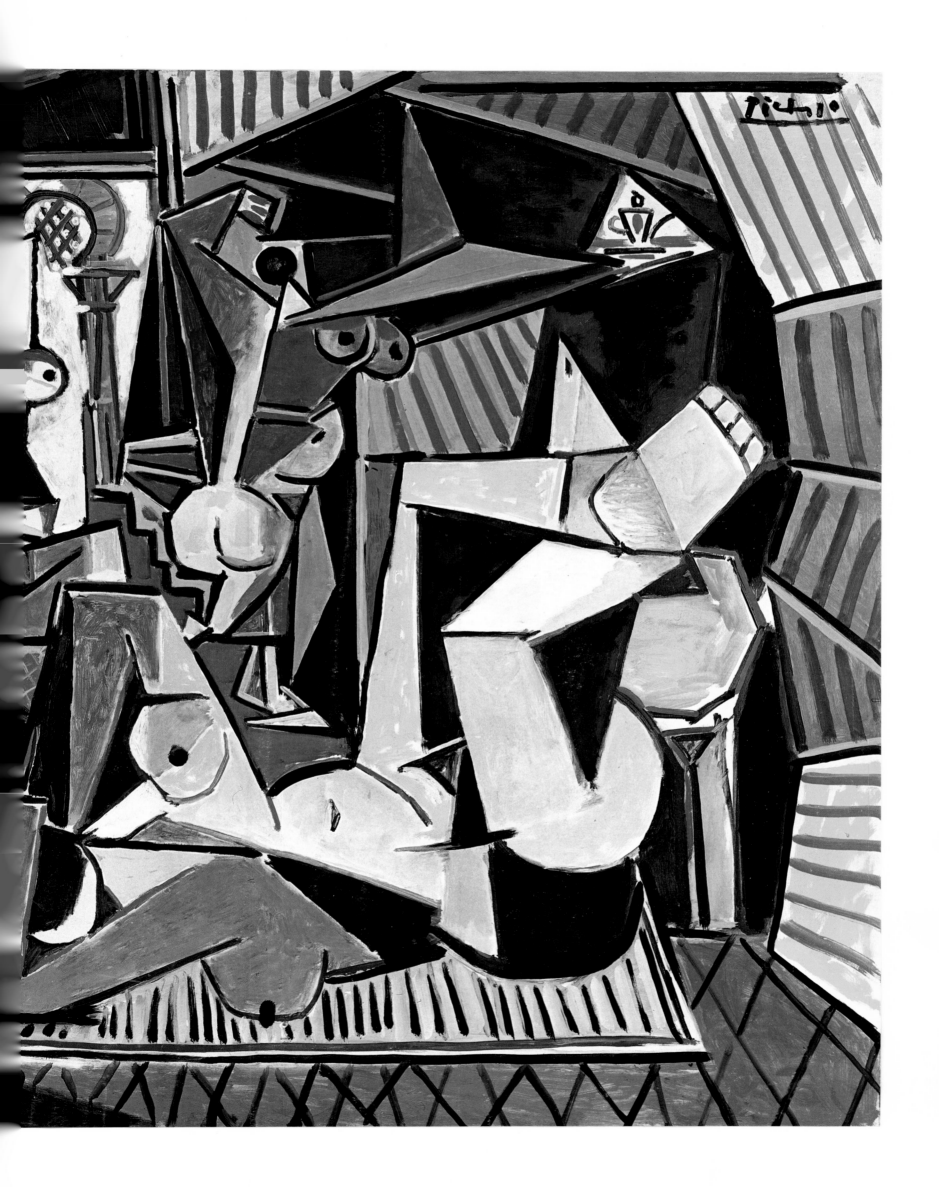

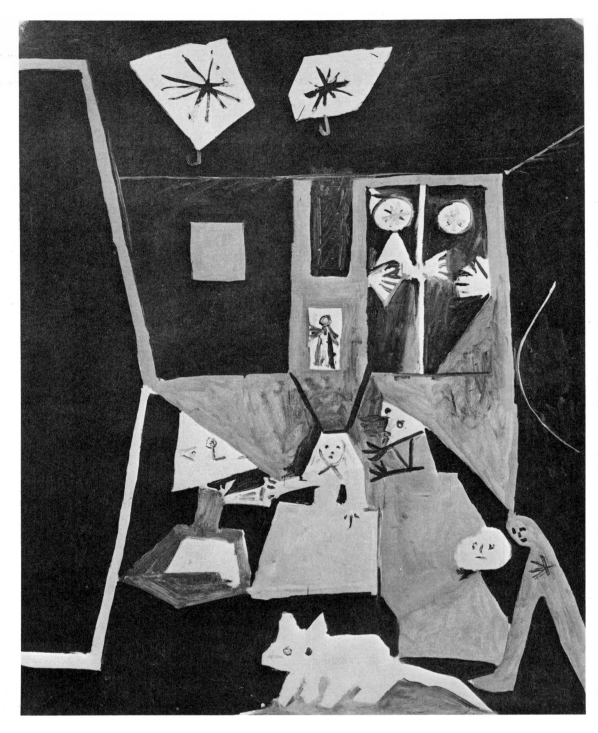

Las Meninas, oil. *19 September 1957*

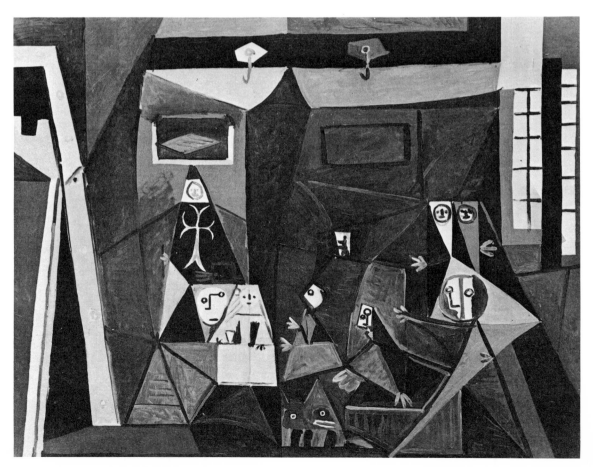

Las Meninas, oil. *3 October 1957*

100

Las Meninas after Velazquez (first version), oil.

17 August 1957

"It's odd," says Picasso, "whenever I do a series of pictures, it's usually one of the first two or one of the last two which I find the best." After the previous double-page plate reproducing the last and most colorful of the fifteen versions of Delacroix's *Women of Algiers*, here, in blacks, whites and grays, is the first, largest and most complete of the forty-four variations on Velazquez' *Las Meninas*. What we find in both cases is an interior beginning on the left with a tall standing figure, scarcely transposed at all, and developing towards the right in an increasingly elliptical style. By and large Picasso here respects the structure of the original composition, the number of figures and the relationships between them, but the vertical format of the original has been reversed in a breadthwise composition and for the court hound Picasso has substituted his own dachshund.

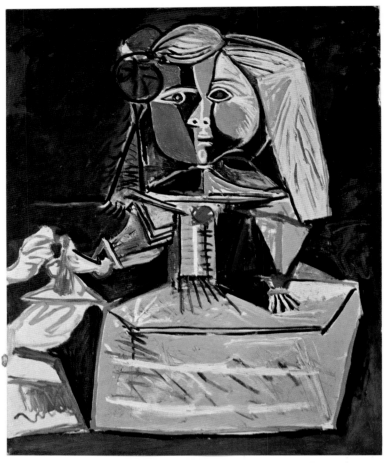

The Infanta, study for "Las Meninas", oil. *14 September 1957*

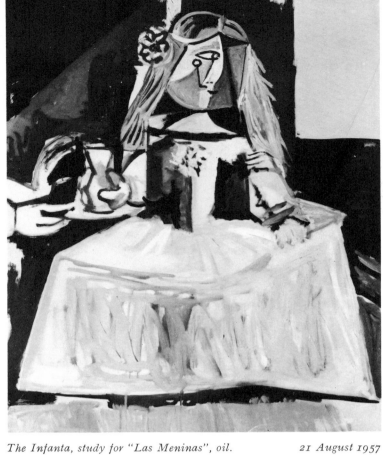

The Infanta, study for "Las Meninas", oil. *21 August 1957*

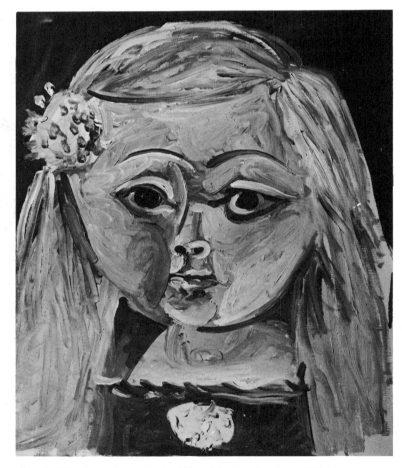

Head of the Infanta, study for "Las Meninas", oil. *6 September 1957*

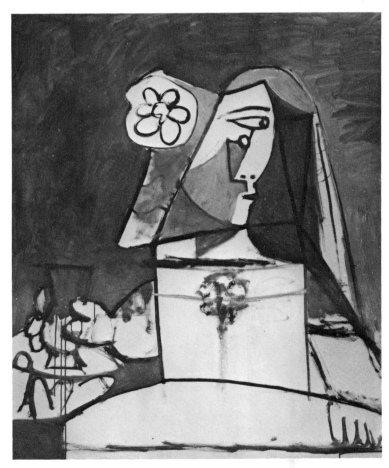

The Infanta, study for "Las Meninas", oil. *20 August 1957*

At the beginning of each picture there is someone working with me. Toward the end, I get the impression that I have been working without a collaborator.

PICASSO, 1935

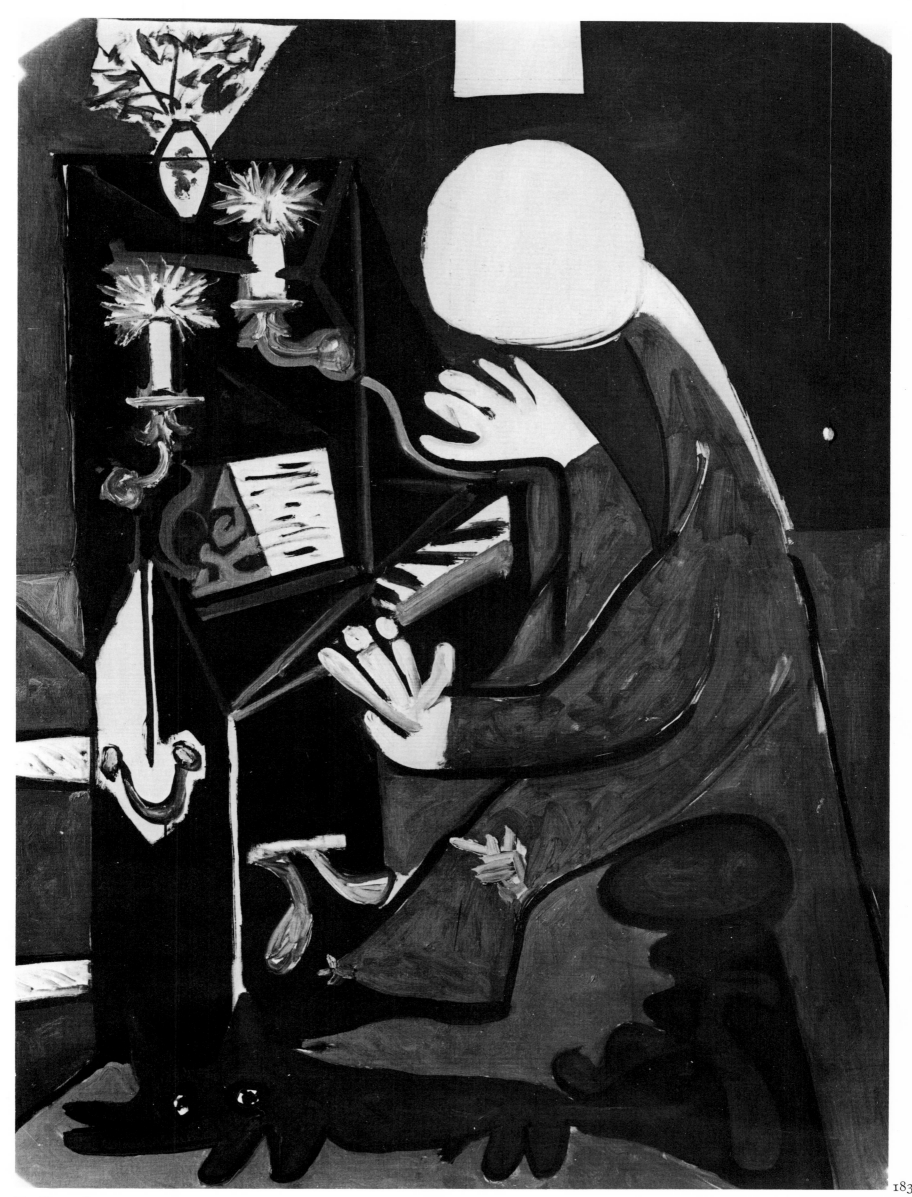

The Piano, oil.

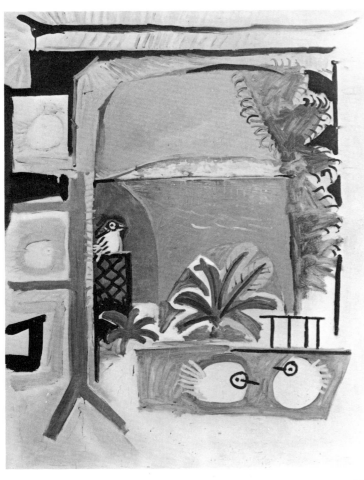

Pigeons, oil. *12 September 1957 III*

Trying his strength against that of his famous compatriot, he worked for weeks, in complete seclusion on the top floor of his villa in Cannes, on his own versions of *Las Meninas*. After laying in the general design of this interior scene, he at once felt the need to enlarge the picture space and to open windows, and proceeded to make separate variations on the central motif of the Infanta. On the side, as if to take a fresh breath, he painted nine pictures of *Pigeons*, of which we reproduce the largest and sparest. Since boyhood he had been in the habit of keeping pigeons, and at Cannes he built an aviary for them on the balcony-terrace of the room which served as his studio, with a grand view over palm trees, the sea and islands. Happily cuddled up, showing white against the blue of the air, these pigeons are conscious of the loving care lavished upon them. The following summer, the brilliant, plunging view over the Bay of Cannes marks the painter's farewell to the by now overcrowded Riviera; it also points to his growing interest in exterior space, subsequently developed in the pictures after Manet's *Déjeuner sur l'Herbe*. He bought the Château de Vauvenargues which he furnished sparely in the old Provençal style, but he chose for the dining room an extravagant black sideboard which at once kindled his pictorial verve. He made seven successive pictures of it; the largest, reworked several times, includes a little girl with her chair, a woman's bust on a pedestal, and the Dalmatian hound also present in the other versions. *Woman with Dog* and the sequence of *Woman and Two Girls* bear the sober, "Spanish" imprint of Vauvenargues.

The Bay of Cannes, enamel paint. *19 April/9 June 1958*

The Dining Room at Vauvenargues, oil.

23 March 1959/23 January 1960

I should like to manage things so that one would never see how my picture was made. What does that matter? All I wish for is that my picture should communicate the emotion that went into it.

PICASSO, 1935

Woman with Dog, oil and enamel paint. 23 May 1959/23 January 1960

Woman with Two Girls, oil and enamel paint. 20–21 August 1960

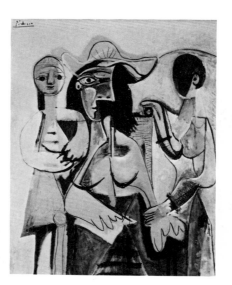

Woman with Two Girls, oil and enamel paint. 19 April 1961

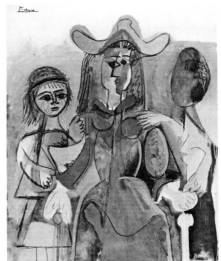

Woman with Two Girls, oil and enamel paint. 20 April 1961

In reality one works with few colors. What gives the illusion of their being many is simply the fact that they have been put in the right place.

<div align="right">PICASSO, 1935</div>

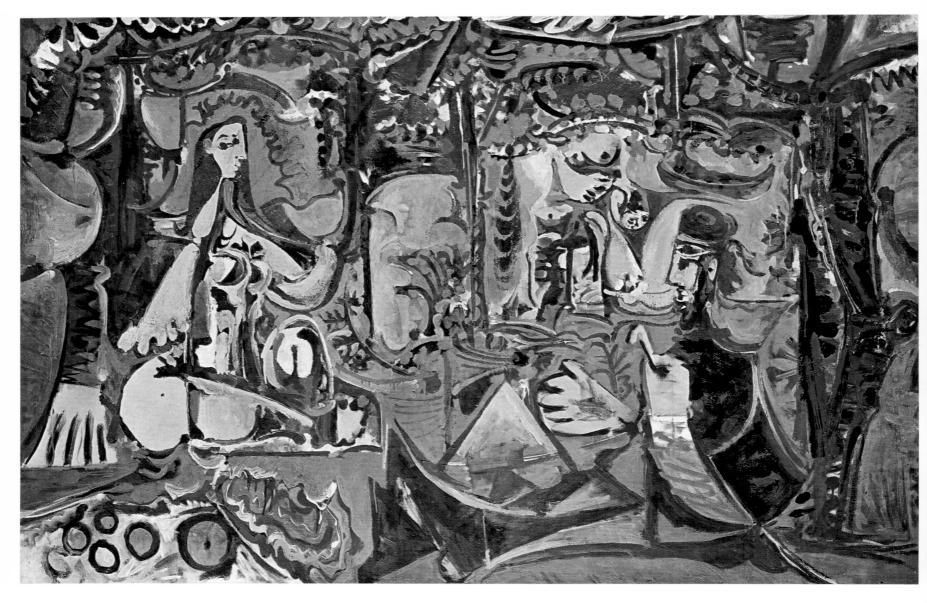

Le Déjeuner sur l'Herbe after Manet (fifth version), oil.

<div align="right">*3 March/20 August 1960*</div>

Confronted here are the principal versions of the two successive series of variations painted in 1960 and 1961 after Manet's *Déjeuner sur l'Herbe*. Out of his own resources Picasso recreates and suggests the richness of the woodland setting, its bright green transparency and luminous vibrancy. The four figures, nude bathers and young painters, are strictly localized in a picture space reminiscent of frescoes or tapestries, and are endowed with new characteristics. A decisive relationship, one that enlivens every picture in the cycle, is established between the man dressed and talking on the right and the nude woman seated on the left, an over-lifesize figure in white and ochre tones who dominates her interlocutor with her enigmatic and majestic power.

You cannot go against nature. She is stronger than the strongest of men! It is in our own interest to be on good terms with her. We can allow ourselves a few liberties; but only in details.

PICASSO, 1935

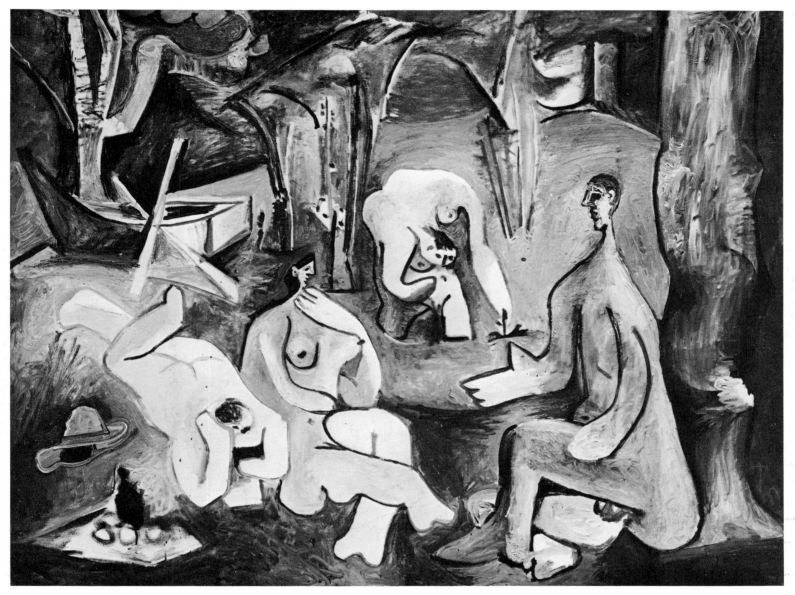

Le Déjeuner sur l'Herbe after Manet, oil. *10 July 1961*

The composition is organized in stronger rhythms, with more forceful architecturing; the figures move and come together, they gain in plastic density. The light has the glow of a cave as much as that of a clearing. "Its importance as a work of art has to be weighed, however, in other terms. That this is an impressive and inspiring painting cannot be doubted. As an image it appeals immediately to the imagination by its inherently poetic mood, formal grandeur, freedom from anecdote, artistic inventiveness and elevation of the everyday to a higher plane. Here we are in the presence of pure painting in the noblest sense" (Douglas Cooper).

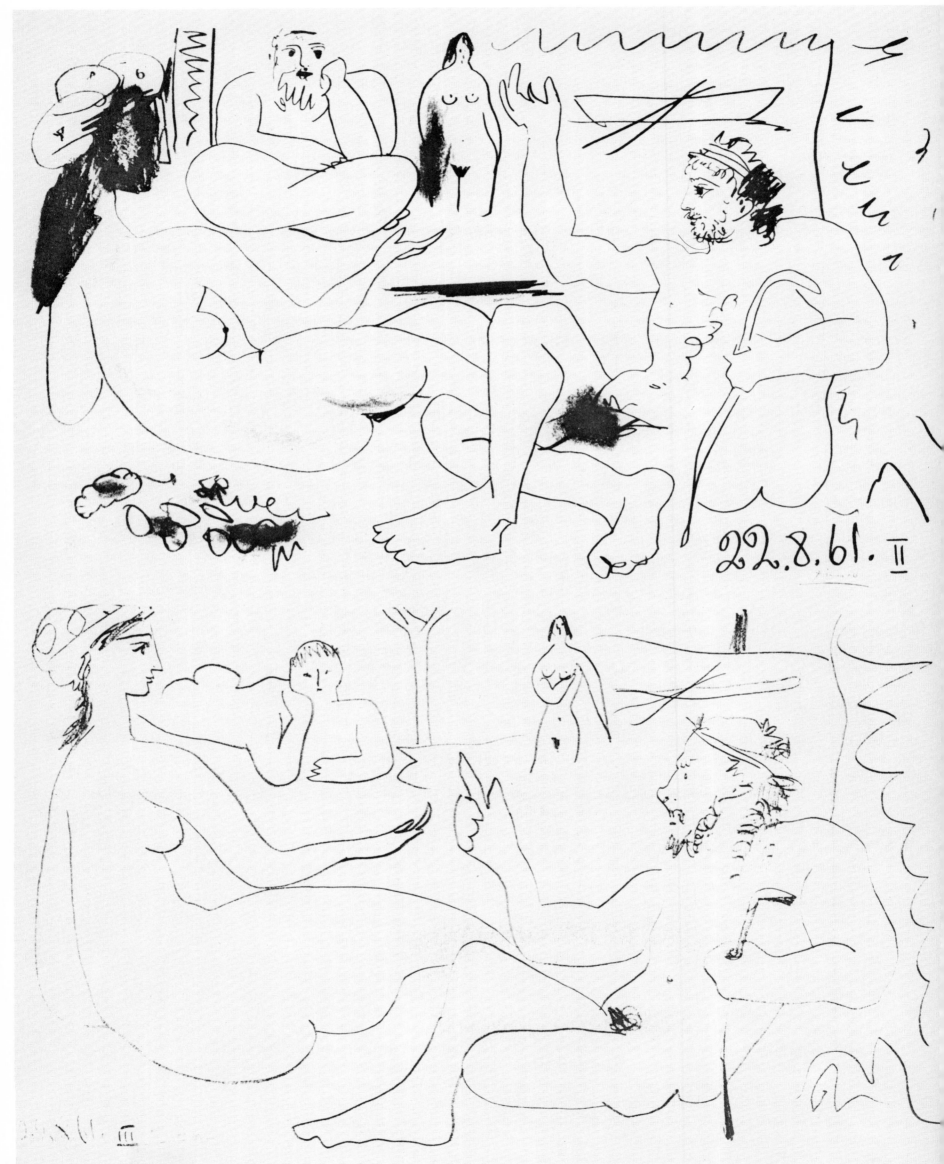

22.8.61. II

Le Déjeuner sur l'Herbe after Manet, pencil.

22 August 19

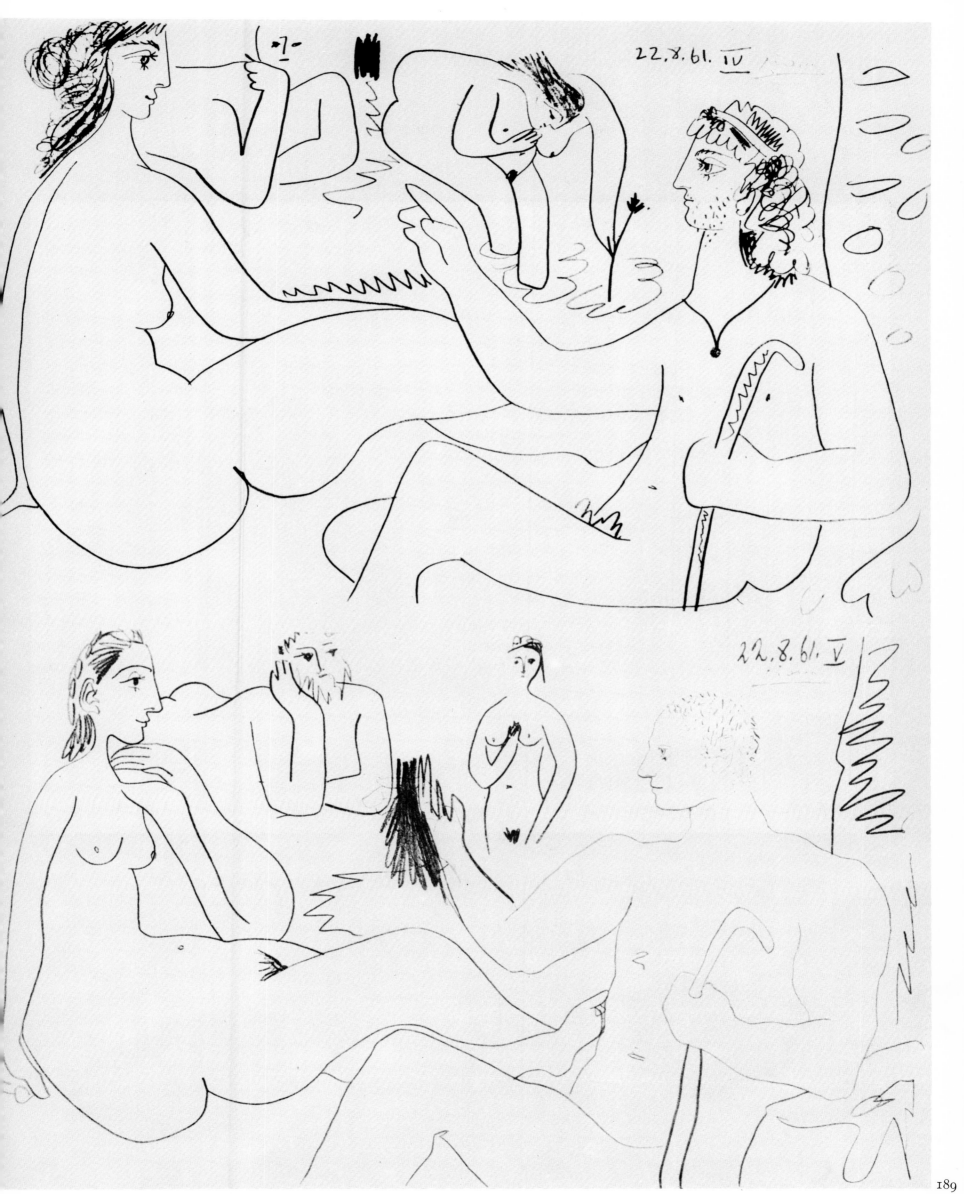

22.8.61. IV

22.8.61. V

Déjeuner sur l'Herbe after Manet, pencil.

22 August 1961

189

Nothing can be done without solitude. I have made for myself a solitude unsuspected by anyone.

PICASSO, 1932

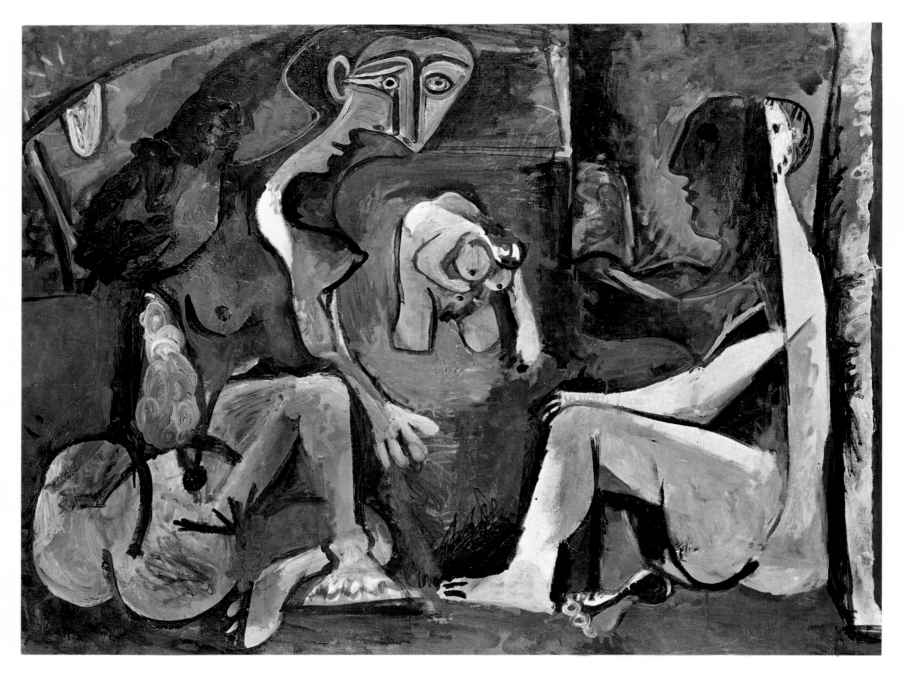

Le Déjeuner sur l'Herbe after Manet, oil.

16 July 1961

It is because he is purely a painter that Picasso hits on poetry: in this he is in the lineage of the masters, and reminds us of one of their most useful teachings. It has been rightly noted that his works do not scorn reality, they *resemble* it, with that spiritual resemblance—that "surreal" resemblance, to use a word quite true in itself—which I have already spoken of. At the prompting of a demon or a good angel? There are moments when one would hesitate to say. But not only are things transfigured in passing from his eye to his hand. At the same time another mystery is hinted at: the painter's soul and flesh are straining to substitute themselves for the objects he paints, to drive away the substance of them, to enter in and pass themselves off under the guise of these things of no account figured on the canvas, and living there a life different from their own.

Jacques MARITAIN, 1932

Painting is stronger than I am, it makes me do what it likes.

PICASSO, 27 March 1963

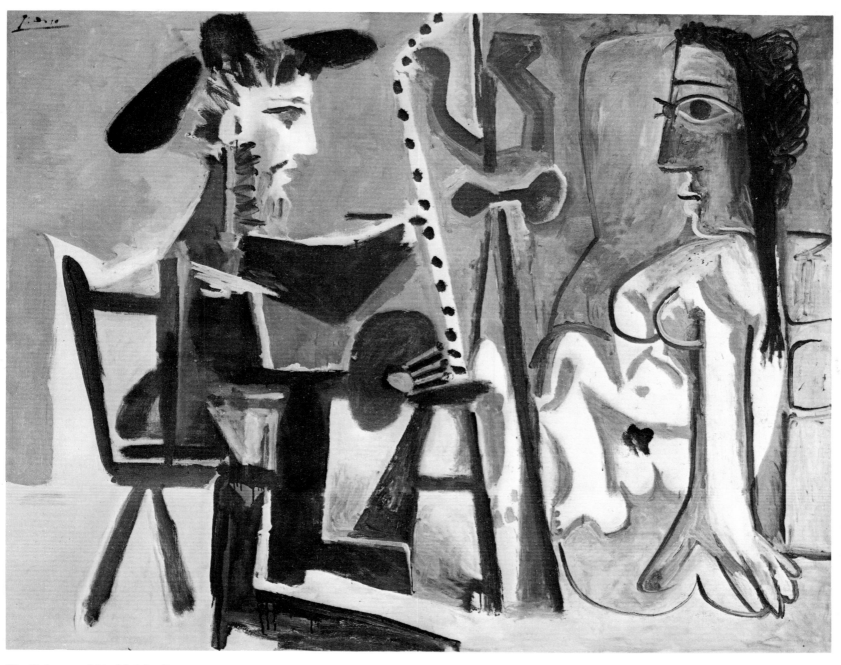

The Painter and his Model, oil.

29 March/1 April 1963

That the artist at work—nearly always the Painter and his Model, which has long been a major theme in Picasso's work — should have become not his only theme, but anyhow the most frequent, shows how important in Picasso's eyes is the very act of painting. And does not this predilection suggest that, despite the autobiographical character of most of his work (not only because of the motivations which his heart provides but because, desiring to work with full knowledge of the facts, he paints chiefly what he is familiar with), the real subject for him—over and above any circumstantial or other meaning—is the actual picture which he is concerned to paint, or rather the way among many others in which it may be painted?

Michel LEIRIS, 1963

One must seek out something that develops all by itself, something natural, not manufactured, displayed just as it is, "in the form taken by nature, not assumed by art".

Grass as grass is, the tree as the tree is, the nude as the nude is.

PICASSO, 1963

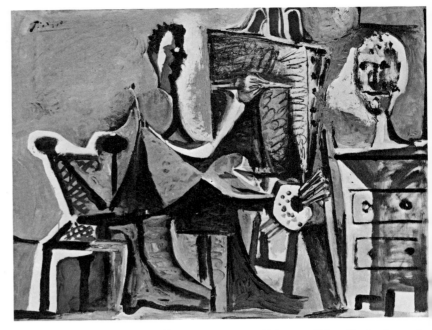

The Painter in the Studio, oil. *22 February II/17 September 1963*

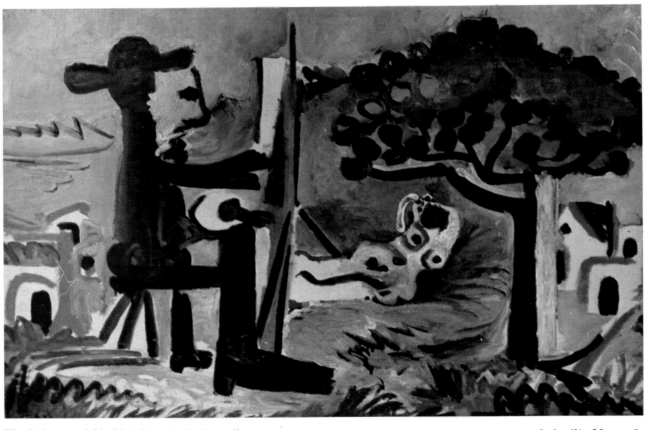

The Painter and his Model in the Garden, oil. *28 April/4 May 1963*

I do not work from nature, but in front of nature, with nature.

PICASSO, 1932

Picasso is as important as Adam and Eve, as a star, a spring, a tree, a rock, a fairy tale, and he will remain as young and as old as Adam and Eve, as a star, a spring, a tree, a rock, a fairy tale.

Jean ARP, 1964

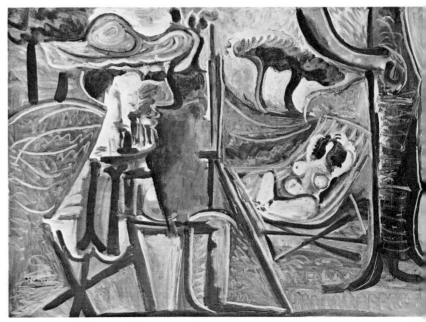

The Painter and his Model in the Garden, oil. *10–11 May 1963*

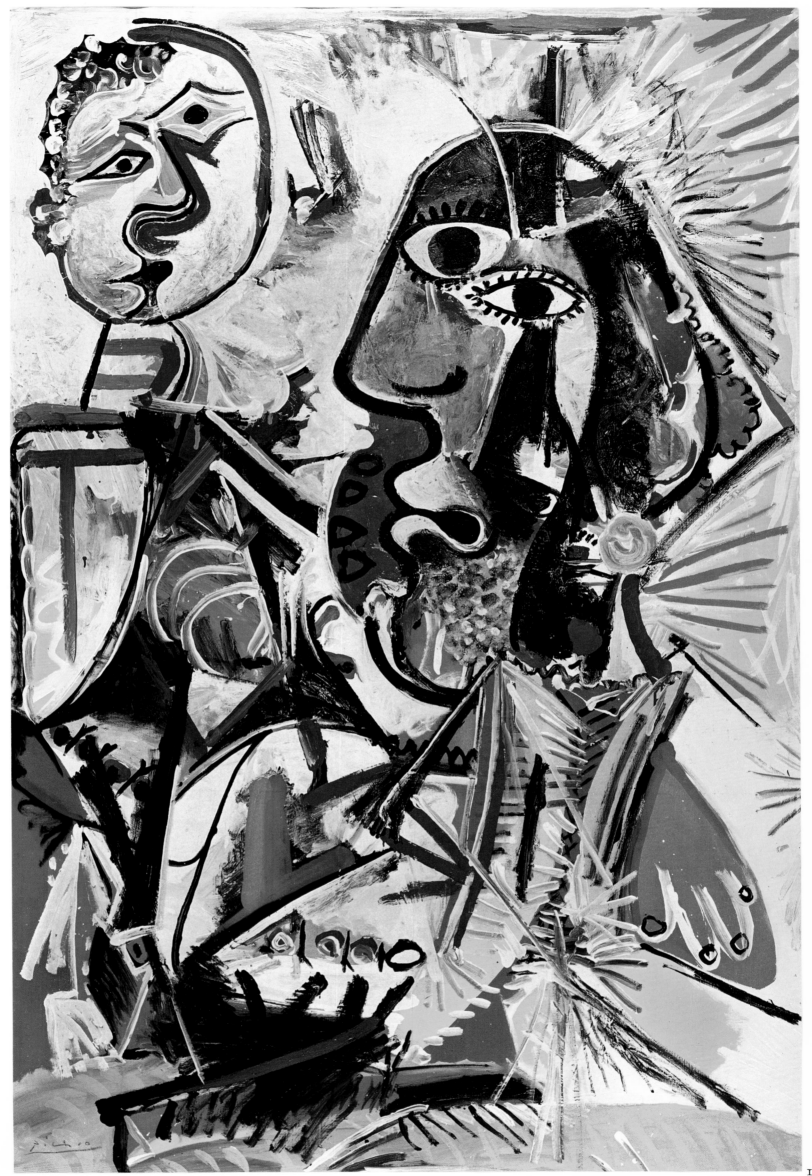

Large Heads, oil.
16 March 1969

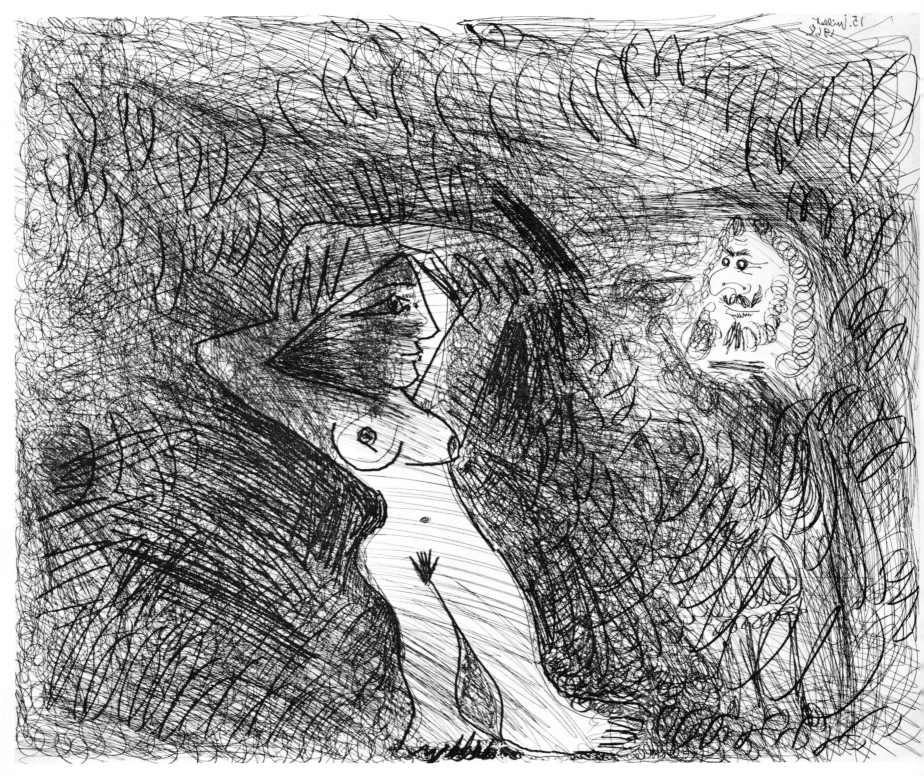

Etching.

15 July 1968 I

But worst of all is the fact that the painter has never finished. There is never a time when you can say: I have worked well and tomorrow is Sunday. As soon as you stop, that means that you begin again. You can leave a canvas aside, saying you won't touch it again. But you can never set down the word END.

<div align="right">PICASSO</div>

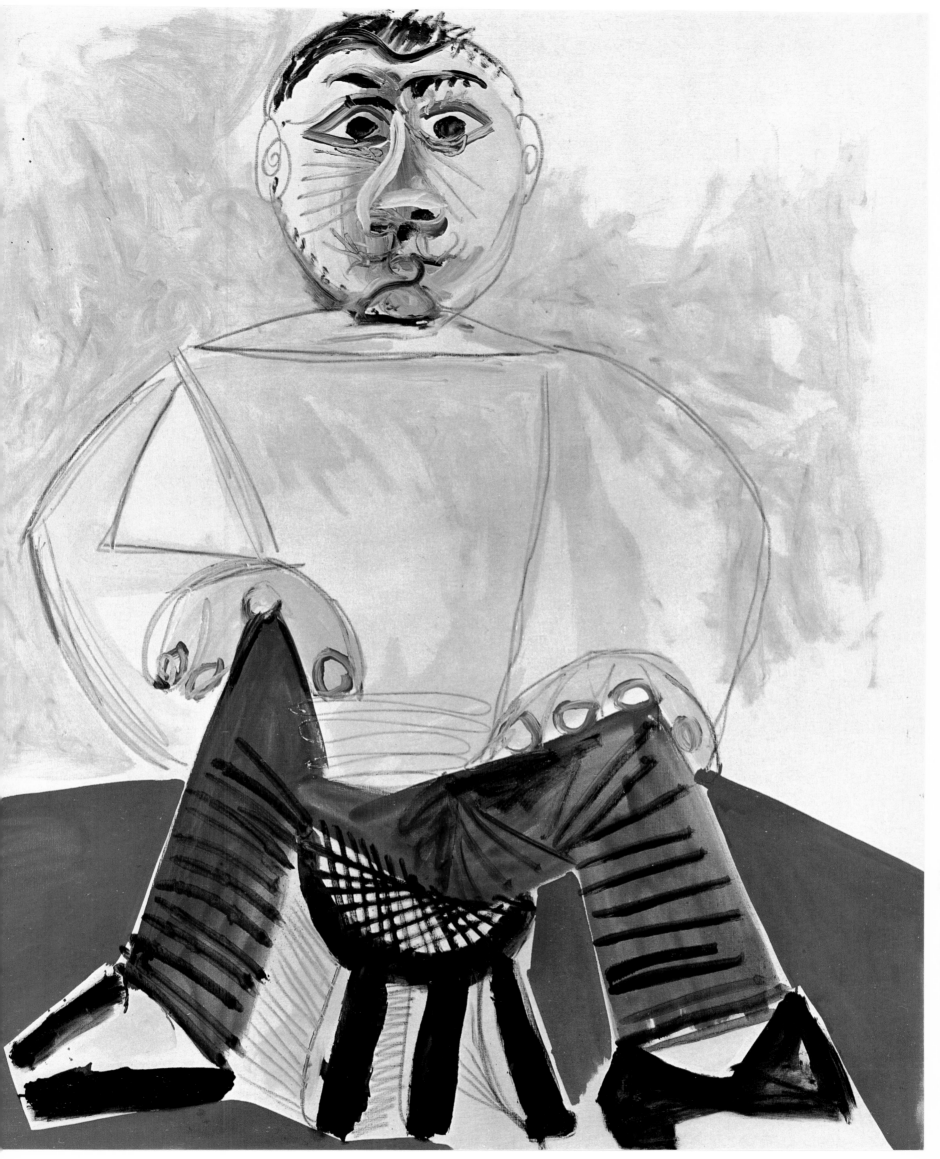

an sitting on a Stool, oil.

Guidelines

Biographical
Notes
by
JEAN-LUC DAVAL

1881-1898

Pablo Ruiz Picasso was born in Malaga (Andalusia), a Mediterranean port in the far south of Spain, on the 25th of October 1881. He was the first child of Don José Ruiz Blasco, a teacher of drawing and painting, and his wife Maria Picasso Lopez.

Biographers, Jaime Sabartès in particular, have done their best to trace and document Picasso's genealogy. These difficult researches have carried his ancestry back on his father's side as far as a noble family living in New Castile in the middle of the sixteenth century. It has been alleged that his mother was of Italian origin, but there seems to be no basis in fact for this assertion.

He grew up in a respectable, unpretentious, middle-class home. Two further children, both girls, were born to his parents: Lola in 1884, Conchita in 1887.

In September 1891, finding it difficult to make ends meet in Malaga, his father accepted a better paid post of art teacher at the Instituto da Guarda, a secondary school in Corunna (La Coruña), on the Atlantic coast of Galicia, in northwestern Spain. So Picasso left the sunny Mediterranean for this damp, northern climate.

Girl with Bare Feet, oil. 1895.

Picasso as a Child, photograph.

There, however, he thrived. His gifts revealed themselves, and working under his father at drawing and painting he developed the natural powers of his hand and eye. At ten he already possessed a remarkable faculty of observation and transcription. His amazing ability to assimilate images—this was to be a fundamental characteristic throughout his career—was revealed and developed in Corunna. Nothing visual is ever lost on Picasso, and many years later, in drawings of his maturity, we find the exact patterns of his early studies and sketches from plaster casts.

In July 1895 the family returned to Malaga for the summer vacation. On the way they stopped in Madrid, where Picasso visited the Prado and saw for the first time the works of Velazquez, Goya and Zurbaran.

Shortly before leaving Corunna for good, he painted the *Girl with Bare Feet*. He was not yet fourteen, and this moving picture shows an amazing precocity both in the choice of the subject and the sureness of the execution.

During this summer stay in Malaga, he made several portrait drawings of members of his family.

In October 1895 his father was appointed professor in the Barcelona School of Fine Arts. The move to Barcelona, and his immersion there in the active, stimulating life of the Catalan capital, was to have a decisive effect in shaping his future work.

With ease and brilliance he passed the entrance examination of the School of Fine Arts (La Lonja), executing in one day the subject for which a whole month was allotted.

But he was very soon disillusioned by the dull routine of the academic teaching methods, which consisted almost entirely in copying plaster casts.

In his book on Picasso (1953) Maurice Raynal rightly emphasized that "it was not in the art schools that Picasso learned to paint. From within came the urgent need to express himself, and painting was the godsent medium for his soaring aspirations, for his personal vision of things."

Divining his son's growing need of independence, Don José allowed him to take an outside studio in Barcelona in 1896. There he painted *Science and Charity*, representing a doctor visiting a patient; the subject was suggested by his father, who sat for the doctor. Already this large picture reaches the limits of an academicism which, with growing self-assurance, the young painter was now to leave behind him. Certain details, notably the hands, prefigure the elongated and disturbing forms of the early Blue Period.

Picasso on his arrival in Barcelona in 1895, photograph.

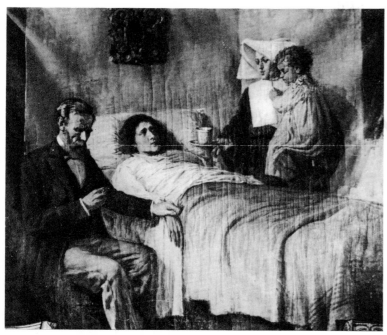

Science and Charity, oil. 1896/1897.

Aubrey Beardsley. Illustration for Oscar Wilde's "Salome", 1894.

After the summer vacation of 1897, the last he was to spend with his family at Malaga, Picasso went alone to Madrid and enrolled in the Royal Academy of San Fernando. But the conventional teaching routine went more and more against the grain, and he did not attend the classes. His means were scanty and he lived on the edge of poverty. This "apprenticeship" of privation gave rise to fresh insights, attested by the few sheets covered with drawings which survive from this stay in Madrid.

Tired and weakened by an attack of scarlet fever, he returned to Barcelona in the early summer of 1898. In June he went with his friend Manuel Pallarés to Horta de San Juan (later renamed Horta de Ebro), the native village of Pallarés in the Catalan uplands, near the borders of Aragon. There he spent several months. His stay at Horta is of some importance, for he felt very much at home there and shared the simple, primitive life of the peasants. He found that life so new and rich that it became an unforgettable memory: "Everything I know I learned in the village of Pallarés." That remark, so often quoted, expresses and perhaps explains his attachment to man, to elementary values, an attachment inspired by this initial contact with rude and simple people. He painted *Customs of Aragon*, awarded a gold medal in a show at Malaga. He returned to Barcelona, his health restored by the open-air life he had led at Horta.

The capital of Catalonia was instrumental in shaping Picasso's art and personality. He himself became very much attached to Barcelona, and many years later he acknowledged his debt in making over to the Barcelona museum nearly the whole body of his earliest canvases, which were thus made directly accessible to the public.

Edvard Munch. The Kiss, woodcut. 1897–1902.

In late nineteenth-century Spain, Barcelona was the scene of a cultural renaissance. There many currents of thought met and mingled with native Catalan aspirations. The main influences came from Germany and the northern countries of Europe. Ibsen's plays were read, acted, and applauded. German mythology fascinated the Catalan intellectuals and Wagner's operas enjoyed a great vogue.

Impressionist painting had been introduced into the Barcelona art world from Paris some years before, but by the late nineties it was giving way to the English Pre-Raphaelites. Local art journals reproduced the graphic work of Beardsley, Rossetti, Burne-Jones, Walter Crane, William Morris, also that of Munch. The prints of Steinlen, closely connected with popular imagery, came into the hands of Picasso and his friends. Among the latter were Jaime Sabartés, Carlos Casagemas, Ramon Pichot, Manolo Hugné, Angel and Mateo Fernandez de Soto, Sebastian Junyer and Isidoro Nonell. Nearly all of them were distinctly older than Picasso.

D. G. Rossetti. Lady Lilith, 1864 (illustration published in "Joventud", Barcelona 1900).

Interior of the Cabaret "Els Quatre Gats" in Barcelona (1897/1903).

Amidst this intellectual ferment Picasso worked hard. He shared a studio with the sculptor Mateo Fernandez de Soto. His mind, quick, responsive and now fast maturing, turned to account everything that came his way, and this rapid and discreet assimilation at once became final. In discussions, though he was no great talker, the brevity and precision of his statements revealed the wide range of his knowledge, which had nothing bookish about it; his friends were often surprised by his sound judgment and sharp insight into men and things.

Their principal meeting place was the famous cabaret of the Four Cats, in Catalan "Els Quatre Gats", something of a cross between a German beer garden and a Parisian café-concert; its name was meant to recall that of the famous "Chat Noir" cabaret in Paris. It opened its doors in 1897 on the ground floor of a building in the neo-Gothic style, built by a Catalan architect in a small street near the Plaza Cataluña. It was founded and run by Pere Romeu with the express purpose of attracting local artists and intellectuals, such as the painter Ramon Casas and the poet, playwright and painter Santiago Rusiñol. Puppet shows and shadow plays were given there under the direction of the Catalan painter and writer Miguel Utrillo (the French artist Maurice Utrillo was his adopted son). Concerts were given at the Quatre Gats by such outstanding musicians as Albeniz and Granados.

The walls were crowded with pictures and drawings by the artists who frequented the place. Picasso exhibited there a series of portrait drawings which, as noted by Josep Palau i Fabre, author of *Picasso en Cataluña*, "seem to fall into two groups, one modernist and fin-de-siècle in tendency, the other pointing to the new century." This capacity for dual transcription is to be found, often disconcertingly, throughout his subsequent career. For "Els Quatre Gats" he did a poster in the Art Nouveau style, showing customers crowding through the door, and also designed a menu card.

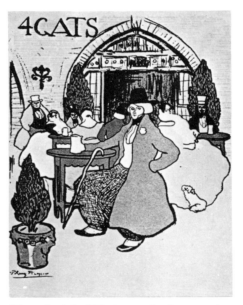

Menu Card for "Els Quatre Gats", watercolor. 1898.

Picasso and his Friends at the Cabaret "Els Quatre Gats", drawing. About 1900.

A self-portrait in charcoal, drawn with telling directness, shows already his mastery of line and his concern to record only the essential of what he sees.

Self-Portrait, charcoal. 1899.

1899

Isidoro Nonell. Group of Beggars. 1899.

Late in 1899 "Els Quatre Gats" housed an exhibition of pictures and sketches by Nonell. A few years older than Picasso, Nonell had already made several stays in Paris. His work had taken a satirical turn under the influence of Daumier. The pictures he now exhibited formed a series entitled *The Cretins*. These studies "symbolized a new tendency in the art circles of Barcelona" (Roland Penrose).

Nonell's influence on Picasso is apparent throughout this period, but it took effect on the themes and mood of his work rather than on his technique. Some of his interiors, for example *The Pot-House* of 1899, well convey the close atmosphere which seems to owe much to Nonell's ascendancy over his young friend.

Intent on a direct and sensitive transcription of life, Picasso now embarked on a long sequence of drawings in which, with a few rapid strokes, he recorded an attitude or atmosphere.

However, in spite of his sensitivity to the world around him and in spite of the revolutionary mood prevailing in the circles in which he moved, he did not feel attracted to politics. This libertarian climate was largely maintained by the struggle and agitation of the Catalan separatists, a group to which he felt alien.

An exhibition of his work was organized at the Quatre Gats at the beginning of 1900. On February 3rd of that year a review of the show appeared in *La Vanguardia*: "A young man, almost a boy, named Ruiz Picazzo [*sic*], has organized an exhibition of colored drawings and sketches..." After deploring the artist's "hesitation" as to the course he should follow, the anonymous reviewer acknowledges his "easy handling of the pencil" and the "praiseworthy sobriety" of his work.

The Pot-House, ink and colored crayons. 1899.

Steinlen. The Street, poster. 1896.

Defeat in the Spanish-American war was followed by the return to Spain of many sick and wounded soldiers. The social climate was one of anarchy and violence. Poverty, loneliness and hardship were widespread. Reality seemed to be taking on the themes and colors of Daumier and Steinlen. Picasso (soon to drop his father's name, Ruiz, as being too common, in favor of his mother's) showed a growing interest in the art of Toulouse-Lautrec; the reproductions of his work which reached Barcelona, together with his posters, revealed the singular modernism and mastery of design of this fine artist. Though continually extending the range of his acquaintance with the work of other painters, Picasso never lost his interest in Lautrec.

Picasso began to feel cramped in this milieu which no longer had much to teach him, and his thoughts turned to Paris. Many of his Spanish friends had already been there, and their memories and impressions of it were a constant subject of talk at the Quatre Gats.

Of all Picasso's early Spanish friends, the poet Jaime Sabartès was probably the most intimate and devoted. Sabartès observed closely the evolution of his work and the mutations of the man. What he saw and learned of Picasso he later recorded objectively in accurate biographical studies. In return, Picasso himself recorded the growth of their friendship in many portraits of Sabartès.

Portrait of Jaime Sabartès Seated, charcoal and watercolor. 1899–1900.

"He draws like others, except that he is concerned to set down only the essentials of what comes into his ken, without wasting his time over details unconnected with his purpose: to give form to expression and movement" (Jaime Sabartès).

Antoni Gaudí. Colonia Güell Church, detail of the crypt. 1898–1914.

During walks in Barcelona he discovered the work of Antoni Gaudí. This gifted Catalan architect introduced into his designs an irrational beauty which exerts a strange fascination on the beholder. At that time Gaudí was at the height of his fame, but it is by no means certain that his art was understood even by his admirers. For one of his wealthy patrons he built a park in Barcelona full of strange buildings: the Parque Güell.

This art, an odd combination of the fanciful and the naturalistic (owing something here to the theories of Ruskin), may have interested Picasso but it did not impress him.

In July 1900, in *Joventud*, a small magazine published in Barcelona, appeared the first reproduction of a Picasso drawing, illustrating a poem.

Giving way to psychological incitements of increasing urgency, Picasso set out for Paris in October, accompanied by his friends Casagemas and Pallarés.

1900

Paris, Entrance of the Métro Station "Bastille". Late 19th century.

1900 was the year of the Paris World's Fair, the Exposition Universelle. Thousands of outsiders flocked to Paris to visit the fair.

Introduced in France a few years before by Eugène Grasset and Émile Gallé, Art Nouveau had now reached its height. Coming down into the street, it appeared in the design of Metro stations, by Hector Guimard, and on the façades of apartment buildings in the fashionable quarters of Paris.

Paris World's Fair of 1900: Esplanade des Invalides, postcard.

Picasso arriving in Paris, pen and colored crayons. 1900.

Never much of a letter writer, Picasso had from boyhood been accustomed to substitute for writing a language which came to him more spontaneously: drawing. By thus replacing the written word by line, he found larger possibilities of expression open to him. If the subject engaged his attention, he could convey by this means a host of details, intelligible at a glance, which could hardly be transcribed in writing.

His "letters" to his parents and friends thus tended to become a sequence of vivid sketches sprinkled with caustic or comic remarks.

In one of these drawings, representing Picasso himself on his arrival in Paris, carrying his suitcases and painting outfit, the tiny bearded figure silhouetted on the lower right might well be Henri de Toulouse-Lautrec, whom Picasso imagined as being in Paris, though in fact Lautrec had by now left the city.

During this first three-months' stay in Paris (October to December 1900), Picasso sold three canvases with bullfighting scenes to Mademoiselle Berthe Weill, who had just opened a small gallery in Rue Victor-Massé. And in Paris he met his first collector, a Catalan industrialist named Pedro Manyac (or Mañach), who offered him 150 francs a month for his entire output.

"The 1900 World's Fair is the magnificent result and extraordinary summing up of a whole century, one so fertile in discoveries, so prodigious in its scientific developments, that it has revolutionized the economic order of the world.

"In the museums distributed here and there among its different sections, the Fair brings to view, step by step, the forward march of progress from the stagecoach to the express train, from the messenger to wireless telegraphy and the telephone, from lithography to radiography, from the first workings of coal in the bowels of the earth to the airplane striving to conquer the air lanes.

"This is the exhibition of the great century which, as it comes to an end, opens a new era in the history of mankind."

Foreword to the Hachette guide to the Paris World's Fair of 1900

Georges Seurat. The Eiffel Tower, oil. 1888–1889.

"His prodigious instinct for satire, not caricature, led him to build up portraits with a series of jostling, contrasting pictorial elements, painted in violent strokes roughly delimited, and drawn with a mastery quite surprising for an adolescent. This is not skill, but vigor and brutality, a certain haughty bitterness which is not without grandeur. Already in this young artist one senses a gnawing dissatisfaction, an unappeased torment, but above all that revolutionary instinct common to the greatest sons of Spain" (Maurice Raynal).

Le Moulin de la Galette, oil. 1900.

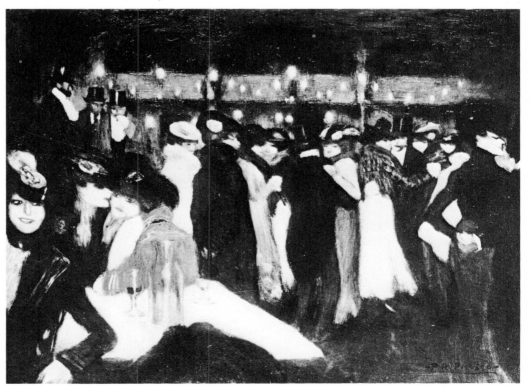

During this first visit to Paris, Picasso lived in Nonell's studio at 49 Rue Gabrielle, in Montmartre. Knowing no French, he frequented a circle of Spanish friends, most of them painters or sculptors. They were poor, but they led a free and exuberant life. With them, he discovered the cafés, dance halls, cabarets and night life of Montmartre. But the amusements of their nocturnal rambles could not close their eyes to the hardships and poverty of daily life in the streets. Picasso worked hard, he stepped up his colors and handled line more freely and firmly. Above all he had his first direct contacts with contemporary French art.

The 1900 World's Fair included two large retrospective exhibitions of painting. Picasso himself was represented in the Spanish section. Item 79 in the catalogue, *The Last Moments* by Picasso, may have been his *Science and Charity*. For the first time he saw the work of the great nineteenth-century masters of French painting.

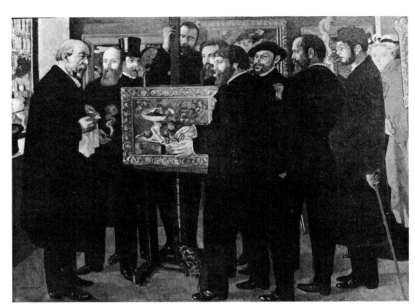

Maurice Denis. Homage to Cézanne, oil. 1900.

Van Gogh and Gauguin were beginning to be known. Though the Symbolists and Nabis were already paying homage to Cézanne (witness the famous canvas by Maurice Denis), he was not really revealed until later. Steinlen continued to interest Picasso, who admired the concision and mournful veracity of his line. Steinlen's poster for the Chat Noir was to be seen on all the walls of Paris.

"He observed Steinlen, Toulouse-Lautrec and Degas in turn, without forgetting to observe himself, that is to compare what he had learned before gaining direct knowledge of the French artists of his time with what he discovered now on their home ground" (Jaime Sabartès).

Shortly before the Christmas holidays of 1900, Picasso returned to Spain with his friend Casagemas. After stopping a few days in Barcelona, they went on together to Malaga.

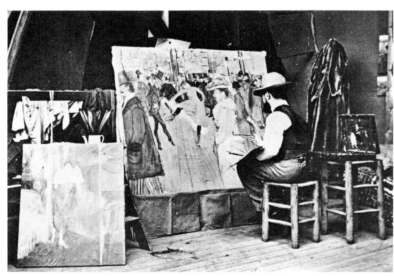

Lautrec in his studio painting "Dance at the Moulin Rouge", 1890.

The Can-Can, pastel. 1900.

Lautrec. The Troupe of Mlle Eglantine, poster. 1897.

Gaudí, whose architectural achievements he had seen in Barcelona, had prepared him to receive the lessons of triumphant Art Nouveau. In *The Can-Can* he made play with the decorative dynamism of the line, suggested by Lautrec's *Dance at the Moulin Rouge*.

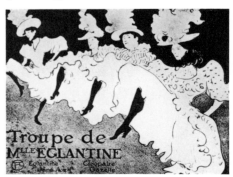

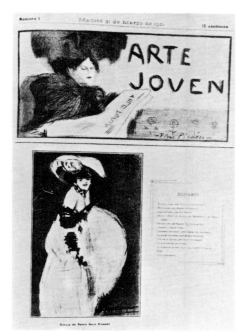

Two drawings for the cover of "Arte Joven", 1901.

1901

Picasso did not stay long in Malaga, which he reached on 30 December 1900 in company with Casagemas, whom an unhappy love affair was driving to drink. By mid-January he had settled in Madrid where he resumed the life of poverty and hardship which he had known during his previous stay there. He became friendly with the writer Francisco Soler and together they founded *Arte Joven* (Young Art), a short-lived magazine in the taste of the period, which proclaimed itself "a sincere journal". The first issue appeared on 11 March 1901, entirely illustrated by Picasso, who acted as art editor; it contained articles by Miguel de Unamuno, Pío Baroja, Jacinto Verdaguer, Ramón Reventós, Martínez Ruiz and a text by Goethe. Picasso contributed to the second issue of the magazine before leaving Madrid.

Bullfight, oil. 1901 (?).

In May he returned to Barcelona. His friends organized an exhibition of his work at the Sala Pares. It elicited an enthusiastic article from Miguel Utrillo, published in the review *Pel y Ploma:* "The art of Picasso is very young, the child of his spirit of observation which does not pardon the weaknesses of the people of our time, and brings out even the beauties of the horrible, which he notes with the sobriety of one who draws because he sees and not because he can do a nose from memory."

Self-Portrait, drawing. 1901.

Picasso worked hard at painting. His *Bullfight* shows a new handling of color and from now on the requirements of style prevailed over those of narration; his adoption of a pointillist technique of color dots gave a new glow and intensity to his palette.

The rhythm of his life seemed to gain speed. In late spring he left Spain for Paris accompanied by a friend, Jaime Andreu Bonsons. Another drawing illustrates this second arrival in Paris. His patron Manyac placed a studio at his disposal, at 130ter Boulevard de Clichy. Henceforth in signing his work he used his mother's name alone.

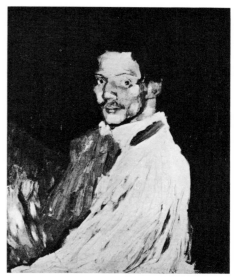

Self-Portrait, oil. 1901.

Picasso and Jaime Andreu arriving in Paris in 1901, drawing.

Manyac introduced him to the dealer Ambroise Vollard, who two years before had exhibited the work of Nonell in his Rue Laffitte gallery. The astute Vollard at once recognized Picasso's talents and held an exhibition of seventy-five Picasso paintings, together with others by the Basque painter Francisco Iturrino. Picasso's work was warmly praised by the critic Félicien Fagus in a review published in the *Revue Blanche. The Bar, Longchamp, The Embrace, La Toilette* and *Child holding a Dove* show that he had fully assimilated the best qualities of contemporary art. He was now free to give expression to his own sensibility. The Blue Period had begun.

Invitation to the Picasso and Iturrino exhibition at Vollard's in 1901.

1901 gal 91

Ω

Vous êtes prié d'assister au vernissage de l'Exposition des œuvres de MM. F. Iturrino et P.-R. Picasso qui se fera le Lundi 24 Juin 1901, dans l'après-midi, **Galeries Vollard**, 6, rue Laffitte.

de la part de Gustave Coquiot

F. Iturrino.
P.-R. Picasso.

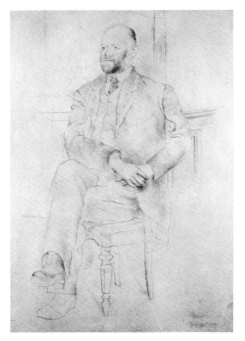

Portrait of Ambroise Vollard, pencil. 1915.

The exhibition sponsored by Vollard (of whom Picasso was to make several portraits), aroused the enthusiasm of the French poet Max Jacob, and he and Picasso at once became close friends. Picasso thus for the first time broke out of the circle of Spanish friends who surrounded him in the early days in Paris. This same year Apollinaire arrived in Paris, but Picasso did not meet him till later.

The Blue Room (or *La Toilette*) represents his studio in the Boulevard de Clichy. Pinned to the back wall is Lautrec's poster of the dancer May Milton, a token of Picasso's interest in the Montmartre painter, who died in September 1901. It may be seen as a tribute to the artist who had done so much to acclimatize him to contemporary painting. *The Blue Room* was bought by Wilhelm Uhde, the German dealer who was one of Picasso's first supporters.

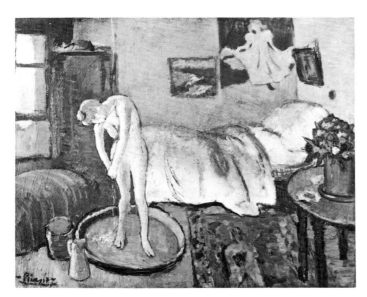

The Blue Room (La Toilette), oil. 1901.

Among his closest friends were the Spanish artists Pablo Gargallo, Julio Gonzalez and Paco Durio. Casagemas, his companion during his first stay, had also come back to Paris, where he shot himself in a café on 17 February 1901; Picasso was deeply affected by his suicide. The *Burial of Casagemas* marks the beginning of Picasso's lifelong brooding over death. The picture is divided into two parts, opposing death to life and love, in a manner reminiscent of El Greco's *Burial of Count Orgaz*. Dream and reality are contrasted with symbolic implications.

Picasso asked Jaime Sabartès to join him in Paris. When the poet arrived he was astonished at the evolution of Picasso's style. Their reunion was commemorated by a *Portrait of Sabartès*, sometimes called *Le Bock*.

The Burial of Casagemas, oil. 1901.

In his *Portraits et Souvenirs* (1946) Jaime Sabartès tells how he became the subject of the canvas entitled *Le Bock*:

"I am alone and obviously bored: on the marble-topped table in front of me is a glass of beer. My short-sighted eyes scan the room and try to pierce the heavy atmosphere of tobacco smoke which prevents me from making out what is going on a few steps away from me. I peer in the direction in which I expect my friends to come... Just when my sense of isolation is at its most intense, Picasso suddenly appears before me; Picasso and the others. But he leads the way, drawn on by the force of his gaze...

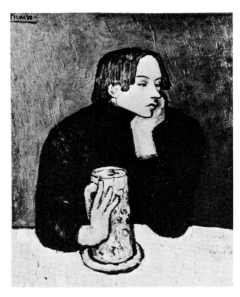

Le Bock (Portrait of Jaime Sabartès), oil. 1901.

"Without knowing it, I serve as the model for a picture: a portrait of which I have two memories. First my unintentional *pose* in the café, at the time and in the manner aforesaid, when, thinking myself alone, I fell into the trap of Picasso's scrutinizing gaze. Then the impression experienced a few days later in his studio in the Boulevard de Clichy.

"Picasso ends up by painting me as he saw me in the café. The canvas is turned to the wall when I arrive. In placing it on the easel, I am astonished to see myself just as he surprised me in a fleeting moment of my walk through life. I see and gaze at myself fixed on the canvas and I understand what I have suggested to the concern of my friend: this is the specter of my solitude, seen from outside... This is the first of my four oil portraits painted between 1901 and 1940.

"To see myself in this wonderful *blue* mirror makes a great impression on me. It is as if the waters of a vast lake held something of me, since I see my reflection in them."

1902

In January 1902 Picasso returned to Barcelona, where he rented a studio in the Calle del Conde del Asalto. He had broken his contract with Manyac, but thanks to the support of his family he was able to go on painting in material conditions which, though sometimes straitened, were still acceptable. The *Self-Portrait* he painted before leaving Paris shows a face drawn and lined, marked by a maturity and experience of suffering unusual in a youth of twenty. Sabartès notes: "The direct expression of an artist we call pure, but not the expression produced in a roundabout way, when the artist does no more than transmit what he has learned without putting anything of his own into it... If we expect sincerity from the artist, we do not admit that it can be achieved painlessly. Picasso thinks art the son of Sadness and Sorrow (and there we agree). He believes that sadness lends itself to meditation and that sorrow is the stuff of life."

Invitation to the Picasso exhibition at the Berthe Weill Gallery, Paris, 1902.

Self-Portrait, oil. Winter 1901.

On the first of April in Paris, during Picasso's absence, Manyac opened at the Berthe Weill Gallery an exhibition of thirty of his paintings and pastels, all dating from the previous year. The portrait Picasso made of Berthe Weill many years later shows that this courageous dealer long continued to follow the young painter's activity. This exhibition, less successful than the one at Vollard's, was again noticed by Félicien Fagus, who again praised Picasso's work in the *Revue Blanche*. The exhibition catalogue was prefaced by Adrien Farge.

Blue became the dominant color of his palette. Freed now from the influence of the past, he produced that "wet painting, blue like the moist depths of the abyss, and compassionate" (Apollinaire).

Portrait of Berthe Weill, drawing. 1920.

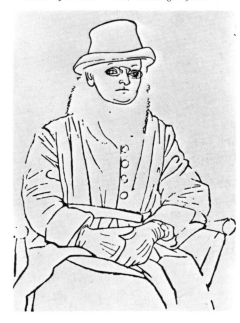

Picasso is all sinew, verve and mettle. With vehement strokes of the brush, dashed on the canvas with a rapidity that strives to keep up with the flight of his idea, he builds these solid and glowing works in which our eyes delight, captivated by brilliant painting in tones now crudely brutal, now knowingly restrained. Sometimes, with him, it is the passion for color that prevails, and then he gives us this luxuriant *Still Life* or this dazzling *Luxembourg*. Next, it is intense observation: this *Courtesan* on display, who shows all her fingers circled with rings, and whose jeweled collar stiffens the studied pose to emphasize the price of the object; this *Errand Girl*, a true flower of the pavement wilted by the impure atmosphere of capitals; this *Virgin with Golden Hair*, arresting in the indefinable expression of her enigmatic gaze, a suggestive and disquieting sphinx with undulating body, lustful mouth, wavy hair, red-painted nails coming like petals at the end of her long supple hands; here, in a word, is the whole woman starting to life, voluptuous in the Virgin aspiring with an indefinable desire toward a coveted Unknown... How much of eloquent symbolism in this curious figure! How much of soul as well in the pensive head of *Baby*, a head weighed down already by all that this innocent has divined of cruel life. Seated on a high chair, in a sumptuous robe of royal blue, the child has already begun to think... Beside it, a *Clown* in glowing yellows and a fanciful *Pierrot* show the ease with which Picasso records attitudes, while a brilliant *14th of July* brings together in the most glittering colors all the surging movement and intense life of a popular holiday.

And what else? Every item in this small exhibition is worthy of special mention, for all denote an admirable independence guided by a scrupulous conscience.

Adrien Farge

Preface to the catalogue of Picasso's second exhibition in Paris,
Berthe Weill Gallery, 1–15 April 1902

In October 1902 he returned to Paris with Sebastian Junyer. He took a room first in the Hôtel des Ecoles in the Latin quarter, then in the Hôtel du Maroc in the Rue de Seine near the Boulevard Saint-Germain, before moving into a room in the Boulevard Voltaire which he shared with Max Jacob. Since breaking his contract with Manyac he had no regular income. He was so poor that he sometimes had nothing to paint on, and there are not many works that can be dated to this third stay in Paris. He did, however, take part in another exhibition at Berthe Weill's, from 15 November to 15 December, showing with four other painters. Charles Morice, the famous Symbolist poet, published a long article on his work in the *Mercure de France* and presented him with a copy of Gauguin's *Noa-Noa*.

Picasso and Junyer arriving at the French frontier in 1903, ink and colored crayons.

1903

On 13 January 1903 he produced a series of bitter and ironic drawings which he called *The True and Simple Story of Max Jacob*; they illustrate the preoccupations and hopes of the two friends. Shortly afterwards, he left again for Spain.

In Barcelona, in a studio in the Riera de San Juan, he worked hard, using blue almost exclusively, so that these pictures are virtually monochromes. The subjects, poor, disinherited characters, are not only images of the poverty he saw around him daily, but rejoin the great tragic figures of Spanish painting: *Celestina*, *The Old Guitarist*, beggars, blind and one-eyed men.

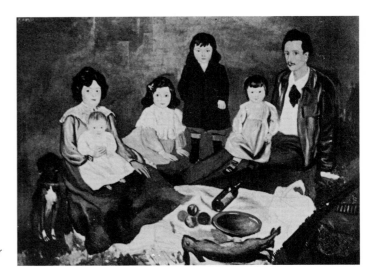

The Soler Family (Le Déjeuner sur l'Herbe), oil. 1903.

He also portrayed his friends, Junyer and the tailor Soler, who made suits for him in exchange for a few canvases. *The Soler Family*, represented picnicking on the grass, is an echo of the famous impressionist theme of the *Déjeuner sur l'Herbe*.

In May 1903 Gauguin died in the South Seas and in Paris a large Gauguin retrospective exhibition was held at the first Salon d'Automne. Picasso again felt the need of the stimulus which only France could give. His fourth journey was to prove decisive. He carefully prepared himself for it, sending his canvases on in advance to a friend who had remained in Paris.

Street in Barcelona, oil. 1903.

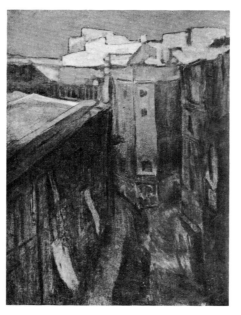

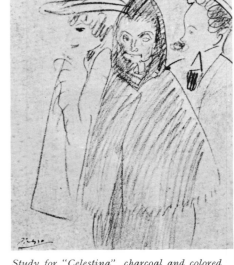

Study for "Celestina", charcoal and colored crayons. 1903.

In his monograph on Picasso (1953) Maurice Raynal described as follows the monochrome pictures of the Blue Period:

"So for now he shared the transient joys and persistent sadness of these imaginary figures. He broke all contact with gaudy color and rakish arabesques, the unselfconscious pleasures of the eye. What was painting lifted from the context of real-life vicissitudes? For Picasso a work of art took effect in the midriff, not in the eye; it dealt in human emotions, not in pleasing trifles. And if it were to carry weight, emotion had to be conveyed by simple, forthright means, free of artifice. Hence the stark, discreet, often trenchant draftsmanship of Blue Period pictures, the trim, spare, meticulous lines limning subjects with which the artist is wholeheartedly in sympathy, eddying here and there into gentle curves that temper the prevailing asceticism of the composition."

1904

Picasso returned to Paris for good in April 1904 with his friend Junyer. He moved into the studio of Paco Durio at 13 Rue Ravignan, on the heights of Montmartre, in a dilapidated building christened by Max Jacob the Bateau-Lavoir, presumably because of some resemblance with the floating washhouses on the Seine. For the first time in Paris he had a studio of his own. He painted the windows blue to suit the mood of his work. Gertrude Stein, who met him shortly afterwards, wrote: "Picasso had once more returned to Paris and it was around 1904 and he brought back with him the pictures of the blue period."

He lived in extreme poverty, but at the Bateau-Lavoir he found the friendships and solidarity that made poverty tolerable. The circle of his Spanish friends was widened to include French poets and painters, and Picasso's studio soon became the meeting place for a whole group of young artists.

Picasso in Paris in 1904, signed photograph.

"After sharing Max Jacob's room in the Hôtel du Maroc, at the Carrefour Buci, Pablo Picasso settled into the Bateau-Lavoir. His studio was so much frequented by friends who would wait there for each other that the threshold was decorated with a fine inscription in colored chalk: *The Rendezvous of Poets...*

Fernande Olivier met Picasso at the end of 1904. In her *Picasso et ses amis* she has left a sensitive portrait of André Salmon:

"A wonderful talker, Salmon told the most outrageous stories with exquisite tact. Very different from his friends Guillaume Apollinaire and Max Jacob, Salmon compelled attention by a delicate, subtle, deft and elegant turn of mind. Caustic, but gentle and kindly, a true poet, he was perhaps more sentimental than the others. A dreamer whose keen senses were always on the alert, tall, slim, distinguished, with bright intelligent eyes in a pale face, he seemed very young. Nor has he changed since then. His long delicate hands held in a way all his own the pipe he was always smoking. His slightly awkward gestures revealed him as a shy man."

Entrance of the Bateau-Lavoir in Montmartre, Rue Ravignan.

"I came there in the middle of the Blue Period... A painter's cabin, made of planks. A small, round, bourgeois table, bought from a bric-a-brac dealer; an old divan serving as a bed; and the easel... On the bourgeois table enriched with moldings in the Napoleon III style burned an oil lamp. Here at No. 13 there was no question of electricity, not even gas. The oil lamp did not give off much light. To paint, and to show his canvases to visitors, a candle was required, that flickering candle which Picasso held up high in front of me when he introduced me humanly into the superhuman world of his starvelings and cripples and mothers whose milk has dried up; the supra-real world of *Blue Woe*."

André Salmon, *Souvenirs sans fin*

Windows of Picasso's studio in the Bateau-Lavoir, postcard.

To bring in a little money, Max Jacob kept visiting the dealers with tireless persistence and so disposed regularly of a few drawings. A bric-a-brac dealer known as Père Soulié could often be persuaded to take a few; he was not very generous but his purchases enabled them to keep afloat. From 24 October to 20 November 1904 Picasso took part in a collective exhibition at Berthe Weill's along with Raoul Dufy and Francis Picabia; deploring the absence of recent works, he was allowed to add a few extra drawings. Late in 1904 a Cézanne exhibition was held at the Salon d'Automne.

The "Lapin A. Gill" (Lapin Agile) in Montmartre about 1872, postcard.

Place Ravignan in Montmartre in 1903, postcard.

In the summer of 1904 he painted the first of his many pictures on the Harlequin theme. He came under the spell of the circus, and at least once a week he spent the evening with his friends at the Cirque Médrano. "Picasso little by little was more and more French and this started the rose or harlequin period" (Gertrude Stein). He also frequented the famous café called the Lapin Agile, run by Frédé; Frédé's daughter Margot, who later married the writer Pierre MacOrlan, sat to Picasso for the *Woman with a Crow*. In Paris his style evolved: lines were spun out, silhouettes elongated, and figures enveloped by space.

Woman with a Crow, drawing and watercolor. 1904.

Harlequin with a Glass (At the Lapin Agile), oil. 1905.

1905

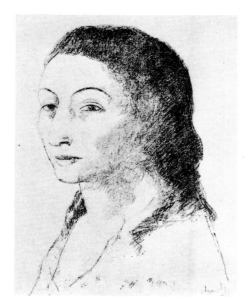

Portrait of Fernande Olivier, pencil. 1905.

At the end of 1904 Picasso had made the acquaintance of a neighbor of his at the Bateau-Lavoir, Fernande Olivier, a beautiful girl hardly out of her teens, who to escape from an unhappy home had married a sculptor whom she hardly knew and who shortly afterwards went mad. Fernande was to become Picasso's companion and model for the next six years.

This year he met Guillaume Apollinaire and his studio became (as in fact his friends called it) the *rendez-vous des poètes*: Max Jacob, Pierre Reverdy, Charles Vildrac, Pierre MacOrlan, André Salmon and Maurice Raynal, in addition to Apollinaire.

Two Acrobats with a Dog, gouache. 1905.

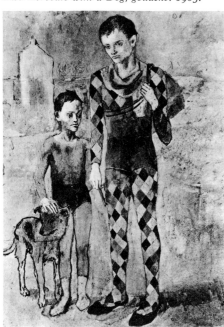

From 25 February to 6 March he exhibited at the Galerie Serrurier in Boulevard Haussmann, presented by Charles Morice: "Even before he was twenty he already possessed this frightening sureness of line, color relations and composition which many artists are still in search of after long experience. An unaccountable miracle. One might almost suppose that in another existence, full of years and works, this boy with the sure and searching gaze had learned everything. And so not needing to study any more he kept on producing, tirelessly, day after day, and drawings and prints and pictures covered the walls of his studio..."

This exhibition was reviewed by Apollinaire in *La Plume*, the poet's first article on Picasso, accompanied by five reproductions. In the *Revue immoraliste* Apollinaire also defended his new friend against the "precocious disenchantment" which Morice had read into his work.

Almost at the same time, probably at the beginning of 1905, Apollinaire met both Max Jacob, with whom this marked the start of a close and often stormy friendship, and Picasso. Poet and painter were at once attracted to each other and bound together by a profound sympathy of temperament. Apollinaire admired "the stubborn and solitary toil" of Picasso, who made many drawings and caricatures of his friend under the most various aspects, poking fun at his love of weapons, his literary ambitions and his collaboration on a magazine of physical education.

The year 1905 brought the transition from the Blue to the Rose Period. "Once more back in Paris he commenced again to be a little French, that is he was again seduced by France, there was his intimacy with Guillaume Apollinaire and Max Jacob and André Salmon and they were constantly seeing each other, and this once again relieved his Spanish solemnity... he let himself go, living in the gaiety of things seen, the gaiety of French sentimentality" (Gertrude Stein).

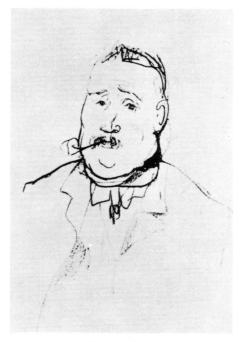

Portrait of Apollinaire, drawing. 1905.

The change of mood and color from blue to rose-pink that took place in 1905 brought with it a widening range of themes. During the summer he paid a visit to Holland, at the invitation of a Dutch writer, Tom Schilperoort, whom he had met in Paris. In the village of Schoorl, where he painted the *Three Dutch Women*, he was fascinated by the opulent and massive forms of the women he saw around him. He was thus led to tackle the problem of expressing volume, as is shown by several paintings, the *Dutch Girl with Lace Cap* for example, and also by the sculptures which he modeled shortly after returning to Paris.

Dutch Girl with Lace Cap, oil and gouache. 1905.

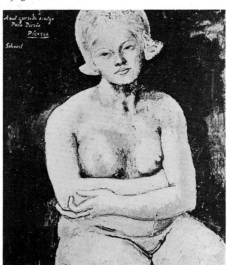

That same year, 1905, he executed his first engravings, some drypoints and etchings. He learned the technique from a friend of Barcelona days, Ricardo Canals, who had come to live in Paris. Graphic art gave fresh scope for his virtuosity, and the precision of the cutting vouched for the acuteness of his eye and the sureness of his hand.

Harlequin's Family, etching. 1905.

Girl with a Basket of Flowers, oil. 1905.

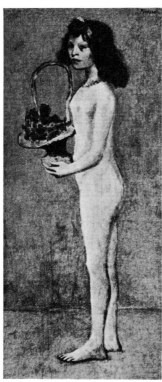

Salome, drypoint. 1905.

Shortly after Picasso's return from Holland, he made the acquaintance of Gertrude and Leo Stein. They were shrewd and active collectors and had just bought one of his recent works, the *Girl with a Basket of Flowers*, from the dealer Clovis Sagot. The two Americans were introduced to Picasso by the French writer H. P. Roché. From then on Gertrude Stein and her brother often crossed the Seine from their Left Bank apartment in the Rue de Fleurus to visit Picasso in Montmartre; they became familiar figures in his Bateau-Lavoir studio and bought many pictures from him.

After his meeting with the Steins, and then with the Russian industrialist Sergei Shchukin, who also became an enlightened and faithful collector of his work, the privations of his early years in Paris came to an end, for in the wake of the Steins and Shchukin came others, many others. The Rose Period brought him his first successes. During the following winter he began his portrait of Gertrude Stein.

Portrait of Leo Stein, gouache. 1906.

Apartment of Gertrude and Leo Stein, 27, Rue de Fleurus, Paris, early 1906.

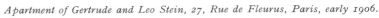

Fernande Olivier describes Gertrude Stein and her brother Leo as she saw them at that time:

"A type pair. He with a professorial look, bald, with gold-rimmed spectacles. A long beard with reddish reflections, a shrewd gleam in his eye. A tall stiff figure with curious attitudes and foreshortened gestures. The true American type of German-Jew... Herself short, squat, massive, a fine strong head, noble, emphatic, regular features, intelligent, penetrating, humorous eyes. A sharp and lucid mind. Masculine in her voice and her whole bearing.

"Both were dressed in tan corduroy, wearing sandals after the manner of Raymond Duncan, who was a friend of theirs. Too intelligent both to care about ridicule, too sure of themselves to mind what others might think."

1906

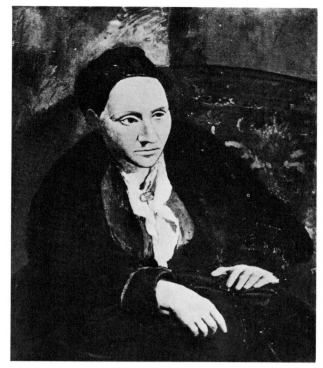

Portrait of Gertrude Stein, oil. 1906.

Gertrude Stein in her apartment at 27, Rue de Fleurus, Paris, about 1905.

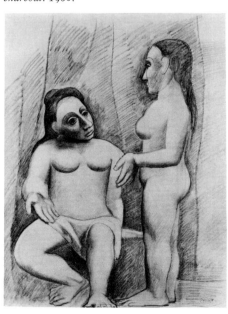

Seated Woman and Standing Woman (detail), charcoal. 1906.

During the spring of 1906 an exhibition of pre-Roman Iberian sculpture, including the Osuna bronzes, was held at the Louvre. A year later Picasso bought two pieces of Iberian sculpture. He bought them without knowing where they came from. As it turned out, they had been stolen from the Louvre by Apollinaire's secretary, Géry-Pieret—with the result that in 1911, when the *Mona Lisa* was stolen from the Louvre, suspicion fell on Géry-Pieret and both Apollinaire and Picasso were questioned at length by the police.

The revelation of Iberian sculpture and a summer stay at Gosol, near Andorra, led now to a decisive change in Picasso's work, a conversion of the earlier sentimental values into pictorial values. These two women, one seated, the other standing, show the rapid transition towards massive, *primitive* forms.

Of his portrait of Gertrude Stein, Picasso once said that she would contrive to resemble it. She herself has described the genesis of the picture:

"Why did he wish to have a model before him just at this time, this I really do not know, but everything pushed him to it, he was completely emptied of the inspiration of the harlequin period, being Spanish commenced again to be active inside in him and I being an American, and in a kind of a way America and Spain have something in common, perhaps for all these reasons he wished me to pose for him... I posed for him all that winter, eighty times and in the end he painted out the head, he told me that he could not look at me any more and then he left once more for Spain. It was the first time since the blue period and immediately upon his return from Spain he painted in the head without having seen me again and he gave me the picture and I was and I still am satisfied with my portrait, for me, it is I, and it is the only reproduction of me which is always I, for me."

Houses at Gosol, oil. 1906.

Vollard was attracted by the canvases of this period and now bought thirty pictures outright for 2,000 francs. After this windfall Picasso made plans for a summer stay in Spain.

The presence of Fernande Olivier inspired him with a more sensual, more broadly modeled image of woman, as shown by the portrait of her painted at Gosol. Picasso and Fernande spent several months in this Spanish village in the Pyrenees, near Andorra; but when typhoid broke out there, they left hurriedly and returned to Paris. By now the so-called Rose Period had come to an end.

Picasso's mind was occupied with other problems which were to set him on the path to Cubism.

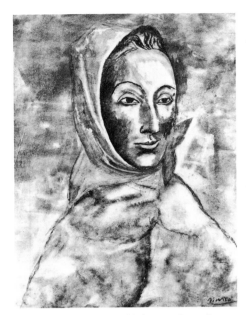

Fernande with a Kerchief, gouache and charcoal. 1906.

"In Spain," writes Fernande Olivier, "I saw him so different from himself, so different from the Picasso of Paris, gay, less shy, more brilliant, full of life, taking an interest in things with quiet self-assurance; in a word, he felt at ease there. Happiness seemed to radiate from him, in contrast with his usual mood and character.

"In Spain he never stayed long in a city. He would spend several days in Barcelona with his family, then go off into the countryside. He would live in an out-of-the-way corner of Aragon, Catalonia, Valencia or elsewhere.

"Immediately on arrival he would seek out some place, a room or a house, where he could settle down and work in peace, freely, all day long. He loved the company of the peasants, and they loved him. He felt himself free, drank with them and joined in their games. There, in those wild, bleak, grandiose landscapes, in those mountains with their cypress-bordered tracks, he did not seem a being apart, an outsider, as he did in Paris.

"At Gosols, a Catalan village above the valley of Andorra, he lived for several months, working regularly, enjoying better health. Cheerful, happy to go hunting or go on an excursion in the mountains, above the clouds trailing in the valley."

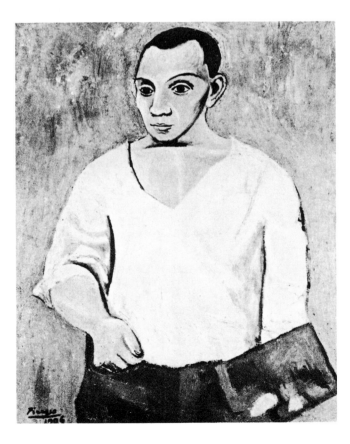

Self-Portrait, oil. Autumn 1906.

"About 1906 we see the picturesque being gradually effaced, giving way to starkness and simplicity. The yearning for classicism, which was to haunt the romantic Picasso again and again, makes itself felt for the first time. It was only a transitional stage, however, for he aspired to a total pictorial expression. At the beginning of the year 1907 he painted the *Demoiselles d'Avignon.* Cubism was born."

D. H. Kahnweiler

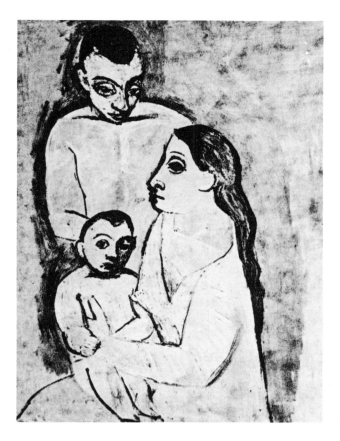

Man, Woman and Child, oil. 1906.

The 1906 Salon d'Automne included a large Gauguin retrospective exhibition which Picasso visited, and we may be sure that he was struck by Gauguin's pictorial striving after an ideal of primitive life and his use of thick black outlines. According to Maurice Raynal, the art critic who became one of Picasso's earliest friends in Paris, it was now that Picasso came to the conclusion that "the picture may be considered as an object independent of any representation of nature, an object capable of suggesting emotion, because subject to the laws of the sensibility and the controlling mind, and that painting will no longer be a simple matter of visual delight."

Paul Gauguin. Whence come we? What are we? Whither go we? 1897.

Paul Cézanne. Three Bathers, oil. 1879/1882.

On 22 October 1906, three days before Picasso's twenty-fifth birthday, Cézanne died at Aix-en-Provence. His influence, already strong, kept growing and affected all the younger painters; his lessons found a fertile development in Cubism.

"Cézanne was for us like a mother protecting her children."

Picasso

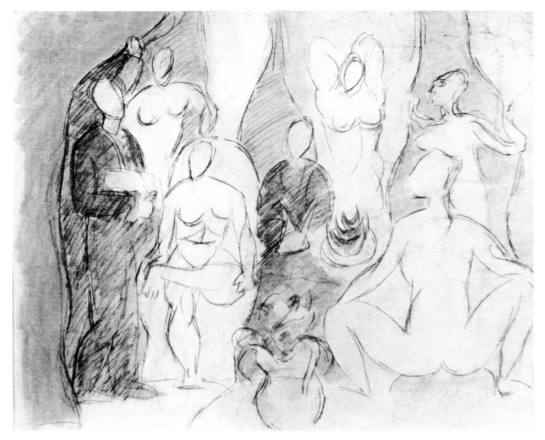

Study for "Les Demoiselles d'Avignon", pencil and pastel. 1907.

"I have never ceased to assert that Cubism began with the right side of the *Demoiselles d'Avignon*. Of course I do not wish in any way to diminish the share of the three other great painters, Braque, Gris and Léger, in the common endeavor, for Cubism was the result of team work. No one was more keenly aware of this than Picasso; he has told me so many times, and again quite recently, lamenting that the outbreak of war in 1914 put an end to this trustful collaboration. But the impetus came from him."

D. H. Kahnweiler
Picasso et le cubisme, 1953

In 1906 Picasso had met Matisse and Derain. They too were keen admirers of Cézanne and African masks and carvings. Matisse exhibited his *Joie de Vivre* at the 1906 Salon des Indépendants (where it was seen and bought by Gertrude and Leo Stein), and he was soon to paint *Le Luxe*, in which he again gave particular emphasis to contour lines. When, at the beginning of 1907, Picasso began work on *Les Demoiselles d'Avignon*, he seemed to be making a clean break with everything that he had done up to this point. But he was undoubtedly prompted to move in this new direction by the realization that both Cézanne's art and that of the African Negro carvers implied different, revolutionary ways of seeing.

Henri Matisse. Le Luxe. oil. 1907.

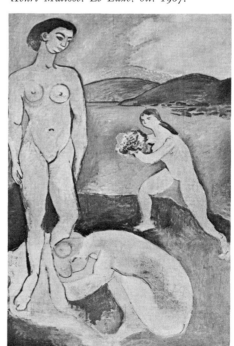

"Picasso: '*Les Demoiselles d'Avignon!* How that name gets on my nerves! It was coined by Salmon. You know at first it was called *The Brothel of Avignon*. You know why? Avignon has always been a familiar name for me, a name connected with my life. I lived [in Barcelona] only a few steps from the Calle d'Avinyó [i.e. Avignon Street]. There I bought my paper and watercolors. Then, as you know, Max Jacob's grandfather was a native of Avignon. We were always making jokes about this picture. One of the women was supposed to be Max's grandmother, another Fernande and another Marie Laurencin, all in an Avignon bawdy-house.'

"'There were also to be some men in the picture, that was my initial idea; you have seen the drawings yourself. There was a student holding a skull. Also a sailor. The women were eating—hence the basket of fruit, which remained. Then it changed and became what it is now.'

"A few days earlier Picasso had told me that this picture was only begun in 1907, not 1906, for he began it, he said, in the spring. He confirmed the fact that there were two different periods of work on the picture. I saw this picture in Rue Ravignan in *its present state*, therefore after the second period of work, fairly early in the summer of 1907. Since Picasso speaks of the spring, he has definite memories of the time and can hardly be mistaken. The second period of work must therefore be placed quite soon after the first. It is this second period that marks, properly speaking, the *birth of Cubism*, and it must accordingly be dated to April or May 1907."

Talk with D. H. Kahnweiler, 2 December 1933

The autumn of 1907 saw the triumph of Cézanne with the great retrospective exhibition held that year at the Salon d'Automne: 56 canvases and drawings. The Bernheim Gallery also exhibited 75 watercolors by Cézanne, and Emile Bernard published several of the Aix master's letters in the October issue of the *Mercure de France*. Here, for the first time, were published those famous words of advice to a young painter which, in the light of later developments, were to assume so prophetic a ring: "Let me repeat what I told you when you were here: treat nature in terms of the cylinder, the sphere and the cone, all this put into perspective, so that each side of an object is directed towards a central point" (letter to Emile Bernard of 15 April 1904).

Catalogue of the Salon d'Automne, Paris 1907.

Portrait of Max Jacob, gouache. 1907.

During the early months of 1907 Picasso worked on the canvas known as *Les Demoiselles d'Avignon*, whose aspect changed continually. The problems of 1906 were worked out before being submerged by a new interpretation of volume under the influence of African Negro art. According to Picasso's own statement, he discovered African and Oceanian art at the Trocadéro Museum in Paris, where he studied with keen delight masks and carvings from the Ivory Coast, the French Congo and New Caledonia.

The shock which the artists of that day received from African and Oceanian art—combined in Picasso's case with the impact of Iberian art—led them on to a more schematic treatment of planes and a breaking up of volumes. In certain nudes above all, painted during the summer, this procedure enabled Picasso to fold back volumes over the picture plane without allowing them to lose their identity, and without making play with eye-fooling perspective and its distortions.

"Picasso", wrote Gertrude Stein, "was the only one in painting who saw the twentieth century with his eyes and saw its reality and consequently his struggle was terrifying, terrifying for himself and for the others, because he had nothing to help him, the past did not help him, nor the present, he had to do it all alone..." She noted: "Picasso first took as a crutch African art and later other things." In its early stages, the *Demoiselles d'Avignon* included seven figures (five women, two men) but in the end only the five women were left.

Engrossed in his work, Picasso did not leave Paris for the summer, but he did set his large composition aside for a time in order to work out in separate pictures some of the problems it involved. In the fall he resumed work on the *Demoiselles d'Avignon*, only to abandon it for good, leaving it unfinished. His friends were staggered by this canvas. It brought him the acquaintance of the man who was to become his dealer and lifelong friend, Daniel-Henry Kahnweiler, who was taken to see it in Picasso's Bateau-Lavoir studio by Wilhelm Uhde. Kahnweiler had just opened his gallery in Rue Vignon, soon to become one of the showplaces of Cubism. About the same time, Apollinaire introduced Braque to Picasso.

African mask belonging to Picasso.

The revelation, from 1905 on, of the arts of Africa and Oceania played for the Fauve and Cubist generation (and the Expressionists in Germany) the same catalyzing role—in the opposite direction—that the discovery of Far Eastern art had played for the Impressionist and Symbolist generation.

The Negro mask reproduced above belongs to Picasso: "The African carvings lying about my studio are tokens more than examples," he said.

Braque, who began buying them in 1908, acknowledged that for him they "opened a new horizon": "they put me in contact with instinctive things, with direct manifestations running counter to the false tradition that was so hateful to me."

Standing Man, painted woodcarving. 1907.

The Douanier Rousseau in his studio.

Douanier Rousseau. A Foreign King visiting the World's Fair.

It was in 1906 that Picasso and Apollinaire met the Douanier Rousseau, who had been exhibiting regularly at the Salon des Indépendants since 1886. The painter Robert Delaunay had also met Rousseau about that time, and both Delaunay and Picasso relished the originality of this "naïve" painter. So did their poet friends. But the general admiration was not without a certain amusement at the Douanier's expense. In 1907 Delaunay's mother ordered the *Snake Charmer* from Rousseau. In 1908 Picasso bought his *Portrait of Yadwiga* and organized a banquet in the Douanier's honor in his Bateau-Lavoir studio. It has remained a famous event in the annals of modern art. All the painters and poets of Montmartre were there to pay tribute to the old man. And Rousseau admired Picasso in return. Witness his famous remark: "Picasso, you and I are the greatest painters of our time, you in the Egyptian style, I in the Modern." Alfred Jarry has recorded that when Rousseau painted a portrait he went about it very seriously, carefully taking the model's measurements with a tape measure.

"As a portrait painter, Rousseau is matchless. There is a half-length portrait of a woman by him, with delicate blacks and grays, which is carried further than a portrait by Cézanne. I have twice had the honor of being portrayed by Rousseau, in his small bright studio in Rue Perret. I have often seen him at work and I know what pains he took with every detail, what skill he had in retaining the original, definitive conception of his picture to the very end, and I know too that he left nothing to chance and above all nothing essential."

Guillaume Apollinaire

Douanier Rousseau, Portrait of Yadwiga.

"Picasso decided to organize in his studio, at his own expense, a banquet in honor of Henri Rousseau. All the decorations were ready, and greenery concealed the columns and beams and adorned the ceiling. At the back, facing the window, in the place intended for Rousseau, a sort of throne, made of a chair raised up on a crate, stood out against a background of flags and lanterns. Above, a streamer reading: All Honor to Rousseau! The table, a long plank, stood on trestles.

"Rousseau, who took it all for gospel truth, came up and with tears in his eyes solemnly took his place under the canopy arranged for him. He drank more than he was accustomed to and in the end dropped off into sweet slumber.

"There were speeches and songs made up for the occasion... After dinner practically all Montmartre came crowding into the studio."

Fernande Olivier, *Picasso et ses amis*

"Rousseau is not *a case*. He represents the perfection of a certain order of thought. The first work of his that I happened to acquire produced an astonishing effect on me. I was going down the Rue des Martyrs. A bric-a-brac dealer had piled up some canvases along the front of his shop. A head was sticking out, a woman's face with a stern gaze, a look of French shrewdness, resolute and clear. It was a huge canvas. I asked the price. — Five francs, said the dealer, you can paint over it.

"It was one of the truest psychological portraits of the French school."

Picasso

Picasso in his Bateau-Lavoir studio, with woodcarvings from New Caledonia.

"By the end of the year Cubism had ceased to be an exaggeration of Fauve painting, whose violent coloring was an exacerbated form of Impressionism. The fresh meditations of Picasso, Derain and another painter, Georges Braque, resulted in genuine Cubism, which was above all the art of painting new ensembles with elements borrowed not from visual reality, but from conceptual reality."

Guillaume Apollinaire

Fruits and Glass, oil. 1908.

1908

Throughout 1908 Picasso reworked and enlarged on the discoveries and conquests of the previous year. Each invention was carried to the extreme limit of its possibilities of development, then integrated into his work. The influence of Cézanne prompted him to carry out a series of more abstract researches. The problem of expressing volume on the plane surface of the canvas remained one of his central concerns; it was accompanied by a strong move toward the rhythmic and dynamic animation of the picture surface.

Georges Braque. Standing Nude, oil. Winter 1907–1908.

Picasso spent the summer in a village called La Rue des Bois, on the river Oise, some thirty miles north of Paris. In the landscapes painted there he returned to a more freely articulated geometry. Each plane is sharply defined, contrasting with the one beside it. During that summer Braque moved in the same direction, working at L'Estaque on the Riviera. In the fall of this year began that close friendship which bound Braque and Picasso until 1914. From this winter on, they shared their outlook, thoughts and experience with a completeness unique in the history of painting. For a while they even ceased to sign their canvases.

"I considered that the painter's personality should not intervene and that consequently the pictures should be anonymous. I was the one who decided that the canvases need not be signed and for a time Picasso followed suit. Seeing that someone else could paint the same way I did, I felt that there was no difference between the pictures and that they should not be signed. Afterwards I realized that all that was not true and I began again to sign my pictures. Picasso too had begun to do so."

Braque

"Traditional perspective does not satisfy me. Being mechanical, this perspective never puts one in full possession of things. It starts from a point of view and never gets beyond it. Now the point of view is a very small thing. It is as if you were to draw profiles all your life, making believe that man has but one eye... When this conclusion was reached, everything changed, you have no idea how much!... What particularly attracted me—and this was the main direction of Cubism—was the materialization of this new space which I sensed."

Braque

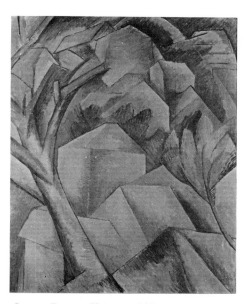

Georges Braque. Houses at L'Estaque, oil. 1908.

"He expresses a beauty full of tenderness and the pearliness of his pictures casts an iridescence over our understanding."

Guillaume Apollinaire
Preface to the catalogue of the Braque exhibition at Kahnweiler's

Braque submitted six of his L'Estaque canvases to the Salon d'Automne. When only two were accepted, he withdrew them all and the whole of his 1908 production was exhibited in November in a one-man show at Kahnweiler's gallery in Rue Vignon; the catalogue was prefaced by Apollinaire. Reviewing the show in *Gil Blas* on 14 November 1908, the critic Louis Vauxcelles wrote: "Braque paints little cubes." The word is said to have been used by Matisse while sitting on the jury of the Salon d'Automne to which Braque first submitted the pictures. Vauxcelles took it up again in his review of the 1909 Salon des Indépendants, speaking now of "cubism".

1909

In 1909 Picasso achieved a masterly synthesis of his researches. Thanks to Kahnweiler's support, the material conditions of his life were fast improving. During the summer he made another stay in Spain. This time he went to Horta de Ebro, staying there with his friend Pallarés. Braque, meanwhile, was painting landscapes in the neighborhood of Paris, at La Roche-Guyon and Carrière-Saint-Denis. The pictures they painted at this time correspond to what was later known as Analytical Cubism.

Gertrude Stein liked to emphasize the affinity between Cubism and the Spanish landscape: "Spanish architecture always cuts the lines of the landscape... the work of man is not in harmony with the landscape, it opposes it and it is just that that is the basis of cubism."

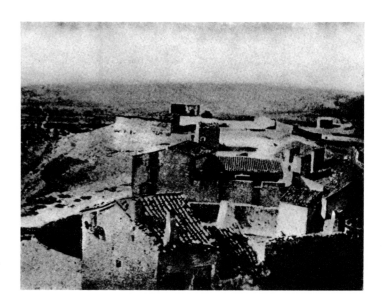

Houses at Horta de Ebro photographed by Picasso. 1909.

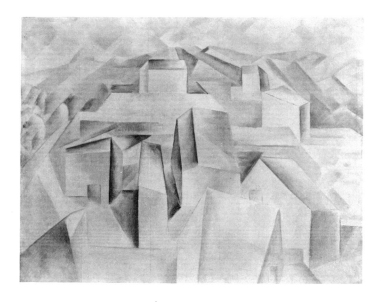

Landscape at Horta de Ebro, oil. 1909.

"The mysterious road on which fear dogs our every step, on which our desire to turn back is only overcome by our fallacious hope of being accompanied—for fifteen years that road has been swept by a powerful projector. For fifteen years Picasso, exploring that road himself, has stretched out his hands, full of light, far out along it. None before him had ventured to look about him and see."

André Breton, 1928

Portrait of Georges Braque, oil. 1909.

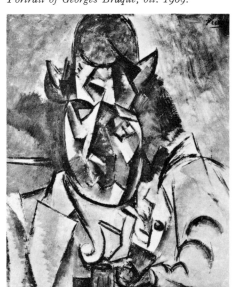

Evoking the early days of Cubism, Gertrude Stein wrote (1938): "Then commenced the long period which Max Jacob has called the Heroic Age of Cubism, and it was an heroic age. All ages are heroic... Picasso said once that he who created a thing is forced to make it ugly. In the effort to create the intensity and the struggle to create this intensity, the result always produces a certain ugliness, those who follow can make of this thing a beautiful thing because they know what they are doing, the thing having already been invented...

"At this time he liked to say and later too he used to repeat it, there are so few people who understand and later when every one admires you there are still the same few who understand, just as few as before."

In September 1909 Picasso moved out of the old, uncomfortable Bateau-Lavoir, where he had lived since 1904, and took an apartment with an attached studio at 11 Boulevard de Clichy, still in Montmartre. From his windows he could see the Sacré-Cœur basilica, which he painted several times. Fernande Olivier has described their new home: "The walls were adorned with old tapestries, African masks, musical instruments, and a small Corot representing a pretty girl."

From that autumn dates his first cubist sculpture, *Woman's Head*, with its play of multiple, dynamically ordered planes.

1910

After a long spell of landscapes and still lifes, he now returned to figure painting, doing several portraits of his friends. All his recent research work led Picasso to multiply the different views of a given object while merging them into a single image, without ever doing violence to the requirements of the flat surface of the canvas.

Portrait of Ambroise Vollard, oil. Winter 1909–1910.

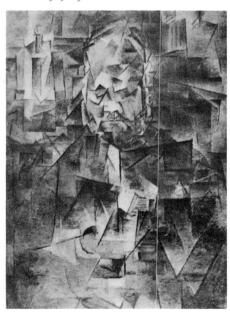

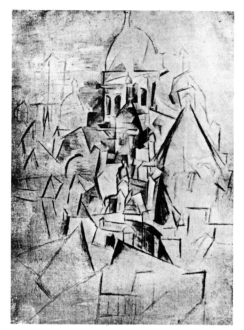

The Sacré-Cœur, oil. 1909.

"We have introduced into painting objects and forms that were formerly ignored."

Picasso

Portrait of D. H. Kahnweiler, oil. 1910.

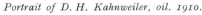
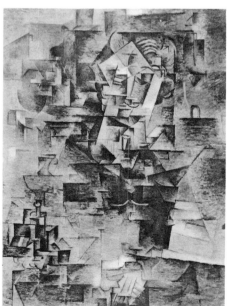

In the spring of 1910 Picasso painted a number of figure studies: *Girl with a Mandolin* and portraits of Vollard, Wilhelm Uhde and Kahnweiler. The latter noted: "Picasso tries repeatedly to give a color to structured form. That is, he not only uses color as chiaroscuro, as an expression of light to show form, but he introduces it into the picture on equal terms, as an end in itself. Each time he is obliged to paint over the color he has used."

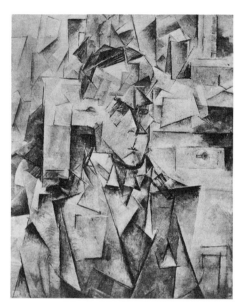

Portrait of Wilhelm Uhde, oil. 1910.

"We never see an object in all its dimensions at once. So there is a gap here in our sight which has to be made up for. Now ideation enables us to perceive the object in all its forms. At the moment when I conceive of a book, I perceive it in no particular dimension, but in all dimensions at once. If, then, the painter contrives to render an object in all its dimensions, he achieves a methodical work of an order superior to that of a work painted only in the visual dimensions. It is because of this 'conceptual' or simultaneous vision that a parallel has often been wrongly drawn between Futurism and Cubism. But Cubism is not an art of movement or a mechanistic modernism. In a cubist canvas the objects which unfold in space and approximate to each other seem to move very slowly, seem to breathe, so to speak. Things never go any further or any faster than that."

Maurice Raynal
Conception et Vision, Gil Blas,
29 August 1912

André Derain. Self-Portrait, red chalk. 1910.

"A continually renewed freshness casts an ingenuous charm over the extreme influences that impinged on him, refined or barbaric, culled without any set purpose, from Cézanne to the Douanier Rousseau, from Persian imagery to popular prints. Archaism crystallized his leanings toward a naïve and somewhat mannered expressiveness, toward geometrized but intense patterning. With a strict economy of means and the most perfect creative ease, Derain produced in his 'Gothic period,' rightly regarded by the best connoisseurs as his golden age, some arresting portraits and admirable compositions which are modern counterparts of Cosimo Tura and Fouquet."

Jean Leymarie

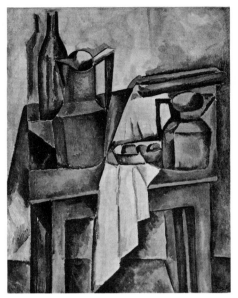

André Derain. Still Life with Pitcher, oil. 1910.

The canvases of this period are rarely dated; the places where he stayed and worked during the summer often provide a clue to the dating and enable us to trace the different phases of his evolution. In 1910 he went to Cadaquès, on the coast of Catalonia, where he was joined by Derain. It was there, according to Kahnweiler, that Picasso "shattered homogeneous form" and arrived at a figurative abstraction. That same year Kandinsky painted his first non-figurative watercolor and Mondrian, the apostle of geometric abstraction, arrived in Paris.

Never, however, did Picasso break away from reality. Jean Metzinger, one of the theorists of Cubism, wrote in *Pan* in October 1910: "Picasso does not repudiate the object and illumines it with his intelligence and emotion." Braque, whose development followed a parallel course, had this to say: "When objects broken into fragments appeared in my painting about 1910, this for me was a way of getting closest to the object, in so far as painting allowed me to do so."

But while for the painters themselves the work attained an unparalleled degree of objectivity, for the spectator it was quite bewildering. The etchings with which Picasso illustrated Max Jacob's poetic novel *Saint Matorel*, published by Kahnweiler, seem to stand on the very limits of a break with reality.

In an undated letter Max Jacob sent in to Kahnweiler the presentation text for *Saint Matorel*:

"The growing success of Guillaume Apollinaire's fine book, which we published last year, has encouraged us to make a fresh venture which we presume to think may be equally successful. For the text of the book which we now offer to the discerning public of bibliophiles, we have applied to one of the young men who has attracted most attention in the world of letters, even though he seems hitherto to have held aloof from it for no apparent cause: *Max Jacob*. For the illustrations we have turned to the master painter whose etchings, all too few for the liking of art lovers, call forth at each appearance the eager interest and approbation of connoisseurs: *Pablo Picasso*.

Mademoiselle Léonie, etching for "Saint Matorel" by Max Jacob. 1910.

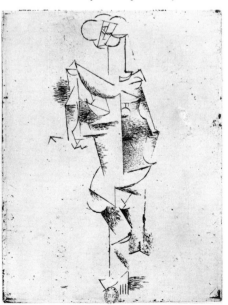

"Max Jacob has chosen his hero in the poorer quarters of Paris. In this small world which he lovingly describes, he has created a sort of Hamlet who later dies in a monastery, smitten with divine grace, not without having converted one of his fellow strugglers of earlier days. Both live again in heaven, in a setting whose apparent fancifulness is soundly based on ancient religious traditions.

"The authority of Picasso's name dispenses us from presenting him to the public. The high purposefulness of his work is well known, the sure and unexpected taste that guides both his brush and his graver. The secret charm of his austere art has made an impression on art lovers. To bring back to the old laws of high aesthetics a pictorial art that was losing its way amid the pretty trifles of pseudo-Japanese styling, to subject painting to the strict control of a simple, complex composition, to rediscover reality only by way of style and thus to rediscover it more truly, such is the exemplary aim of this artist."

Max Jacob ended his letter to Kahnweiler as follows: "When you get Picasso's etchings, it would be a pleasure for me to see them. May I ask that of you? It is not the etchings themselves I care about; I am no connoisseur. I am only curious to see how Faust has been inspired by Homunculus. Homunculus is Matorel."

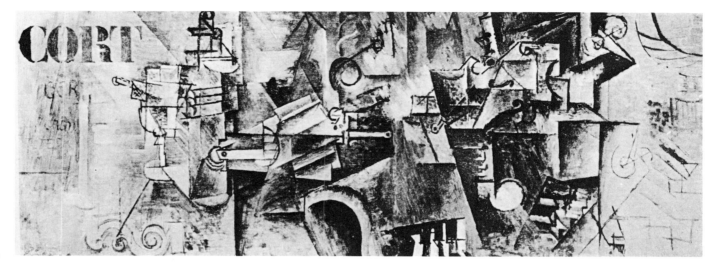

Still Life on a Piano, oil. 1911.

At the 1910 Salon d'Automne, for the first time, some cubist canvases were accepted: two by Metzinger, one by Fauconnier. These, however, were but faint reflections of the main lines of cubist research. Apollinaire spoke out and said so: "This is a flat and lifeless imitation of works not exhibited here, painted by an artist with a strong personality who, moreover, has entrusted his secrets to no one else. This great artist is Pablo Picasso. But then Cubism at the Salon d'Automne is only the jackdaw in borrowed feathers."

"He returned to Paris unsatisfied in the following autumn, with some canvases still unfinished, though he had been working hard on them for weeks. But the great step had been made. Picasso had now broken free of closed form. A new tool had been forged for new purposes" (D. H. Kahnweiler).

1911

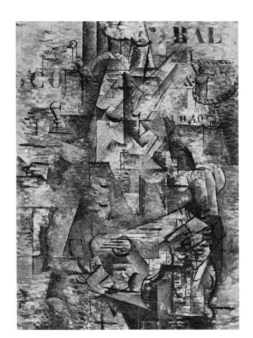

Georges Braque. The Portuguese, oil. 1911.

"Picasso and Braque [in 1910-1911] passed beyond a structure which *interpreted* the seen object to the creation of a structure which though *suggested by* the seen object existed by virtue of its own monumental coherence and power."

Sir Herbert Read

Between the autumn of 1910 and the beginning of 1912, the work of both Picasso and Braque showed a mounting concern for pictorial organization, each trying to render the subject matter more clearly recognizable. At the end of 1910 Braque began introducing naturalistic details, nails painted in *trompe-l'œil* or lettering, which provided clues to the understanding of the subject. Now, too, the title of the picture took on a specific meaning. In the spring of 1911, with *The Portuguese*, Braque made use of numbers and letters of the alphabet stenciled on the canvas, heralding the appearance of pasted papers, the famous *papiers collés*. Picasso showed the same concern in his *Still Life on a Piano* and the *Mandolin Player*.

The two painters spent the summer at Céret, a small town at the foot of the French Pyrenees.

Picasso did not exhibit in Paris this year. In 1909 Kahnweiler had organized an exhibition of his work at the Thannhauser Gallery in Munich; now he arranged for the first Picasso exhibition in the United States, at the Photo-Secession Gallery in New York where Alfred Stieglitz courageously defended the European avant-garde.

Fernande now passed out of his life and a new companion entered it: Eva.

Picasso in his studio at the Bateau-Lavoir in 1908.

1912

After the multiplication of *trompe-l'œil* effects and the introduction of lettering, which continued to appear in *The Aficionado*, Picasso at the beginning of the year produced the *Still Life with Chair Caning*, a small oval painting on which he pasted a strip of oilcloth realistically patterned to look like chair caning. This was one of the first examples of *collage*, a technique which by the autumn of this year had become widely used. Picasso himself has explained his intentions: "We were trying to express reality with materials which we did not know how to handle, and which we appreciated precisely because we knew that they were not indispensable, that they were neither the best available nor the best adapted."

In early May he left for Avignon with Eva, then went on to Sorgues, a small town in the plains six miles north of Avignon, where he settled for the summer in a villa called Les Clochettes. From there he wrote to Kahnweiler and referred to Eva in glowing terms: "I love her very much and I shall write her name on my pictures." He painted *Ma Jolie* as a tribute to her. Braque and his wife joined Picasso and Eva at Sorgues for the summer.

There Braque did the first of his pasted papers, and from now on both painters resorted frequently to collage. By means of these pasted cutouts, form was separated from color. "With these works," Braque said later, "we succeeded in plainly dissociating color from form, in putting it on a footing independent of form, for that was the crux of the matter. Color acts simultaneously with form, but has nothing to do with form."

Thus, by means of collage, reality was no longer imitated, it was integrated bodily into the picture. The works produced by Braque and Picasso in this period were later described as Synthetic Cubism.

Back in Paris, Picasso moved from Montmartre to Montparnasse, taking a studio apartment first in Boulevard Raspail, then in Rue Schoelcher.

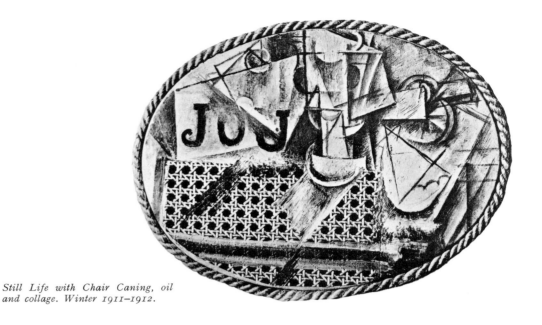

Still Life with Chair Caning, oil and collage. Winter 1911–1912.

"I know of no art that is autobiographical to this degree. There is no figure by Picasso, no figure of a woman, that is not the portrait of his girl friend of the moment. These are never fancied or invented heads: it is always that of the woman he loves. I have often spoken about this. There was a time in his life, from 1912 to 1914 when, considering the purposes he had in mind, it was impossible for him to do portraits. But even at that time he wished to bear witness to his love in his pictures. I have a letter from him in which he writes something like this: 'I am in love with Eva and I shall write it in my pictures.' And in fact there are pictures of that period in which he has painted a heart of gingerbread and written over it: *J'aime Eva*.

"There are other pictures of the same period bearing the words *Ma Jolie*. 'Ma Jolie' was a popular love song with a refrain running: *Oh Manon, ma jolie, mon cœur te dit bonjour*. We used to hear it sung in the Montmartre night spots at the time he was wooing Eva. It was this girl he had in mind when he wrote 'Ma Jolie' on these pictures."

D. H. Kahnweiler

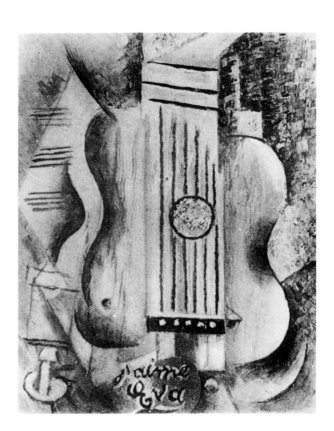

Guitar (J'aime Eva), oil. 1912.

The year 1912 was a year of momentous importance in the evolution of contemporary art.

In February the Italian Futurists exhibited in Paris at the Bernheim-Jeune Gallery. Grouped under the aegis of the poet Marinetti, they had drawn up a manifesto dated 11 February 1910, which they solemnly proclaimed on 8 March in the Chiarella Theater in Turin. These painters, Boccioni, Balla, Carrà, Russolo and Severini, born of Cubism, pursued their researches in a quite different direction, being chiefly concerned with the problem of movement.

A similar dynamism characterized the work of Robert Delaunay, who at the 1912 Salon des Indépendants exhibited his *Simultaneous Windows* and created a kind of colored Cubism which Apollinaire christened Orphism.

Fernand Léger. Woman in Blue (II), oil. 1912.

"I should like to arrive at tones that isolate each other, a red very red, a blue very blue. Delaunay moved towards the nuance, while I made straight for outspoken color... In 1912 I hit on pure colors enclosed in a geometric form. Example: *The Woman in Blue*."

Fernand Léger
Statement to André Verdet

"Picasso thought well of this first picture exhibited by Léger at the Indépendants. Léger himself certainly thought very highly of Picasso. But then there was that remark by Delaunay, quoted by Picasso himself: 'But these fellows paint with cobwebs.' In other words he was reproaching them for the absence of colors. And it is a fact that Léger's early things were also monochromes. Léger has always had a great regard for Picasso, and Picasso certainly respected Léger.

"Léger was a delightful person. Physically he was the genuine 'Norseman,' tall, sandy-haired, freckled, exactly what one imagines the man of the North to be, and as indeed he is. I only met Léger in 1910. He had already done some painting before that, which he almost entirely destroyed afterwards."

D. H. Kahnweiler

Robert Delaunay. The Eiffel Tower, oil. 1910.

Catalogue of the Futurist exhibition at the Bernheim-Jeune Gallery, Paris 1912.

Manifesto of the Futurist painters of 3 March 1912.

abstraits de chaque objet, d'où jaillit une source de lyrisme pictural, inconnue jusqu'ici.

UMBERTO BOCCIONI,

CARLO D. CARRÀ,

LUIGI RUSSOLO,

GIACOMO BALLA,

GINO SEVERINI.

N. B. — *Toutes les idées contenues dans cette préface on été longuement développées dans la conférence sur la Peinture futuriste, tenue par le peintre Boccioni au Circolo Internazionale Artistico de Rome, le 29 mai 1911.*

— 14 —

MANIFESTE
des
Peintres Futuristes

Le 8 mars 1910, à la rampe du théâtre Chiarella de Turin, nous lancions à un public de trois mille personnes — artistes, hommes de lettres, étudiants et curieux — notre premier Manifeste, bloc violent et lyrique qui contenait toutes nos profondes nausées, nos mépris hautains et nos révoltes contre la vulgarité, contre le médiocrisme académique et pédant, contre le culte fanatique de tout ce qui est antique et vermoulu.

Ce fut là notre adhésion au mouvement des Poètes futuristes commencé il y a un an par F. T. Marinetti dans les colonnes du Figaro.

La bataille de Turin est restée légendaire. Nous y échangeâmes presque autant de coups de poing que d'idées, pour défendre d'une mort fatale le génie de l'Art italien.

Et voici que dans une pause momentanée de cette lutte formidable nous nous détachons de la foule, pour exposer avec une précision techni-

15

"The rising fame of his compatriot Picasso," wrote D. H. Kahnweiler in his book on Juan Gris, "had brought Gris to No. 13, Rue Ravignan... The friendship between Gris and Picasso, and the perhaps racial affinity between the two, led Juan Gris toward the mode of pictorial expression called Cubism."

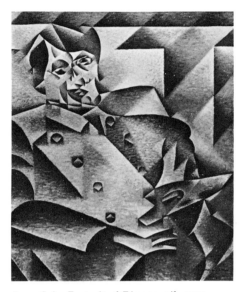

Juan Gris. Portrait of Picasso, oil. 1912.

At the 1912 Salon des Indépendants Gris exhibited his *Homage to Picasso*. This Spanish artist had arrived in Paris in 1906 and settled in the Bateau-Lavoir. At first he had to earn his living by doing cartoons but by 1911 he was able to devote himself to painting. His "homage" testifies to the younger men's admiration for the great creator, and the fascination he exerted. On friendly terms with Jacques Villon and his two brothers, Marcel Duchamp and the sculptor Raymond Duchamp-Villon, Juan Gris acted as the connecting link between Picasso and the Section d'Or group, which included Gleizes, La Fresnaye, Léger, Metzinger, Picabia and Kupka, who forgathered in Jacques Villon's studio at Puteaux. To Cubism Gris gave a more theoretical emphasis. Commenting on his work at the Salon des Indépendants, Apollinaire wrote: "Juan Gris exhibits a *Homage to Picasso*, which must be praised above all for the great effort that went into it and for its great disinterestedness. This picture by Juan Gris might be described as integral Cubism." From now on he became friendly with Braque and took to collage. He also participated in the first Section d'Or exhibition at the Galerie La Boétie. Marcel Duchamp, in his *Nude descending a Staircase*, followed a line of research parallel to that of Cubism and Futurism.

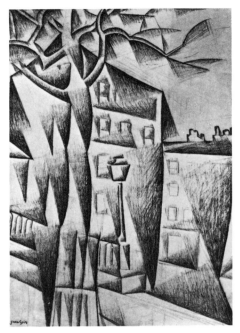

Juan Gris. Place Ravignan, pencil. 1912.

A heavy cubist contingent (not including Picasso) exhibited at the 1912 Salon d'Automne and their work raised a storm of abuse and criticism that was even taken up in the Chamber of Deputies. A socialist deputy named Jean-Louis Breton took the floor and exclaimed: "It is absolutely inadmissible that our national buildings should house exhibitions of so distinctly an anti-artistic and anti-national character." Marcel Sembat replied: "When a picture seems to you to be a bad one, you are entitled to turn away from it and look at others. But there's no reason to call in the police."

Gleizes and Metzinger wrote *Du Cubisme* and Apollinaire published some articles which were reissued in 1913 as *Les peintres cubistes*.

Marcel Duchamp. Nude descending a Staircase, oil. 1912.

Exhibited at the 1912 Salon d'Automne, the Cubist House, designed by Marcel Duchamp and the decorator André Mare, included the projected façade of a dwelling house, together with a suite of three rooms on a level, furnished by Marie Laurencin, Gleizes, Metzinger, La Fresnaye, Villon and Duchamp-Villon. Paul Poiret bought the clock designed by La Fresnaye and the pierglasses designed by Marie Laurencin, while Michael Stein and Walter Pach decided to ship the Cubist House to New York and exhibit it at the Armory Show, held in 1913.

This venture was, however, based on an equivocation. Despite the initial idea of Mare and Duchamp, there was very little about the house that could be described as cubist, and it gave countenance to the notion of Cubism as an avant-garde decorative art—a path followed by several second-rate artists, who turned to account the notoriety now achieved by Cubism.

Raymond Duchamp-Villon. Cubist House (project).

Guitar, sheet metal. 1912.

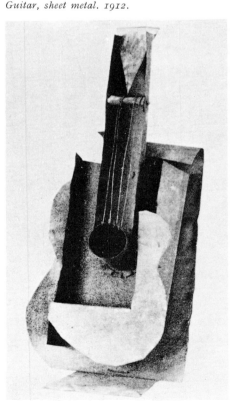

1913

Juan Gris. Landscape at Céret, oil. 1913.

The collage technique, which he applied in all the pictures of this period, enabled Picasso to achieve a very unusual degree of freedom. Making play with pasted papers and other materials real or simulated with eye-fooling illusionism, together with bright pure colors, he recomposed arresting fragments of reality. Now that he had moved to Montparnasse, he saw less of Braque, who however pursued a parallel line of research. Braque wrote: "Later I introduced sand, sawdust and iron filings into my pictures... I saw how much color depends on the material... And what was much to my liking was this very 'materiality' which was provided by the various materials which I introduced into my pictures."

Portrait of Apollinaire, cubist composition for the first edition of "Alcools". 1913.

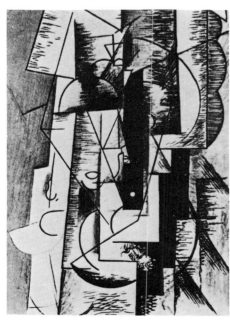

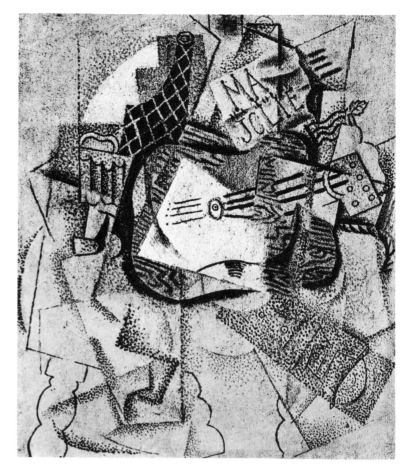

Glass, Bottle and Guitar on a Table (Ma Jolie), oil. 1913.

Picasso was also attracted by the possibilities of sculpture and made some paper reliefs and wood constructions. In 1913 the sculptors Archipenko and Lipchitz began their investigations, followed soon afterwards by Henri Laurens.

The summer of 1913 saw Picasso again at Céret, this time with Braque, Juan Gris and Max Jacob. He made a set of three drypoints to illustrate Jacob's book *Le Siège de Jérusalem*, published by Kahnweiler.

Picasso continued to see much of Apollinaire; their friendship was close and abiding. This year Apollinaire published the first book on Cubism, *Les peintres cubistes*; but he had to give up the editorship of the monthly magazine *Les Soirées de Paris* in which he had defended his friends. The publication of cubist drawings by Picasso in the first issue of the second year had brought such loud expressions of disapproval from the subscribers that Apollinaire had been forced to resign. Picasso's name was famous, not to say notorious, but his work was still rarely shown in exhibitions.

Cover of "Les Soirées de Paris". 1913.

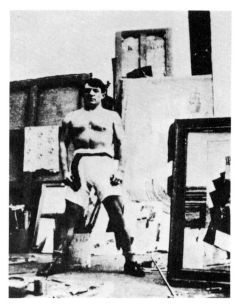

Picasso in his Rue Schoelcher studio in Montparnasse in 1913, photograph.

"The historiographic role that painting had played in a narrative manner before Masaccio, in a dramatic manner after him, had ceased to exist. That is why the painting of our time has become lyrical. Pure, exalting joy inspired by the beauty of things, that is the prompting behind it. Of that beauty it sings with enthusiasm, without any epic or dramatic overtones. It sets out to enshrine it in the unity of the work of art. This is what plainly characterizes the essence of modern painting, at once descriptive and constructive. Descriptive in that it wants to reproduce the beauties of form. Constructive in that it wants to include those beauties of form in the picture."

D. H. Kahnweiler

"Severely, he questioned the world. He accustomed himself to the immense light of the depths. And sometimes he did not disdain to bring into the light authentic objects, a popular song, a real postage stamp, a piece of the daily paper, a piece of oilcloth patterned with chair caning. The painter's art could add no picturesque element to the truthfulness of these objects.

"Surprise laughs savagely in the purity of light, and quite insistently do figures and molded letters appear as picturesque elements, a novelty in art, and long since imbued with humanity.

"It is not possible to divine the possibilities or all the tendencies of so profound and thorough an art.

"The real or simulated object is called upon no doubt to play a more and more important role. It is the inner frame of the picture and marks its deeper limits just as the frame marks its outer limits."

Guillaume APOLLINAIRE, Montjoie!, 14 March 1913

Pipe, Glass and Bottle of Vieux Marc (Lacerba), pasted paper and pencil. Winter 1913–1914.

By now Cubism had triumphed. It was the dominant influence on all the movements then on the rise in Europe. Delaunay and Léger moved toward an ever more abstract idiom. In Russia Malevich launched Suprematism, which also had its roots in Cubism. Cubist works had made their way to Germany where they were regularly exhibited and commented on. In August 1913 Léger published an important article in the Berlin review *Der Sturm*, the organ of the German avant-garde, of which Kandinsky was one of the moving spirits. This year the French painters were brilliantly represented at the first German Autumn Salon organized by *Der Sturm*. In New York the Armory Show opened in February 1913: a vast exhibition of great historical importance bringing together 400 works of modern art, from Ingres to Marcel Duchamp; its impact on the taste of the American public and American collectors was decisive.

Cover of "Der Sturm". August 1913.

The revolutionary review *Lacerba*, founded in Florence in 1913, served as the mouthpiece of poets and writers, and of the painters and theorists of the Futurist movement Boccioni, Carrà, Russolo, Marinetti and Severini. Up to the time of Italy's entry into the First World War (1915), they kept up a violent campaign against traditional ideas and institutions in the field of the arts, as well as in letters and politics.

1914

"On 2 August 1914 I took Braque and Derain to the station in Avignon. I never saw them again." In these terse phrases Picasso summed up the deep and lasting break with the past brought by the war. The cubist movement as such was now at an end and henceforth each artist followed a path of his own.

During the early summer of 1914 Picasso and Braque worked together for the last time at Avignon, where they were joined by Derain. Picasso pursued fresh lines of research which led him on to create works which have been described as object-pictures. This notion was magnificently exemplified in reliefs and sculptures and more particularly in the famous *Absinthe Glass*, a polychrome cubist sculpture in the round.

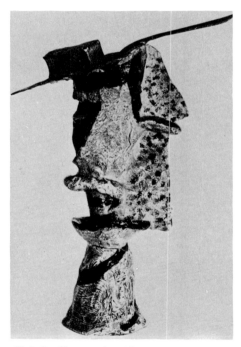

Absinthe Glass, painted bronze. 1913–1914.

"The character of 'transparency' thus to be found for the first time in *relief* appeared in European sculpture in the round in 1914, in Picasso's *Absinthe Glass* in painted bronze. The inside of the glass is shown in it at the same time as its outward form... Thus *emblem sculpture* takes the place, in European art, of *sculpture derived from casts made from life*, and the way lay open to all that has been achieved since: the 'space design' of sculptures made of wire, iron rods, string and wickerwork, constructions in wood or iron, etc. Such sculpture creates not only volumes but spaces, just as architecture does, thus enlarging its domain, to magnificent effect."

D. H. Kahnweiler

Beginning in 1913, Apollinaire wrote some "cubist" poems in which he made play not only with words and images, but with the typographical layout of the words on the page. In 1916, in *Le cornet à dés*, Max Jacob published some prose poems which also formed a sort of poetic parallel to some of Picasso's researches.

Picasso between Modigliani and Salmon, photograph. Paris 1915.

Max Jacob was one of the few of Picasso's intimate friends who remained in Paris during the war (he was physically unfit for military service). Braque and Derain had been called up and Apollinaire had volunteered. Kahnweiler was caught in Italy at the outbreak of war, and as a German he could not return to France. The Steins were in England. In Montparnasse Picasso still saw something of Amedeo Modigliani who, on his arrival in Paris from Italy in 1906, had settled in the Bateau-Lavoir at the prompting of André Salmon. Modigliani had a great admiration for Picasso who, however, was irritated by the rowdy behavior and exhibitionism of the young Italian artist.

Giorgio de Chirico, whose pictures were to be so much admired by the Surrealists in the 1920's, left Paris for Ferrara where he pursued his "metaphysical" researches. In 1914 he painted a portrait of Apollinaire, who had once called him "the most astonishing painter of his time." Disturbing and premonitory, this portrait shows the poet under the aspect of a target, with bullet holes for eyes. On 17 March 1916 Apollinaire was in fact wounded in the head, and very seriously. Chirico subsequently wrote: "One of the strangest sensations that prehistory has left us is that of premonition. It will always exist. It is like an everlasting proof of the nonsensicalness of the world."

Giorgio de Chirico. Premonitory Portrait of Apollinaire, oil. 1914.

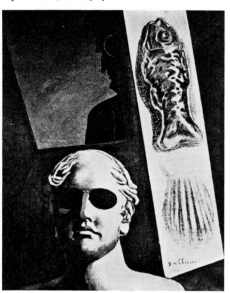

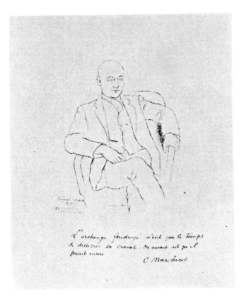

Portrait of Max Jacob, drawing. 1916.

"I am sitting for Pablo, in his studio; he is doing a pencil portrait of me which is very fine. It looks at the same time like a portrait of my grandfather, of an old Catalan peasant, and of my mother."

Letter from Max Jacob
to Apollinaire

Amedeo Modigliani. Portrait of Picasso, pencil. 1915.

Portrait of Jean Cocteau, pencil. 1917.

The studios of Paris, from Montmartre to Montparnasse, which a few months before had been full of aspiring artists from all over the world, were by now practically deserted. The carefree Paris which they had known, and which had left its mark on all of them, had donned the drab livery of wartime.

In the winter of 1915–1916 Eva fell ill, wasted away and died in January. Picasso's closest friends knew what she had meant to him and they rallied round him at the funeral. Afterwards Juan Gris wrote to Maurice Raynal at the front: "There were seven or eight friends at the funeral, which was a very sad affair, and Max's jokes added enormously to the horror of it." Max Jacob had recently been converted to Catholicism, and he asked Picasso to stand godfather to him during the ceremony of baptism, which took place on 20 January 1915.

Eva's death was a blow for Picasso, who had been much attached to her. He then gave up his Montparnasse studio in Rue Schoelcher and moved to a small suburban house in Montrouge. According to Gertrude Stein, many cubist constructions in paper, wood and brass perished in the bustle of moving.

Life in wartime Paris became very difficult. Kahnweiler and Wilhelm Uhde, the first dealers to support Cubism, were both Germans; that was enough for some people in France to regard Cubism as an anti-patriotic provocation.

Picasso produced in quick succession a series of works in completely different styles. Some were further developments of Cubism, others were in a classical style which has led this period to be described by some as Ingresque. This latter trend is illustrated by the beautiful portrait drawings of Vollard and Max Jacob.

In 1916, through the composer Edgar Varèse, Picasso was introduced to the young Jean Cocteau, already well known in fashionable circles as a poet and wit. They at once became fast friends. One of Picasso's first portraits of him dates from this year.

Cocteau was working on the libretto of a ballet for Diaghilev. Cocteau had set his heart on this project—which became *Parade*, produced in Paris at the Théâtre du Châtelet in 1917—for which he persuaded Erik Satie to write the music and Picasso to design curtain, sets and costumes.

Recalling the gestation that gave birth to the ballet *Parade*, Cocteau wrote: "I think of the admirable months in which Satie, Picasso and I lovingly worked over, planned out and devised this little show so full of good things, whose unpretentiousness lies precisely in the fact that there is nothing aggressive about it. The idea occurred to me during leave in April 1915 (I was then in the army), while listening to Satie play the piano... Satie invented some profound melodies and called them *Pieces in the Form of a Pear*. A sort of telepathy inspired both of us with a desire for collaboration."

Since its first season in Paris in 1907, Diaghilev's Russian Ballet had earned a high reputation thanks to the unrivaled skill of its dancers. That reputation was further enhanced now, when Diaghilev engaged the young choreographer Léonide Massine and, through Cocteau, brought in Picasso to design sets and costumes for *Parade*. It had seemed unlikely that Picasso would accept the proposal, and when he did most of his painter friends severely disapproved. "Never did Monsieur Renan more scandalize the Sorbonne than Picasso did the Café de la Rotonde by accepting my proposal" (Cocteau). He set to work enthusiastically and his fertile imagination added many new ideas, greatly enriching the stage effects and scenery.

1915-1916

Portrait of Erik Satie, pencil. 1920.

Caricature of Massine, Bakst and Diaghilev (dedicated to Bakst), India ink. 1917.

1917

Picasso and Massine at Pompeii in 1917, photograph.

"Jean Cocteau left for Rome with Picasso, 1917, to prepare Parade," wrote Gertrude Stein. "It was the first time that I saw Cocteau, they came together to say good-bye, Picasso was very gay, not so gay as in the days of the great cubist gaiety but gay enough, he and Cocteau were gay, Picasso was pleased to be leaving, he had never seen Italy. He never had enjoyed travelling, he always went where others already were, Picasso never had the pleasure of initiative. As he used to say of himself, he has a weak character and he allowed others to make decisions, that is the way it is, it was enough that he should do his work, decisions are never important, why make them."

In Rome Picasso lived in Via Margutta, the street of painters. He became friendly with Massine, the conductor Ernest Ansermet and Igor Stravinsky, who was one of Diaghilev's closest collaborators. With Stravinsky he visited Rome and the Campagna. He also went on to Naples and Pompeii, delighted with all he saw. But the most important event of his Italian sojourn was his meeting with Olga Koklova, one of Diaghilev's ballerinas, who was to become his wife.

The Villa Medici in Rome, pencil. 1917.

Portrait of Igor Stravinsky, pencil. 1920.

In his autobiography Igor Stravinsky tells of his stay in Italy with the Russian ballet and his visit to Naples with Picasso:

"Diaghilev, Picasso, Massine, and I went on from Rome to Naples. Ansermet had gone in advance to prepare for the performances that Diaghilev was to give there... I took advantage of my leisure to inspect the town, generally in Picasso's company. The famous aquarium attracted us more than anything else, and we spent hours there. We had both been greatly taken by the old Neapolitan water colors and fairly combed all the little shops and dealers' establishments in the course of our frequent expeditions."

Picasso's contribution to the ballet *Parade* was of vital importance. "When Picasso showed us his sketches we realized how effective it would be to set off the three real characters, as colorful as prints stuck to a canvas, against other characters, inhuman or superhuman, set in a graver key and representing, in short, the sham reality of the stage, so much so as to reduce the real dancers to the proportions of puppets. Thus I came to imagine the Managers," wrote Cocteau in a letter to Paul Dermée, editor of *Nord-Sud*.

The first performance took place in Paris on 18 May 1917 at the Théâtre du Châtelet, where Picasso had painted the great drop curtain on the spot. This famous ballet cemented "the alliance of painting and dancing, of sculpture and miming, which plainly betokens the advent of a more complete art," wrote Apollinaire in the program notice, and he added: "*Parade* has given rise to a sort of surrealism in which I see the starting point of a series of manifestations in this New Spirit."

"The Russian Ballet has come back to Paris," wrote Leon Bakst, who had created many settings and costumes for Diaghilev's company. "Here is *Parade*, a cubist ballet... Picasso gives us his own vision of a fairground sideshow, in which the acrobats, the Chinese conjuror and the managers move as in a kaleidoscope, at once real and fantastic."
"The simplicity and fantasy of Picasso's curtain pleased the audience, and the Chinese conjuror's costume was charming in its old-fashioned Orientalism; but the cubist constructions in which the managers moved about brought howls of protest, as did the various noises —typewriters in particular—with which Cocteau had thought it necessary to enliven Erik Satie's score" (André Fermigier).

"As the ballet came to an end the mounting anger of the audience expressed itself in an uproar... Cries of 'Sales Boches' (the worst possible insult in the wartime atmosphere of Paris) were shouted at the company. The audience rose to their feet in an ugly mood menacing the producer as well as Picasso and his friends. The situation was saved however by the presence of Apollinaire. The black bandage on his head and his Croix de Guerre commanded respect. Patriotism and sentimentality finally prevailed over the audience's conviction that they had been insulted" (Roland Penrose).

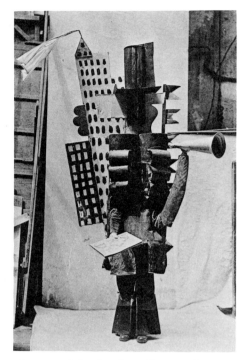

Costume of the American Manager for "Parade". 1917.

When Cocteau met Erik Satie in 1915, the latter was still little known as a composer. In Cocteau's own words, he learned from Satie "the greatest audacity of all: to be simple." In *Le Coq et l'Arlequin* (1918) Cocteau had this to say: "The piano score of *Parade* for four hands is... a masterpiece of architecture. This is something that cannot be understood by ears accustomed to waves and quivers. A fugue starts to wobble and gives rise to the very rhythm of the sadness pervading fairgrounds. Then come three dances. Their numerous motifs, each quite distinct, like separate objects, follow each other without any development and do not become entangled."

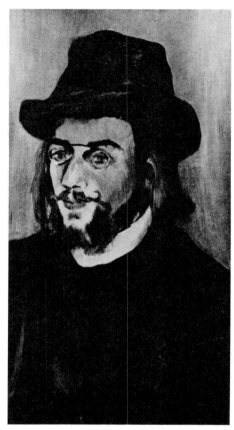

Suzanne Valadon. Portrait of Erik Satie, oil.

Drop curtain for "Parade", size painting. 1917.

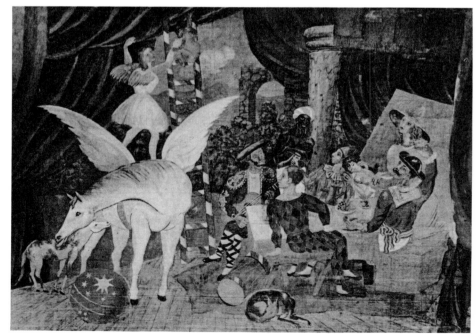

His meeting in Rome with the young ballerina Olga Koklova, daughter of a Russian colonel, who had been dancing for Diaghilev since 1912, was to change the course of Picasso's life. The many months he spent in company with dancers, musicians, theatrical folk and people of fashion led him to frequent very different circles from those of his Bohemian friends in Montmartre and Montparnasse. His way of life changed accordingly.

At the end of the Paris season of 1917, Diaghilev took his troupe to Madrid and Barcelona and Picasso followed them. He had not been back to Spain for five years. His father had died in 1913, and his mother was now living with his sister Lola, who had married a Barcelona doctor, Don Juan Vilato Gomez. Picasso was warmly welcomed in Barcelona by many of his old friends from early days. There he painted *Olga in Spanish Costume* in which he combines his two loves, his wife-to-be and his native land. When Diaghilev and the Russian Ballet left Barcelona for a tour of South America, Olga stayed behind.

Picasso in 1912 in his studio at 11 Boulevard de Clichy, Paris. Photograph by Frank Haviland.

Jean Cocteau. Portrait of Picasso, drawing. 1917.

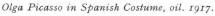

Olga Picasso in Spanish Costume, oil. 1917.

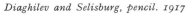

Diaghilev and Selisburg, pencil. 1917

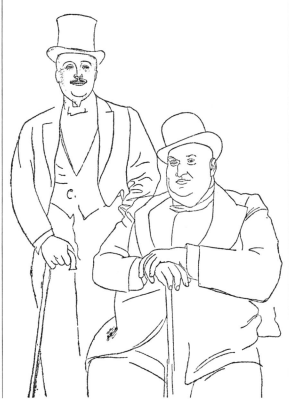

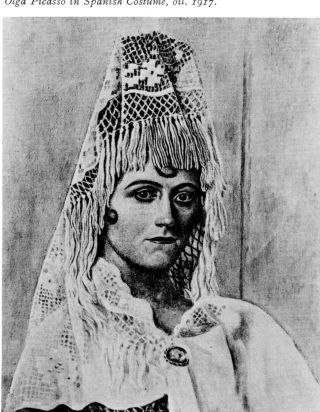

Corner of Rue Miromesnil and Rue La Boétie in Paris, pencil. 1919.

1918

Portrait of Olga Picasso, red chalk. 1921/1922.

Olga and Picasso were married in Paris on 12 July 1918; the witnesses were Guillaume Apollinaire, Max Jacob and Jean Cocteau. Picasso gave up the suburban house in Montrouge and they took a two-story apartment in Rue La Boétie, a fashionable quarter in the center of Paris. He now began a more regular life; he was better groomed than ever before. "Unbelievable the pains he takes with his clothes!" exclaimed his friend Sabartès.

The English painter, art critic and collector Roland Penrose, who did so much to familiarize the British public with Picasso's work, has described the move to Rue La Boétie: "Olga took an active part in seeing that the new drawing-room on the street and dining-room giving on to a garden were furnished according to her taste, and that there were sufficient goodlooking chairs to seat the numerous visitors whom she intended to entertain in correct style. Picasso made his studio on the floor above, taking with him his hoard of objects that had found their way into his life by choice or by chance."

The Studio in Rue La Boétie, pencil. 1920.

The war was not yet over and Kahnweiler, as a German national, was still in exile in Switzerland; his property in France had been confiscated. Picasso was now taken up by the dealer Paul Rosenberg, who had found his new apartment for him and who, in his gallery in the Faubourg Saint-Honoré, organized a joint exhibition of Matisse and Picasso from 23 January to 15 February 1918. Picasso showed not only cubist pictures but others in a naturalistic vein. The catalogue was prefaced by Apollinaire: "Picasso is the heir of all the great artists... He changes direction, retraces his steps, sets off again with a firmer step, continually growing, fortifying himself by contact with unexplored nature or by the test of comparison with his peers from the past."

He and his wife spent the late summer on the Atlantic coast at Biarritz, where he took up afresh the theme of girls on the beach. Henceforth, now that the bulk of his work was being handled by the dealer Paul Rosenberg and his brother Léonce, Picasso's painting began to reach a wider public.

On Armistice Day Guillaume Apollinaire died in Paris at the age of thirty-eight. Weakened by his war wounds, he was carried off in the great epidemic of Spanish 'flu that occurred at the end of the war. "With the death of Apollinaire Picasso lost the most understanding of his youthful friends. He was overcome with grief" (Roland Penrose).

1919-1920

Picasso's manner of life since his marriage disconcerted his friends. On 3 September 1919 Juan Gris wrote to Kahnweiler: "Picasso still produces some fine things when he has time between a Russian ballet and a fashionable portrait." And Max Jacob spoke ironically of this as his "Duchess Period".

Picasso remained in contact with Diaghilev and his company, who were now in London. There Picasso went in May 1919, with his wife and Derain, to design the curtain, sets and costumes for *The Three-Cornered Hat*, a ballet on a Spanish theme, taken from a novel by the nineteenth-century Spanish writer Pedro de Alarcón. Having commissioned the music from Manuel de Falla, Diaghilev turned to Picasso for the scenery. Here he was in his element and he went to work with gusto. Many sketches exist of the drop curtain, which represents a bull ring. He concerned himself with every detail of scenery and costumes, even including the dancers' make-up.

Portrait of André Derain, pencil. 1919.

Picasso spent three months in London. Returning to France, he went down to Saint-Raphaël on the Riviera, where he painted a long series of pictures representing a table in front of an open window.

After *The Three-Cornered Hat*, Picasso was called on again by Diaghilev and Massine to collaborate on a new project, a ballet called *Pulcinella* inspired by an episode from the *commedia dell'arte*. It was in Naples in 1917 that Picasso and his friends had seen and hugely enjoyed plays from the traditional repertory of the Neapolitan comedy. Early in 1919 Massine and Stravinsky were already working on this idea, and they turned to Picasso for the scenery. The first performance of *Pulcinella* took place in Paris in May 1920. Shortly afterwards, Picasso left for a summer stay at Juan-les-Pins on the Riviera.

Drop curtain for "The Three-Cornered Hat", size painting. 1919.

Portrait of Léonide Massine, pencil. 1919.

Stage design for "Pulcinella", watercolor. 1920.

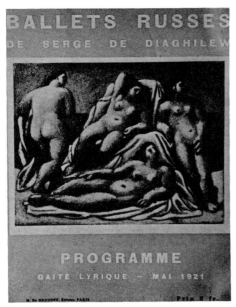

Program cover for Diaghilev's Russian Ballet. May 1921.

1921-1923

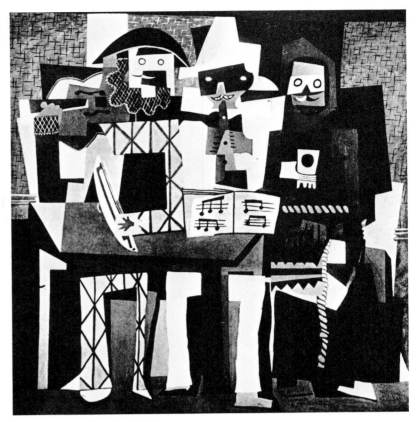

The Three Musicians, oil. Summer 1921.

The following year he designed sets and costumes for the ballet *Cuadro Flamenco*, which opened in Paris on 22 May 1921 at the Théâtre de la Gaîté Lyrique. The most famous and significant paintings of this year are the two versions of *Three Musicians*.

On 4 February 1921 his son Paul was born.

In 1922 Picasso painted the drop curtain for *L'Après-midi d'un Faune*, and he did the sets, curtain and masks for Cocteau's *Antigone*, performed in Paris at Dullin's Théâtre de l'Atelier. He spent the summer of 1922 at Dinard in Brittany.

Paul, the Artist's Son, oil. 1922.

"Those who set out to explain a picture usually go wrong. A short time ago Gertrude Stein elatedly informed me that at last she understood what my picture 'Three Musicians' represented. It was a still life!"

Picasso

Henceforth Picasso multiplied his cubist and naturalistic renderings in portraits, still lifes and landscapes. In a statement made to Marius de Zayas, published in *The Arts* (New York, May 1923), Picasso said: "I can hardly understand the importance given to the word *research* in connection with modern painting. To find, is the thing... The several manners I have used in my art must not be considered as an evolution, or as steps toward an unknown ideal of painting... I do not believe I have used radically different elements in the different manners I have used in painting."

Among the figures who regularly haunt Picasso's work, Harlequin occupies a privileged place. He appeared as early as the Rose Period, and while Cézanne imposed him on the Cubists as an ideal figure, he has never ceased to be present in Picasso, the archetype of the pictorial figures who lend themselves to all the experiments and all the expressions in which the artist records his own life.

Portrait of Olga Picasso, oil. 1923.

1924

During 1924 Picasso painted a drop curtain for the new Russian ballet *Le Train bleu* and worked for the last time with Massine on *Mercure*, with music by Erik Satie, who said in an interview for *Paris-Journal*: "Though it has a subject this ballet has no plot. It is purely decorative and you can guess what a marvelous contribution Picasso has made to it."

The first performance of *Mercure* took place in Paris on 18 June 1924 at the Théâtre de la Cigale, in Place Blanche. Its reception was on the whole unfavorable, but Breton, Aragon, Ernst, Péret, Soupault and their friends published a statement in *Les Soirées de Paris* on 20 June: "We desire to testify to our profound and total admiration for Picasso who, in the teeth of sanctions already received, has never ceased to create the modern state of restlessness and to provide the highest expression of it. Now with *Mercure* he again provokes general incomprehension, in giving the full measure of his boldness and talent. In the light of this event which takes on an exceptional character, Picasso, over and above those grouped around him, stands out today as the eternal personification of youth and the unquestioned master of the situation."

Since 1920 Picasso had got into the habit of spending his holidays in the South of France, either at Juanles-Pins or Cap d'Antibes. He was at home in the Mediterranean climate: "I don't want to pretend to clairvoyance, but really I was staggered: everything was there just as it was in the canvas which I had painted in Paris. Then I realized that this landscape was mine" (statement recorded by Antonina Vallentin).

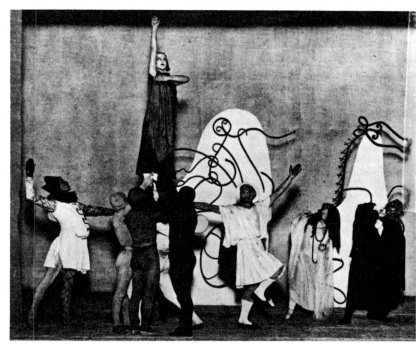

Scene from the ballet "Mercure", photograph. 1924.

Portrait of André Breton, drawing. 1923.

Page from "Les Soirées de Paris". June 1924.

"It remains for us to salute the example of Picasso. He teaches us not to confuse discipline and fear... He shows that personality lies not in the repetition of a bold stroke, but on the contrary in the independence afforded by a bold stroke. The reason why Picasso exploits none of his discoveries is to be found in the fact that they fall from him fully ripe. Everyone tries to find in them a point of departure, a seed, an unripe fruit, instead of savoring them in silence. For your Frenchman is fond of tombs; he despises youth, and only at a later day, when they are canned, does he treat himself to the fruits of the season."

Jean COCTEAU

Landscape at Juan-les-Pins, oil. 1924.

From 1919 to 1924 events in the art world followed each other at a dizzying pace; publications and exhibitions abounded, and a thousand new ideas were in the air. Cubism had made mincemeat of traditional aesthetics and radically changed accepted notions of painting. New directions in painting tended toward the abstract—Malevich and Suprematism, Mondrian and his researches into geometric poetry. In 1918 Ozenfant and Jeanneret (Le Corbusier) published *Après le cubisme*, the manifesto of Purism, and in 1920 they launched the review *L'Esprit Nouveau* in which they called for an art adapted to the modern world. In 1919, at Weimar, Walter Gropius founded the Bauhaus, the famous school of design which called for functional forms not only in architecture but in the applied arts, the graphic arts and even furniture.

In the midst of the war, in 1916, the Dada movement was launched in Zurich. A year later, in Barcelona, Picabia started the review *391*. Returning to Paris, where he soon attracted the Dadaists from Zurich (in particular Tristan Tzara), Picabia made contact with the young revolutionary poets André Breton, Aragon and Philippe Soupault, who had just founded the review *Littérature*. Dada was reborn in Paris. In 1921 the painter Max Ernst produced what are now some of his most famous pictures and exhibited his collages for the first time. All these artists and writers had the highest admiration for the innovating art of Picasso.

Laszlo Moholy-Nagy. Cover design for the first Bauhaus book. 1923.

Cover of the review "391" edited by Picabia.

Cover-poster for the Dada exhibition at the Galerie Montaigne, Paris 1920.

Invitation for the Dada exhibition, April 1921.

Title page of "L'Esprit Nouveau", No. 1, 1920.

238

In 1924 the surrealist movement took over where Dada left off. Its moving spirit was André Breton. He published the Surrealist Manifesto and on 1 December 1924 brought out the first issue of *La Révolution surréaliste*, the review in which he himself, Eluard, Aragon, Desnos, Benjamin Péret, Reverdy and Soupault were to develop a set of ideas which lie at the basis of one of the great cultural revolutions of our century. Among the participating painters were Max Ernst, Chirico, Masson, and a little later Miró, Arp and Tanguy. In this first number of the review a cubist relief by Picasso was reproduced. The poet Pierre Reverdy was one of the links between the painter and the young Surrealists. In 1922 Picasso had done the etchings which went to illustrate Reverdy's book of poems *Cravates de chanvre*. In the fourth issue of *La Révolution surréaliste* (15 July 1925), Breton published his important text *Le Surréalisme et la Peinture*, lavishly illustrated with works by Picasso. "Surrealism," wrote Breton, "if it wants to lay down a line of conduct for itself, has only to take the way which Picasso has taken and which he will continue to take; I hope in saying that to show myself very exacting. I shall always object to seeing an absurdly restrictive label applied to the activity of the man of whom we have the highest expectations. For a long time the cubist label has had this restrictive character. While it may fit others, it seems to me urgent that Picasso and Braque should be relieved of it."

Portrait of Pierre Reverdy, pencil. 1921.

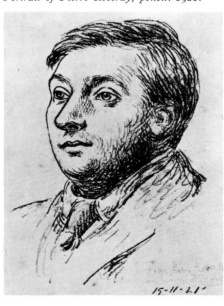

LA RÉVOLUTION SURRÉALISTE

IL
FAUT
ABOUTIR A UNE
NOUVELLE DÉCLARATION
DES DROITS DE L'HOMME

SOMMAIRE

Préface : J.-A. Boiffard, P. Eluard, R. Vitrac.
Rêves : Georgio de Chirico, André Breton, Renée Gauthier.
Textes surréalistes :
Marcel Noll, Robert Desnos, Benjamin Péret, Georges Molkine, Paul Eluard, J.-A. Boiffard, S. B., Max Morise, Louis Aragon, Francis Gérard.
Le rêveur parmi les murailles : Pierre Reverdy.

Chroniques :
Louis Aragon, Philippe Soupault, Max Morise, Joseph Delteil, Francis Gérard, etc.
Notes.
Illustrations : Photos Man Ray.
Max Morise, G. de Chirico, Max Ernst, André Masson, Pablo Picasso, Pierre Naville, Robert Desnos.

ABONNEMENT.
les 12 Numéros
France : 45 francs
Étranger : 55 francs

Dépositaire général : Librairie GALLIMARD
15, Boulevard Raspail, 15
PARIS (VII)

LE NUMÉRO :
France : 4 francs
Étranger : 5 francs

Cover of the first issue of "La Révolution surréaliste", 1 December 1924.

"The poet is in an always difficult and often perilous position, at the intersection of two cruelly sharp-edged planes, the plane of dream and that of reality. The prisoner of appearances... he overcomes the obstacle in order to attain the absolute and the real; there his spirit moves with ease. And thither he must indeed be followed, for what *is* is not this obscure, timid, despised body which you run into absentmindedly on the sidewalk—that body will pass away like the rest—but these poems lying outside book form, these crystals deposited after the mind's effervescent contact with reality.

"And underlying reality — the real—is what mind alone is capable of grasping, detaching, modeling, whatever in everything, including matter, obeys the mind's solicitation, accepts its dominion, avoids and escapes the fallacious sway of the senses. Wherever the senses rule reality fades and vanishes."

Pierre REVERDY,
La Révolution surréaliste,
No. 1, 1924

"A very narrow conception of 'imitation', taken as the aim of art, is the root cause of the grave misunderstanding which we see perpetuated down to the present... Painters have shown themselves too conciliatory in the choice of models. They erred in thinking that the model could only be taken from the external world... The magic power of figuration possessed by a happy few is put to sorry use if it serves only to preserve and reinforce that which would exist anyway, without those few. There has been an inexcusable abdication here. It is in any case impossible in the present state of thought, above all at a time when the external world seems to be of a more and more questionable nature, to agree any longer to such a sacrifice as this. If it is to answer the need for an absolute revision of real values, which all minds today agree in calling for, the work of art, then, must either refer to a *purely inner model* or fail to exist."

André BRETON,
La Révolution surréaliste,
No. 4, 1925

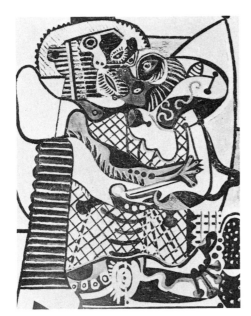

Seated Woman, oil. 1925.

1925

Still from Fernand Léger's film "Ballet mécanique", 1924.

Still from Luis Buñuel's film "Un Chien andalou", 1928.

Picasso departed now for good—except for an occasional drawing or print—from the classicizing spirit which had dwelt in his work for several years. Harmony was followed by convulsiveness, equilibrium by movement, serenity by stridence. Breaking away from naturalistic vision, Picasso moved steadily closer to Surrealism and seemed to fall in with André Breton's dictum: "Beauty will be convulsive or will not be."

Although primarily a literary movement, Surrealism also became an art movement. This year, at the Galerie Pierre in Paris, was held the first surrealist exhibition, showing works by Arp, Chirico, Max Ernst, Klee, Man Ray, Masson, Miró, Picasso and Pierre Roy; and in March 1926 the Galerie Surréaliste opened its doors. In 1925 Max Ernst produced his first rubbings, a technique which, with automatic writing and collage, represents one of the privileged means of access to super-reality through its capacity to record the upsurge of chance. Surrealism, moreover, soon spread to all fields of creative activity. In 1924 Fernand Léger had made a film in an entirely new spirit, *Le ballet mécanique*, and in 1928 Luis Buñuel was to make *Un Chien andalou*, a surrealist film which now ranks among the classics of the cinema.

"La Révolution surréaliste",
page from No. 6, March 1926.

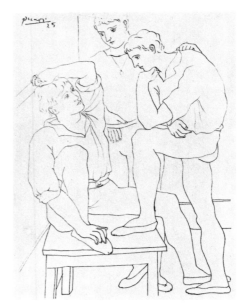

Three Dancers Resting, ink. 1925.

"Early in 1925, several months after the publication of the Surrealist Manifesto and several years after the appearance of the first surrealist texts (*Les Champs magnétiques* had begun publication in *Littérature* in 1919), the possibility that painting might meet the requirements of Surrealism was still being discussed. While some denied that there could be such a thing as surrealist painting, others felt that it was already latent in certain recent works or even that it already existed."

André BRETON, 1941

In Paris in January 1926 appeared the first number of the magazine *Cahiers d'Art*. Lavishly illustrated, this "monthly bulletin of current artistic events", aiming to establish itself as the "avant-garde review in all countries", was edited by Christian Zervos, an art critic of Greek origin. Thanks to the activities of his gallery and the wide readership of his magazine, Zervos made his offices at 14 Rue du Dragon into one of the nerve centers of the Paris art world, though he was never the exclusive supporter of any single tendency. Throughout his life, Zervos has defended Picasso's art with unfailing admiration and friendship.

Cover of "Cahiers d'Art" edited by Christian Zervos.

In 1927 Picasso made a series of etchings which were used by Vollard to illustrate an edition of Balzac's *Le Chef-d'œuvre inconnu* which he brought out in 1933. Among these etchings figures the theme of the Painter and his Model which, at several different times in the future, and in particular some twenty years later, was to become a major theme in Picasso's work, being continually taken up and renewed. Of the etching reproduced here, A. H. Barr has observed that one might really suppose that Picasso had in mind Balzac's hero, the painter Frenhofer, so strongly does this image suggest Frenhofer's obsessional search for an unattainable beauty. Other etchings treat the theme of the sculptor, a theme which reappeared again in the series published in 1937 and generally known as the Vollard Suite. He filled several sketchbooks with a long series of transformations or deformations of the human body, creating surrealistic figures suggestive of a hostile and impenetrable world.

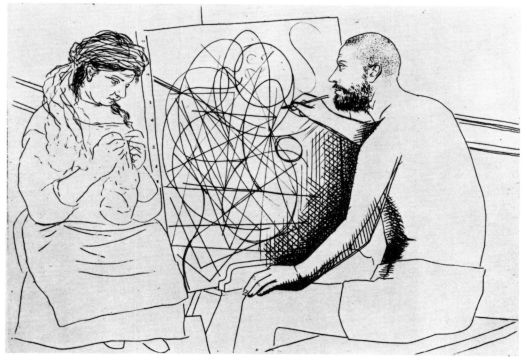

Painter and Knitting Model, etching for Balzac's "Le Chef-d'œuvre inconnu". 1927.

1926-1927

"The sturdy, vehemently handled figures he then represented bring before our eyes a series of astounding metamorphoses. Here again reference has been made to anamorphoses... For the artist himself, they represent a new organization of the visual world" (Christian Zervos).

An Anatomy, drawings.
February 1933.

Cephalus killing his wife Procris by mistake, etching for Ovid's "Metamorphoses". 18 September 1930.

Meleager slaying the Calydonian boar, etching for Ovid's "Metamorphoses". 18 September 1930.

1928-1933

In 1931 appeared the masterly series of thirty etchings done by Picasso in 1930-1931 to illustrate an edition of Ovid's *Metamorphoses* published by Albert Skira. An incomparably luminous beauty of line exalts the theme of metamorphosis, one peculiarly well suited to the spirit and character of Picasso's art.

"It is certainly not by chance that Picasso, whose whole work is a prestigious metamorphosis of the world, of himself, indeed of the painting of others, has now illustrated the *Metamorphoses*; or if it is, then chance has arranged things so well that it may be called destiny" (Pierre Guéguen).

Picasso was also busy now with sculpture. During the summer of 1927 he had conceived the idea of a series of monumental sculptures to be set up along La Croisette, the sea front at Cannes; he made a large number of designs for them, but nothing came of this bold project. For several years thereafter, however, "there was hardly a picture of his of this period which was not touched by the spirit of sculpture" (Christian Zervos).

Wire Construction. 1928/1929.

Sculptures in Picasso's studio at Boisgeloup. Photograph by Brassaï, 1933.

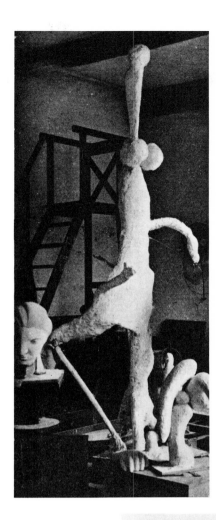

In 1930 Picasso bought the château of Boisgeloup, near Gisors (Eure), about forty miles northwest of Paris. There he fitted up a large sculptor's studio in one of the outbuildings. From 1929 on he turned more and more to sculpture, also doing some wire constructions, a technique into which he was initiated by his friend and compatriot Julio Gonzalez; he also worked in plaster and clay. "Later, in 1931, when he was working at sculpture—the Apollinaire Monument—I often heard him say: 'Once again I feel myself as happy as I was in 1908'... I have repeatedly noticed that no form leaves him indifferent; he looks at everything, at every turn, since for him all forms represent something; he sees everything with a sculptor's eye," wrote his friend Gonzalez, whom Maurice Raynal called the "sculptor of the void".

Brassaï was sent out by the review *Minotaure* to photograph Picasso's recent sculptures. He has told of his first visit to Boisgeloup:

"It was an odd sort of chateau—most of the rooms were completely unfurnished, with just a few large Picassos scattered here and there on the naked walls. He and Olga and Paulo occupied two small rooms beneath the mansard roof. We also made a whirlwind tour of the dilapidated little chapel, which was entirely covered with ivy. Picasso told us that it dated from the thirteenth century, and mass was still celebrated there on some occasions. But we were pressed for time. 'There are too many sculptures to photograph, and it will be dark very early,' he said, and led us off toward a row of barns, stables, and sheds that lined one side of the courtyard across from the house. I imagine that when he visited the property for the first time it was not so much the little chateau which had intrigued him as the sight of these vast, empty dependencies, waiting to be filled. He would at last be able to gratify a long-repressed desire: to sculpt really large statues. He opened the door of one of the great boxlike structures, revealing its multitude of sculptures, dazzling in their whiteness."

The sculpture studio at Boisgeloup. Photograph by Brassaï for "Minotaure", No. 1, 1933.

In a special issue of *Le Point* brought out in 1952, D. H. Kahnweiler published some notes of conversations he had had with Picasso on 2 October 1933.

"Picasso told me that to avoid casting he had just been making at Boisgeloup some concave sculptures in clay. He would then pour plaster into the hollows. The result was plaster sculpture in relief.

"Picasso: And I'd like to paint these sculptures. After all, painting will never be anything but an art of imitation... Obviously, line drawing alone evades imitation. That is why I was telling you the other day how much I liked the *Metamorphoses* [published by Skira with Picasso's etchings].

"D. H. K.: Yes, in line drawing there is no imitated light, whereas the very purpose of painting is to imitate light.

"Picasso: That's right, line drawing has its own light, self-created, not imitated."

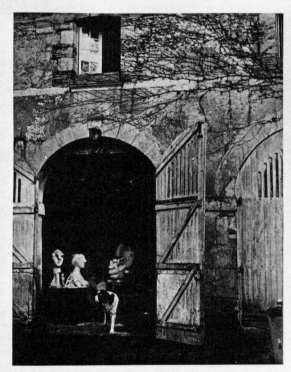

L'ATELIER DE SCULPTURE

DANS L'INTÉRIEUR DE CET ATELIER PHOTOGRAPHIÉ DE JOUR ET DE NUIT, SE TROUVENT LES SCULPTURES EXÉCUTÉES AU COURS DE CES DERNIÈRES ANNÉES: LES STATUES MÉTALLIQUES, LES CONSTRUCTIONS EN FIL DE FER, LES SCULPTURES EN BRONZE DORÉ, LA SÉRIE DES TÊTES MONUMENTALES, LES PETITES STATUES DE PLÂTRE, L'OISEAU, LA GÉNISSE ET LE COQ.

(Photographies exécutées par Brassaï.)

Picasso's cover design for the first issue of "Minotaure", 1933.

"One afternoon, when I went to see Picasso at his studio, I found him at work on the composition of the first cover for *Minotaure*. He was making a montage of rare light-heartedness. On a wooden plank, he had thumbtacked a section of crushed and pleated pasteboard similar to those he often used for his sculptures. On top of this he placed one of his engravings, representing the monster, and then grouped around it some lengths of ribbon, bits of silver paper lace, and also some rather faded artificial flowers, which he confided to me had come from an outmoded and discarded hat of Olga's. When this montage was reproduced, he insisted strenuously that the thumbtacks must not be neglected. On the twenty-fifth of May 1933 the first issue of *Minotaure* appeared, with this handsome work as its cover. In succeeding issues, Derain, Matisse, Miró, André Masson, René Magritte, Salvador Dali, each supplied his version of the monster for the cover of the review, measuring his strength against the fabled creature just as Theseus once had done."

Picasso's studio in Paris. Photograph by Brassaï, 1933.

The first issue of the review *Minotaure*, edited by Albert Skira, appeared on 25 May 1933, with a special cover illustration by Picasso, and indeed the bulk of the contents was devoted to him. It included a long study of his recent sculpture by André Breton, admirably illustrated with photographs by Brassaï, who had only arrived in Paris shortly before. Brassaï writes:

"*Minotaure!* Who proposed this title from among many others? Georges Bataille? André Masson? In any case, it was adopted unanimously and joyfully. It placed the review under a sign dear to Picasso. The fabulous creature made its first appearance in his work in 1927, in *Le Minotaure et la Femme Endormie*, and had long been one of his major themes. Several years later it was the inspiration for a whole series of prints included in the *Suite Vollard* and also for the beautiful etching *Minotauromachie*. And even after the distress of his marital difficulties Picasso maintained a predilection and fondness for his symbol, representing himself as a blind minotaur, or as the mythical beast harnessed to a chariot laden with household goods."

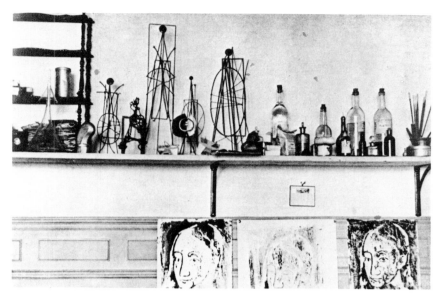

Shelf in Picasso's Paris studio. Photograph by Brassaï, 1933.

Article on Picasso by André Breton in the first issue of "Minotaure", 25 May 1933.

PICASSO

DANS SON ÉLÉMENT

par ANDRÉ BRETON

DANS LES ILLUSTRATIONS QUI ACCOMPAGNENT CETTE ÉTUDE,
L'ON PEUT VOIR LA PALETTE DE PICASSO, LES DIVERS
ASPECTS DE SON ATELIER A PARIS, SON ATELIER DE
SCULPTEUR A BOISGELOUP ET SES SCULPTURES RÉCENTES.

(Photographies exécutées par Brassaï.)

In his long article on Picasso's sculptures in the first issue of *Minotaure*, André Breton wrote:

"Now that certain pictures by Picasso are solemnly taking their place in all the museums of the world, what I admire most of all is the generosity with which he thus shares everything that must never be allowed to become a focus of feigned admiration or an object of speculation other than intellectual. In this too, the view he takes of his own work may be described as being absolutely dialectical. The time has come to emphasize the point, on the occasion of this bringing together and presentation in the first issue of this review of a large part of his recent *extra-pictorial* production.

"A sort of choir is organized around me in which I recognize the charmed and irritated voices of the younger generations: spare us the plaster, so eager and insatiable an artist as Picasso need not waste his time mixing plaster. Yet, I fear, the truth is that here it is their own dialectical sense and not his that is caught napping.

"A spirit so constantly, so exclusively inspired is capable of poetizing anything, of ennobling anything. He has in highest degree the knack of perplexing, of thwarting the dark designs of all those who, for unavowable purposes, attempt to set man against himself and, to that end, see to it, by working on his weak points, that he does not escape from the sickening uneasiness caused and maintained by the habit of dualistic thought."

André Breton,
Picasso dans son élément,
Minotaure No. 1, 1933

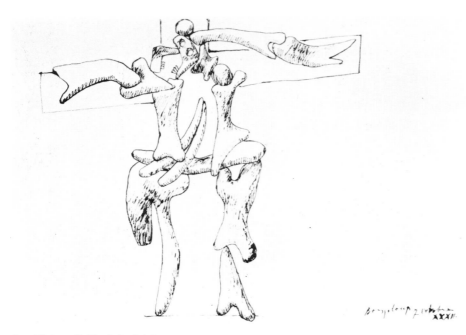

Crucifixion, India ink. October 1932.

In 1932 Marie-Thérèse Walter, a young woman he met by chance, entered his life. He was captivated by her youth and spirits, her robust vitality and fine, healthy figure. Deeply in love, he made many portraits of her both in sculpture and painting, endowing them all with a sensual expression often combined with an exhilarating sense of happiness which had not come over him for a long time.

The first issue of *Minotaure* was also illustrated with a series of Picasso drawings inspired by the central panel of Grünewald's Isenheim Altarpiece (Musée d'Unterlinden, Colmar), representing the Crucifixion. Picasso had already treated this theme in a painting of 1930 and reverted to it in 1932. To Brassaï, who had come out to photograph the drawings, he said: "I love that painting, and I tried to interpret it. But as soon as I began to draw, it became something else entirely." And Brassaï adds: "I mention this series for a specific purpose, since it was the first time, to my knowledge, that a great painting had touched off the creative spark in him and he had concentrated his energies on a masterpiece, in order to extort its secret."

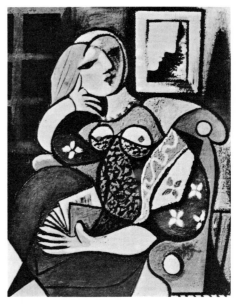

Woman holding a Book, oil. 1932.

Sculptor and Kneeling Model, etching. April 1933.

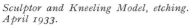

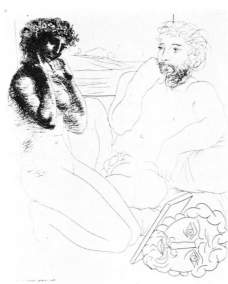

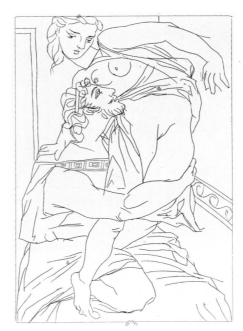

Cinesias and Myrrhina, etching for Aristophanes' "Lysistrata". January 1934.

At Boisgeloup Picasso worked a good deal at sculpture and did many engravings. In 1933 appeared Bernhard Geiser's *Picasso, peintre-graveur*, a catalogue of his graphic work from 1899 to 1931; it revealed to the public another unexpected aspect of his genius.

This same year Picasso began the set of engravings which later went to form the Vollard Suite. The copperplate printer Louis Fort, whom Vollard had introduced to Picasso, even brought out a hand-press and installed it in the Boisgeloup studio. Besides *The Sculptor's Studio*, the Vollard Suite includes *The Rape* and *The Minotaur*, violent themes which coincide with the first outbursts of those destructive forces which were soon to be unleashed over Europe.

In 1934 appeared the six etchings illustrating the *Lysistrata* of Aristophanes. These revert to the classical vein, though with an admixture of parody.

The worldwide depression of the early thirties worsened and brought political unrest in many countries. For Picasso, this climate of instability and insecurity coincided with the disruption of his own family life. During the summer of 1934 he made a long journey through Spain, going to San Sebastian, Madrid, Toledo and Barcelona. But by the end of 1934 his marriage had broken up. In 1935 Marie-Thérèse gave birth to a little girl, Maia. Picasso's working life was overshadowed by the emotional conflicts of this situation.

For a time Picasso stopped painting altogether. Contrary to his usual habits, he did not leave Paris during the summer of 1935. He wrote poems, some of which were published in a special number of *Cahiers d'Art* in February 1936. Late in 1935 he wrote to his old friend Jaime Sabartès, asking him to come and live with him in Paris, and Sabartès accepted.

According to Sabartès, Picasso at this time "took pleasure in setting down on paper, in the form of words, the images which before he had embodied in works of art. Sometimes the image dictates a word to him, and the word is the starting point of a memory or a thought; and if a contradiction appears at the tip of his pencil, he seizes upon it to disguise an emotion, just as he himself has shown a thousand times in his canvases, drawings and sculptures that without the help of the lie it is difficult to give credence to truth."

Plate with four etchings for "La barre d'appui" by Paul Eluard. 1936.

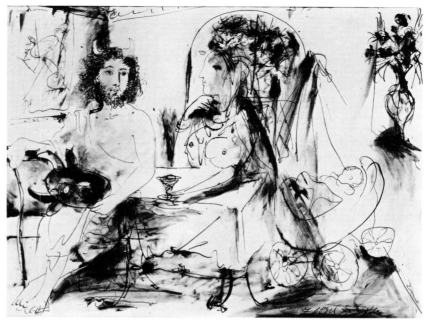

Young Faun, Woman and Child, India ink. 1936.

1934-1936

A close and lasting friendship sprang up between Picasso and the poet Paul Eluard, who with André Breton had played a prominent part in the rise of Surrealism and had been one of the most enthusiastic supporters of the review *Minotaure*. Eluard's young wife Nusch was about the same age as Marie-Thérèse, and her intriguing, rather enigmatic charm inspired several portraits of her which number among Picasso's most famous works. Early in 1936 Eluard went to Spain on the occasion of the large Picasso retrospective exhibition—the first exhibition in his own country since 1901—which was shown in Barcelona, Bilbao and Madrid. The lecture on Picasso's work given by Eluard in Barcelona remains one of the most penetrating and sensitive appreciations of his art. It was entitled: *Je parle de ce qui est bien*, I speak of what is good.

In Paris a Picasso exhibition at the Galerie Rosenberg was also a resounding success. Finding himself too much in the limelight, he went down to Juan-les-Pins in March. "A good day, I have seen my friends without a care in the world," wrote Eluard in May, about the time when Picasso engraved a plate with two poems dedicated to Eluard. A month later, Eluard wrote his marvelous poem *Grand air*, which Picasso surrounded with ornamental figures.

Both in Spain and France, these were the triumphant days of the Popular Front. Then, in July 1936, civil war broke out in Spain. Picasso was named director of the Prado by the Republican government.

Portrait of Paul Eluard, pencil. January 1936.

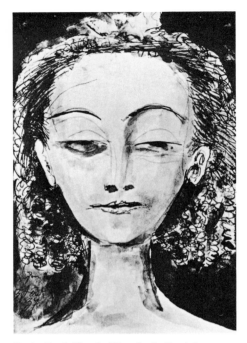

Portrait of Nusch Eluard, India ink. 1937.

As civil war spread through Spain, history made its tragic irruption into Picasso's life and work. To its miseries and sorrows, to the slaughter and bestiality that attended it, Picasso and Eluard replied by denouncing aggression and cruelty. They created a new and poignant language to speak of the drama and tragedy of Spain, which they recognized as the prelude to the convulsion that was soon to afflict the whole of Europe. From now until the poet's death (in 1952), Picasso was on the closest terms of friendship with Eluard, sharing with an equal generosity his friend's unrelenting struggle in the cause of peace.

Bust Figure of a Woman, oil. November 1936.

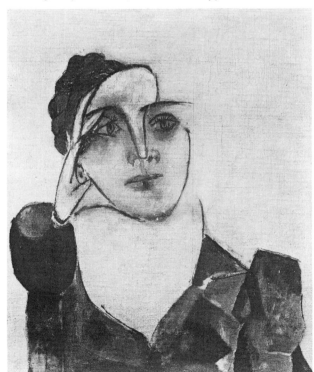

Paul Eluard photographed in his Paris apartment in Rue Marx-Dormoy by Brassaï, 1942.
On the wall, Picasso's portraits of Dora Maar and Nusch Eluard, the latter now in the Musée d'Art moderne, Paris.

At this period, the portraits he made of Nusch and of Dora Maar, a young woman painter and photographer introduced to him by Eluard, are the only bright spots, together with the pictures of his daughter Maia, in a darkening and dramatic context.

Dora Maar Asleep, pencil. March 1937.

The month of August 1936 Picasso spent with Paul Eluard at Mougins, a hilltop village near Cannes, while Dora Maar was staying with friends at nearby Saint-Tropez. By the time he got back to Paris her image was gradually invading his painting. At this time he also worked in a studio fitted up at Le Tremblay-sur-Mauldre, near Versailles, which Vollard had placed at his disposal; Picasso worked there repeatedly up to 1939. At Le Tremblay he painted several interiors, some still lifes and a series of large nudes on the beach.

"To think that so many of us were afraid of the storm. Today it is taken for granted that the storm was life. To think that so many of us were afraid of lightning, afraid of thunder. How naïve we were! The thunder is an angel, the lightning flashes are its wings, and we never went down to the cellar to avoid seeing the horror of nature on fire. Today it is the end of our world, each one of us shows his blood."

Paul ELUARD,
commentary for the film on *Guernica*
produced by Alain Resnais
and Robert Hessens in 1950

Minotaur embracing a Woman. January 1936. This drawing was used as a frontispiece for "Dépendance de l'Adieu" by René Char, Paris, G.L.M. 1936.

The Dream and Lie of Franco (Sueño y Mentira de Franco), etching and aquatint. January 1937.

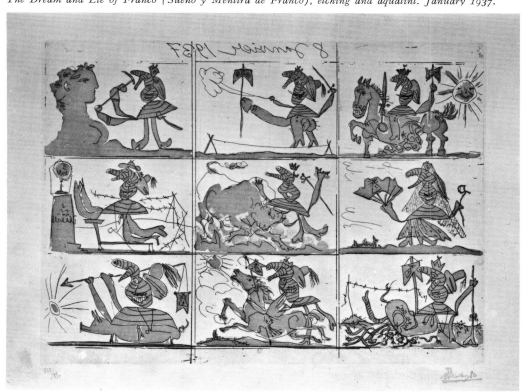

The war in Spain was a source of anxious concern to him. "He had lost Spain and here was Spain not lost, she existed, the existence of Spain awakened Picasso" (Gertrude Stein). Eluard, for his part, was increasingly sympathetic to the Communist Party. On 17 December, in the French Communist paper *L'Humanité*, he published a poem on the Spanish Civil War, *Novembre 1936*, which profoundly stirred the European conscience.

On 8-9 January 1937 Picasso wrote and illustrated a virulent pamphlet, *Sueño y Mentira de Franco* (The Dream and Lie of Franco), denouncing him as the apostle of violence and cruelty. Using the style of the comic strip, he identified Franco with a horse, while the valiant Spanish people was given the image of a bull. *Dream and Lie* consists of two etched plates, the first divided into nine scenes, the second into five, each measuring $3\frac{1}{2} \times 5\frac{1}{2}$ inches. A second state heightened with aquatint was printed on 25 May, and in a third state engraved on 7 June Picasso completed the second sheet with four additional scenes. These eighteen designs were subsequently printed on post cards and sold for the benefit of the Spanish Republic.

AU PONT BINEAU
deux voitures se sont rencontrées

L'avant d'une des voitures témoigne de la violence du choc. **LIRE PAGE 3**

L'accident
d'une grande violence
a fait deux morts
et deux blessés graves

Le dépeceur COLLINI
était-il l'adepte
d'une secte ?...

Les Assises du Rhône jugent aujourd'hui ce personnage étrange

De notre envoyée spéciale Edith THOMAS

Lyon, 30 avril. — (Par téléphone). — Lyon, ville obscure, enfumée, rues mornes, fleuve blafard ; quelque chose de la grandeur démesurée de Londres avec une tristesse plus pressante encore.

Le gris colle aux pierres comme à la peau, et c'est peut-être pourquoi l'on tente de s'évader plus qu'ailleurs et par les pratiques les plus mystérieuses et les plus folles ; celles d'un autre temps où la terre hostile et incompréhensible ne pouvait être dominée que par magie ou sortilège.

(LIRE LA SUITE DANS LA 3ᵉ PAGE)

LE CUIRASSE INSURGE
"ESPANA" coulé devant Bilbao

(D'UN DES ENVOYES SPECIAUX DE L'AGENCE HAVAS)

Bilbao, 30 avril. — Le cuirassé insurgé « Espana » a été coulé par l'aviation loyale.

6ᵉ édition

Ce soir
GRAND QUOTIDIEN D'INFORMATION INDÉPENDANT

6ᵉ édition

PREMIÈRE ANNÉE — NUMERO 41

Ope. 99.34 - 15.60 (8 lig. groupées) — 30 cent. Samedi 1ᵉʳ Mai 1937 30 cent. — 31, rue du 4-Septembre, Paris-2ᵉ

CE QUE SERA LA FÊTE DU TRAVAIL

Deux grands cortèges défileront demain
A TRAVERS PARIS
pour se disloquer à la porte de Vincennes

Avant la dislocation MM. Léon Jouhaux et Henri Raynaud prononceront des discours qui seront radiodiffusés par les postes d'Etat

Qui n'a pas son brin de muguet porte-bonheur ?

Les organisations ouvrières assureront le transport des manifestants et les besoins normaux de la population

M. RACAMOND secrétaire général adjoint de la C. G. T.
dit à "Ce soir" le sens de cette journée

M. Racamond nous a reçu dans son bureau du nouvel immeuble de la C. G. T., un building blanc et ensoleillé, digne d'une organisation forte de cinq millions d'adhérents.

« Nous nous préparons, nous a-t-il dit, à célébrer, en ce Premier Mai 1937, les victoires obtenues par des luttes longues et rudes. Cette année, le 1ᵉʳ Mai sera la fête des quarante heures, des congés payés, la fête célébrant une vie un peu plus saine et un peu plus joyeuse pour les travailleurs.

« Toutefois, beaucoup reste encore à faire !

« Trop souvent, les réformes décidées, sournoisement sabotées, restent lettre morte. C'est pourquoi nous nous préparons également à rendre sensible à l'opinion, le 1ᵉʳ Mai, notre légitime impatience de voir enfin les lois sociales *effectivement* et *loyalement* appliquées, avant d'être étendues à des catégories toujours plus larges de travailleurs...

« Malgré la pression patronale et la concurrence des syndicats fondés par le grand patronat, nous enregistrons tous les jours de nouvelles adhésions...

« Les effectifs de presque toutes nos fédérations sont constamment en progrès...

« Notre plus cher désir est de voir l'unité syndicale, qui a donné de si brillants résultats sur le plan national, se réaliser enfin sur le plan international.

« Dites que ce 1ᵉʳ Mai sera l'expression de cette volonté qui s'affermit tous les jours...

« Enfin, le bilan, satisfaisant bien qu'incomplet, de notre action, ne nous fait pas oublier ce qui n'a pas cessé de nous préoccuper : l'aide à l'Espagne républicaine aux prises avec le fascisme international. Dites encore aux lecteurs de votre journal que le 1ᵉʳ Mai, nous signifierons notre

résolution de ne pas tolérer l'invasion du sol espagnol par les armées étrangères ; c'est l'intérêt de la France elle-même.

« Il faut que cesse enfin la carence des démocraties, que des mesures soient prises, mettant fin aux actes de guerre internationale que constitue l'intervention fasciste en Espagne.

« Voilà le sens que nous allons donner à la fête du Travail du 1ᵉʳ Mai. »

LES DEUX CORTEGES

Cette année, le défilé formera deux cortèges, qui se rejoindront à la place de la Nation, pour aller, sur double largeur, jusqu'à la Porte de Vincennes.

Les travailleurs seront groupés, cette fois, par profession, avec leur syndicat.

La tête du cortège, place Voltaire, sera composée par le Bureau et la Commission administrative de la C. G. T., et de l'Union des Syndicats de la Région parisienne. Les membres du Comité national et régional du Front Populaire sont invités.

Puis, par le boulevard Voltaire, la place de la République, le boulevard Magenta, le faubourg Saint-Martin, jusqu'au rond-point de la Villette, se formera le premier cortège.

Le second cortège partira de la place de la Bastille, par la rue de Lyon, l'avenue Daumesnil et le boulevard Diderot. La concentration aura occupé les boulevards, entre la Bastille et la République, le boulevard du Temple, la rue Réaumur et le boulevard Sébastopol, jusque vers le Châtelet.

Le premier groupe du premier cortège sera formé par les syndicats du Bâtiment, le premier groupe du deuxième cortège par les métallurgistes, et les deux plus grandes Fédérations de la région marcheront côte à côte sur le Cours de Vincennes. **LIRE EN PAGE 3**

VISIONS DE GUERNICA EN FLAMMES
A Galdacano 22 trimoteurs allemands ont mitraillé la population

Un de nos photographes vient de rentrer de Guernica avec ces photographies qui montrent la ville historique en flammes et un vieillard de 81 ans que les bombes ont blessé. On lira dans la page 3 le récit de notre reporter photographe, les informations et les dépêches de notre envoyé spécial Mathieu Corman

300 millions d'œuvres d'art arrivent à Paris

« La Vierge », de Jean Fouquet, du musée d'Anvers

...Pour l'exposition des chefs-d'œuvre de l'art français : 18 nations ont contribué à son succès

par Georges-Henri RIVIERE

Lire l'article dans la neuvième page

A 950 MÈTRES SOUS TERRE UNE EXPLOSION...
Dix-sept victimes dont deux ont succombé sont ramenées à la surface

(De notre correspondant particulier)

Charleroi, 30 avril. — (Par téléphone). — A six heures, ce matin, l'aube était à peine levée qu'une nouvelle sinistre se répandait dans les quartiers populeux de Marcinelle.

— Un coup de grisou au Grand-Mambourg ! se répétaient avec effroi les femmes dont les maris étaient déjà descendus à leur travail.

Hélas ! cette veille du 1ᵉʳ mai, qui est toujours célébrée avec un particulier ferveur par les mineurs de Charleroi, se transformait en une veillée de deuil.

Lire la suite dans la 3ᵉ page

L'agent de Franco à Toulouse interviewé malgré lui

Lire l'article de Charles REBER dans la neuvième page

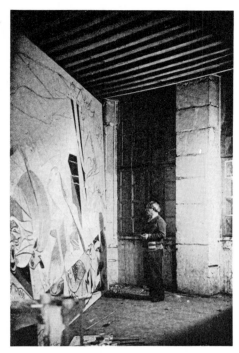

Picasso in his Paris studio in front of "Guernica". Photograph by Dora Maar, 1937.

1937

Picasso promised the Spanish Republican government to take part in decorating its pavilion at the Paris World's Fair. He thought vaguely of some large composition which would strike the public, but had not yet fixed on any precise theme. Early in the year he fitted up a large studio in Rue des Grands-Augustins, in a seventeenth-century house near the Seine, on the Left Bank, which Dora Maar had found for him; he also rented an apartment on the next floor above, and it was there that he lived and worked throughout the German Occupation.

On 26 April German bombers in Franco's service raided the small Basque town of Guernica, a place of no strategic importance. Bombed steadily for three hours in broad daylight, the town was totally destroyed and two thousand people killed. The world was stunned by the news.

Here was the theme of his mural for the Spanish pavilion, and on the first of May an angry, indignant Picasso set to work on it. The work went on throughout the month of May, as he multiplied his sketches and studies and gradually transposed them onto the huge canvas ($11\frac{1}{2} \times$ 26 feet). He carried it out by detail, and Dora Maar made a photographic record of each stage. "In this way," said Picasso, "one might perhaps understand the mental process leading to the embodiment of the artist's dream."

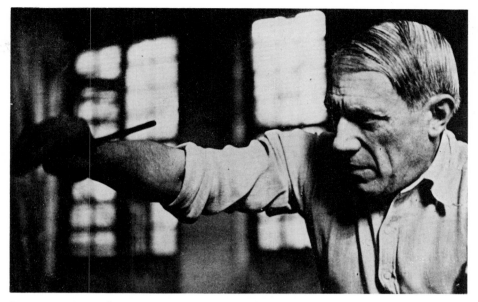

Picasso working on "Guernica". Photograph by Dora Maar, 1937.

Fully conscious of the message he had to give, he stated:

"The Spanish war is the fight of reaction against the people, against freedom. My whole life as an artist has been nothing but a continuous struggle against reaction and the death of art. In the panel I am now working on, which I shall call *Guernica*, and in all my recent works, I clearly express my abhorrence of the military caste which has plunged Spain into an ocean of pain and death."

The finished work met with a mixed reception. After some hesitation, it was exhibited in the Spanish pavilion at the Paris World's Fair alongside a poem by Paul Eluard, *La Victoire de Guernica*.

"In a black and white rectangle, so that the ancient tragedy is made visible for us, Picasso sends us our letter of bereavement: everything we love is about to die. And so it was necessary that everything we love should be summed up, like the outpouring of great gods, in something unforgettably beautiful."

Michel Leiris

"Guernica" on view in the Spanish pavilion at the Paris World's Fair, 1937. In the foreground, Calder's "Fountain of Mercury".

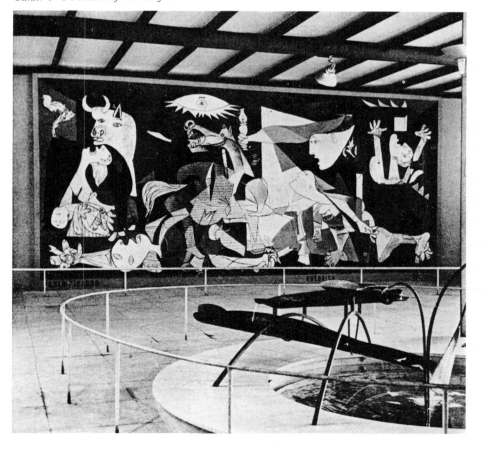

Picasso canvases exhibited at the Musée du Jeu de Paume, Paris 1937.

1938-1939

In 1939 a memorable Picasso retrospective exhibition was organized by Alfred H. Barr at the Museum of Modern Art, New York, and later shown at the Art Institute of Chicago; grouping over 350 paintings, sculptures, watercolors, drawings and prints, it firmly established Picasso's fame in the United States.

With the fall of Madrid on 28 March 1939 and that of Valencia on the 29th, the Spanish Republic virtually ceased to exist. That same month, Hitler entered Prague in violation of the Munich agreement. The mood and imagery of Picasso's painting reflected these events, growing ever more somber and anguished.

He spent the early summer on the Riviera, at Antibes, where Sabartès joined him. At the news of Vollard's sudden death on 23 July, he hurried back to Paris for the funeral, shaken and saddened by the loss of one who had been among the first to give him understanding and support. Then he returned to Mougins and Antibes. He painted a huge canvas, *Night Fishing at Antibes*, inspired by the sight of the fishermen using acetylene lamps to attract their catch—a scene he often watched during his evening walks in the port with Dora Maar.

In conjunction with the Paris World's Fair, a large exhibition entitled "Masters of Independent Art from 1895 to 1937" was to be held in the Petit Palais. After choosing the works of the leading contemporary painters and having them shipped to Paris at great expense, the organizing committee decided that they were unworthy of the rooms of honor which were to be visited by the President of the Republic and they were relegated to the basement of the museum.

A counter-exhibition was accordingly organized by Yvonne Zervos at the Jeu de Paume. Centering on Picasso, Matisse, Braque and Léger, it offered the public a genuine retrospective of modern art: Fauvism, Cubism, Futurism, Purism, Dada, Surrealism, and other works, still little known, by Delaunay, Kandinsky, Kupka and the young Hartung.

In late spring Picasso went back to Mougins with Dora Maar. He paid a visit to Matisse in Nice and in the autumn made a brief trip to Bern to meet Paul Klee.

As the Spanish Civil War continued, storm clouds gathered over Europe. On the night of March 11 and 12, 1938, Austria was taken over by Hitler's troops. Fear and anguish spread through Europe, and their specter loomed up in Picasso's work, even in simple, everyday subjects: still lifes with oranges, jugs and heads, a woman holding a rooster, or portraits.

A large international surrealist exhibition was organized in Paris by André Breton and Paul Eluard early in 1938 at the Galerie Beaux-Arts, in Rue du Faubourg Saint-Honoré. With this show, pre-war Surrealism had shot its bolt. It was an immense success with the fashionable public that milled around a host of disconcerting inventions: a ceiling hung with 1200 sacks of coal, revolving displays, "magic eyes", "perfumes of Brazil" (roasting coffee), etc. All the Surrealists were present, but Picasso stood aloof despite his close ties with Paul Eluard. The war was soon to separate all these artists and scatter them over the world.

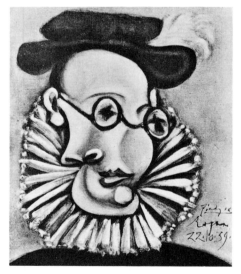

Portrait of Jaime Sabartès as a Spanish Grandee, oil. 1939.

Official posters announcing mobilization orders began to appear on the walls of Antibes. He finished his big canvas and on 26 August, a few days before the outbreak of war, he was back in Paris—only to leave again shortly with Dora Maar for Royan, near Bordeaux, where he lived for the rest of 1939 and most of 1940.

Invitation to the International Surrealist Exhibition at the Galerie Beaux-Arts, Paris 1938.

Picasso broke his stay at Royan with several brief trips back to Paris in order to obtain the residence permit which, as a foreigner, he needed to live in wartime France, and also to buy painting materials. His dramatic style reflected the tension of these suspenseful days.

From March on, he remained in Paris, returning to Royan on 17 May as the Germans were overrunning northern France; and there he stayed until August. *Café at Royan*, painted in that month, is a sort of farewell to the little town on the Gironde estuary. Though well knowing that he was considered by the Nazis one of the arch-exponents of "degenerate art," he refused invitations to take refuge in the United States and went back to Paris. There, in his bare, comfortless studio in the Rue des Grands-Augustins, on the Left Bank, he lived and worked, unmolested, for the next four years.

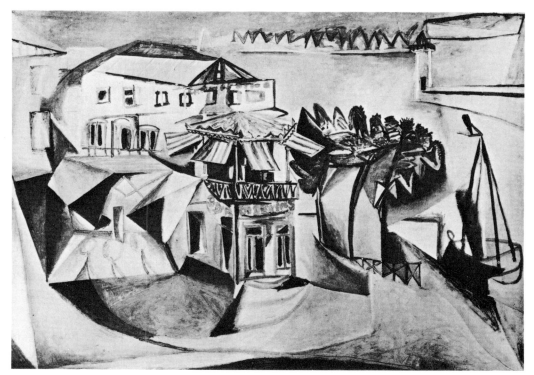

Café at Royan, oil. August 1940.

1940

Self-Portrait, pencil. August 1940.

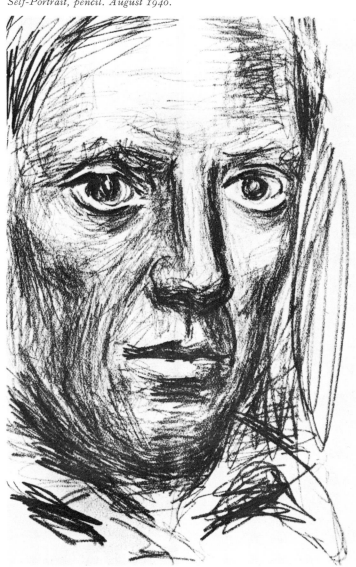

Picasso in his Paris studio in Rue des Grands-Augustins during the war. Photograph by H. Roger Viollet, Paris.

1941-1943

During the years of the German occupation, his output was steady and abundant. He made portraits of his friends, Dora Maar and Nusch Eluard above all, painted landscapes and still lifes. He took up sculpture again and wrote a short play, *Desire caught by the Tail*, which he finished on 17 January 1941; it was to be performed privately in 1944. "He had simply allowed his mind to wander, following the dictum of 'automatic writing', a verbal trance that gives full rein to dreams, obsessions, unconfessed desires, odd confrontations of ideas and words, absurd and everyday banalities. Picasso's sense of humor and inexhaustible spirit of invention are revealed in it in their purest form" (Brassaï).

His ties with his Paris friends, Christian and Yvonne Zervos, Paul Eluard and his wife Nusch, Michel and Louise Leiris, became closer than ever.

"Chasuble of blood flung over the bare shoulders of green wheat shivering between wet sheets symphonic orchestra of mangled flesh hanging from the blossoming trees of the ochre-painted wall shaking its great apple-green and mauve-white wings tearing its beak against the panes architectures of congealed soot on the waves of perfumes of earth of music and of birds shopping basket full of food supplies surrounded by climbing roses stitched like a swarm of bees in the loose hair of the landscape basking in the sun, the four paws of the mountain of rice of the rocks lying on the stones sinking in the mud of the sky up to the heels—the plough's hanging tongue sticking to the tilled fields sweating the leaden weight of the effort committed in the center of the bouquet twisted by the chains of the teeth of the flowers surprised amidst the rough skin of their eyes staring up and down the dress and its torn folds, the wear and tear of the cloth covered with stains the thousand and one rents its dirtiness, the vermin the golden arches of stone strutting and swaggering and windows closed in the distance on the houses..."

Picasso, 13 May 1941

Shutting up his Right Bank apartment in Rue La Boétie (a reminder now of too many painful memories), Picasso installed himself for the duration in the rooms above his Left Bank studio in Rue des Grands-Augustins, near the Seine. He scarcely left it during 1942, one of the bleakest, most trying years of the occupation. Something of its hardships and hopelessness may be read into his canvases, with their stark, essential, emphatic forms, of an immediate, unmistakable significance. Sometimes his subjects are the commonplace things of daily life: the view from his window, a chair in his studio, etc. Sometimes he reverted to familiar themes of the past, a seated woman or a reclining nude, bearing a cruel significance and an almost intolerable violence in the tragic break-up of their forms; one among many is *L'Aubade*, which seems to be a parody of the *Concerts* of which the Venetian masters were so fond. On 27 March his old friend the sculptor Julio Gonzalez died in Paris. Picasso attended the funeral.

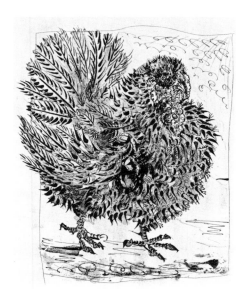

The Turkey, etching for Buffon's "Histoire naturelle". 1940–1941.

This same year, Vollard's successor Martin Fabiani succeeded, though the times were unpropitious and the difficulties many, in publishing a limited, de luxe edition of Buffon's *Histoire naturelle* illustrated with etchings by Picasso. These, together with the etchings for Ovid's *Metamorphoses* (1932), are probably his finest book illustrations.

During the summer he made many preliminary drawings for *Man carrying a Sheep*, his most popular piece of sculpture. Cast in bronze after the war, it was set up in the little square in the center of Vallauris.

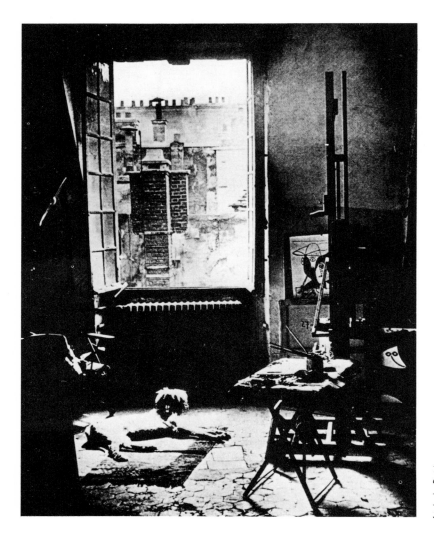

The studio in Rue des Grands-Augustins, Paris.
Photograph by Brassaï, 3 May 1944.

254

Studies for "Man carrying a Sheep", India ink. 1942.

Picasso worked on *Man carrying a Sheep*. He illustrated books by his friends Georges Hugnet, Robert Desnos, Eluard. He painted still lifes and above all landscapes. To André Malraux, who wondered at his landscapes of Paris, he said: "It surprises you, doesn't it? I have never been considered a landscape artist. And, in a way, it's true. I haven't painted many landscapes in my life. But it just happened. Since I couldn't travel during the occupation, I often walked along the Seine... and I drank in all the images of the trees along the quais, the Pont Neuf, the Pont Saint-Michel. Then one day all of these things which had become part of me without my even knowing it began to come out" (Brassaï).

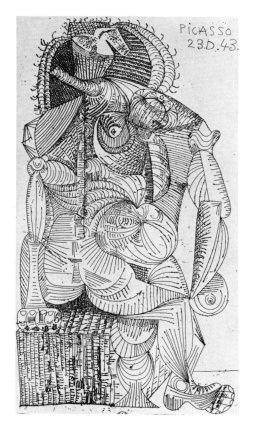

Etching for "Contrée" by Robert Desnos. 1943.

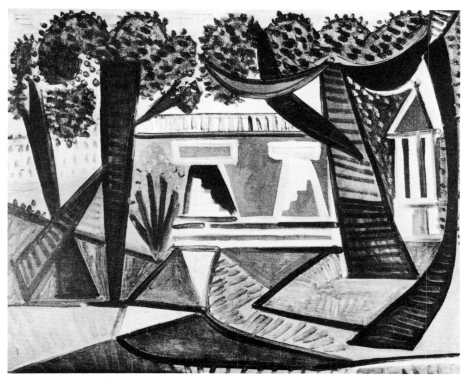

The Vert-Galant, Paris, oil. June 1943.

Frontispiece for "La chèvre-feuille" by Georges Hugnet, line engraving. 1943.

"The war made itself felt in Picasso's work. Not that he painted monsters, as people suppose. He has always painted the women he loved. At the beginning of the war, throughout the war, it was Dora Maar. He had no wish to present her as a monster. But there is something else. As Picasso told me himself: 'At the time the Germans were overrunning France I was at Royan and one day I did a portrait of a woman (it was Dora Maar), and when the Germans arrived a few days later I saw that the head resembled a German helmet.' Obviously he didn't make a monster, but all the same the war is in every one of his pictures. An ivory tower is all very well, but any painter in whose work a war like that of 1940-1945 could not be felt, I don't mean in externals but through almost imperceptible things, well, that man would not be a great painter."

D. H. Kahnweiler

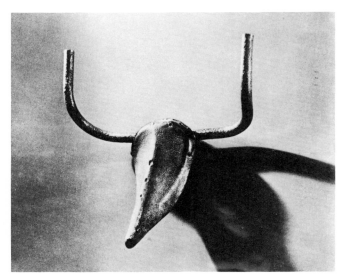

Bull's Head, bronze. 1943.

"Guess how I made that head of a bull. One day, in a rubbish heap, I found an old bicycle seat, lying beside a rusted handlebar... and my mind instantly linked them together. The idea for this *Tête de Taureau* came to me before I had even realized it. I just soldered them together. The thing that's marvelous about bronze is that it can give the most diverse objects such unity that sometimes it's difficult to identify the elements that make up the whole. But that's also a danger: if you no longer see anything but the head of a bull, and not the bicycle seat and handlebar that formed it, the sculpture would lose its interest."

On 19 March 1944, a few months before the end of the occupation, an improvised performance of Picasso's play *Le désir attrapé par la queue* took place in the Paris apartment of Michel and Louise Leiris, she the sister-in-law of D. H. Kahnweiler and manager of his gallery, he a writer and ethnologist, the author of many texts on painting, both of them old friends of Picasso.

"The idea for this presentation—or, more accurately, this reading—of the play came from Michel Leiris, I believe. He confided the direction to a man of the theater: Albert Camus... Leiris played the role of Bigfoot; Raymond Queneau was Onion; Jean-Paul Sartre, Roundbutt; Georges Hugnet, Fatty Agony; Jean Aubier, the Curtains; and Jacques-Laurent Bost, Silence... Zanie de Campan, Louise Leiris, Dora Maar, and Simone de Beauvoir shared the feminine roles... There were several afternoons of rehearsal in the Leiris apartment, and Picasso sometimes attended these—worried, but also intrigued and moved.

"On the day of the reading, a considerable audience crowded into the apartment. Braque was among the many artists and writers present" (Brassaï).

Picasso's studio in Rue des Grands-Augustins, Paris. Photograph by Brassaï, 1944.

Gathering in Picasso's studio in Rue des Grands-Augustins for a reading of his play "Desire caught by the Tail". Photograph by Brassaï, 1944.

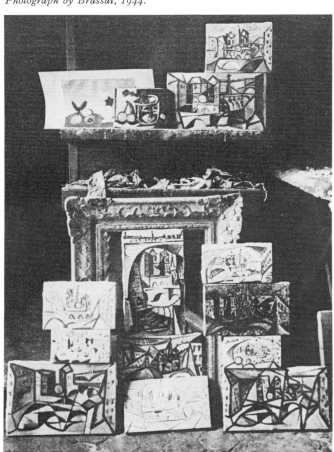

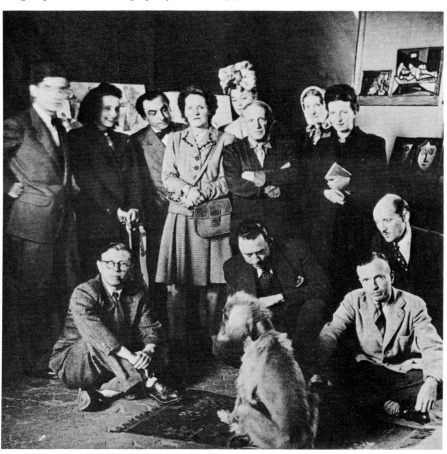

Catalogue of the 1944 Salon d'Automne.

On 5 October *L'Humanité*, the communist daily, announced that Picasso had joined the French Communist Party. In an interview published in *L'Humanité* on 29 October, Picasso made the following statement: "My joining the Communist Party is the logical outcome of my whole life, my whole work. For I am proud to say that I have never considered painting as an art intended merely for pleasure and amusement. Through line and color, since those are my weapons, I have tried to penetrate towards an ever deeper knowledge of the world and of men, so that that knowledge may liberate us all a little more each day. I have tried, in my own way, to utter what I considered the truest, the rightest, the best, and naturally this was always the most beautiful, as the greatest artists know very well.

"Yes, I am conscious of having always struggled through my painting as a genuine revolutionary. But I have realized now that even that is not enough; these years of terrible oppression have shown me that I must fight not only through my art, but with my whole being."

Presentation text of the Liberation Salon, Paris, autumn 1944.

1944

A few days after the opening of the Salon d'Automne, an outbreak of violent protest occurred among a party of visitors in the room where Picasso's works were exhibited. Angered by an art which they could not understand and resenting the artist's political commitment to Communism, they made a disturbance and attempted to remove some of the offending paintings. But on the whole Picasso's wartime work received an enthusiastic reception at this exhibition, especially among his fellow artists, to whom it seemed to herald a wholesome restoration of artistic freedom after the dark years of Nazi oppression.

"I knew that this demonstration would take place. Some young hotheads who seemed to be followers of Doriot [a French Fascist leader] and had better things to do than enlist in the Resistance forces, together with some middle-aged, rather too righteous-minded gentlemen, ran along the line of pictures in the Picasso room, shouting 'Money back!' and 'Down with them!' And in fact they did take some canvases down and would have trampled them underfoot, had not the artists present snatched them out of their hands," wrote André Lhote in *Les Lettres françaises.*

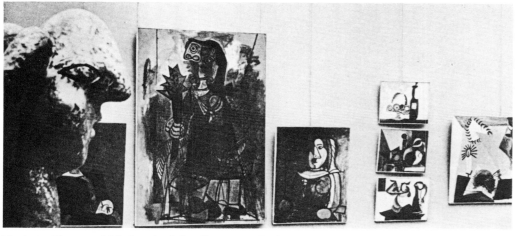

Works by Picasso exhibited at the Salon d'Automne, Paris 1944. Photograph by Marc Vaux, Paris.

Paris was liberated on 25 August 1944. Six weeks later the Salon d'Automne opened its doors. Picasso was invited to participate and a whole room was set aside for him. For the first time in his life he exhibited at the official autumn salon: 74 paintings and 5 sculptures, all done during the war. In *Les Lettres françaises*, the leftwing literary weekly edited by Jean Paulhan and Paul Eluard, Louis Parrot wrote on 7 October: "It is right and fitting that the artists of Paris who have helped in the liberation of the capital should pay homage to the painter who has most effectively symbolized the spirit of the Resistance."

Most of his friends, notably Eluard, had already joined the party. Moreover Picasso was on friendly terms with Laurent Casanova, one of the intellectual leaders of the French Communist Party, who during the dangerous years of the Resistance had repeatedly taken refuge in the apartment of Michel and Louise Leiris. Casanova's powerful personality exerted a great influence on French intellectuals.

PICASSO PAPIER DÉCHIRÉ 1943

Je parle de ce qui est bien

par Paul Eluard

PICASSO PORTRAIT 1936

JE parle de ce qui m'aide à vivre, de ce qui est bien. Je ne suis pas de ceux qui cherchent à s'égarer, à s'oublier, en n'aimant rien, en réduisant leurs besoins, leurs goûts, leurs désirs, en conduisant leur vie, c'est-à-dire la vie, à la répugnante conclusion de leur mort. Je ne tiens pas à me soumettre le monde par la seule puissance virtuelle de l'intelligence, je veux que tout me soit sensible, réel, utile, car ce n'est qu'à partir de là que je conçois mon existence. L'homme ne peut être que dans sa propre réalité. Il faut qu'il en ait conscience. Sinon, il n'existe pour les autres que comme un mort, comme une pierre ou comme du fumier.

Parmi les hommes qui ont le mieux prouvé leur vie et dont on ne pourra dire qu'ils ont passé sur la terre sans aussitôt penser qu'ils y restent, Pablo Picasso se situe parmi les plus grands. Après s'être soumis le monde, il a eu le courage de le retourner contre lui-même, sûr qu'il était, non de vaincre, mais de se trouver à sa taille. « Quand je n'ai pas de bleu, je mets du rouge », a-t-il dit. Au lieu d'une seule ligne droite ou d'une courbe, il a brisé mille lignes qui retrouvaient en lui leur unité, leur vérité. Il a, au mépris des notions admises du réel objectif, rétabli le contact entre l'objet et celui qui le voit et qui, par conséquent, le pense, il nous a redonné, de la façon la plus audacieuse, la plus sublime, les preuves inséparables de l'existence de l'homme et du monde.

*

A tous ceux qui ne sauraient apercevoir à quel point la démarche de Picasso fut bouleversante, nous expliquerons ceci :

En général, la pensée essaie de distinguer d'abord les choses et leurs rapports : les choses fournissant des idées concrètes, leurs rapports des idées abstraites, et pour cela, il faut aller du sujet à l'objet. Or, pour parcourir ce chemin du sujet à l'objet, il faut une certaine dose de sympathie ou d'antipathie, donc des idées de valeur. Ceci mène souvent les animaux, les enfants, les sauvages, les fous, les poètes aux erreurs ou aux évidences les plus simples. Ils prennent un verre pour un gouffre ou un piège, le feu pour un joyau, la lune pour une femme, une bouteille pour une arme, un tableau pour une fenêtre. Ils font une erreur quand ils établissent le rapport par antipathie, mais quand ils l'établissent par sympathie, on peut affirmer que ce rapport leur sert à fonder leur vérité. Ils sont donc tour à tour fortifiés et victimes de cette faculté qu'ils ont de comparer. La vie est donc tour à tour bonne ou mauvaise pour eux, comme pour les autres. Quelques-uns ne sortiront de cet état stagnant que pour retomber dans un autre état, aussi stagnant : les animaux se domestiquent, les enfants atteignent l'âge de raison, les sauvages se civilisent, les fous guérissent,

PICASSO EN 1901

A Pablo Picasso

L'oreille du taureau

L'oreille du taureau à la fenêtre
Et la lumière d'aujourd'hui le prisme de la force
Sur la paille du vaincu sur l'or du pauvre

Sur la table au niveau du vin dans la bouteille
L'œil qui saisit la bouche et l'embrasse
Et regarde il fait beau

Et regarde au sillon du laboureur sanglant
Le taureau le beau taureau lourd de désastres

Et regarde il fait beau
Sous le ciel de la bouche ouverte à l'amour
Un nuage lourd qui soutient le soleil
Le sang du laboureur le pain des noces

Le drapeau du taureau
Que le vent tend comme une épée.

REPRODUCTION D'UN POÈME AUTOGRAPHE DE PAUL ELUARD

les poètes s'oublient. Seuls, certains poètes parviennent à surmonter cette triste alternative et, propageant leur individualité, à transformer le cœur des hommes en leur montrant, toute nue, une raison poétique.

*

Les peintres ont été victimes de leurs moyens. La plupart d'entre eux s'est misérablement bornée à reproduire le monde. Quand ils faisaient leur portrait, c'était en se regardant dans un miroir, sans songer qu'ils étaient eux-mêmes un miroir. Mais ils en enlevaient le tain, comme ils enlevaient le tain de ce miroir qu'est le monde extérieur, en le considérant comme extérieur. En copiant une pomme, ils en affaiblissaient terriblement la réalité sensible. On dit d'une bonne copie d'une pomme : « On en mangerait ». Mais il ne viendrait à personne l'idée d'essayer. Pauvres natures mortes, pauvres paysages, figurations vaines d'un monde où pourtant tout s'agrippe aux sens de l'homme, à son esprit, à son cœur. Tout ce qui importe vraiment, c'est de participer, de bouger, de comprendre. Picasso, passant pardessus tous les sentiments de sympathie et d'antipathie, qui ne se différencient qu'à peine, qui ne sont pas facteurs de mouvement, de progrès, a systématiquement tenté — et il a réussi — de dénouer les mille complications des rapports entre la nature et l'homme, il s'est attaqué à cette réalité que l'on proclame intangible quand elle n'est qu'arbitraire, il ne l'a pas vaincue, car elle s'est emparée de lui comme il s'est emparé d'elle. Une présence commune, indissoluble.

L'irrationnel, après avoir erré, depuis toujours, dans des chambres noires ou éblouissantes, a fait, avec les tableaux de Picasso dérisoirement appelés cubistes, son premier pas rationnel et ce premier pas lui était enfin une raison d'être.

*

Picasso a créé des fétiches, mais ces fétiches ont une vie propre. Ils sont non seulement des signes intercesseurs, mais des signes en mouvement. Ce mouvement les rend au concret. Entre tous les hommes, ces figures géométriques, ces signes cabalistiques : homme, femme, statue, table, guitare, redeviennent des hommes, des femmes, des statues, des tables, des guitares, plus familiers qu'auparavant, parce que compréhensibles, sensibles à l'esprit comme aux sens. Ce qu'on appelle la magie du dessin, des couleurs, recommence à nourrir tout ce qui nous entoure et nousmêmes.

Le texte de Paul Eluard ainsi que les reproductions des dessins et peintures de Picasso qui l'accompagnent sont extraits de l'ouvrage *Picasso* à paraître prochainement aux Editions des Trois Collines à Genève.

Page from issue of "Larinthe", 1944.

The publisher Albert Skira, who had returned to Geneva at the beginning of the war, launched a new monthly review in October 1944, entitled *Labyrinthe*. The twenty-three issues of *Labyrinthe* form the connecting link between the pre-war and the post-war intellectual world. Several of the old contributors to *Minotaure* reappeared in *Labyrinthe*, and they were joined by Malraux, Sartre, Simone de Beauvoir, Hemingway and many others. In the first issue, Eluard spoke at length of his faithful friend Picasso.

During 1946-1947 Picasso composed a set of 125 lithographs, abstract red signs of great power designed to adorn the handwritten pages of Pierre Reverdy's book of poems, *Le chant des morts*, which was issued in 1948 by the publisher Tériade.

Lithograph for "Le chant des morts" by Pierre Reverdy. 1946–1948.

1945-1946

Woman Standing, lead pencil. May 1946.

The Charnel House, preparatory study. 1945.

With the return of prisoners and deportees from Germany, the full horror of the concentration camps became known for the first time. It was under the impact of this revelation that in the winter of 1944-1945 Picasso painted *The Charnel House*, his largest canvas since *Guernica*.

He also did some still lifes and figure paintings. In August, leaving Paris for the first time since 1940, he went down to Golfe-Juan on the Riviera. During this trip he visited the Provençal village of Ménerbes (Vaucluse), where he bought a house which he gave to Dora Maar as a present. Two important exhibitions of his work were organized abroad: one, with Matisse, at the Victoria and Albert Museum in London, the other in Brussels.

Lithograph for "Le chant des morts" by Pierre Reverdy. 1946–1948.

Returning to Paris in the autumn, he spent most of his time making lithographs, many of them portraits of a young woman he had recently met: Françoise Gilot. For four months during the autumn and winter, he went to work every day in the atelier of the Paris printer Fernand Mourlot, where his technical audacities, inventiveness and disregard of traditional rules amazed even the most experienced of Mourlot's engravers and craftsmen.

The winter of 1945-1946 was severe and Paris was still short of fuel. Picasso "did lithographs because he was warm. Or rather he settled down in a place where he was warm, and in this place he could do lithographs. The art of Picasso is always an art of circumstances... and so for about six months in the winter of 1945-1946 he made a series of lithos which marks the real beginning of Picasso's lithographed work, which is a wonderful thing" (D. H. Kahnweiler).

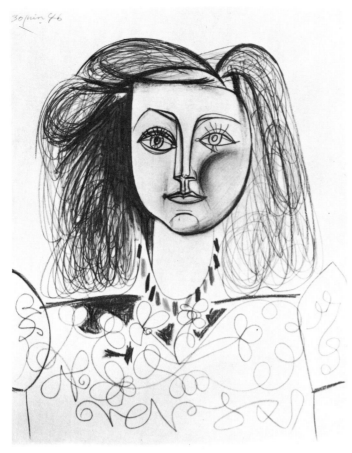

Portrait of Françoise Gilot, colored crayons and lead pencil. June 1946.

"All Picasso's models look like their portraits. Picasso's line re-establishes the truth of things, for from an infinitely variable appearance, a million instantaneous views, he disengages a constant, he sums up the images. He totalizes his experiences."

Paul Eluard

During the winter of 1945-1946 and the following spring, Picasso continued to work at lithography, doing many faces and silhouettes directly inspired by Françoise Gilot. "Françoise is the new model," noted Pierre Daix, "the testing stand for all his pictorial inventions." In the spring she suggested to him the image of the woman-flower which became the subject of a series of variations, the goddess of light, joy and fecundity.

In February 1946 Françoise went down to Golfe-Juan where Picasso joined her; and on their return to Paris they set up house together. In summer they went back to the Riviera, this time to Antibes, living in the house of Louis Fort, the first printer of Picasso's etchings; and there Eluard, presiding over the Film Festival at nearby Cannes, joined them.

"If you know exactly what you're going to do, what's the good of doing it? Since you know, the exercise is pointless. It is better to do something else."

Picasso

In September 1946 he met the curator of the Antibes museum, Dor de la Souchère; and when Picasso complained of having no studio in which to paint the large works he hankered after, Dor de la Souchère offered him the upper floor of the museum, which is housed in the medieval castle of the Grimaldi. There Picasso worked for the next four months on the extraordinary Antipolis series of paintings (Antipolis was the ancient name of Antibes). These works, a fantastic revival of Mediterranean mythology, full of *joie de vivre*, he presented to the museum. Canvas still being scarce, he worked on whatever materials Dor de la Souchère was able to find for him, chiefly plywood and fibrocement. He wrote to Sabartès: "I did there the best I could and I went at it with pleasure." His dancing fauns, nymphs, centaurs and satyrs mingle with real and mythical figures, all partaking of the exuberant joy of nature. These works, redolent of the Golden Age, are now the central attraction of the Antibes museum, which in fact has been renamed the Musée Picasso. The artist later confided to Dor de la Souchère: "When we started we had no idea where we were going. If you had said, We'll make a museum, I wouldn't have come. But you said, Here's a studio for you! You yourself had no idea what you wanted to do. That is why it has all come out so well, because you had no intention of imitating a museum."

Late in the autumn came sad news: the death of Nusch, Eluard's wife.

The Château and Museum at Antibes where Picasso worked in 1946.

Lucas Cranach. David and Bathsheba, 1526.

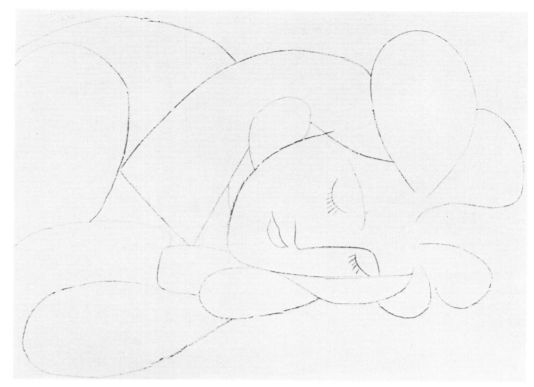

Woman Sleeping, colored crayon. October 1946.

1947

Picasso spent the first part of 1947 in Paris where, on 15 May, a son was born to Françoise, christened Claude. He continued to do lithographs in Mourlot's atelier, reverting to several of the Antipolis themes and also taking up a new subject, *David and Bathsheba,* his eye having been caught by a reproduction of Cranach's picture on this theme in the Berlin museum. He did a set of forty-one etchings to illustrate twenty poems by Gongora; the poems themselves were written out in Spanish in his own hand and adorned with marginal drawings.

David and Bathsheba after Cranach, lithograph. March 1947.

"Starting from a picture by Manet, El Greco, Cranach, Courbet or Poussin in order to make something else out of it—isn't this tantamount to a continual invention of new signs for the figuration of the same objects? And turning to one's own account the work of an earlier painter—isn't this tantamount to treating it as an integral part of life, as something which cannot be left dormant and which must be induced to carry out its natural evolution? Nothing (one must assume) can remain inert once it has come before Picasso's eyes or into his hands. Whether he transforms them at once or acts as the recording witness of the adventures and vicissitudes undergone by his figures, he shows the same refusal to allow any being or object to lapse into fixity or to let anything come to rest."

Michel Leiris

Two etchings illustrating "Twenty Poems" by Gongora. 1947–1948.

Summer saw him again on the Riviera, with Françoise and Claude. The year before he had revisited the village of Vallauris, near Cannes, where he had stayed several times with Eluard before the war. Vallauris had once had an active ceramic industry, but business had fallen off badly since the war, and one by one the workshops were closing down.

In 1946 he had met there the ceramists Georges and Suzanne Ramié and modeled a few figures in their small ceramic factory. On his return to Vallauris in 1947 he began working seriously with the Ramiés and pottery became a passion with him: he delighted in molding the clay with his fingers, inventing figures, testing out colors and awaiting in suspense the results of the firing. He stayed through the winter of 1947-1948, modeling and coloring pots, jugs, plates, animals and figures, bringing back to life the ancestral traditions of Spanish and Greek pottery. In the space of a year he produced over 2,000 pieces, using at first the traditional techniques, then indulging in ever bolder experiments. Again he proved himself a master creator of forms; indeed, his inventive powers seemed to be stimulated by the confrontation with objects of daily use. He found himself now thoroughly at home in the Mediterranean setting and henceforth returned to Paris only for short visits.

1948

Painted terracotta vase. 1948.

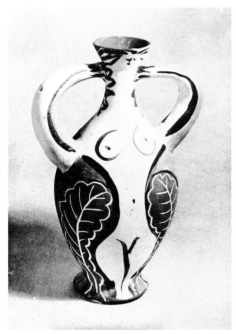

Lithograph by Picasso for an exhibition at Vallauris (Mourlot, Paris 1948).

"Picasso's venture moves us deeply... above all because he has felt the need to return to the sources, to resume contact with the manual side of this art, with the actual making process. It is as if he needed new strength and the earth alone could give it to him. The stream of endeavor from which *homo faber* has sprung, and which is the mainstream of present-day creative thought, was strong enough to sweep him away... and this is perhaps the primary source of our delight in this pottery, together with the joy we feel in finding in it the 'mother forms' of our civilization."

Jean Bouret,
Arts, 26 November 1948

Painted terracotta jug. 1948.

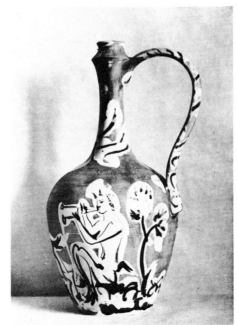

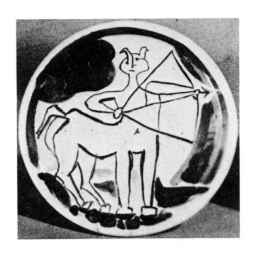

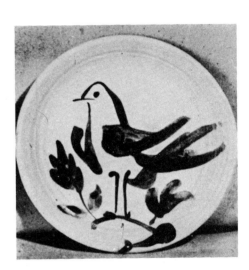

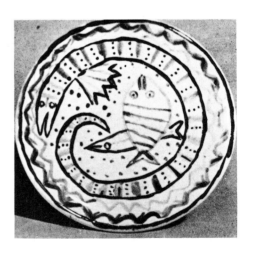

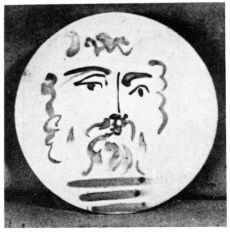

Four painted terracotta plates. 1948.

View of the pottery workshop at Vallauris.

"Picasso, workman in clay and fire... This new vein of expression must be seen as prefiguring the social role which the artist will be called upon to play in the society of tomorrow... The potters of tomorrow will be in the service of the peoples. And it is in this sense that Picasso's ceramics, sumptuous and magnificent as they are, point to the future... Clay and fire, in Picasso's hands, become for us the living figuration of mind and matter, of their combat and victory."

Léon Moussinac
Les Lettres Françaises, 2 December 1948

"It certainly was an odd chance that led Picasso's steps to Vallauris, nearly two years ago. Vallauris is a village in Provence where for thousands of years pottery has been made in the manner of the ancient Romans. Today as in the past the land thereabouts yields the clay which will serve to model the form, and the neighboring forest supplies the wood with which to fire the kilns. Perhaps this rudimentary industry reminded Picasso of Malaga where the same kind of pottery is made in roughly the same way?... The fact remains that, happening to pass that way, he stayed."

Georges Ramié, 1948

Picasso among his ceramics at Vallauris. Photograph by Robert Doisneau, Paris.

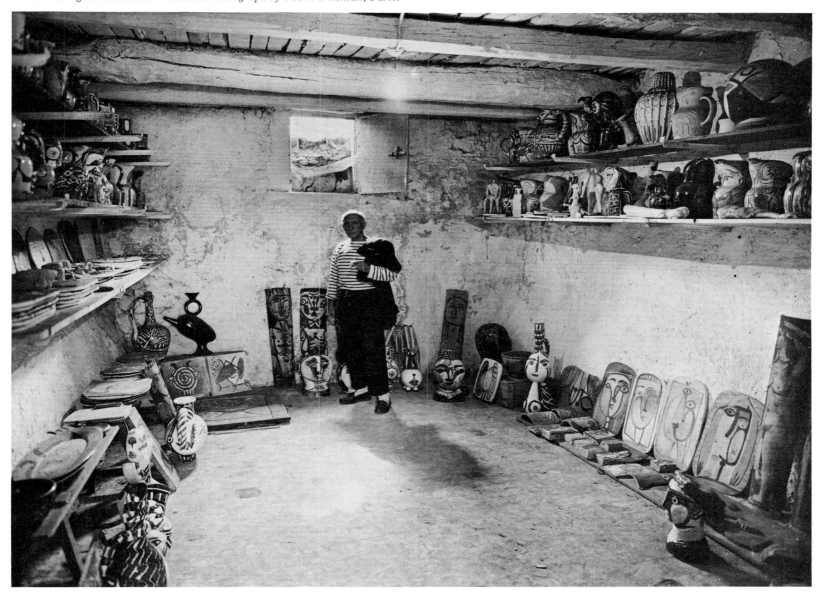

While still devoting the bulk of his time to pottery and the wide-open field of experiment with which it provided him, Picasso continued his graphic work.

With his move to the South of France, he began to see less of his old friends, though they paid him a visit whenever they could; this year, for example, Miró and Braque came to see him. Now, however, he was closer to Matisse, who lived at Vence.

Matisse and Picasso were bound together by a profound mutual respect, and Kahnweiler has quite recently recalled the admiration and interest each had for the other's work—so much so that one day Picasso piled some canvases in his car and motored over to Vence to show them to Matisse, while the latter, in spite of age and illness, made a point of visiting the Antibes museum in order to do some drawings "after Picasso".

Late in August 1948 Picasso flew to Poland with Paul Eluard to take part in the first of the communist-sponsored Peace Congresses, held this year in Wroclaw (Breslau). He spent two weeks in Poland, visiting Warsaw, Cracow and Auschwitz.

Françoise Gilot and her Son Claude, oil. 1948.

Returning to the French Riviera, he settled with Françoise Gilot in a small villa called "La Galloise" on the hillside near Vallauris; it was not an attractive or comfortable house, but it was conveniently close to the pottery workshops. There he painted many pictures of Françoise and his son Claude.

At the end of the year he returned to Paris where a large exhibition of his ceramics had been organized at the Maison de la Pensée Française. This same year Albert Skira published a color-illustrated portfolio of Picasso's ceramics, with an introductory text by Georges and Suzanne Ramié.

1949

In the spring of 1949 Françoise Gilot gave birth to a daughter. Picasso was then taking an active part in the second Peace Congress, held this year at the Salle Pleyel in Paris. The birth of Françoise's two children turned Picasso's attention back to themes of maternity and childhood. To his little daughter he gave the Spanish name Paloma, which means dove, an image very much in his mind at this time. For Aragon had asked him to design a poster for the 1949 Peace Congress in Paris, and leafing through Picasso's portfolios, the writer was struck by the many drawings of birds, chiefly pigeons and doves, which the artist had made over the years, often from life, for Picasso kept a white pigeon in a cage in his Paris studio in the Rue des Grands-Augustins. So the dove was chosen to symbolize peace and Picasso's lithograph of it has become one of his most popular works, known throughout the world.

Claude in Polish Costume, oil. 1948.

Paloma in her Little Chair, oil. 1950.

The Russian writer Ilya Ehrenburg speaks of Picasso in his memoirs:

"Some commentators have tried to present his political convictions as an accident or whim. For them, Picasso is an eccentric: he is fond of bullfighting and the fancy took him to become a communist. Now Picasso's political views have in fact always been for him a matter of serious thought. I remember lunching with him in his studio the day the Peace Congress opened in Paris. He had just had a daughter, whom he had named Paloma (in Spanish, dove). There were three of us at table: he, Paul Eluard and myself... Picasso told how, when he was still a boy, his father, who painted a lot of doves, left it to him to finish them, but his patience gave out when he came to the feet... Picasso is fond of doves, he always has a few in his studio; but he said with a laugh that he could not see why these greedy and quarrelsome birds had become the symbol of peace. Finally, he spoke of his own doves and showed us the hundred or so drawings that had gone to the preparation of his poster. He knew that it would go around the world. He went on talking to us about the Congress, the war, and politics."

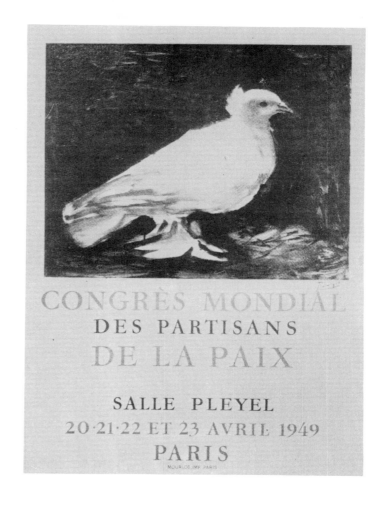

Poster for the World Peace Congress, Paris 1949.

Portrait of Ilya Ehrenburg drawn by Picasso at Warsaw, August 1948.

"It has been said of friendship, as of love, that it requires one's presence and that a long absence makes it perish. It has happened that eight or ten years have gone by without my seeing Picasso, but never have I found him changed in any way... I remember the studios he has had: Rue La Boétie, in a fashionable part of Paris where he cut the figure of an intruder, almost a burglar; Rue Saint-Augustin [*sic*], in a very old house, a vast room full of Spanish women, doves and enormous canvases, where there reigned that methodical disorder which Picasso engenders everywhere; the shed at Vallauris, his scrap metal, modeling clay, drawings, glass balls, shreds of posters, pillars of cast iron, and the hut where he slept on a bed littered with newspapers, letters and photographs."

Ilya Ehrenburg,
Souvenirs sur Picasso, 1961

At Vallauris, where he lived most of the time, he continued to produce pottery. He also did a considerable amount of graphic work: thirty-eight copperplate engravings for Mérimée's *Carmen*; fourteen lithographs and the handwritten texts of his own poems for *Poèmes et lithographies*, published in 1954 by the Louise Leiris Gallery in Paris; and a set of etchings for *Corps perdu* by his friend Aimé Césaire, published in 1950.

Published in 1949, Kahnweiler's book *Sculptures de Picasso* focused attention on a still little known aspect of his work—though in fact sculpture had never ceased to be a central preoccupation of Picasso's. His recent work as a potter, moreover, had once again engrossed him in the problem of volume. The Maison de la Pensée Française in Paris now organized another large Picasso exhibition, devoted to his work of the years 1945-1949.

Two etchings for "Corps perdu" by Aimé Césaire. 1949.

In February 1950, in a sort of painted rethinking of earlier masterpieces, he produced his *Girls on the Banks of the Seine* after Courbet and the *Portrait of a Painter* after El Greco; both served as a vehicle for his new conception of volume treated in terms of patterned planes.

In June the Korean War broke out. As an active peace partisan, Picasso attended the third peace congress held in November at Sheffield in England.

During 1950 he resumed his activity as a sculptor, creating such famous works as the *Woman with a Pram* and *The She-Goat*.

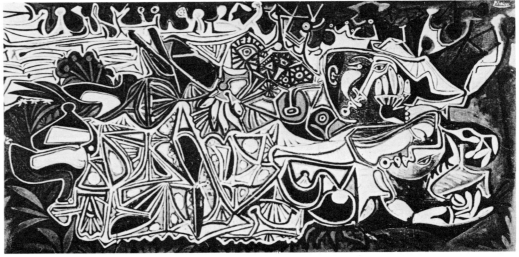

Girls on the Banks of the Seine after Courbet, oil. 1950.

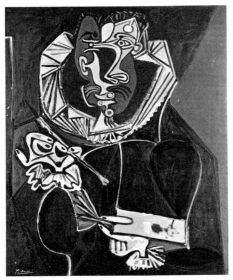

Portrait of a Painter after El Greco, oil. 1950.

El Greco. Portrait of a Painter, 1600/1604.

Courbet. Girls on the Banks of the Seine, 1856.

Thanks to his presence Vallauris enjoyed an unexpected celebrity. The municipal council expressed its gratitude by making him an honorary citizen. Picasso in return presented the town with the large bronze of his *Man carrying a Sheep*. Set up in the marketplace, the sculpture was solemnly inaugurated in October by Laurent Casanova. Eluard was present at the festivities with Dominique, his new companion.

In November Picasso was awarded the peace prize for painting. Pablo Neruda, winner of the same prize for literature, exclaimed: " Picasso's dove flies over the world... It has taken wing around the world and no criminal fowler can now arrest its soaring flight. "

Inauguration of the bronze by Laurent Casanova at Vallauris in 1950.

1950

Man carrying a Sheep, bronze set up in the market place in Vallauris.

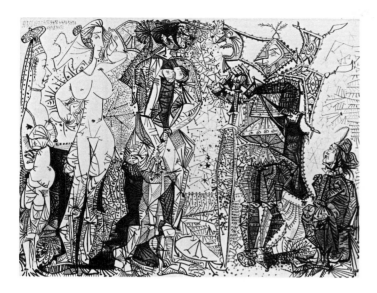

1951-
1952

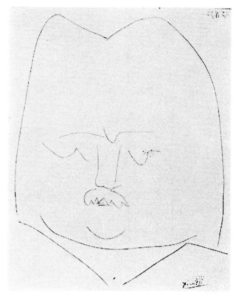

The Judgment of Paris,
India ink. April 1951.

Portrait of Balzac, lithograph. November 1952.

Picasso painted *Massacre in Korea,* a picture vibrant with echoes of Goya's *Third of May.* The modern weapons and robot soldiers are assimilated to the ironclad knights of the Middle Ages, more telling in their aggressiveness.

Picasso also wrote a new play inspired by the talk of his children; he called it *The Four Little Girls.* His children and also his friends provided the subject matter of many paintings; among others, he made a portrait of Hélène Parmelin, wife of his friend the painter Edouard Pignon, both of whom were frequent visitors to Picasso's studio. Hélène Parmelin was to write several books which are valuable witness accounts of Picasso and his work in progress.

In June 1951 Paul Eluard married Dominique Laure in the town hall of Saint-Tropez. Picasso and Françoise Gilot attended the ceremony as witnesses.

Portrait of Madame H. P., oil and enamel paint. 1952.

Picasso's sculptures were exhibited in Paris at the Maison de la Pensée Française, while two large exhibitions were also held in Tokyo and London (drawings and watercolors from 1895 on). By now his name was a household word all over the world; the master image-maker, one of the outstanding men of our time, he enjoyed a popularity which perhaps Charlie Chaplin alone could rival.

He continued his activity as a sculptor, creating among other works the astonishing *Monkey and her Baby.* He engraved ten drypoints to illustrate a book by Adrian de Monluc, *La Maigre,* and did a series of heads of Balzac, with a view to designing a frontispiece for *Le père Goriot*; the whole series was published in 1957 with a presentation text by Michel Leiris entitled *Balzacs au bas de casse et Picassos sans majuscule.*

On 18 November 1952 Picasso was profoundly shaken by news of the sudden death of Paul Eluard, for many years one of his closest and most faithful friends.

Child with an Orange, oil. 1951.

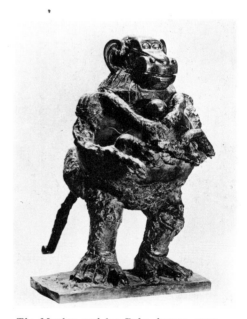

The Monkey and her Baby, bronze. 1952.

Paloma with her Doll, oil. 1952.

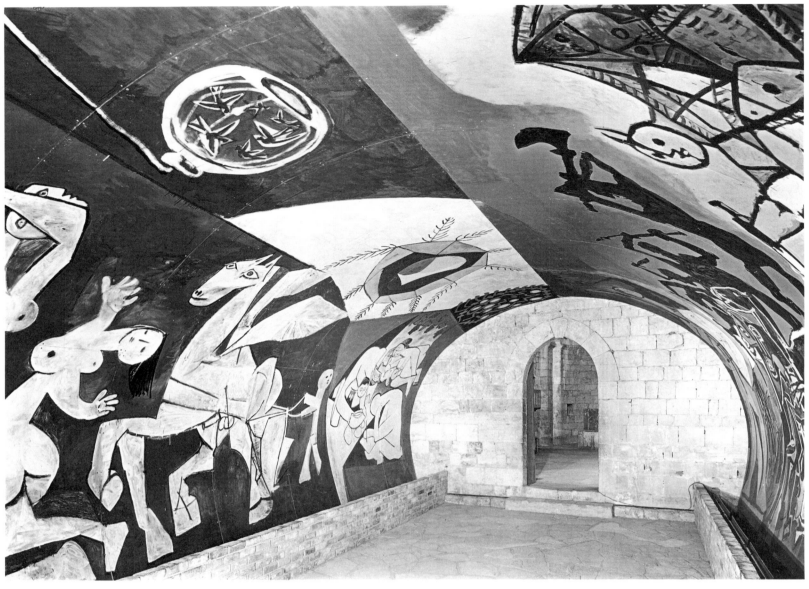

Overall view of the Temple of Peace at Vallauris.

The reign of violence continued unchecked throughout the world. Picasso was shocked in March 1952 to hear that Beloyannis had been executed in Greece. He expressed his horror with the pen: "The glow of the oil lanterns lighting the clear night of Madrid on a May evening and the noble faces of the people shot by the rapacious foreigner in Goya's picture have the same seed of horror sown by handfuls from the projector on the open breast of Greece by governments reeking of fear and hatred. An immense white dove sprinkles the anger of its bereavement over the earth."

The municipality of Vallauris placed at the disposal of its honorary citizen a twelfth-century chapel that had been deconsecrated. Picasso turned it into the Temple of Peace. Between 28 April and 14 September 1952 he did over 250 drawings, then in rapid succession the two large panels, each over 100 square yards, illustrating War and Peace. The panels were then fixed to the walls and vaulting of the chapel.

"If peace prevails in the world, the *war* I have painted will belong to the past... Then war will be spoken of in the past tense, and all the rest will be in the present and future. The only blood to be shed will be in front of a fine drawing or picture; come too close and scratch it, and a drop of blood will form on it, proving that the work is alive."

Picasso

The Dove of Peace, detail of the Temple of Peace. 1952.

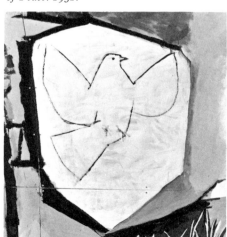

"I know I've won when what I do starts talking without me. What I've managed to do now, I think, is to go beyond the mere craftsmanship of drawing: you know, when you draw a foot and a hand, and the word *foot* is all but written on the drawing of the foot, and the word *hand* on the drawing of the hand... People, that's the only thing of real interest. You paint and draw in order to get to know people, to know yourself. When I was working on this series of drawings, I said to myself every day: 'What am I going to learn now that I didn't know before?' And when it is no longer for me to speak, but for my drawings to do so, and when they get away from me and taunt me, then I know I've achieved my purpose." Statements made to Claude Roy, who followed step by step the creation of *War* and *Peace*.

Faintly showing through under the dove is the Medusa's head, the image borne on shields in antiquity.

1953

The year 1953 was memorable for a series of large-scale Picasso exhibitions in Lyons, Rome, Milan and São Paulo. Before taking their final place in the Temple, the *War* and *Peace* panels were thus exhibited and aroused the admiration and astonishment of the public. Luciano Emmer now produced a film on Picasso in which the artist himself appeared in two sequences. The mood of his canvases, however, was again one of cruelty and pain. The *Rape of Europa* and *Woman with a Dog* are violent expressions of his inner tension: again his emotional life was profoundly disturbed and at the end of the year he and Françoise Gilot separated. The children went to live with their mother, but often returned on months-long visits to their father.

From November to February of the following year he did a series of 180 drawings on the theme of the old painter and his model. These autobiographical drawings show a new aspect of his art: Picasso in the role of narrator.

Woman with a Dog, oil. March 1953.

"At the very time when contemporary art hesitates whether to capitulate before the engineer-architect or seek escape in neo-surrealist or neo-abstract solutions, Picasso—obstinately figurative and humanist in his own way when it seems that no one else is any longer—takes his stand once again in opposition. Not so long ago people could not understand the revolutionary artist. Today they are surprised that he does not, like so many others, settle down to imitate himself. 'Imitate oneself, how contemptible!... One becomes one's own admirer. I don't sell myself anything.'"

Pierre Dufour

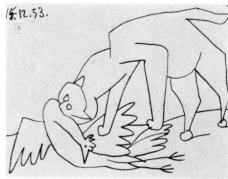

Cat with a Bird, two Conté crayon drawings. December 1953.

Michel Leiris defined the series of cruel and ironic drawings executed during the winter of 1953-1954 as a "visual diary of a hateful season in hell, a crisis in his private life leading him to question everything." In this series Picasso once again raised all the fundamental questions of life and its exigencies, of art and its meaning, and paid a now ironic, now mournful tribute to woman, to beauty, to love. He pursued this theme in a series of lithographs in which, here and there, the image of the Minotaur slyly re-emerges; these lithographs were published in a special issue of *Verve*.

At the beginning of the year he made several portraits of Sylvette David, whose blonde beauty captivated him. He also produced several sculptures consisting of sheet-metal cutouts, folded and painted—fabulous premonitory signs of his coming sculptures in concrete.

Portrait of Sylvette David, pencil. 1954.

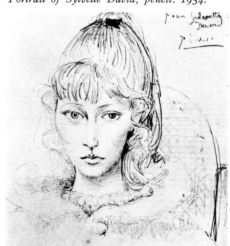

Woman and Grotesques, India ink. December 1953.

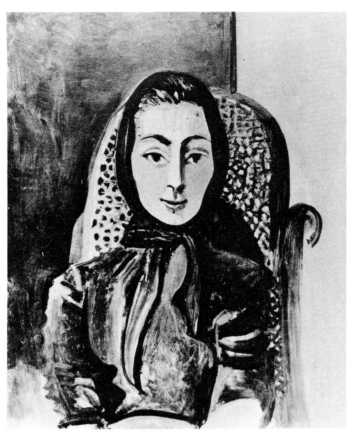

Portrait of Jacqueline with a Black Kerchief, oil. October 1954.

Delacroix. Women of Algiers, 1834.

1954

On 3 June 1954 Picasso painted the *Portrait of Madame Z with Clasped Hands*, one of the first of his masterly pictures of the young woman, Jacqueline Roque, who from now on was to be the constant inspirer of his art and, in private life, the close companion on whose fund of affection and intelligence he could always depend. They were to be married in 1958. Through Jacqueline's face Picasso entered into direct and vitalizing contact with paintings of the past. He saw in her a close resemblance with one of the Moorish women in Delacroix's *Women of Algiers*, and on this theme he proceeded to paint an opulent series of fourteen pictures between 13 December 1954 and 14 February 1955. He also rediscovered Manet: a portrait of Jacqueline as Lola de Valence preceded the first drawings inspired by the *Déjeuner sur l'Herbe*.

In October he paid a visit to Paris where he took part in a book sale organized by the National Writers' Committee in the old Vélodrome d'Hiver, or Vel' d'Hiv.

During 1954 he was saddened by the loss of more old friends, Derain, Maurice Raynal, Matisse.

The Museum of Modern Art in Rio de Janeiro presented a large retrospective exhibition of his work.

The beauty and love of Jacqueline Roque gave fresh stimulus to Picasso's creative powers. She took him back to Delacroix by way of the *Women of Algiers*, and he was prompted to move in the same direction by memories of Matisse and his Odalisques. To Roland Penrose he said, "When Matisse died he left his odalisques to me as a legacy."

"The art of Picasso has always been autobiographical and has grown increasingly so with advancing age. Today we can observe an extremely odd development—*narrative* art. As he said to me not long ago, 'After all, a picture that tells a story is not such a bad thing.' An art of this type is poles apart from an 'abstraction' that does not want to represent anything and whose products are therefore but empty decorations which remain confined to the wall instead of blossoming out in the spectator's mind. For a veritable work of art can only be engendered with the collaboration of the spectator who observes it. I may be wrong, but it seems to me that a revival of narrative painting is taking place at the present time. Needless to say, it will owe nothing to the anecdotic painters of the nineteenth century."

D. H. Kahnweiler

Women of Algiers after Delacroix, India ink. December 1954.

Villa "La Californie" at Cannes. Photograph by Edward Quinn.

Portrait of Jacqueline, charcoal and India ink. October 1955.

"In *The Picasso Mystery*, the point was not to unveil the mystery of Picasso at work; the point was to show what Picasso was capable of making us see in painting with the resources of the camera, and what the camera could invent, starting out from a man painting in front of it and painting for it...

"The most admirable moments of all, however, were not those when the whole canvas was magically transformed on the screen, when the color changed and the figures moved; and all that was extraordinary enough. What was finest, truest, most alive, was the line advancing, creeping, speeding over the transparent paper with the noise of Picasso's pencil as it moved."

Hélène Parmelin, *Notre-Dame-de-Vie*, 1966

At Nice he "starred" in a color film made by Henri Clouzot, *Le Mystère Picasso*, showing him at work on drawings and paintings. It proved to be something of an ordeal, working in the glare of the spotlights, with the camera recording every step and gesture of the creative act, but he saw it through with amazing aplomb. With the camera trained on him, he created the *Beach of La Garoupe*, a bewildering vision of his exploration of the unknown.

1955

Picasso and Jacqueline now settled for good on the Riviera, where he bought a house, a large ornate villa in the 1900 style, called "La Californie," standing on a hillside above Cannes, with a fine view over Golfe-Juan, Cap d'Antibes and the isles of Lérins out at sea. The atmosphere of his house entered at once into his work.

In one of its high-ceilinged rooms, with large windows surrounded by stylized carvings in the manner of Gaudí, overlooking an exuberant garden, he set up his studio; and *The Studio* became the subject of many pictures in which he recorded its various features and changing light.

The Beach of La Garoupe, oil. 1955.
First version photographed by Edward Quinn in Picasso's studio.

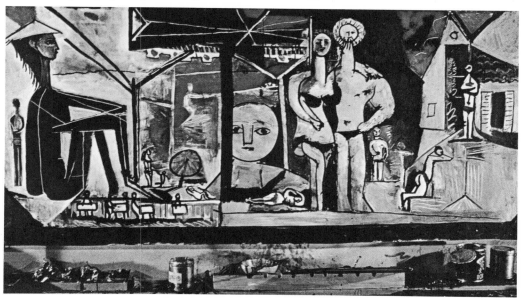

A room in "La Californie". Photograph by Edward Quinn.

The Studio in "La Californie", oil. October 1955.

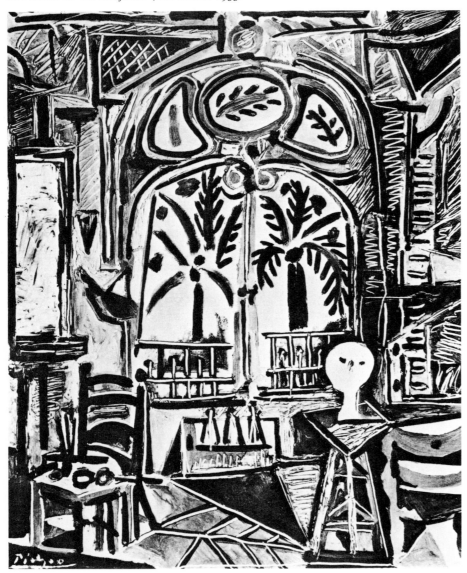

The year 1956 was marked by a series of outstanding Picasso exhibitions. At the Palais des Beaux-Arts in Brussels, then at the Stedelijk Museum in Amsterdam, *Guernica* was shown along with seventy preliminary studies, variants and "postscripts"; in Cologne and Hamburg representative selections of his work were shown. But for Picasso himself all this belonged to the past: for him only the present counts. In 1932 he had said to Tériade: "When you come down to it, all you really have and hold is your Self. You have that Self lodged in your belly, like a sun with a thousand rays. The rest is nothing." He went on working with eager, steady concentration, producing over fifty canvases in the space of eight months. At the beginning of the year he did a series of nudes; then he painted *Spring* and above all the *Studios*, which he described as "inner landscapes." Jacqueline appears in them again and again. With her he found a happiness that inspired canvases imbued with a new lyrical sweep, rich in new inventions. The *Studios* represent a veritable series in the sense already given to the word by Monet.

1956

He met the Norwegian painter and sculptor Carl Nesjar, inventor of a novel technique called "bétograve" or sandblasted concrete. Picasso took a great interest in this technique which enabled him to produce sculptures on an architectural scale. Over the next few years he made about a dozen of these huge, totemic figures of concrete containing gravel or crushed stone—tall posts supporting a strikingly simplified head reduced to an assemblage of intersecting planes. The first one was set up in Oslo in 1956.

His output of engravings continued to be prolific. Here his most important achievement was a set of thirteen drypoints illustrating Roch Grey's *Chevaux de Minuit*.

In the early months of 1957 he did a large amount of painted pottery. He also did some sculpture and painted many portraits of Jacqueline as well as some landscapes. But the most absorbing piece of work which he now undertook was the series of forty-four canvases inspired by *Las Meninas* of Velazquez. The first is dated 17 August, the last 30 December. The theme was one which he had been turning over in his mind for several years. Already in 1952 Sabartès had recorded these remarks by Picasso: "Suppose you just want to copy *Las Meninas*. If I were to set myself to copying it, there would come a moment when I would say to myself: now what would happen if I put that figure a little more to the right or a little more to the left? And I would go ahead and try it, in my own way, without attending any more to Velazquez. This experiment would surely lead me to modify the light or to arrange it differently, from having changed the position of a figure. So little by little I would proceed to make a picture, *Las Meninas*, which for any painter who specialized in copying would be no good; it wouldn't be the *Meninas* as they appear to him in Velazquez's canvas, it would be my *Meninas*." To paint this series Picasso moved his studio to the top floor of his villa, La Californie, where doves were continually fluttering over the balcony: there he worked on it in concentrated seclusion for several months. The Infanta, the maid of honor, the dwarf, the painter, and all the themes evoked in his mind by this or that element in the closed space of Velazquez's picture, became for him like the characters and story line of a serial novel—which happened to be entitled *Las Meninas*. By way of relaxation, he would raise his eyes to the window and paint the balcony and the doves.

Velazquez. Las Meninas, 1656.

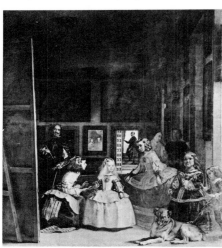

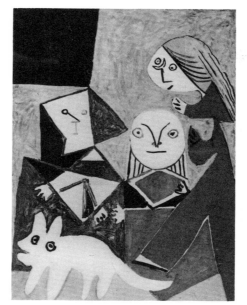

Las Meninas (Doña Isabel de Velasco, Dwarf, Child and Dog), oil. October 1957.

1957

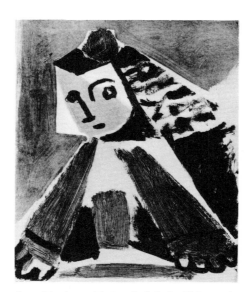

Las Meninas (Doña Isabel de Velasco in half length), oil. November 1957.

Pigeons, oil. September 1957.

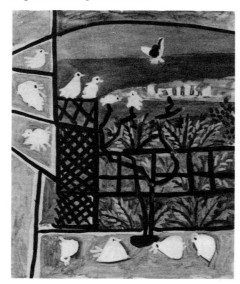

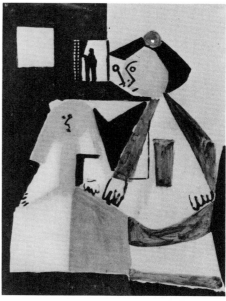

Las Meninas (Doña Isabel de Velasco and the Infanta Margarita), oil. November 1957.

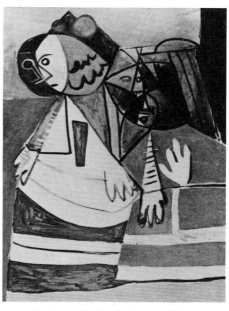

Las Meninas (Doña Isabel de Velasco and the Dwarf), oil. November 1957.

The Museum of Modern Art in New York and the Art Institute of Chicago sponsored a large retrospective exhibition to commemorate his seventy-fifth birthday, while an exhibition of his graphic work was held at the Nationalgalerie in Berlin. In Paris, D. H. Kahnweiler and Louise Leiris inaugurated their new gallery in Avenue Monceau with a Picasso show, and on this occasion he made a series of portraits of his old friend Kahnweiler. In December he did a famous series of lithographed portraits of Jacqueline entitled *Femme au corsage*.

Roland Penrose, a close friend of Picasso's since the 1920's, published his *Portrait of Picasso*.

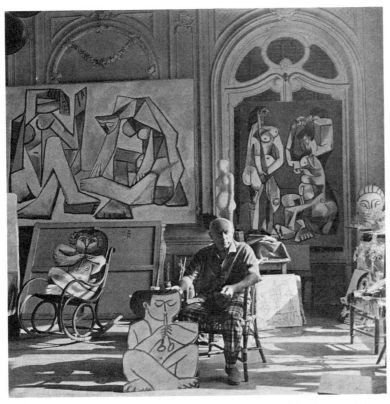

Picasso in the drawing room of "La Californie". Photograph by Edward Quinn.

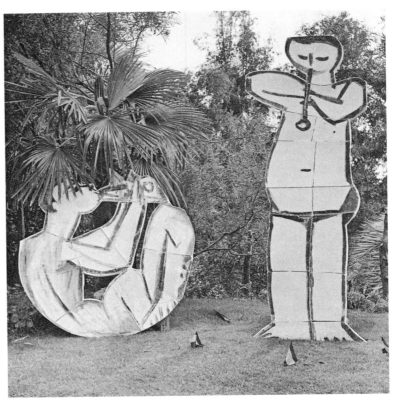

Flute-playing fauns, ceramic figures set up in the garden of "La Californie". Photograph by Edward Quinn.

1958

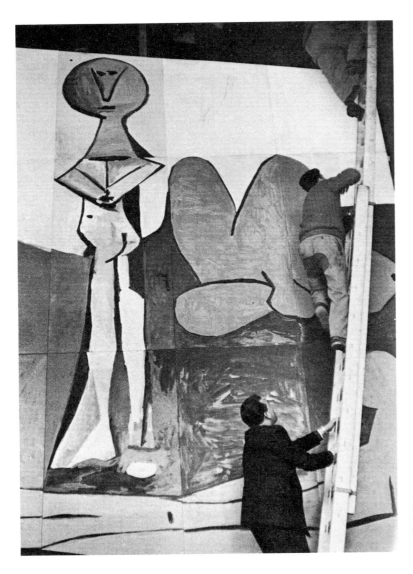

Panels of the mural decoration for the Unesco Building in Paris being assembled in the town hall at Vallauris. (Photo Unesco-Morath Magnum)

At the beginning of 1958 Picasso was engrossed in a piece of work commissioned to decorate the new Unesco Building in Paris. Made up of a series of panels two meters high, it was to cover a wall surface of 100 square meters. To this mural, the outcome of a long and eventful metamorphosis, Picasso gave no title: it was Georges Salles who suggested *The Fall of Icarus*, a myth whose dramatic significance remains topical. A confused political situation had been created by the war in Algeria, and Picasso returned to the still life theme of the bull's skull, reflecting the ominous climate of contemporary France. But he also painted many pictures of Jacqueline, beautiful and serene, reflecting the happiness of his private life. La Californie was filling up with the works he had created. He now bought another house, the vast, austere Château de Vauvenargues, which in the 18th century had belonged to the French moralist of that name; not far from Aix-en-Provence, it stands on the slopes of Mont Sainte-Victoire, made famous in the paintings of Cézanne. He never settled there permanently, but divided his time between this bleaker inland region and the smiling Riviera landscape at La Californie.

He continued to innovate in the field of sculpture, with his astonishing object-assemblages, such as *Playing Bather* and *Head*. He also worked hard at engraving, experimenting now with linocuts.

From February 1959 date the first paintings made at Vauvenargues, imbued with a new gravity: portraits of Jacqueline and the *Sideboard at Vauvenargues*; their new mood was perhaps inspired by the wild and rugged landscape of this region near Aix-en-Provence, which reminded him of Spain. He worked off and on at Vauvenargues up to April 1961, producing there some large mural paintings. Bullfighting scenes continually recurred, many in the form of ink wash drawings: these were gathered together and published in 1961 in a book introduced by Jaime Sabartès, *A los toros*. Bullfighting also provided the subject matter for many engravings, in particular the twenty-six etchings and aquatints illustrating *La Tauromaquía* by José Delgado. He did twenty-two drypoints illustrating *Le Frère mendiant*, published in Paris by Latitud Cuarenta y Uno. In the autumn of this year he was attracted more and more by the "new" technique of the linocut; working both in black and white and in color, he drew from it unsuspected effects by a resourceful use of broad areas of flat monochrome.

The slopes of the Sainte-Victoire mountain inspired some astonishing Bacchanals with fauns and centaurs. After the closed space of Velazquez, he turned to the open, naturalistic space of the Impressionists, elaborating on it in a series of variations on Manet's *Déjeuner sur l'Herbe*. The first drawings relating to it date from 10 and 11 August 1959, and from then until the end of 1961 he produced a long sequence of paintings and drawings on this theme.

Picasso exhibitions were organized at the Musée Cantini in Marseilles and at the Louise Leiris Gallery in Paris. His bronze sculptures of *Bathers* were shown for the first time at Documenta II in Cassel.

The Village of Vauvenargues, oil and enamel paint. April 1959.

1959

The Château de Vauvenargues near Aix-en-Provence. Photograph by Edward Quinn.

In the early months of 1960 Picasso reverted to the theme of the *Déjeuner sur l'Herbe*, setting it aside temporarily to do some sheet metal cutouts. Then he returned to the *Déjeuner* theme in April, on 17 June and throughout the summer; he was to take it up again in 1961, carefully dating each state and each drawing. In January 1960 he produced a singular "translation" of Rembrandt's *Bathsheba*. The theme of a fully clothed man confronting a naked woman led him back little by little to the dialogue between the painter and his model: this subject was to dominate his work throughout the decade of the sixties.

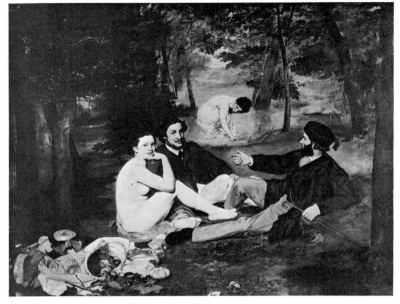

Manet. Le Déjeuner sur l'Herbe, 1863.

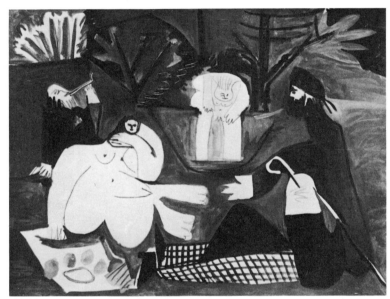

Le Déjeuner sur l'Herbe after Manet, oil. February 1960.

For the Paris exhibition of Picasso's *Romancero du picador*, organized at the Louise Leiris Gallery, Michel Leiris wrote: "The painter and his model, the woman and her reflection, the lover and his beloved, the picador and the bull, all these—if we may be allowed to weave such threads to guide us through the labyrinth of Picasso's work—are like personifications of the two poles of a dialectic in which everything seems to be based on the unresolved opposition of two beings face to face, the living image of that tragic duality: mind confronted by what is foreign to it."

For the Arts Council of Great Britain, Roland Penrose organized a major retrospective exhibition of Picasso's paintings at the Tate Gallery in London, from July to September. Picasso generously lent a hundred pictures from his own collection, selecting them himself. To Brassaï, who wondered why he never visited his exhibitions, Picasso replied: "Why should I waste my time going to see my paintings again? I have a good memory, and I remember all of them. I loaned a great many of my canvases to the exhibition [at the Tate Gallery], and that gave me quite enough trouble. They are only going to exhibit paintings, and very few of my recent works. But there will be the big curtain for *Parade*. Exhibitions don't mean a great deal to me anymore. My old paintings no longer interest me. I'm much more curious about those I haven't yet done."

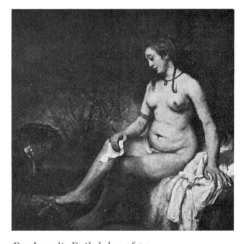

Rembrandt. Bathsheba, 1654.

Bathsheba after Rembrandt, oil. January 1960.

Picador and Girl, ink wash. June 1960.

In the spring of 1961 Picasso left first the Château de Vauvenargues, then La Californie, and moved into a large villa called Notre-Dame-de-Vie at Mougins, a few miles inland from Cannes. He preferred Mougins to Cannes, now fast losing its original character and charm as new highrise buildings sprang up in chaotic profusion. In his new studio at Mougins he again took up the theme of the *Déjeuner sur l'Herbe*, not leaving it until December. During the summer he returned to bathing themes and also reinterpreted another Manet painting, the *Old Musician*.

His eightieth birthday was the occasion of festive commemorations at Vallauris in which all his friends took part. It was also saluted by the publication of two important books: *A los toros*, introduced by Jaime Sabartès and reproducing the great series of bullfight drawings which he had made over the past two years; and *Picasso's Picassos* by David Douglas Duncan, which revealed several hundred pictures unknown to the public; here was the most astonishing Picasso Museum of all: his own collection.

During 1961 Picasso did an extensive series of painted metal cutouts, of figures, faces and animals.

A large exhibition of his work took place in the United States at the University of California Art Gallery, Los Angeles, aptly entitled: *Bonne Fête Monsieur Picasso*.

1961

The Angel, statue of reinforced concrete set up on the grounds of D. H. Kahnweiler's house at Saint-Hilaire on 21 October 1962. Photograph by Brassaï.

Notre-Dame-de-Vie at Mougins. Photograph by Edward Quinn.

1962

Picasso worked with undiminished energy and enthusiasm on engraving, doing nearly a hundred plates, most of them linocuts. The subjects are varied: the Déjeuner sur l'Herbe, female portraits, still lifes, the painter and his model. For his linocuts he worked out a new cutting and printing technique which enabled him to obtain brilliant and unexampled effects.

He continued to devote much of his time to sculpture and produced a masterly series of female heads. Nine leading art galleries in New York cooperated in organizing an important exhibition, *Picasso, An American Tribute*, with a catalogue edited by John Richardson. He made many drawings on various themes, some of them quite unexpected, like the Family Portraits in which he almost seems to be illustrating some outmoded nineteenth-century novel.

In October came the Cuban missile crisis. The danger of a third world war had never seemed so near, and Picasso again expressed his anguish in his painting. Beginning on 24 October, the idea of war entered his work as he painted the *Rape of the Sabine Women*, a theme he explored and developed over a period of several months in the following year.

The Rape of the Sabine Women, crayon drawing. 26 October 1962.

"In painting one can try anything. One has a right to, in fact. Provided one doesn't do it again."

Picasso

Still Life under the Lamp, linocut. 1962.

Study for the Rape of the Sabine Women, pencil. October 1962.

1963

Bathsheba, pencil and colored crayons. 1963.

The Painter and his Model, oil. October 1964.

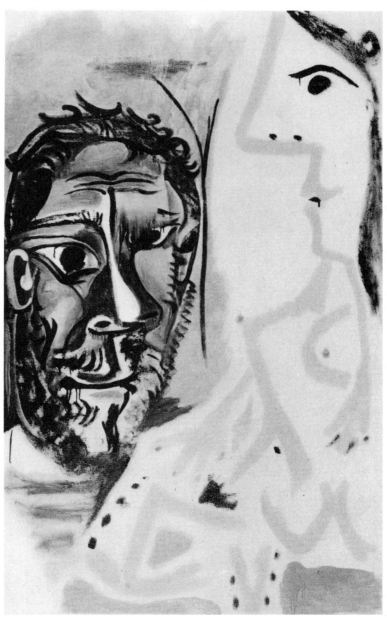

At the beginning of 1963 he continued his variations on the theme of the *Rape of the Sabine Women*, which evoked both Poussin and David.

To Hélène Parmelin, who expressed her surprise at the "classical" character of his warriors, Picasso confided: "Naturally a warrior is much easier to do if he has no helmet and no horse and no head. But in that case, as far as I'm concerned, he is of no interest whatsoever. In that case, it might just as well be a man taking the subway. What interests me in the warrior is the warrior."

In 1963 he returned to the theme of Bathsheba bathing, which he had already "translated" in 1960 into his own language, after Rembrandt's painting. Now he treated it in colored crayons, a technique which had been attracting him for some time. He also returned to the theme of the Painter and his Model, working at it with his usual resourcefulness, multiplying problems and their solutions.

Between March and June he painted forty-five canvases representing *The Painter and his Model*, a searching dialogue between art and nature, between painting and reality. This was the subject which best enabled him to deal with his current preoccupation, the nude. "I don't want to do the nude myself. I want it to be done in such a way that one cannot help seeing the nude as it is" (Picasso).

At the end of the year he carried the nude over from painting into his graphic art, where the theme was sometimes transformed into an "embrace." It continued to occupy him until February of the following year.

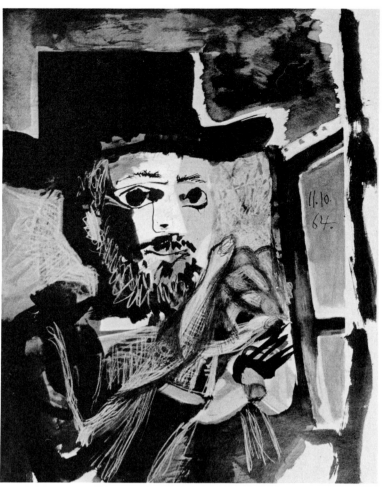

The Painter at Work, oil. October 1964.

1964-1965

The *Painter and his Model* remained one of his favorite themes and inspired a multitude of variations in different media.

In March 1964 he painted a series of canvases representing *Jacqueline with a Black Cat*. He did many portraits, together with a series of variations on *The Smoker*, which also appeared in a number of prints. He began the series of ten aquatints illustrating Pierre Reverdy's poem *Sable mouvant*, published in 1965. In October 1964 he painted a brilliant sequence of pictures on the theme of *The Painter at his Easel*.

In 1965 one of his gigantic female heads in sandblasted concrete was erected at Kristinehamn, Sweden, on the shore of Lake Vänern. Fifty feet high, on top of a concrete column measuring just over six feet in diameter, this head was executed from models prepared by Picasso in the form of cut and bent sheet iron. Similar sculptures in concrete were erected in Oslo, Barcelona, Marseilles, Stockholm and Chicago.

Large exhibitions of his work were held in Japan, at Tokyo, Kyoto and Nagoya, and in Canada, at Montreal and Toronto.

"Though little inclined to wane, his output seems to vary like the phases of the moon. He breaks through every defense and follows up with a home thrust. He must be seen at work, plying his sword of line or color and, though filled with awe, shearing off the excess reality from his models, so as to indemnify us for offering up their essence."

René Char

To some pages he had written for his friend in 1939, the poet René Char added further reflections in 1969 for a book reproducing a series of drawings done by Picasso between March 1966 and March 1967:

"Thirty years ago! Since then Picasso has moved on from several planets, after having furnished and heated them to the top of their bent. It is desire against power, and with this admirable murderer desire always prevails and always will; for he joins rage with love, non-function with function. And nothing is less sure than what you think may be held against him for certain."

Woman's Head, concrete statue set up on the shore of Lake Vänern at Kristinehamn, Sweden. 1965.

1966

In October Picasso celebrated his 85th birthday, and the whole world celebrated it with him. In Paris, at the Grand Palais and Petit Palais, Jean Leymarie organized a "Homage to Picasso" exhibition of spectacular proportions, bringing together over five hundred works from many different countries. Held from November 1966 to February 1967, this exhibition covered every period and phase of his activity and attracted nearly one million visitors. This, moreover, was the first time that the public was privileged to see so large a group of his sculptures. At the same time a remarkable exhibition of his graphic work was organized in Paris at the Bibliothèque Nationale.

In the South of France, at Notre-Dame-de-Vie, Picasso himself went on quietly working. The amazing freedom and unpredictability of his line was demonstrated in many drawings and engravings which provide fascinating insights into his inner world. These sheets of drawings and prints form a sort of private diary which shows his thoughts turning more and more to love themes.

Picasso's studio at Notre-Dame-de-Vie.

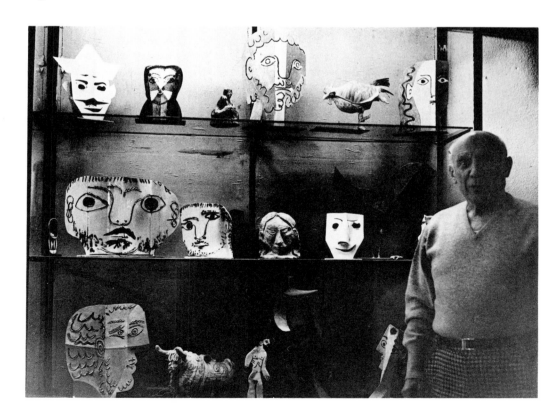

Picasso in his studio at Notre-Dame-de-Vie in 1966.

His work of these years showed an exuberant wealth of invention, both in subject matter and expression. Mythology made its reappearance. In the catalogue of the exhibition of drawings from 1966-1967, held at the Louise Leiris gallery in Paris in 1968, Michel Leiris noted: "The figures appear now singly, now in pairs (sometimes, it would seem, with love in mind: about to make it, in the act of making it, or just having made it)." He handled these subjects with a racy and uninhibited freedom. As he said himself: "It is only when painting is not painting that there can be any question of outrage."

During 1967 major exhibitions were held in London, New York, Fort Worth and Dallas, prolonging the success of the great "Homage to Picasso" show in Paris.

1967-1970

Graphic art remained one of his central concerns. Between 16 March and 5 October 1968 he produced a series of 347 prints, mostly etchings, and mostly on erotic themes.

In 1968 was published *Le Cocu magnifique* by Fernand Crommelynck illustrated with twelve etchings and aquatints by Picasso and printed by the son of the author, who worked regularly with Picasso at Mougins.

Etching, 20 August 1968 (I).

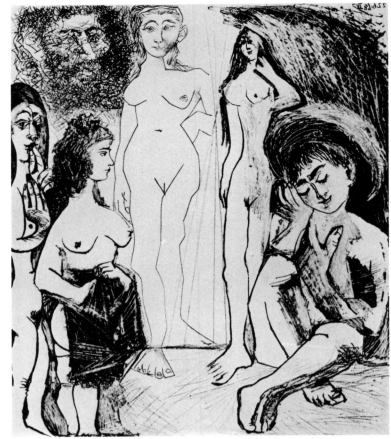

Aquatint and drypoint, 22 June 1968 (IV).

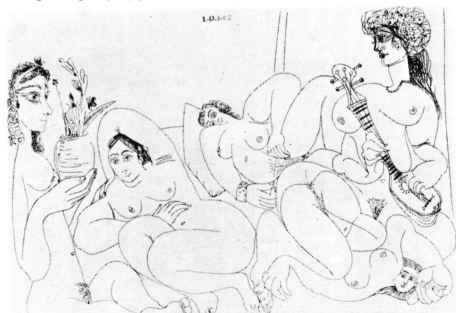

Picasso returned to painting with, as he demonstrated, renewed powers of expression. A group of 140 canvases from this period was exhibited in 1970 at the Palace of the Popes in Avignon. Christian Zervos, publisher of the complete catalogue of Picasso's work, and his wife Yvonne had marveled at the beauty and abundance of these paintings during a visit to Mougins in October 1969. Yvonne Zervos persuaded Picasso "to lay before the public the paths of creation which it had fascinated her to follow."

The artist gave his consent, and the exhibition organized by Yvonne Zervos in the Palace of the Popes, as part of the Avignon Festival, marked a further stage in the growing popularity of his work. It came as a revelation. The public was astounded by the creative vitality of a man of eighty-eight who had never seemed so young. For Picasso himself the success of the exhibition was dimmed by the death of Yvonne Zervos, followed shortly by that of Christian, who succumbed to a heart attack on 12 September 1970. With their passing, he lost two of his oldest and dearest friends, who had followed the long course of his career with unfailing loyalty and understanding. The introduction to the Avignon exhibition catalogue was the last text devoted by Zervos to the art of his friend.

The exhibition at the Palace of the Popes opened on 1 May 1970. The actor Jean Vilar declared: "Picasso is one who has lived a full life and has suffered much, and he provides us here with a lesson from man to man. Work combined with the need to create and invent is one of the greatest things offered to man, and once more we are grateful to Picasso for reminding us of it."

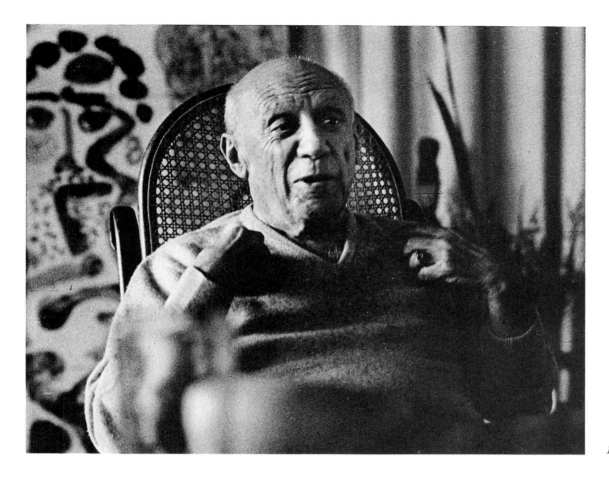

Picasso at Notre-Dame-de-Vie, 1971.

Poster for the Picasso Exhibition at Avignon, 1970.

The figures in the Avignon paintings are often musketeers. "In these musketeers, he says, we may see ourselves. They sound the secret depths of men who, in their loneliness, their courage, their disappointments, find themselves bound by a common brotherhood which means much to them, and means all the more when they come under stress of the terrible tensions involved in the search for something within themselves and their perpetual desire to be transfigured" (Christian Zervos).

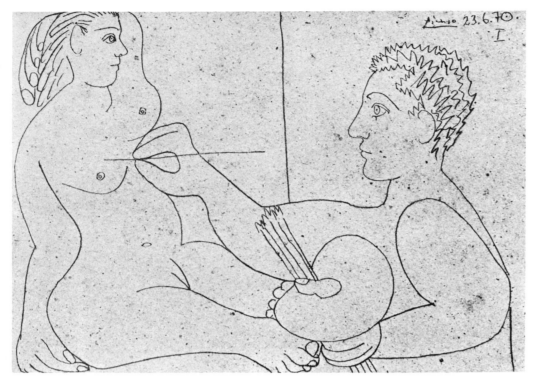

The Painter and his Model, pencil on cardboard. 23 June 1970 (I).

1971

On the 25th of October he celebrated his ninetieth birthday. The Louvre showed a selection of his work in the Grande Galerie, the first time this honor had been paid to a living artist. The Musée d'Art Moderne in Paris showed major early paintings from the Hermitage, Leningrad, and the Pushkin Museum, Moscow; some had not been seen in France since before World War I. In New York a loan exhibition spanning seventy years of his work was shared between the Marlborough and Saidenberg galleries. In London schoolchildren carrying a reproduction of Picasso's *Child holding a Dove* gathered on the steps of the Tate Gallery and ninety pigeons were released to mark the occasion.

In Paris, early in 1970, the Louise Leiris Gallery revealed to the public the set of 347 prints made in 1968, as astonishing in their vitality, variety and free invention as the Avignon paintings. And Picasso kept working. During 1970 he did some 200 drawings; their imagery—couples, the painter and his model, Harlequin—testifies to a continually renewed dialogue between the artist and art. During the summer he created works in which model and image virtually merge; what is seen and what is created become one. Despise no aspect of life to the detriment of art, and vice versa—this perhaps is the watchword that accounts for the Picasso miracle.

Late in 1970 the Picasso Museum opened its doors in Barcelona. For political reasons, and at the artist's express desire, the official inauguration was postponed.

The Picasso Museum in Barcelona contains some 800 canvases, comprising those from the artist's own collection preserved in Spain first by his mother, then by his sister Lola; the collection of Jaime Sabartès; works from several Spanish private collections; and the *Las Meninas* series, together with the studies for it, donated by Picasso in 1968. The idea of this museum was suggested by Sabartès, and its creation began in 1962 when the municipality offered to house it in the Aguilar Palace.

In Barcelona, in 1969, appeared a book with a text and thirteen engravings by Picasso: *El entierro del Conde de Orgaz.*

Picasso examining the page make-up of this book, spring 1971.

Picasso and his wife Jacqueline in Nice, 29 April 1971. Photo AGIP, Paris.

President Georges Pompidou opening the Picasso exhibition in the Grande Galerie of the Louvre on 21 October 1971. Photo AGIP, Paris.

Schoolchildren celebrating Picasso's 90th birthday on the steps of the Tate Gallery in London. Photo United Press International.

1972

As true as ever in 1972 was Adrien Farge's characterization of him in 1902: "Picasso is all sinew, verve and mettle."

Paying little attention to the honors and celebrations called forth in France and other countries by his birthday, Picasso went on working in the solitude of Notre-Dame-de-Vie at Mougins. Since the Avignon paintings of 1969-1970, he had concentrated chiefly on black and white work, proving himself as resourceful and inventive as ever. In the early months of 1972 he produced a fresh spate of drawings and prints, including many etchings and ink washes imbued with a new intensity and range of feeling.

Two Women, ink wash. 14 February 1972 II.

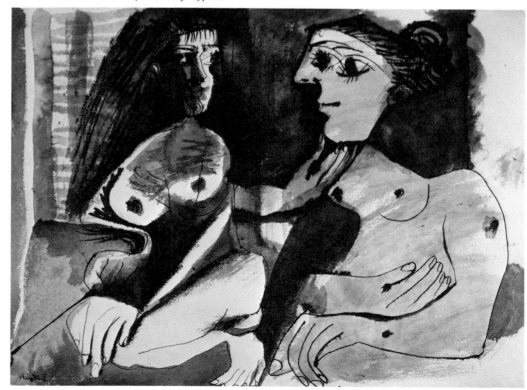

Select Bibliography

The standard catalogue of Picasso's work, edited by Christian ZERVOS, with each item illustrated, has been published at intervals since 1932 by Editions "Cahiers d'Art", Paris, and now numbers twenty-three volumes:

I, *Œuvres de 1895 à 1906*, 1932 (reprinted 1957). — II, *Œuvres de 1906 à 1912* and *Œuvres de 1912 à 1917*, 2 parts, 1942. — III, *Œuvres de 1917 à 1919*, 1949. — IV, *Œuvres de 1920 à 1922*, 1951. — V, *Œuvres de 1923 à 1925*, 1952. — VI, *Supplément aux volumes I à V*, 1952. — VII, *Œuvres de 1926 à 1932*, 1955. — VIII, *Œuvres de 1932 à 1937*, 1957. — IX, *Œuvres de 1937 à 1939*, 1959. — X, *Œuvres de 1939 et 1940*, 1959. — XI, *Œuvres de 1940 et 1941*, 1960. — XII, *Œuvres de 1942 et 1943*, 1961. — XIII, *Œuvres de 1943 et 1944*, 1962. — XIV, *Œuvres de 1944 à 1946*, 1963. — XV, *Œuvres de 1946 à 1953*, 1965. — XVI, *Œuvres de 1953 à 1955*, 1965. — XVII, *Œuvres de 1956 et 1957*, 1966. — XVIII, *Œuvres de 1958 et 1959*, 1967. — XIX, *Œuvres de 1959 à 1961*, 1968. — XX, *Œuvres de 1961 et 1962*, 1968. — XXI, *Supplément aux années 1892-1902*, 1969. — XXII, *Supplément aux années 1903-1906*, 1970. — XXIII, *Œuvres de 1962 et 1963*, 1971.

MONOGRAPHS AND GENERAL STUDIES

Maurice RAYNAL, *Picasso*, Paris 1922. — Jean COCTEAU, *Picasso*, Paris 1923. — Pierre REVERDY, *Picasso*, Paris 1924. — Waldemar GEORGE, *Picasso*, Rome 1924 (text in English). — Oskar SCHÜRER, *Pablo Picasso*, Leipzig 1927. — Wilhelm UHDE, *Picasso et la tradition française*, Paris 1928. — André LEVEL, *Picasso*, Paris 1928. — Eugenio d'ORS, *Pablo Picasso*, Paris and New York 1930. — Christian ZERVOS, *Picasso*, Milan 1932. — Fernande OLIVIER, *Picasso et ses amis*, Paris 1933. — Jaime SABARTÈS, *Picasso*, Milan 1937. — Jean CASSOU, *Picasso*, Paris 1937 (text in French, English and German). — Gertrude STEIN, *Picasso*, London 1938 and New York 1939. — Robert MELVILLE, *Picasso, Master of the Phantom*, London 1939. — Jean CASSOU, *Picasso*, Paris and New York 1940. — Helen F. MACKENZIE, *Understanding Picasso*, Chicago 1940. — Robert DESNOS, *Picasso: seize peintures 1939-1943*, Paris 1943. — Eugenio d'ORS, *El Arte de Picasso*, Madrid 1945. — W. S. LIEBERMAN, *Picasso and the Ballet*, New York 1946. — Alfred H. BARR, Jr., *Picasso, Fifty Years of his Art*, New York 1946; reprinted 1967. — Sidney and Harriet JANIS, *Picasso: The Recent Years, 1939-1946*, New York 1946. — Jaime SABARTÈS, *Picasso*,

Portraits et Souvenirs, Paris 1946. — Juan LARREA, *Guernica*, New York 1947. — Paul ELUARD, *A Pablo Picasso*, Geneva and Paris 1947. — Tristan TZARA, *Pablo Picasso*, Geneva 1948. — Jacques LASSAIGNE, *Picasso*, Paris 1949. — Roland PENROSE, *Homage to Picasso*, London 1951. — Maurice GIEURE, *Initiation à l'œuvre de Picasso*, Paris 1951. — André VERDET, *Pablo Picasso au Musée d'Antibes*, Paris 1951. — Tristan TZARA, *Picasso et la poésie*, Rome 1953. — Claude ROY, *Picasso, La Guerre et La Paix*, Paris 1954. — Franco RUSSOLI, *Pablo Picasso*, Milan and Paris 1954. — Jaime SABARTÈS, *Picasso, Documents iconographiques*, Geneva 1954. — Wilhelm BOECK and Jaime SABARTÈS, *Picasso*, London and New York 1955. — Frank ELGAR and Robert MAILLARD, *Picasso*, Paris and London 1955. — VERCORS, D. H. KAHNWEILER and Hélène PARMELIN, *Picasso, Œuvres des musées de Leningrad et de Moscou*, Paris 1955. — Maurice JARDOT, *Picasso 1900-1955*, Paris 1955. — Pierre DESCARGUES, *Picasso*, Paris 1956. — Roland PENROSE, *Portrait of Picasso*, London 1956, New York 1957; revised edition 1972. — Antonina VALLENTIN, *Picasso*, Paris 1957, New York and London 1963. — Roland PENROSE, *Picasso, His Life and Work*, London and New York 1958. — D. D. DUNCAN, *The Private World of Pablo Picasso*, New York and London 1958. — Jaime SABARTÈS, *Picasso, Les Ménines*, Paris 1958. — Hélène PARMELIN, *Picasso sur la place*, Paris 1959. — L. GUNTHER, *Picasso : A Pictorial Biography*, New York 1959. — L. G. BUCHHEIM, *Picasso*, London 1959. — Jacques PRÉVERT, *Portraits de Picasso*, Milan 1959. — P. de CHAMPRIS, *Picasso, ombre et soleil*, Paris 1960. — Gaston DIEHL, *Picasso*, Paris 1960. — Dor de la SOUCHÈRE, *Picasso à Antibes*, Paris 1960. — L. M. DOMINGUIN and Georges BOUDAILLE, *Toros y toreros*, Paris 1961. — D. D. DUNCAN, *Picasso's Picassos*, London 1961 and New York 1963. — Rudolf ARNHEIM, *Picasso's Guernica, The Genesis of a Painting*, Los Angeles and London 1962. — Douglas COOPER, *Picasso, Les Déjeuners*, New York and London 1963. — Françoise GILOT and Carlton LAKE, *Life with Picasso*, New York and London 1964. — BRASSAÏ, *Conversations avec Picasso*, Paris 1964; *Picasso and Company*, New York and London 1966. — Pierre DAIX, *Picasso*, Paris 1964, New York and London 1965. — Hans L. C. JAFFÉ, *Picasso*, New York and London 1964. — Mario de MICHELI, *Scritti di Picasso*, Milan 1964. — Hélène PARMELIN, *Les Dames de Mougins*, Paris 1964. — John BERGER, *Success and Failure of Picasso*, London 1965. — Hélène PARMELIN, *Le peintre et son modèle*, Paris 1965. — Edward QUINN and Roland PENROSE, *Picasso at Work*, London and New York 1965. — Hélène PARMELIN, *Notre-Dame-de-Vie*, Paris 1966. — Lael WERTENBAKER, *The World of Picasso*, New York 1967. — André FERMIGIER, Michel del CASTILLO, Jean GRENIER, Paul GUINARD, D. MILHAU, Gaëtan PICON, Claude ROY and Dora VALLIER, *Picasso*, Paris 1967. — Douglas COOPER, *Picasso : Theatre*, London and New York 1968. — Anthony BLUNT, *Picasso's Guernica*, Oxford 1969. — Pierre DUFOUR, *Picasso 1950-1968*, Geneva 1969 (English, French and German editions). — André FERMIGIER, *Picasso*, Paris 1969. — Klaus GALLWITZ, *Picasso at 90, The Later Work*, New York and London 1971.

THE EARLY WORK

Alexandre CIRICI-PELLICER, *Picasso antes de Picasso*, Barcelona 1946; revised French edition, *Picasso avant Picasso*, Geneva 1950. — Denys SUTTON, *Picasso, peintures, époques bleue et rose*, Paris 1948. — J. F. RAFOLS, *Modernismo y Modernistas*, Barcelona 1949. — W. S. LIEBERMAN, *Picasso : Blue and Rose Periods*, New York 1952. — *Picasso, Œuvres des musées de Leningrad et de Moscou, 1900 à 1914*, exhibition catalogue, Maison de la Pensée française, Paris 1954. — *Els Quatre Gats*, exhibition catalogue, Sala Parés, Barcelona, 1954. — Frank ELGAR, *Picasso, époques bleue et rose*, Paris 1956. — Anthony BLUNT and Phoebe POOL, *Picasso, The Formative Years, A Study of his Sources*, London and New York 1962. — Jaime SABARTÈS, *Picasso, Les Bleus de Barcelone*, Paris 1963. — Georges BOUDAILLE, *Picasso, première époque, 1881-1906*, Paris 1964. — Pierre DAIX and Georges BOUDAILLE, *Picasso 1900-1906*, Neuchâtel and Paris 1966; *Picasso : The Blue and Rose Periods. A Catalogue Raisonné, 1900-1906*, London and New York 1966. — Josep PALAU I FABRE, *Picasso en Cataluña*, Barcelona 1966 (text in Spanish, English, French and German). — Juan Eduardo CIRLOT, *Picasso, Birth of a Genius : The Unknown Masterpieces of his Youth*, New York and London 1972.

CUBISM

Albert GLEIZES and Jean METZINGER, *Du cubisme*, Paris 1912. — Guillaume APOLLINAIRE, *Les peintres cubistes*, Paris 1913 and 1965; *The Cubist Painters*, New York 1944. — Gustave COQUIOT, *Cubistes, futuristes, passéistes*, Paris 1914. — D. H. KAHNWEILER, *Der Weg zum Kubismus*, Munich 1920 and Stuttgart 1958; *The Rise of Cubism*, New York 1949. — Alfred H. BARR, Jr., *Cubism and Abstract Art*, New York 1936. — Ramón GÓMEZ DE LA SERNA, *Completa y verídica historia de Picasso y el cubismo*, Turin 1945. — Christopher GRAY, *Cubist Aesthetic Theories*, Baltimore 1953. — *Le cubisme*, exhibition catalogue, Musée d'Art moderne, Paris, January-April 1953. — François FOSCA, *Bilan du cubisme*, Paris 1956. — Frank ELGAR, *Picasso : Cubist Period*, New York 1956. — José CAMÓN AZNAR, *Picasso y el cubismo*, Madrid 1956. — Guy HABASQUE, *Cubism*, Geneva 1959 (editions in English, French and German). — John GOLDING, *Cubism*, London and New York 1959, new edition 1969. — Guillaume APOLLINAIRE, *Chroniques d'Art 1902-1918*, edited by L. C. Breunig, Paris 1960. — Robert ROSENBLUM, *Cubism and Twentieth-Century Art*, New York and London 1960-1961. — Pierre CABANNE, *L'Epopée du cubisme*, Paris 1963. — D. H. KAHNWEILER, *L'Art nègre et le Cubisme*, in *Confessions esthétiques*, Paris 1963. — Edward F. FRY, *Cubism*, London and New York 1966. — Jean LAUDE, *La peinture française (1905-1914) et l'Art nègre*, Paris 1968. — Jean PAULHAN, *La peinture cubiste*, Paris 1970. — Douglas COOPER, *The Cubist Epoch*, London and New York 1971. — P. W. SCHWARTZ, *Cubism*, New York 1971.

GRAPHIC WORK

Bernhard GEISER, *Picasso, peintre-graveur, Catalogue illustré de l'œuvre gravé et lithographié, 1899-1931*, Bern 1933; reprinted 1955. — Fernand MOURLOT, *Picasso lithographe*, Vols. I to V, Monte Carlo 1949, 1950, 1956, 1965, 1970. — E. ROSENTHAL, *Picasso, Painter and Engraver*, San Francisco 1952. — *L'œuvre gravé de Picasso*, exhibition catalogue, Musée Rath, Geneva 1954. — *Das graphische Werk Picassos*, exhibition catalogue, Kunsthaus, Zurich 1954. — *Picasso, L'œuvre gravé*, exhibition catalogue, Bibliothèque Nationale, Paris 1955. — Hans BOLLIGER, *Picasso, Vollard Suite*, London 1956, and *Picasso for Vollard*, New York 1956. — *Picasso : Fifty Years of his Graphic Art*, exhibition catalogue, Arts Council, London 1956. — *Picasso : 45 gravures sur linoléum 1958-60*, exhibition catalogue, Galerie Louise Leiris, Paris 1960. — *Picasso, 60 ans de gravure*, exhibition catalogue, Galerie Berggruen, Paris 1964. — J. K. FOSTER, *The Posters of Picasso*, New York 1964. — Bernhard GEISER and Hans BOLLIGER, *Picasso : His Graphic Work*, Vol. 1, 1899-1955, London 1966. — Kurt LEONHARD, *Picasso : His Graphic Work*, Vol. 2, 1955-1965, London 1967. — *Picasso, 347 gravures 16.3.68-5.10.68*, exhibition catalogue, Galerie Louise Leiris, Paris 1968. — C. CZWIKLITZER, *290 affiches de Pablo Picasso*, Paris 1968. — Bernhard GEISER, *Picasso, peintre-graveur, Catalogue illustré de l'œuvre gravé et des monotypes, 1932-1934*, Bern 1968. — Georges BLOCH, *Picasso, Catalogue de l'œuvre gravé et lithographié, 1904-1967*, Vol. 1, Bern 1968. — Georges BLOCH, *Picasso, Catalogue de l'œuvre gravé et lithographié, 1966-1969*, Vol. 2, Bern 1971. — C. CZWIKLITZER, *Picasso Posters*, New York 1971.

SCULPTURE

Julio GONZALEZ, "Picasso sculpteur", *Cahiers d'Art*, II, No. 6-7, Paris 1936. — Enrico PRAMPOLINI, *Picasso scultore*, Rome 1943. — D. H. KAHNWEILER, *Les Sculptures de Picasso*, Paris 1948 (photographs by BRASSAÏ); *The Sculptures of Picasso*, London 1949. — G. C. ARGAN, *Scultura di Picasso*, Venice 1953 (text in Italian and English). — Pierre GASCAR, Georges PATRIX, Michel RAGON, D. L. GERVIS, *Picasso et le béton*, Galerie Jeanne Bucher, Paris 1966. — Roland PENROSE, *The Sculpture of Picasso*, New York 1967. — Gjon MILI, *Picasso's Third Dimension*, New York 1970. — Werner SPIES, *Picasso Sculpture*, with complete catalogue, New York and London 1972.

DRAWINGS

Waldemar GEORGE, *Picasso, Dessins*, Paris 1926. — S. SOLMI, *Disegni di Picasso*, Milan 1945. — Christian ZERVOS, *Dessins de Picasso, 1892-1948*, Paris 1949. — Jean BOURET, *Picasso, Dessins*, Paris 1950. — Paul ELUARD, *Picasso, Dessins*, Paris 1952. — *Verve*, VIII, No. 29-30, Paris 1954 (special issue devoted to a series of 180 drawings). — D. H. KAHNWEILER, *Picasso: Dessins 1903-1907*, Paris 1954. — *Picasso, Dessins, Gouaches, Aquarelles 1898-1957*, exhibition catalogue, Musée Réattu, Arles 1957. — Douglas COOPER, *Picasso, Carnet catalan*, Paris 1958. — Georges BOUDAILLE, *Pablo Picasso, Carnet de La Californie*, Paris 1959. — Maurice JARDOT, *Picasso, Dessins*, Paris 1959. — Jacob ROSENBERG, *Great Draughtsmen from Pisanello to Picasso*, Cambridge, Mass. 1959. — Francis PONGE and J. CHESSEX, *Dessins de Pablo Picasso, Epoques bleue et rose*, Lausanne 1960. — *Picasso, Dessins 1959-60*, exhibition catalogue, Galerie Louise Leiris, Paris 1960. — A. MILLIER, *The Drawings of Picasso*, Los Angeles 1961. — John RICHARDSON, *Picasso, Watercolours and Gouaches*, London 1964. — *Picasso, 150 Handzeichnungen aus sieben Jahrzehnten*, exhibition catalogue, Kunstverein, Frankfurt and Hamburg 1965. — Jean LEYMARIE, *Picasso Drawings*, Geneva 1967. — *Picasso, Drawings, Watercolors and Pastels*, exhibition catalogue, Fort Worth Art Center Museum 1967. — Charles FELD, preface by René CHAR, *Picasso Dessins 27.3.66-15.3.68*, Paris 1969.

CERAMICS

Suzanne and Georges RAMIÉ, *Céramiques de Picasso*, Geneva 1948; *Picasso, Ceramics*, Geneva 1950. — *Cahiers d'Art*, Paris 1948 (special number on the ceramics). — Jaime SABARTÈS, *Picasso ceramista*, Milan 1953. — D. H. KAHNWEILER, *Picasso, Keramik. Ceramic. Céramiques*, Hanover 1957 (text in English, French and German). — Georges RAMIÉ, *Picasso: Pottery*, New York 1962.

MAGAZINE ARTICLES AND SPECIAL ISSUES

Max JACOB, "Souvenirs sur Picasso", *Cahiers d'Art*, Paris 1927. — *Documents*, No. 3, Paris 1930. — *Cahiers d'Art*, 7, No. 3-5, Paris 1932. — C. G. JUNG, "Picasso", *Neue Zürcher Zeitung*, No. 13, Zurich 1932. — *Cahiers d'Art*, 10, No. 7-10, Paris 1935. — *Gaceta de Arte*, Tenerife 1936. — *Cahiers d'Art*, 12, No. 4-5, Paris 1937 (on *Guernica*). — *Cahiers d'Art*, 13, No. 3-10, Paris 1938. — J. J. SWEENEY, "Picasso and Iberian Sculpture", *Art Bulletin*, 23, No. 3, New York 1941. — *Ver y Estimar*, I, 2, Buenos Aires 1948. — *Verve*, V, No. 19-20, Paris 1948 (Picasso at Antibes). — *Cahiers d'Art*, 23, No. 1, Paris 1948 (drawings, ceramics and the Antibes Museum). — Christian ZERVOS, "Œuvres et images inédites de la jeunesse de Picasso", *Cahiers d'Art*, 2, Paris 1950. — *Verve*, VII, No. 25-26, Paris 1951 (Picasso at Vallauris). — *Le Point*, XLII, Souillac and Mulhouse, October 1952. — *Commentari*, IV, No. 3, Rome 1953. — *La Biennale di Venezia*, No. 13-14, Venice 1953. — *Realismo*, 9-10, 11-12, Rome, March-April 1953. — *Du*, No. 7, Zurich, July 1954. — *Verve*, VIII, No. 29-30, Paris 1954 (on a series of 180 drawings). — R. BERNIER, "Barcelone, 48 Paseo de Gracia", *L'Œil*, No. 4, Paris 1955. — John RICHARDSON, "Picasso's Ateliers and Other Recent Works", *Burlington Magazine*, XCIX, London, June 1957. — John GOLDING, "The Demoiselles d'Avignon", *Burlington Magazine*, C, London, May 1958. — Phoebe POOL, "Sources and Background of

Picasso's Art", *Burlington Magazine*, CI, London, May 1959. — *Papeles de Son Armadans*, V, No. 49, Valencia 1960. — L. PREJGER, "Picasso découpe le fer", *L'Œil*, Paris, October 1961. — *Du*, Zurich, October 1961 (80th birthday number). — *La Nouvelle Critique*, No. 30, Paris, November 1961. — G. C. ARGAN, "Picasso, il simbolo e il mito", *España libre*, 1965. — Jean SUTHERLAND BOGGS, "Picasso and the Theatre at Toulouse", *Burlington Magazine*, London, January 1966. — Anthony BLUNT, "Picasso's Classical Period (1917-1925)", *Burlington Magazine*, London, April 1968. — Robert ROSENBLUM, "Picasso and the Coronation of Alexander III: A Note on the Dating of some *Papiers Collés*", *Burlington Magazine*, London, October 1971.

PRINCIPAL BOOKS ILLUSTRATED BY PICASSO

Consult: H. MATARASSO, *Bibliographie des livres illustrés par Picasso*, Nice 1956. — Abraham HORODISCH, *Picasso as a Book Artist*, New York and London 1962. — Georges BLOCH, *Picasso, Catalogue de l'œuvre gravé et lithographié*, Vol. I (1904-1967), Bern 1968, and Vol. II (1966-1969), Bern 1971 (with a list of all books containing engravings, etchings and lithographs by Picasso).

Max JACOB, *Saint Matorel*, Paris 1911 (4 etchings); *Le Siège de Jérusalem*, Paris 1914 (3 etchings and drypoints). — André SALMON, *Le manuscrit trouvé dans un chapeau*, Paris 1919 (38 drawings). — Pierre REVERDY, *Cravates de chanvre*, Paris 1922 (3 etchings). — Honoré de BALZAC, *Le Chef-d'œuvre inconnu*, Paris 1931 (13 etchings and 67 drawings). — OVID, *Les Métamorphoses*, Lausanne 1931 (30 etchings). — ARISTOPHANES, *Lysistrata*, New York 1934 (6 etchings). — Paul ELUARD, *La barre d'appui*, Paris 1936 (3 etchings). — Pablo PICASSO, *Sueño y Mentira de Franco*, Paris 1937 (an engraved title and 2 aquatints). — ILIAZD, *Afat*, Paris 1940 (6 engravings). — BUFFON, *Histoire Naturelle*, Paris 1942 (31 etchings). — Georges HUGNET, *Non Vouloir*, Paris 1942 (drawings); *La Chèvre-feuille*, Paris 1943 (drawings). — Ramón REVENTÓS, *Dos Contes*, Paris-Barcelona 1947 (4 etchings); *Deux Contes*, Paris 1947 (4 etchings). — ILIAZD, *Escrito*, Paris 1948 (6 etchings). — GONGORA, *Vingt Poèmes*, Paris 1948 (41 etchings and some drawings). — Pierre REVERDY, *Le chant des morts*, Paris 1948 (125 lithographs). — Prosper MÉRIMÉE, *Carmen*, Paris 1949 (38 copperplate engravings). — Yvan GOLL, *Elégie d'Ihpétonga*, Paris 1949 (4 lithographs). — Aimé CÉSAIRE, *Corps perdu*, Paris 1950 (12 etchings). — Tristan TZARA, *De mémoire d'homme*, Paris 1950 (9 lithographs). — Paul ELUARD, *Le visage de la paix*, Paris 1951 (29 drawings). — Adrian de MONLUC, *La maigre*, Paris 1952 (10 drypoints). — Maurice TOESCA, *Six contes fantasques*, Paris 1953 (6 copperplate engravings). — Pablo PICASSO, *Poèmes et lithographies*, Paris 1954 (14 lithographs). — Tristan TZARA, *A haute flamme*, Paris 1955 (6 celluloid cuts). — Roch GREY, *Chevaux de minuit. Epopée*, Paris 1956 (13 drypoints and copperplate engravings). — Max JACOB, *Chronique des temps héroïques*, Paris 1956 (3 drypoints and 3 lithographs). — José DELGADO (alias Pepe Illo), *La Tauromaquía, o Arte de torear*, Barcelona 1959 (26 aquatints and 1 etching). — Pablo PICASSO, *Le frère mendiant*, or *Libro del Conocimiento*, Paris 1959 (18 drypoints). — Pablo NERUDA, *Toros*, Paris 1960 (15 wash drawings). — Jaime SABARTÈS, *A los toros avec Picasso*, Paris 1961 (103 wash drawings and 4 lithographs). — Pierre REVERDY, *Sable mouvant*, Paris 1966 (10 aquatints). — René CHAR, *Les transparents*, Alès 1967 (4 celluloid cuts). — Fernand CROMMELYNCK, *Le Cocu magnifique*, Paris 1968 (12 etchings and aquatints). — Pablo PICASSO, *El entierro del Conde de Orgaz*, Barcelona 1969 (1 copperplate engraving, 9 etchings, 3 etchings and drypoints). — Fernando de ROJAS, *La Célestine*, Paris 1971 (66 engravings).

List of Illustrations

PICASSO: WORKS REPRODUCED

OTHER WORKS REPRODUCED

Source List
of
Quotations

Page 5.
APOLLINAIRE Guillaume, *Marches de Provence*, February 1912, reprinted in Guillaume Apollinaire, *Chroniques d'Art 1902-1918*, edited by L. C. Breunig, Gallimard, Paris 1960. © Editions Gallimard 1960.

Pages 10, 12, 22, 118, 211, 212.
APOLLINAIRE Guillaume, *La Plume*, Paris, 15 May 1905, reprinted in *Chroniques d'Art 1902-1918*, edited by L. C. Breunig, Gallimard, Paris 1960. © Editions Gallimard 1960.

Pages 17, 20, 21.
APOLLINAIRE Guillaume, *Alcools*, Paris 1913, reprinted in *Œuvres poétiques*, edited by Marcel Adéma and Michel Décaudin, Gallimard, Bibliothèque de la Pléiade, Paris 1965. © Editions Gallimard 1965.

Pages 46, 232.
APOLLINAIRE Guillaume, preface to the program of *Parade*, Paris 1917. Reprinted in *Chroniques d'Art 1902-1918*, edited by L. C. Breunig, Gallimard, Paris 1960. © Editions Gallimard 1960.

Pages 218, 223, 226, 228, 234.
APOLLINAIRE Guillaume, *Chroniques d'Art 1902-1918*, edited by L. C. Breunig, Gallimard, Paris 1960. © Editions Gallimard 1960.

Pages 41, 51.
ARAGON Louis, *La peinture au défi*, preface to a collage exhibition at the Galerie Goemans, Paris 1930.

Page 192.
ARP Jean, 1964, answer to a questionnaire.

Page 232.
BAKST Leon, quoted in Jean Cocteau, *Entre Picasso et Radiguet*, Miroirs de l'Art, Hermann, Paris 1967.

Page 114.
BARR Alfred H., Jr., *Picasso, Fifty Years of His Art*, The Museum of Modern Art, New York 1946.

Page 101.
BERGAMIN José, "Picasso furioso", *Cahiers d'Art*, Paris 1937, No. 4-5.

Page 262.
BOURET Jean, *Arts*, Paris, 26 November 1948.

Page 36.
BRAQUE Georges, "Propos de Braque", *Cahiers d'Art*, Paris 1935, No. 7-10.

Pages 38, 217, 219, 222, 224, 227.
BRAQUE Georges, "Propos recueillis par Dora Vallier", *Cahiers d'Art*, Paris 1954.

Pages 68, 105, 243, 244, 246, 254, 255, 256, 276.
BRASSAÏ, *Picasso and Company*, translated from the French by Frank Price, Doubleday, New York, and Thames and Hudson, London 1966.

Pages 34, 37, 220, 239.
BRETON André, *Le surréalisme et la peinture*, Gallimard, Paris 1928; revised edition, Gallimard, Paris 1960.

Pages 62, 245.
BRETON André, "Picasso dans son élément", *Minotaure*, No. 1, Paris 1933.

Page 240.
BRETON André, *Genèse et perspective artistiques du surréalisme*, Brentano's, New York 1945.

Page 41.
BRETON André, "Hommage à Picasso", *Combat*, Paris, 6 November 1961.

Page 88.
CASSOU Jean, *Picasso*, Hypérion, Paris 1940.

Pages 115, 280.
CHAR René, 1939, preface to Charles Feld, *Picasso Dessins*, Editions du Cercle d'Art, Paris 1969.

Pages 230, 232, 237.
COCTEAU Jean, *Entre Picasso et Radiguet*, Miroirs de l'Art, Hermann, Paris 1967.

Page 187.
COOPER Douglas, *Pablo Picasso : Les Déjeuners*, Harry N. Abrams, Inc., New York, and Thames and Hudson, London 1963.

Page 260.
DAIX, Pierre, *Picasso, L'homme, son œuvre*, Somogy, Paris 1964.

Pages 111, 129.
DESNOS Robert, 1943, text published by Editions du Chêne, Paris 1950.

Page 158.
DOMINGUIN Luis Miguel, 1957, preface to *Toros y toreros*, Editions du Cercle d'Art, Paris 1961.

Page 123.
D'ORS Eugenio, "Lettre à Picasso", *Almanach des Arts*, Fayard, Paris 1937.

Page 269.
DUFOUR Pierre, *Picasso 1950-1968*, Skira, Geneva 1969.

Page 265
EHRENBURG Ilya, "Souvenirs sur Picasso", *La Nouvelle Critique*, special issue, Paris, November 1961.

Pages 40, 50, 74.
ELUARD Paul, "Je parle de ce qui est bien", *Cahiers d'Art*, Paris 1935, No. 7-10.

Page 100.
ELUARD Paul, "La victoire de Guernica", poem, *Cahiers d'Art*, Paris 1937, No. 4-5.

Pages 38, 52, 56, 57, 78, 105.
ELUARD Paul, *A Pablo Picasso*, Editions des Trois Collines, Geneva-Paris 1944.

Page 121.
ELUARD Paul, "Le travail du peintre", in *Voir*, Editions des Trois Collines, Geneva-Paris 1948.

Pages 125, 260.
ELUARD Paul, *Œuvres complètes*, Bibliothèque de la Pléiade, Gallimard, Paris 1968. © Editions Gallimard 1968.

Page 127.
ELYTIS Odysseus, *Verve*, VII, No. 25-26, Paris 1951, special issue on Picasso at Vallauris.

Pages 207, 285.
FARGE Adrien, preface to the Picasso exhibition at Berthe Weill's, Paris, April 1902.

Page 232.
FERMIGIER André, preface to Jean Cocteau, *Entre Picasso et Radiguet*, Miroirs de l'Art, Hermann, Paris 1967.

Page 158.
GOMEZ DE LA SERNA Ramón, *Cahiers d'Art*, Paris 1932, No. 3-5.

Page 243.
GONZALEZ Julio, "Picasso sculpteur", *Cahiers d'Art*, Paris 1936, No. 6-7.

Page 242.
GUÉGUEN Pierre, *Cahiers d'Art*, Paris 1932, No. 3-5.

Page 58.
HEINE Maurice, *Documents*, No. 3, Paris 1930.

Page 226.
KAHNWEILER Daniel-Henry, *Juan Gris*, Gallimard, Paris 1946.

Page 114.
KAHNWEILER Daniel-Henry, *Verve*, VII, No. 25-26, Paris 1951, special issue on Picasso at Vallauris.

Pages 216, 243.
KAHNWEILER Daniel-Henry, *Le Point*, Souillac-Mulhouse, October 1952, special Picasso number.

Page 216.
KAHNWEILER Daniel-Henry, "Picasso et le cubisme", preface to the catalogue of the Picasso exhibition, Musée des Beaux-Arts, Lyons 1953.

Page 214.
KAHNWEILER Daniel-Henry, preface to the exhibition *Picasso, Dessins 1903-1907* at the Galerie Berggruen, Paris 1954.

Pages 31, 33, 224, 225, 255, 259.
KAHNWEILER Daniel-Henry, *Entretiens avec Francis Crémieux*, Gallimard, Paris 1961.

Pages 221, 228, 229.
KAHNWEILER Daniel-Henry, *Confessions esthétiques*, Gallimard, Paris 1963.

Page 270.
KAHNWEILER Daniel-Henry, introduction to Pierre Dufour, *Picasso 1950-1968*, Skira, Geneva 1969.

Page 225.
LÉGER Fernand, quoted by André Verdet, *Fernand Léger*, Cailler, Geneva 1955.

Page 251.
LEIRIS Michel, "Faire-part", *Cahiers d'Art*, Paris 1937, No. 12.

Pages 160, 276.
LEIRIS Michel, preface to the catalogue of the Picasso exhibition *Romancero du picador*, Galerie Louise Leiris, Paris, November-December 1960.

Page 191.
LEIRIS Michel, preface to the catalogue of the exhibition *Picasso, Peintures 1962-1963*, Galerie Louise Leiris, Paris, January-February 1964.

Page 261.
LEIRIS Michel, *Brisées*, Mercure de France, Paris 1966.

Page 282.
LEIRIS Michel, preface to the catalogue of the exhibition of Picasso drawings at the Galerie Louise Leiris, Paris 1968.

Page 222.
LEYMARIE Jean, *Derain*, Trésors de la Peinture Française, Skira, Geneva 1948.

Page 190.
MARITAIN Jacques, *Cahiers d'Art*, Paris 1932, No. 3-5.

Page 263.
MOUSSINAC Léon, *Les Lettres Françaises*, Paris, 2 December 1948.

Pages 209, 213, 214, 218, 223.
OLIVIER Fernande, *Picasso et ses amis*, Stock, Paris 1933.

Page 200.
PALAU I FABRE Josep, *Picasso en Cataluña*, Barcelona 1966.

Page 67.
PARMELIN Hélène, *Les Dames de Mougins*, Editions du Cercle d'Art, Paris 1964.

Pages 162, 271.
PARMELIN Hélène, *Notre-Dame-de-Vie*, Editions du Cercle d'Art, Paris 1966.

Pages 201, 232, 234, 270.
PENROSE Roland, *Picasso: His Life and Work*, Victor Gollancz Ltd, London, and Harper & Row, New York 1958.

Page 16.
PONGE Francis, *Picasso, Dessins époques bleue et rose*, Mermod, Lausanne 1960.

Page 263.
RAMIÉ Georges (Madoura), *Cahiers d'Art*, Paris 1948, No. 1, special Picasso number.

Page 69.
RAMIÉ Georges, *Verve*, VII, No. 25-26, Paris 1951, special issue on Picasso at Vallauris.

Page 221.
RAYNAL Maurice, "Conception et vision", *Gil Blas*, Paris, 29 August 1912.

Page 203.
RAYNAL Maurice, *Le Point*, Souillac-Mulhouse, October 1952, special Picasso number.

Pages 198, 208, 215.
RAYNAL Maurice, *Picasso*, The Taste of Our Time, Skira, Geneva 1953.

Page 223.
READ Herbert, *A Concise History of Modern Painting*, Thames and Hudson, London 1959.

Pages 6, 31, 54.
REVERDY Pierre, *Picasso*, Les Peintres Français Nouveaux, Paris 1924.

Page 20.
RILKE Rainer Maria, *Duino Elegies*, translated from the German by J. B. Leishman and Stephen Spender, The Hogarth Press, London, and W. W. Norton and Company, Inc., New York 1939.

Page 143.
ROY Claude, *L'amour de la peinture*, Gallimard, Paris 1956 (*Picasso, chemin faisant*).

Pages 206, 207.
SABARTÈS Jaime, *Picasso, Portraits et Souvenirs*, Editions Louis Carré, Paris 1946.

Pages 202, 204, 234, 247.
SABARTÈS Jaime, *Picasso, Documents iconographiques*, Cailler, Geneva 1954.

Page 147.
SALLES Georges, *Quadrum*, 1958.

Page 1.
SALMON André, *Cahiers d'Art*, Paris 1932, No. 3-5.

Page 209.
SALMON André, *Souvenirs sans fin*, Gallimard, Paris 1955.

Pages 209, 210, 211, 213, 220, 231, 249.
STEIN Gertrude, *Picasso*, B. T. Batsford, Ltd, London 1938, and Charles Scribner's Sons, New York 1939.

Page 231.
STRAVINSKY Igor, *An Autobiography*, W. W. Norton and Company, Inc., New York 1936.

Page 71.
TZARA Tristan, *Picasso et les chemins de la connaissance*, Trésors de la Peinture Française, Skira, Geneva 1948.

Pages 170, 176.
VALLENTIN Antonina, *Picasso*, Doubleday, New York, and Cassell, London 1963.

Pages 241, 242.
ZERVOS Christian, *Picasso, Œuvres de 1926 à 1932*, Vol. VII, Editions Cahiers d'Art, Paris 1955.

Pages 282, 283.
ZERVOS Christian, preface to the catalogue of the Picasso exhibition at the Palace of the Popes, Avignon 1970.

STATEMENTS BY PICASSO

Pages 42, 43, 218.
PICASSO, quoted by Florent Fels, *Propos d'artistes*, Paris 1925.

Pages 75, 165.
PICASSO, letter published in *Formes*, No. 2, 1930.

Pages 80, 129, 155, 190, 192, 272.
PICASSO, "Propos à Tériade", *L'Intransigeant*, Paris, 15 June 1932.

Pages 35, 77, 79, 89, 105, 106, 107, 112, 168, 182, 185, 186, 187, 236.
PICASSO, "Conversation avec Christian Zervos", *Cahiers d'Art*, Paris 1935, No. 7-10.

Page 257.
PICASSO, interview published in *L'Humanité*, Paris, 29 October 1944.

Page 115.
PICASSO, interview given to Simone Téry, *Les Lettres Françaises*, Paris, 24 March 1945.

Page 254.
PICASSO, text written on 13 May 1941 and published in *Cahiers d'Art*, Paris 1948, No. 1, special Picasso issue.

Pages 178, 216.
PICASSO, *Entretiens avec D. H. Kahnweiler*, published in *Le Point*, Souillac-Mulhouse, October 1952, special Picasso number.

Pages 143, 268.
PICASSO, quoted by Claude Roy, *L'amour de la peinture*, Gallimard, Paris 1956 (*Picasso, chemin faisant*).

Page 237.
PICASSO, quoted by Antonina Vallentin, *Picasso*, Doubleday, New York, and Cassell, London 1963.

Page 221.
PICASSO, quoted by Herbert Read, *A Concise History of Modern Painting*, Thames and Hudson, London 1959.

Page 215.
PICASSO, quoted by D. H. Kahnweiler, *Entretiens avec Francis Crémieux*, Gallimard, Paris 1961.

Page 181.
PICASSO, quoted in the catalogue of the exhibition *Picasso, An American Tribute*, New York 1962.

Pages 169, 191.
PICASSO, quoted in the preface to the catalogue of the exhibition at the Galerie Louise Leiris, Paris, January-February 1964.

Pages 68, 104, 105, 256, 276.
PICASSO, quoted by Brassaï, *Picasso and Company*, translated from the French by Frank Price, Doubleday, New York, and Thames and Hudson, London 1966.

Pages 100, 251, 260, 268.
PICASSO, quoted by Pierre Daix, *Picasso, L'homme, son œuvre*, Somogy, Paris 1964.

Pages 78, 88, 166, 167, 192, 194, 260, 278, 279, 282.
PICASSO, quoted by Hélène Parmelin, *Picasso dit*, Gonthier, Paris 1966.

Page 236.
PICASSO, statement to Marius de Zayas, *The Arts*, New York, May 1923, quoted by Alfred H. Barr, Jr., *Picasso, Fifty Years of His Art*, The Museum of Modern Art, New York 1946.

ACKNOWLEDGMENTS

Harry N. Abrams, Inc., New York, and Thames and Hudson, Ltd, London: From *Pablo Picasso: Les Déjeuners* by Douglas Cooper, 1963.

Doubleday & Company, Inc., New York, Thames and Hudson, Ltd, London, and Editions Gallimard, Paris: From *Conversations avec Picasso* (Picasso & Co.) by Brassaï, © Editions Gallimard 1964, from *Picasso and Company* by Brassaï, translated by Frank Price. Copyright © 1966 by Doubleday & Company, Inc. Reprinted by permission of Doubleday & Company, Inc., Thames and Hudson, Ltd, and Editions Gallimard.

Doubleday & Company, Inc., New York, and Cassell & Co. Ltd, London: From *Picasso* by Antonina Vallentin, translated by Michel Hoffman. This translation Copyright © Cassell & Co. Ltd, 1963. Reprinted by permission of Doubleday & Company, Inc., and Cassell & Co. Ltd.

Harper & Row, Publishers, New York, and Victor Gollancz, Ltd, London: From *Picasso: His Life and Work* by Roland Penrose, 1958.

David Higham Associates, Ltd, London: *Picasso* by Gertrude Stein, B. T. Batsford, Ltd, London 1938, and Charles Scribner's Sons, New York 1939.

Mr Stephen Spender, St. John's College, Oxford, the Hogarth Press, Ltd, London, and W. W. Norton & Company, Inc., New York: From *Duino Elegies* by Rainer Maria Rilke, translated by J. B. Leishman and Stephen Spender. Copyright 1939 by W. W. Norton & Company, Inc., and the Hogarth Press. Copyright © renewed 1967 by Stephen Spender and J. B. Leishman. By permission of W. W. Norton & Company, Inc., and the Hogarth Press.

M. and J. Steuer: From *Igor Stravinsky, An Autobiography*.

Index of Names and Places

PUBLISHED MAY 1972

TEXT, COLOR PLATES AND BLACK-AND-WHITE ILLUSTRATIONS
PRINTED BY IMPRIMERIES RÉUNIES S.A., LAUSANNE
UNDER THE TECHNICAL DIRECTION OF
EDITIONS D'ART ALBERT SKIRA, GENEVA

BOUND BY MAYER & SOUTTER S.A., RENENS-LAUSANNE

PRINTED IN SWITZERLAND